THE DREAM COLONY

THE DREAM COLONY

A LIFE IN ART

WALTER HOPPS

Edited by Deborah Treisman,
from interviews with Anne Doran

Introduction by Ed Ruscha

BLOOMSBURY

NEW YORK • LONDON • OXFORD • NEW DELHI • SYDNEY

Bloomsbury USA
An imprint of Bloomsbury Publishing Plc

1385 Broadway	50 Bedford Square
New York	London
NY 10018	WC1B 3DP
USA	UK

www.bloomsbury.com
BLOOMSBURY and the Diana logo are trademarks of Bloomsbury Publishing Plc

First published 2017

ISBN: HB: 978-1-63286-529-8
 ePub: 978-1-63286-531-1

LIBRARY OF CONGRESS CATALOGING-IN-PUBLICATION DATA

Names: Hopps, Walter, author, interviewee. | Treisman, Deborah, 1970– editor. | Doran, Anne, 1957– interviewer. | Ruscha, Edward, writer of introduction.
Title: The dream colony: a life in art / by Walter Hopps; edited by Deborah Treisman, from interviews with Anne Doran; introduction by Ed Ruscha.
Description: New York: Bloomsbury USA, 2017.
Identifiers: LCCN 2016055073 | ISBN 9781632865298 (hardback)
Subjects: LCSH: Hopps, Walter. | Art museum curators—United States—Biography. | BISAC: BIOGRAPHY & AUTOBIOGRAPHY / Cultural Heritage. | ART / History / Contemporary (1945–). | ART / Popular Culture.
Classification: LCC N406.H67 A3 2017 | DDC 708.0092 [B]—dc23
LC record available at https://lccn.loc.gov/2016055073

2 4 6 8 10 9 7 5 3 1

Typeset by Westchester Publishing Services
Printed and bound in the U.S.A. by Berryville Graphics Inc., Berryville, Virginia

To all the artists I have ever known, and
to Caroline, the most magical one of all.

I had my own secret world for many years. Still do. Calvin Tomkins once asked me how many artists I actually thought about. I said, "You mean the living ones? Or the ones I'm interested in?" He said, "Well, just in American art." And I said, "Well, it's near a thousand." And he said, "What?" And I said, "Somewhere between eight hundred and a thousand." He said, "Well, what do you mean 'think about'?" I said, "If I've looked at it, I'm thinking about it. Haven't you looked at that many artworks, visiting museums and galleries and so on? How can you help thinking about them?"

—Walter Hopps

As we walked slowly through the galleries, I remarked on the number of times I had been told that Hopps had the sensibility and the temperament of an artist. Had he ever thought of being an artist, I inquired, or was what he did close enough to that?

He pondered the question for a moment. "I think of myself as being in a line of work that goes back about twenty-five thousand years," he said then. "My job has been finding the cave and holding the torch. Somebody has to be around to hold the flaming branch, and make sure there are enough pigments. I've been involved in what I consider getting this stuff made. Anyway, to answer your question, yes, I'd say that what I do is quite close enough."

—Calvin Tomkins, "A Touch for the Now,"
The New Yorker, July 29, 1991

CONTENTS

FOREWORD

I met Walter Hopps for the first time in the winter of 1993. I was twenty-three and living in New York, and was applying to be the managing editor of *Grand Street*, the literary and art quarterly for which Hopps was the art editor. Having been told by Jean Stein, the editor and publisher of the magazine, that anyone she hired had to be approved by Walter first, I was nervous about my limited background in art. I didn't know much about Walter at the time—only that he was the director of the Menil Collection, in Houston, and that he'd had a renowned career as a curator of contemporary art. Walter called to arrange an interview and suggested that we meet at the Temple Bar on Lafayette Street. Thirty minutes after our scheduled time, he appeared in the Temple Bar's dark, velvet-lined room, along with the artist (and *Grand Street* contributing editor) Anne Doran, carrying several folders of contact sheets. "We're trying to put together a portfolio of photographs of graffiti memorials to dead gang members," he barked. "Which of these pictures would you use?" I sorted through the images as he watched. "Right," he said. "Now we just need to give this a damn title."

Two weeks after I started the job, in February, 1994, Walter suffered a brain aneurysm that left him hospitalized for a few months. (It was a testament to Walter's tenacity that he came through it as rapidly as he did and made an almost unprecedented recovery.) In the days after an operation to repair the aneurysm, disoriented and suffering from short-term memory loss, Walter was convinced that it was 1963 and that he was in Pasadena, California, with a show to hang.

It was no coincidence that the strongest memory to surge up came from his time in Pasadena. It was as the director of the Pasadena Art Museum, in the mid-sixties, when still in his early thirties, that he established his reputation as one of the most innovative curators working in the United States.

There, he was the first American museum curator to mount retrospectives of the works of Marcel Duchamp and Joseph Cornell and the first to honor Pop Art with an exhibition, before it was even known as Pop Art. But his involvement in the art world had begun much earlier. In his teens, as part of a group of gifted high-school students in Los Angeles, Hopps had been taken on a tour of the home of Walter and Louise Arensberg, the famous collectors of Dadaist and Surrealist art, and had been so startled and intrigued by what he saw there that he repeatedly skipped class to spend days at their house exploring and studying their collection. At age twenty, he opened his first gallery, Syndell Studio, in L.A. Five years later, he and the then unknown artist Edward Kienholz cofounded the Ferus Gallery, which would support the work of a new generation of groundbreaking artists, Andy Warhol, Ed Ruscha, Roy Lichtenstein, and Frank Stella among them.

In 1967, when the thirty-four-year-old Hopps became the director of Washington's Corcoran Gallery of Art, the *New York Times* billed him as "the most gifted museum man on the West Coast (and, in the field of contemporary art, possibly in the nation)." A few years later he became the curator of twentieth-century American art at the Smithsonian's National Collection of Fine Arts (NCFA), where he mounted a retrospective of Robert Rauschenberg's work and created the Joseph Cornell Study Center. In 1980, Hopps began working with Dominique de Menil to create the Menil Collection in Houston. In de Menil, he found a patron and a colleague who was willing to lend full support to his unorthodox approach and work habits.

For much of his working life before Houston, Walter was chronically late—his staff at the Corcoran actually had buttons made that said "WALTER

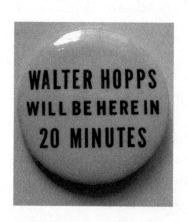

Button created by the staff of the Corcoran Gallery, c. 1970. Photograph by Caroline Huber.

HOPPS WILL BE HERE IN 20 MINUTES"—and he sometimes went missing for days at a time, only to return and work straight through the night hanging a show. ("If I could find him, I'd fire him," Joshua Taylor, his boss at the NCFA, used to say.) In 1978, Hopps staged "Thirty-Six Hours" at the Museum of Temporary Art, in D.C.—a show in which he hung every art work that was brought to him over the course of a day and a half. Erratic in his schedule, he was never erratic in his commitment to the art he loved. In his two and a half decades in Houston, he continued to discover, befriend, and champion the work of young artists. In the years before he died, in 2005, at age seventy-two, he was responsible for major retrospectives of the work of Edward Kienholz (at the Whitney Museum), Robert Rauschenberg, and James Rosenquist (both at the Guggenheim Museum).

Unrelenting independence and nonconformism marked Walter's life as well as his curatorial and critical mind. The late Anne d'Harnoncourt, then the director of the Philadelphia Museum of Art, claimed that his success came from "his sense of the character of works of art, and of how to bring that character out—without getting in the way." Hans-Ulrich Obrist, in a 1996 *Artforum* article, called him "both consummate insider and quintessential outsider." Or, as the writer Calvin Tomkins explained it in *The New Yorker* in 1991, "In a Hopps exhibition, considerations of art history and scholarship are often present, along with ideas about style and influence and social issues, but the primary emphasis is always on how the art looks on the wall, and this, surprisingly, makes Walter Hopps something of a maverick in his profession."

Walter's maverick qualities made him one of the most influential figures in mid to late twentieth-century American art. What makes him live in the minds of those who knew him are his forthrightness, his eccentricity, his imagination—and his storytelling. Over decades at the forefront of American creativity, he accumulated a store of anecdotes, scenes, ideas, and insights that could have filled several books. He was a riveting, funny, and discerning narrator. As Paul Richard recalled, in the *Washington Post*, "His speech was like a Jackson Pollock drip painting, swooping, swelling, doubling back. He mesmerized. He taught." The stories Walter had to tell were not academic or critical, as such, although his thinking incorporated both scholarship and history; rather, they were vivid, personal, surprising, irreverent, and

enlightening—an extremely privileged view into some of the greatest artistic minds of the century.

Walter did not, when we embarked on this project many years ago, feel comfortable with the idea of writing his own life story, but he did feel able to speak much of it onto tape. In the course of more than a hundred hours of taping, Anne Doran worked with him, interviewing, prodding, eliciting information and narrative. The plan was for me to distill those tapes into a book, and for Walter and me to edit a final draft together. Unfortunately, Walter died before we reached that stage. (This is why certain elements of his life, and most particularly his years in Houston and at the Menil Collection, are underrepresented here.) I worked with the tapes and a few other scattered sources and interviews, including several taped conversations with Jean Stein and with his wife, Caroline Huber, to compile the raw material of this book, which I shaped and structured without, I hope, losing the sound of Walter's original and unforgettable voice.

—Deborah Treisman

INTRODUCTION
THIS CRAZY BUT GENIUS WALTER HOPPS

I first met Walter in 1960 or '61. I don't remember exactly how, but I knew that he was part of the Ferus Gallery and he was in touch with people in all the arts—in the jazz world and the poetry world and artists of all stature. He was actually living behind the gallery, in a little garage apartment, near the storage areas where the gallery kept paintings and sculpture. So he was kind of a compact unit there at 723 North La Cienega Boulevard. There was a wild bunch of artists who formed a sort of community around the gallery— John Altoon, Billy Al Bengston, Ed Moses, Robert Irwin, Craig Kauffman, Ken Price, Larry Bell, Llyn Foulkes, and others, all young artists who were just beginning to be known. Every one of those artists had his own voice. They were very distinctive, distinctively on their own, but they were all friends who showed their work at Ferus Gallery, and it never failed to be a noisy, vibrant, avant-garde scene. One night, I remember, they rented big movie searchlights, which they put up on La Cienega for a John Altoon opening. There were hijinks like that, which you couldn't ignore. All the artists in town who were showing at other galleries seemed rather bland by comparison. Wallace Berman had shown at Ferus earlier on. Ed Kienholz showed there; he was a very humorous guy—part of the pack, so to speak. And concurrent with all that activity were exhibits of non-Californian artists like Kurt Schwitters and Jasper Johns and Andy Warhol. Ferus showed work by a primitive painter named Streeter Blair, and there was a very interesting Giorgio Morandi exhibit. It was Walter—or "Chico," as we called him—who got those things going.

Walter had somehow met my oldest friend, Joe Goode. Joe and I grew up together in Oklahoma, came out to California a year apart, and went to art school here. Somewhere along the way, Joe met Walter, and I met Walter through him. Walter came to my studio, in Echo Park, and then he started

bringing other people to my studio: Bill Copley, Henry Geldzahler, Dennis Hopper, Judd and Katherine Marmor, and others. I didn't even know what that was about. He would bring people over and sometimes they would buy something from me. Walter was never part of that equation: he never once said, "Hey, I should get a commission on this." He wasn't a businessman in that sense; he wasn't a percentage man. He actually had a distaste for the gallery mechanics. He was just into the aesthetics of art. And we jibed together. He had a curiosity about what I was doing. I felt like I was doing the whole thing for sport; the idea of making a vocation out of it and selling work—there was just no possibility of that that I could see. I didn't know where I fit in, but Walter made me feel welcome, and I learned a lot just sitting at his feet. The breadth of his knowledge was so impressive. He made me feel that I was doing the right thing. He always had great sound bites; he could put his thoughts together with an economy of words, well chosen, and it always made sense.

Then Walter included some paintings of mine in his show "New Painting of Common Objects," at the Pasadena Art Museum in 1962. It was the first museum show of Pop Art, though the term hadn't even been invented yet, and it included work by Roy Lichtenstein, Jim Dine, Andy Warhol, Phil Hefferton, Bob Dowd, Wayne Thiebaud, Joe Goode, and me. Walter had introduced us to Hefferton and Dowd; they both painted pictures of money— whimsically, clumsily painted interpretations of a dollar bill or a ten-dollar bill, big six-foot paintings. It was primitive work—it didn't come out of the usual traditions of abstraction and modern art—and some of those paintings were in that show. "New Painting of Common Objects," a title coined by Walter, was a big thing for me, of course. It was the first time work of mine was hung on a museum wall or in any exhibit at all—and the fact that it was in the Pasadena Art Museum made it even better. The Pasadena Museum was considered the primary, most interesting place for art in Southern California then, far more important than the L.A. County Museum of Art. It had great stature in the community, and people knew that it was run by this crazy but genius Walter Hopps.

Walter wanted to make a catalogue for the show. He was never famous for his catalogues; he started too many and finished none. Eventually, maybe in Washington, he saw a few catalogues into completion. For this catalogue,

Walter's idea was that every artist would do a page. But time was marching on, the deadline had passed, and he saw that there was no chance he'd ever have a binding for the book. So he decided on single sheets of paper, reproduced on a mimeograph machine and distributed in an envelope. He also came up with the idea of doing a poster and he asked me to do it. I said, "Maybe we can do it at the Majestic Poster Press," which was a press downtown that used wooden type and made posters for movies, circuses, and boxing matches. He said, "We've got to get this thing done now. No rough ideas. You've got to just spell it out right now. Best way to do that is over the telephone." So we got on the phone in his office at Pasadena and I talked to the people at the Majestic and spelled the whole thing out. I said, "Make the poster and make it loud!" That was how the poster was actually done on schedule, because we got on the phone and didn't waste time driving downtown. Walter was happy about that: he finally got some action on something.

A year later, he put together a Marcel Duchamp show at the Pasadena Art Museum. Joe Goode was living in Walter's house then—he had a studio in the back—and Joe and I would go to the museum and see what Walter was up to. I met Duchamp through him, and that was a big thing for me.

There was a large gap between being an artist, or attempting to be an artist, and reaching the next plateau—making a career out of it, or having a voice that the public could hear. And Walter was right in the middle of that gap, because he was able to talk to both sides. If someone had got a bunch

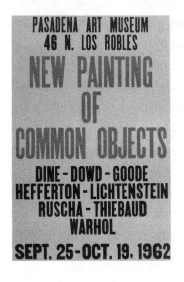

Poster for the exhibition "New Painting of Common Objects," 1962. Wood-type letterpress on paper.

of gangsters from South Central L.A. together and said, "We're going to have somebody come and talk to you about art," they probably would have laughed. But then Walter would have stepped in and started speaking and had them at rapt attention. He could bridge the gap with people you couldn't bridge the gap with and he could reach people who had no interest in art whatsoever. He had a message that went beyond trying to placate or educate, and, as soon as he opened his mouth, people took notice. There was such vitality to the things he said. He had the ability to rhapsodize: he knew everything that was happening and all the crosscurrents. He was into music and literature and all the arts and how they came together, but around us the subject was usually art. He didn't just talk about famous artists and preach their success. He talked about artists who were obscure, oddballs who were out in the sticks, not necessarily accepted by the mainstream of the art world. He had a deep knowledge of things that were going on out in the far corners—the dust bunnies. He was very catholic in his tastes, and he had real respect for every bit of it.

Thanks to him, we all began to see art in a different light: it wasn't about how to sell your paintings and get famous and live in New York; it was about learning what's going on in art and in the world and then putting that into play. Walter was able to convince us of that. He earned our respect—more so than somebody who wanted to make a splash and sell artworks. Walter never had any advice at all about the commercial aspects of making art or selling it or how to fit into somebody's collection. I have very fond memories of him bumming a cigarette from me, puffing and pacing back and forth from one end of the room to the other while telling me what was going on. He had such a commanding presence. He was always making comparisons. If he saw you doing something with blocks of red, he might start talking about Malevich, and he'd spark some interest in you and next thing you know you'd be looking up Malevich. He wasn't a classical scholar of Renaissance painting—almost all of his efforts were put into contemporary activity—but he was more than proficient at the genealogy of art; he had an encyclopedic knowledge of what was happening and what had come before. Walter had a completely open mind to any art that was difficult for the general public to accept. Not only was he open to it and curious about it but he leapt on it. It became his whole reason for being. I remember once we were talking

about the kind of graffiti that you see in bathrooms and he said, "The other day I saw one that said, 'Fuck the world, and fuck you if you don't love it.'" That really struck Walter.

Walter didn't live by normal standards. He'd work throughout the night and then he'd be asleep at eleven in the morning. We'd get calls from him in the middle of the night, just to talk about nothing special, at two a.m. He had a completely unorthodox approach to any kind of scheduling, to making a day work; most common business practice was secondary to him. Naturally, we artists were amused by that and we backed him on it. He was an iconoclast, in that sense. He accomplished a lot but the people he worked with said, "You didn't show up on time, you didn't do that, you didn't do this." That was true, but his accomplishments outweighed the failures. He was never entirely taken up by a job; he followed his instincts and his interests. Not too many people are like that. They either check into a job or they're out to make money or score a coup. For most of his working life, Walter was just being his special self.

He could go for a long time with things not falling into place, but finally they did, and he didn't panic. He never seemed to panic at all. He'd just walk around in his imperious way, but at the same time he was really approachable. He wasn't a difficult person, but he had a knack for getting his way at the end of the day. We all knew what a powerful figure he was. It wasn't a kind of power linked to control; it was his ability to cut through the fog and get to the heart of the matter. I don't see anybody on the horizon that even comes close to him.

When Walter left California, it wasn't a bomb that was dropped on us, but there was a hole in the scene. I remember visiting him once in Houston, when he was living at Dominique de Menil's house. He walked me through the whole house and into his tiny little room. He had a bed and a table, with some paper and a pencil ready to go, and he had some boots there. It was like a frontier outpost that he was living in. But he pointed to certain things that were on the walls. I remember there was a Jasper Johns painting of numbers just inside the front door. Walter showed it to me and said something to the effect of "I'm not sure how that got up on the wall there. That's just where we parked it." I liked that—it was just parked there, like him, in its temporary quarters.

—Ed Ruscha

1.

CHILDHOOD

My parents collected plein-air California paintings, and that was the art that hung in the Hopps household. In 1936, when I was four, one of the artists they collected—a man called André Roth—came to the house to paint portraits of me and my brother, Harvey, who was still a baby. I remember being perched on a high stool, naked to the waist, while he stood at his easel painting. Apparently, I was a difficult subject, because I wouldn't sit still; I kept getting down and running around the easel to see what Mr. Roth was doing. I'd never seen anyone paint before, and I was fascinated with the process of capturing a likeness; I thought it was magic. How can this disagreeable man, whom I have to sit still for, produce something that looks like me? I'd rush into the next room, where there was a mirror, to see if I really looked like the painting; I drove that poor artist crazy by trying to keep track of his progress.

My next experience with art took place in the home of my Irish-American grandfather, Carle Phinney. My parents and my brother and I lived in a house on Maywood Avenue, in Eagle Rock, in the northeast corner of Los Angeles, just west of Pasadena. Eagle Rock is home to a giant rock with a crack that makes it look like an eagle's head. (In fact, it looks more like a skull, but apparently no one wanted to call the town Skull Rock; as a child, I often wondered why not.) My mother's parents and her uncle, Harry, lived next door to us, in a bigger house, where my grandfather, who was a doctor, kept his medical office and laboratory as well. In my grandparents' house, there was a big Brunswick standard pool table, where the men would retreat to shoot pool. It had originally belonged to a branch of my family that had gold mines in Cripple Creek, Colorado, and, much to my mother's dismay, it was shipped to California when that family died out. When the sunroom at the back of the house became the poolroom, my mother made sure that

the glass doors were made opaque, so that you wouldn't have to sit in the proper living room and look at a damn pool table.

My grandfather's house had art that fit his turn-of-the-century sensibilities. There were several prints of hunting scenes and pictures of amusing animals—dogs playing poker—framed and hung around the house. But what thrilled me most was a pair of risqué Victorian-era black-and-white engravings—mass-produced prints, not fancy etchings—that hung in the pool room. The first engraving showed two women, stripped to the waist, sword fighting. In the second, one of the women had prevailed and the other was lying on the ground, dead or wounded. Those engravings had the first breasts I remember seeing, other than my mother's, and I was fascinated by them. I knew that the prints were exciting in a way that I didn't understand, and after my grandfather died, in 1938, I made a big point of wanting to have them.

The first time I got in trouble for my approach to art was in first grade, at Eagle Rock Elementary School, when my classmates and I were given an assignment to decorate a large plywood dollhouse, about four feet high. We were given wheat paste and wallpaper—rolls of it—and told to cut it out and wallpaper the rooms. That seemed so stupefyingly obvious to me. I decided that, instead, we should tear up the wallpaper and make multicolored collages for the walls—though I didn't know then to call them collages. The other kids loved doing this—tearing up the paper and making patterns with it—but the teacher was very upset. In her view, of course, we'd done exactly the wrong thing.

My grandfather's brother, Harry, ran the mortuary in Eagle Rock. There was a mean-spirited gag that went around at the time: "If Doc Phinney can't cure you, his brother will bury you." I liked Uncle Harry very much, and when I was four or five he made me an album—a horizontal scrapbook covered with pink-and-blue fabric. He told me to cut out pictures of things I liked in magazines and glue them into the album. On the cover, he'd pasted a first image—a little boy in rompers, running with an American flag. The boy didn't look like me—he was blond—but since then I've always had a soft spot for images of the American flag. I still remember some of the pictures that I pasted in: there were flashy cars and ads for Campbell's Soup, with little tomato-headed people making the soup. I was very partial

to those; later, Paul McCarthy's work reminded me of them. Looking back at that scrapbook as an adult, I was shocked to see how many of the images I chose then presaged the work of artists I met later in life. In my teens, I kept up the habit of clipping images from magazines that came to the house that struck my fancy. I wouldn't cut up art magazines, but if I saw things in *Time* and *Life* that interested me I'd clip them out and mount them in an album. I remember *Time* magazine doing a piece on Max Ernst when he was in Sedona, Arizona, and I was just fascinated by him.

The Hopps family came to the New World from Yorkshire, England, passing through Virginia to what became the state of Missouri, where they worked in the lead mines. Then, during the California gold rush, my great-grandfather, Howard Hopps, headed west, from Joplin, Missouri, and settled in Oakland, on the east side of the San Francisco Bay. Howard and his children worked mostly in the boatyards, where they built, among other things, the old San Francisco ferryboats; I believe there are still a few left in circulation with the Hopps name on plaques mounted on the sides. There wasn't much interest in art in the family at that point, though one relative did make the stained-glass dome for the San Francisco department store called City of Paris, which later became Neiman Marcus. And somewhere I have a painting done by an ancestor in the eighteen-fifties, a dark little landscape of the Bay.

Howard had several sons and a daughter with his wife, but by 1880 he had more or less gone crazy. He became a self-proclaimed man of God and lived off his sons while he walked the streets, preaching and impregnating as many young women converts as he could. He was a constant embarrassment to the family. When his son, my grandfather, Walter Sr., couldn't stand it anymore, he took off, panning for gold and working his way through the country to seek his fortune. In Naco, Arizona, near the Mexican border, he met up with a cousin of his, Perry Fike, a wild young man, who was running a horse ranch there with his widowed mother, Lydia. Perry Fike was up for an adventure, so he crossed the border with my grandfather, and they continued on to a city on the gulf called Tampico, north of Vera Cruz. Walter decided to open up a hardware store there. He'd never had a day of

college, but he was smart and a natural mechanic. Soon after he got to Tampico, there was a crisis in the town. Something had gone wrong with the bank vault, and they couldn't get it open. Since Walter had worked in mines, he knew how to handle dynamite, and he volunteered to blast open the safe without destroying the money and gold that were in it. This really impressed the banker, who loaned him money to get his hardware store going. Walter also did some contracting with Perry Fike. My grandfather was a great brickmason, and he laid a lot of the brickwork at the Eagle Rock house in his later years.

Once the hardware store was profitable, my grandfather decided that he wanted to have a citrus plantation. Tampico is in a lush area, and he bought some land on the outskirts of town. By 1900, he had a wonderful plantation going, with tangerines and sweet lemons, grapefruit and blood oranges, and he developed an interesting clientele: British ships would come into the Tampico harbor with metal goods, knives and steel from Manchester and Sheffield, and they'd take back citrus fruit. Shipboard, they'd make marmalades, jellies, and chutney, which they'd eat on the boat and sell to dealers when they got home.

A lot of American expatriates came to Tampico, too, and at some point my grandfather befriended a man from Atlanta named Leo Fleishman. Fleishman was bringing a product from Atlanta into Mexico, and he offered to take my grandfather on as a partner in this deal. My grandfather passed on the offer; he had an idea for a different food product that he was trying to perfect and promote: peanut-butter tacos. The Mexicans hated them. What he'd passed up was the opportunity to be a fifty-percent partner in bringing Coca-Cola into Mexico. And that's why the Hopps family isn't rich today.

My grandfather was well liked in the Tampico community, but, at a rather advanced age, well into his forties, he decided that he wanted a wife, and he settled on the idea of an American schoolteacher. He took a trip back to the States to find one. In the Midwest, he drove around from town to town in a horse and buggy, courting teachers at town dances and ceremonies, until finally, in Caney, Kansas, he met one who agreed to marry him and go back with him to Mexico. My grandmother, Belle McIlwain, had no idea what she was getting into. All she took with her was a basket of clothes

and a trunk full of books. Still, she grew to like it there. It was a hard life: my grandfather was boisterous and willful, but also an interesting, gentle man. They had three children in rapid succession: my father, Walter Jr., in 1903, and then a daughter, Rosita, and another son, Byron.

There was trouble brewing in Mexico that would change the course of my grandfather's life. The Mexican Revolution, which took place around the time of the First World War, was a truly bloody affair. The revolutionaries hated the Catholics—and they had reason to. My grandfather told me that he had once seen a priest walking down the center of the street in Tampico with a man with a bullwhip in front of him and another behind him to whip anyone who didn't fall to his knees as the priest went by. During the revolution, a lot of Catholics, priests and nuns, were slaughtered. Walter Sr., American expatriate that he was, was sympathetic to the workers, who had been exploited horribly by the landowners. He always paid the highest possible wages to the people who worked on his plantation. One of the other landowners even hired someone to assassinate him for that reason. My grandfather had a scar on his chest where a bullet had bounced off a rib and torn through the skin. (After that happened, one of my grandfather's plantation workers hunted down the would-be assassin, took him to the Tampico town square, and hacked him apart with a machete, leaving the body there as a warning that no one should try to harm Señor Hopps.)

My grandfather even helped to smuggle in some rifles for the revolutionaries, wrapped in burlap on the trunks of the young citrus trees he had sent down from Arizona by train. That kept his plantation safe, but the plantation house became a hospital, with people dying in the orchards. My father, Walter Jr., saw so much carnage in his early teens—he helped to bury the dead in his own garden—that it turned him against Mexico. It broke his father's heart that he didn't take over the plantation, but he chose to go to America and become a doctor. The only time I ever saw my father cry was when I took him to see *The Treasure of the Sierra Madre*, which is partly set in Tampico. John Huston made Tampico look the way it did when my father was young, and Walter Huston, John Huston's father, played an old man who was very like my grandfather. There's a wonderful line in which Walter Huston tells the other characters, who are standing on gold and

don't know it, "You're so dumb, you don't even see the riches you're treadin' on with your own feet."

When things got very bad during the revolution, the family was evacuated by ship to Galveston, and then traveled by train to Los Angeles, where Belle got a job with the Board of Education. My grandfather went back to Tampico and didn't return until three years later. He checked with the school board and found his family, just as they'd planned. "Everything's in order," he told them. "I saved the plantation, and things are settling down, and now I want us to do something together." He said, "First thing we're going to do is go out and buy a big car." So they went out and bought a Buick. The second thing they did was drive up into the Sierra Nevadas to build a cabin. Near Mammoth Lakes, an old mining town, they got a piece of Forest Service land and built a little house. It had no running water or electricity then, though it did by the time I was spending my summers there. After the children had finished high school, Walter Sr. and Belle went back to Mexico.

My mother's side of the family was Irish and Scotch, and most of them settled in the Midwest, but my grandmother, Myrtle May Hemstreet, and her parents were a frontier family in California. Myrtle May's mother, Annie Durkee, was the first woman trained as a surgeon in the state of California. She treated people in the parks after the great San Francisco earthquake. Myrtle May, who was born in Hillsborough, south of San Francisco, went to medical school, too, and that was where she met my grandfather, Carle Phinney. Carle had been born into an Irish family, in rather poor circumstances, and his family had expected him to become a priest, but he ran away from all that, disavowed Catholicism, and went out west to study medicine. Eventually he became the head of the old Pacific College of Osteopathy, which is now part of the medical school at the University of California, Irvine. Carle and Myrtle May had two daughters—my mother, Katherine, and her younger sister, Marian. Marian had a tragic accident when she was eleven: she was riding a little cart down a sidewalk in Eagle Rock, when she fell out and hit her head. She lived into her thirties, but

mentally she never advanced much beyond the age she was at the time of the injury.

My mother's first serious boyfriend, when she was a teenager, was an actor named Marion Morrison, who, I think, lived in Glendale, next to Eagle Rock. Later, he became well-known as John Wayne. That connection somehow survived my mother's marriage to my father, who maybe not coincidentally looked a lot like John Wayne. My mother met my father when she was a student at the Pacific College. My maternal great-grandmother, great-aunt, grandfather, grandmother, and mother were all doctors. After my father and mother were married, they moved into the small house next door to the Phinney grandparents, and it became a kind of family compound; we'd gather together for meals. Often a dozen of us would sit down for breakfast, with one member of the family cooking in the kitchen. Sometimes my grandfather would get frustrated that the food wasn't coming out fast enough. He'd go and fetch a big plate of toast from the kitchen and start tossing it at people at the table, to see who could catch it; a lot of toast ended up on the floor, but he didn't care. I loved this, though, of course, it upset his wife and everyone else.

My grandmother was still practicing medicine then, and so was my mother, who went on working a little after my brother and I were born. She saw some patients during the Depression, when most people had only the

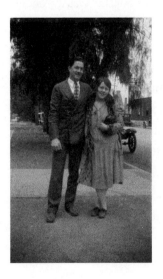

Walter Wain Hopps Jr. and Katherine Phinney, on the day of their graduation from the Pacific College of Osteopathy.

eggs or the vegetables they raised to pay with. There was no health insurance, and you didn't turn people away. My mother was a school doctor for a while, and the progressive Broadoaks School in Pasadena let us attend for free because she treated the children there. My mother was a great admirer of Carl Jung, and later in life she always told me that, if her health hadn't failed, she would have gone to Zurich and studied at the Institute. She lived her whole life on Maywood Avenue in Eagle Rock. First in her parents' house, then in the little house next door with my father, then later, after my grandfather died, in a house up at the top of the street, which was where I mostly grew up.

Eagle Rock had been a separate town, next to Pasadena, and a little more rural. Above us there were some estates with horses and cattle. Carle Phinney had helped to found the town and he was its first health officer; he was also in charge of the waterworks, at a time when water was a major issue in Southern California. In those days, my father informed me, L.A. had corrupt mayors and a corrupt police force, whose activities have been at least in part accounted for in the noir novels of James Ellroy.

Carle Phinney was a practicing surgeon, but he also taught at the medical school—orthopedics, which was my father's specialty as well. He had very skilled hands; I inherited from him some incredibly delicate Viennese dissecting tools with tortoiseshell handles. He carved cabinets and chairs and tables and huge model ships that I loved as a boy. He was a wonderfully indulgent grandfather. Whenever there were parties for the adults and I was put to bed early, he always slipped up with a glass of ginger ale for me, because he knew I was awake. At one point, he went away to New Orleans to get further training at Tulane. He came back on the train with two baby alligators, which he put in the fishpond in the backyard of the Eagle Rock house. Of course they ate all the fish, which really irritated my grandmother. The alligators didn't live too long, either. I think they were disposed of somehow. My grandfather came up with one of the most amazing birthday presents I can remember: he gave me a big old-fashioned windup alarm clock and a hammer, and said, "Find out what it's made of." I pounded that clock to pieces and took out all the little parts, which was exactly what a child would most want to do. I was six or so when he died, but I remember him very well.

After he died, the house was sold, and my grandmother went to live in Laguna Beach, south of Los Angeles, where the family had had property since the turn of the century. They were by Woods Cove, which was named after my great-great-uncle Harry Woods, a relative of Myrtle May's, whose family had gone from the mines in Colorado to the mines in California. The Woodses were wealthy, and when they moved out to Laguna Beach, they built a big house on a rocky point by the water. Bette Davis bought that house when the Woods family died out.

My grandparents, who weren't so rich, bought a smaller house up on the bluff above the Woods house, a beach house where I would stay during the summer when I was young while my parents were off doing their own thing. I happened to be there when we first heard about the atomic bomb. I was twelve or thirteen, and I knew that this was important, that it wasn't just a normal bomb. I'd sleep out on the sun porch, which my grandfather had built onto the house; instead of glass, he'd glazed X-ray plates as windows. So there was a big bank of X-rays, four panes high, and eighteen across, that made for subdued sunlight. It was just crazy to look at and I loved it.

One summer when I was there, a man came to the door, a large man, balding. When my grandmother answered it, he said, obviously trying to control his emotions, "Myrtle, I'm your brother David." This brother had gone on the lam after fighting a duel and wounding another man about fifty years before, and no one had heard from him since. He said, "I just wanted to see you again and let you know I was alive. And I'd like to know if any of our sisters are living here." So my grandmother and two of her sisters got together to talk to this man. They didn't know whether to believe him or not. He said, "There's a way I can prove it to you. Do you remember that, in that terrible duel, I took a bullet, too, and it lodged in my hand? It's given me trouble over the years, but it's stayed there all this time. I would like you all to feel it." So, one by one, they went over to him and felt his hand. There were tears and amazement. He explained that he wasn't asking for anything from them, that he'd fled to South Africa and had done very well in the mines there, and that he had married and had a family. Eventually he'd managed to figure out where his sisters were living and had come back to

look them up. We all went out to dinner, and I think they kept in touch after that.

After Carle died, my grandmother built another house and a set of apartments on the property at Woods Cove, and she rented these to other relatives, re-creating the Phinney compound there. Harry Woods had blasted out the rocks on the edge of Woods Cove, which meant that there was a terrifying blow hole over an underwater cave, but also a wonderful little pool, which was only about five feet deep, and that was where I learned to swim.

In the thirties, when my mother was still practicing medicine, she hired a couple of nannies to watch my brother and me. The first woman, Miss Howland, was spinsterish and had all the personality of a sour pickle. She disappeared one day, and suddenly we had this amazing babysitter, whose name was Chancellor Foster or Foster Chancellor. She said that the order of the names wasn't important. She was a Choctaw Indian who had grown up on the reservation in Oklahoma but had moved to California and married a white man, who later ran off. She had two grown-up children—her daughter's name was Jack, and her son was Foster. She would stay with us in the house and fix our meals. One of her specialties was stewed tomatoes with sugar and white bread mixed in. We hated that. Chancellor didn't believe in beds and mattresses—she thought they weren't healthy. So when my parents were away on a trip and she was caring for us, she would peruse the house and decide where the best vibrations were for sleeping that night— under the dining-room table, or under the piano, or in the middle of the living room. Then she'd make a pallet with blankets and sheets, and we'd sleep there with her on the floor. She explained to me and my brother that it was probably not a good idea to tell our parents this. She said, "Your parents are good people but they just wouldn't understand about this." So we kept it our secret.

When my brother, Harvey, and I were little, my mother still liked to go to Hollywood parties. My dad's rule was that she could go out on a Hollywood date if she took the boys along. So I can remember being taken to Ciro's nightclub in Beverly Hills, where my brother and I were turned

over to a waitress or a hat-check girl and put upstairs to have our dinners in an office away from all the adults.

One day, when I was six and Harvey was four, our mother got us together and announced, "Boys, we're packing up and going to Mexico." I said, "Why? What's going on?" She said, "We're going to stay with your grandparents in Tampico until your father comes to his senses." When I got older, I understood what that meant. Clearly, my father had become involved with another woman or transgressed in some way, and my mother did a very smart thing. She couldn't leave my father and go home to her family, because her family all lived nearby. So she went home to his, whom she liked. That way he'd know exactly where she was, and when he came to his senses he could show up.

We went to Tampico by train and were met at the station by my grandfather, Walter Sr., a tall, quiet man, who drove us out to his plantation. It was the first time I'd met my father's parents, and we stayed there for the better part of a year. It was a large, wooden two-story house, with verandahs all around and a central courtyard with semitropical plants and trees. What intrigued me most of all was the number of pets my grandparents kept. Beyond the yard were tamarind trees and then the orchards, where several fine-looking dogs roamed about, but the best pets were in the central courtyard. My grandparents had caught and tamed two kinds of *tejones*, or Mexican badgers, several flying squirrels, and a wild javelina that Walter Sr. called McGinty, because she looked like a stocky little Irishman. He'd had McGinty since she was a baby—her mother had been killed and he'd rescued her—and the dogs had learned to respect her very quickly; she could have killed them easily. She ran around loose and terrified everyone with her tusks, but she was completely bonded with my grandfather; she'd always come to him when he called. Eventually, on one of her expeditions, McGinty got pregnant. She had her babies and raised them near the house, and when they were old enough the whole group disappeared for good. I took for granted the idea that wild animals could be tamed, because at home, in California, my father had tamed a roadrunner, which lived in our garden.

One of the things I loved to do was go to the big market in Tampico with my grandfather. Once, when we were there, he suggested that I look around and choose a pet for myself. I saw some very exotic-looking birds

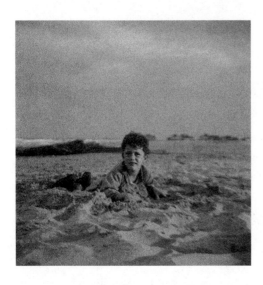

*Walter on the beach in
Tampico, Mexico, c. 1938.*

with fantastic colored feathers and topknots, and I told him that I wanted one of them. He said, "No, you can't have one of those, because they're going to die." He explained that the salesmen had glued feathers and topknots onto these not-so-exotic birds, and that the glue would poison them.

Another time I was sitting with my grandfather on the verandah of the plantation house when the dogs all started barking and a Mexican man came up with a mule, pulling a cart. In the cart was a big crate-like cage, and when he opened it out came a large, frightening bird with chains on its feet. It was some kind of vulture, and it was clanking the chains and struggling and making terrible noises. I could tell that my grandfather was very upset by this. He ordered the man, who wanted to sell him this bird, off the property. He wanted no part of that kind of cruelty. Soon after, my grandfather let me choose a dog of my own, which I loved and raised and was sad to leave when it came time to return to the United States.

There was a young Mexican boy on the ranch, the son of one of the workers, whose job it was to make sure that I didn't get into any trouble. When it was hot, we'd crawl under the verandah of the house and lie there in the cool shade, next to the giant iguanas. For a child my age, it was like lying down with dragons, but the Mexican boy told me that they wouldn't hurt us and they'd keep the flies away. One time we were far out in one of the orchards and I saw what looked like an abandoned hut, so I went inside and found a rifle. I took it and brought it home that evening. The Mexican

boy didn't challenge me, but my grandfather was stern. He said, "You never ever touch another man's gun. You get no dinner until you put it back exactly where you found it." And that was the only trouble I got into in Mexico.

One day there was a stir in the house because my father was on his way down to take us home. We all went to the train station to meet him, and the next day he and my mother went off together to Mexico City to work things out. When they came back, everything was fine, and we packed up and headed home to Eagle Rock.

Not long after we moved back, in the middle of third grade, I was taken out of school with what was diagnosed as rheumatic fever. Since it was an inflammation of the heart, the treatment in those days was endless bed rest, which was the cure for tuberculosis as well, before the advent of antibiotics. I was in and out of convalescence for years, for most of which I was confined to a bedroom, a bathroom, and a library on the second floor of my parents' house. I would leave that area only to go to appointments with doctors and a heart specialist; my pulse would go up to 160 whenever I walked down the hall to go to the bathroom. Very occasionally I'd go downstairs for a meal, but mostly my food was brought to me upstairs. I was cut off from other kids, so the life of the imagination was what I had. I'd conjure up all sorts of imaginary trips. I constantly dreamed about my grandfather's house in Mexico. Since there was no television, I did a lot of reading.

In the winter of 1942, my father got the idea that we should go to Mexico for Christmas, in case the war intervened after that and we weren't able to make the trip. He was suddenly homesick and anxious to see his parents. Because he was a doctor, he had an A gasoline ration card and could get plenty of gas, so we all piled into my mother's Cadillac to drive to Tampico. But along the way I came down with a terrible fever. It was night, and we'd got about halfway—as far as El Paso, Texas—when my grandmother noticed that I was sick and started pounding on my father's back, saying, "You've got to stop. Walter's burning up." We couldn't find a hospital that night, and the only hotel my father could find was a cheap, seedy place. I remember my grandmother stomping her foot and saying to my father, "Walter, you have taken us to a whorehouse!" The next morning,

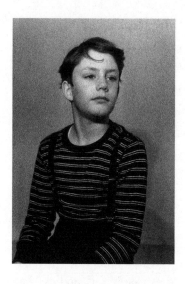

Walter, c. 1942.

they had me admitted to the closest hospital, which was a Catholic Charity place, Hotel Dieu. I remember the admitting nurse asking my mother what religion I was, and she got impatient and said, "Oh, just put down 'heathen'!"

It turned out that I had a kind of pneumonia. There were no antibiotics there, but they had sulfanilamide, which made my kidneys ache. I can remember creeping around like an old man afterward, stooped over. But there were two things about that hospital stay that were special to me. One was that they served tripe all the time. Meat was hard to get, and tripe was cheap. I've loved it ever since. The other was that, with the very high fever, I had my first hallucinations. There were whitish-beige curtains hanging on the windows in my hospital room, and anytime a door would open or a breeze would ruffle them, they'd swirl with incredible psychedelic colors. I'd sit through the day, ignoring my headache, watching a light show on the curtains. We didn't make it to Mexico; we had Christmas in El Paso that year.

Soon after that, Walter Sr., down in Tampico, got sick, too. He was an ingenious inventor, and when he suddenly had painful kidney stones, he built a device that he rammed up his own penis to try to pump them out. My grandmother got my dad on the phone—we didn't do a lot of telephoning in those days—and told him, "Your father has gone mad." So my grandparents left their workers to run the ranch, and my father brought them up to California and got Walter Sr. into the hospital for some more

orthodox treatment. When my grandfather was better, they stayed on in Eagle Rock. He developed an incredible victory garden, where he raised chickens and harvested eggs. He also put together a woodworking and metal-working shop in one of our garages. He patented a couple of inventions. One was a stepladder that would level itself on an uneven surface. Another was a grading machine to sort out the sizes of fruits. He was working on a perpetual-motion machine when he died. My father used the metalworking shop himself to make medical instruments. He redesigned some surgical knives and developed some chrome-plated screws to hold bones together.

While I was sick, my grandmother Belle tutored me. As irritating as I found it, I was actually getting ahead of kids in regular school. And I had my parents' whole library to choose from. I was lonely, but I read Havelock Ellis on sexual pathology and learned about things like foot fetishism; I read novels; I explored the *Encyclopædia Britannica* and medical magazines. I rigged my radio so that the light on it wouldn't show, and I had a wire with one piece of a headphone hidden in my pillow so that I could listen to music at night when my parents thought I was asleep. I'd tune in to the black stations—this was in the forties, and it was all still segregated. There was no modern jazz yet, but I loved rhythm and blues, which was called "race music" then. There was a DJ named Hunter Hancock, a white Texan, who had a funny line of patter and was one of the first to play rhythm and blues and rock and roll on the radio. Another DJ was Gene Norman, who ran a Hollywood nightclub called the Crescendo. I think that was when I first developed my taste for jazz music. I also heard some really macabre radio plays. A radio announcer and horror writer called Arch Oboler had picked up on the Orson Welles tradition, and occasionally someone would replay one of Welles's Mercury Theatre productions. And I listened to *The Shadow*. But the most morbid thing I ever heard on the airwaves was a horror series called *The Hermit's Cave*, which was introduced by a spooky cackling hermit. There was an episode about guests at a weekend country house who woke up every morning to find that parts of their bodies had been amputated—a mad doctor was on the loose, and he'd slip in at night, anesthetize the guests, and carefully remove fingers or arms. This was before I even knew that Surrealism existed.

When my father was in high school, soon after the First World War, he

joined an alternative to the Boy Scouts—which seemed too militaristic to him—called the Woodcraft Rangers. A man named Harry James, who was very sympathetic to the Native Americans, ran the local unit of the Woodcraft Rangers. Several times he took my father out to the Hopi reservation to witness ceremonies. It turned out that he was doing undercover work to see if the Department of the Interior was mistreating the Indians. One time, when I was seven or eight and had a high fever, I woke up suddenly and heard a strange sound. It was my father sitting by my bed, chanting in a way I'd never heard. Then I saw him pick something up and stick it under my pillow. I drifted off to sleep again, and in the morning I woke up feeling better. Of course, I reached under the pillow to see what he'd put there. It was a little leather bag, soft like deer hide, with the initial "W" on it and drawstrings holding it tight. When I opened it up, there was nothing inside. So when my father came home at the end of the day, I asked him, "What happened last night?" He said, "I was concerned about your fever and there wasn't anything else we could do in terms of medicine, so I did something an Indian shaman would do. I did it as best I could." I said, "What is this little bag?" "That's a medicine bag." "But there's nothing in it." He smiled and said, "Oh, no, it's not empty. Everything that's important is in there." It was a special moment with my father. The one time we ever really spoke in that way: *Everything that's important is in there.*

In those days, doctors still made house calls, and my father would sometimes have me ride around with him. The first time I met an African-American person my own age was at one of the houses he visited. I enjoyed talking to this boy, and my father clearly looked favorably on that. Later he said to me, very seriously, "After today, don't ever forget how lucky you are." He meant it in terms of resources, not race. Having grown up in Mexico, my father had a great openness and empathy. He and my grandfather had a large number of Japanese patients in their practice before the Second World War, and they were very upset when the internment camps came. My father made a point of showing me one of the collection points where they were rounding up Japanese to be sent to the Mojave Desert; it was a vicious-looking place with gun towers. The same day he drove me by a park where men wearing swastikas were marching. He said, "They're not rounding up the Nazi sympathizers, but they're doing it to the Japanese."

My father was a good man, but he had no psychological insight. In 1936, when I was four years old, he did something that haunted me for the rest of my life: he told me that my mother—who was in the hospital—was dying, and he wanted to take me to see her for the last time. So I went to see her, and it was very sad. The twist on it was that she didn't die, but I spent the rest of her life expecting her to die at any time. From then on, she ceased to be someone I could count on having. It seemed like a betrayal on my father's part. At that age, you think of your father as knowing all. But he was wrong about that, and he wronged me.

When I was ill with rheumatic fever, my parents gave me a camera, a Baby Brownie Special, a plastic camera that used 127mm film, and I started taking pictures—of pets, of friends, of relatives. My mother liked exotic flowers and plants, so they ended up in my pictures, too. Then, around 1944, when I was twelve or so, my father gave me a Voigtländer miniature view camera, which he'd acquired from a friend of his, and he converted a cedar closet off the library into a darkroom. I read the instructions and learned how to use everything, and I'd photograph whatever was around. Often I'd make prints from my negatives, cut them up, grid them out randomly upside down, so that I couldn't see what I was doing, and rearrange them in mosaics until they became kind of irrational Chuck Closes. From my grandfather Phinney, I had inherited three human skulls and other human bones. I had all of his laboratory equipment and a chemistry kit I'd been given as a child, along with a set of bird brains preserved in bottles. (The brains came from birds I had shot prior to my illness.) My first really good still life involved a microscope I had, an old professional microscope, some antique medical journals, a scalpel, and so on. I also did a series of pictures of the skulls. My father, violating all common sense and the Hippocratic oath, had removed my appendix himself and he presented it to me, in a bottle, after the surgery. He also gave me a preserved fetus. I always meant to take a picture of it, but somehow didn't or couldn't. When I was thirteen or fourteen, I began rephotographing illustrations from books—pages of texts, drawings. If I liked the image I'd photograph it out of a book and then just print it as my own photograph. I had no theory for this at the time, but I was thinking of it as my own work, in a curious way. I didn't show any of those photographs to other people. I didn't think that anyone would understand

why I thought of it as my own photography. So I was delighted when I saw Richard Prince's rephotographing years later; it had a very familiar ring to me.

Later, when I was fifteen and starting to learn about the adult world of photography, I subscribed to the only publication I could find that would tell me what was going on, something called the *U.S. Camera Annual.* There was a lot of trivial photography in there that didn't interest me, but I also saw important things—for instance, photographs from a major show that Edward Steichen put on at the Museum of Modern Art in 1948 called "In and Out of Focus." That was where I saw my first Walker Evans photographs; there was a Louis Faurer image in that show as well. So I began to see what serious photographers were trying to do. I was in high school then, and the drafting teacher at my school was also interested in photography, so we started a kind of camera club. I found other people who were interested and had a couple of shows.

For seventh and eighth grade, I went to the Polytechnic School, a day school attached to Caltech. To get into the Polytechnic, you had to either be rich or score high on the entrance exams. Those of us who'd got in by doing well on the test knew who we were within a week of starting school. But there were some fascinating people there. Our board of trustees overlapped with

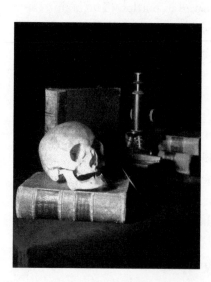

Still life with skull. Photograph by Walter Hopps, mid-1940s.

Caltech's; one trustee was Robert Millikan, who had won the Nobel Prize in Physics. But after I collapsed with rheumatic fever for the third time in ninth grade, I had to drop out. When I finally recovered, I demanded to go to a regular public high school in Eagle Rock. I was starving just to be with regular kids; I felt completely cut off from my own generation. My mother said, "Why don't you want to go to the Cape School or one of the other prep schools?" These were all boys' schools, and I gave her a one-word answer: "Girls." She said, "Oh, I understand."

There were only a couple of luxuries in my mother's life. She liked fur coats, and she liked fancy automobiles: she had a Chrysler Airflow and a flashy Cadillac with a big V-8 engine. The Cadillac was like a tank, and the V-8 engine was literally what they used in tanks. Sometimes, when my mother wasn't along, my father would drive it across the Mojave and take it right up to 120 on the speedometer. But my mother was traumatized by her sister Marian's accident, and I wasn't even allowed to have a bicycle. I'd go over to other streets and ride my friends' motor scooters, but I didn't have a car of my own until I was in my sophomore year of college and my grandmother gave me her Chevy Coupe. You can imagine what a handicap it was for a Southern California boy not to have a car. How are you going to get anywhere and how are you going to make out with girls? When I was sixteen, I made myself a fake driver's license using photographic paper in my darkroom—the licenses were on reverse photographic paper then—so that I could drive my friends' cars without my parents' knowing.

But, in general, my mother was a champion at providing me with what I'd been denied, growing up with rheumatic fever. As a visiting doctor at some of the public high schools, she had met a bright boy a few years older than me from a Syrian family; his name was Abad Dugali—we called him Abbott—and his father was serving a life sentence in the penitentiary for murder. My mother knew that it was a real handicap for me not to have been around girls or in a regular school during my convalescence, and she wanted me to have an older brother who would teach me the ways of the world, so she took Abbott in as a foster child; it was a great gift on her part. My younger brother seemed infinitely younger than me, and I had a lot of pressure from my father at that time about my weird interests. My father was confused by Abbott—who was this boy and why was he living in our

house? But he accepted it. I don't think my mother ever told him the real reason.

Abbott was terrific. He was one of the coolest, most suave guys in the whole school and one of the finest athletes. His great interest was gymnastics, which was an enormously competitive high-school sport at the time, and he encouraged me to go out for the team. He told me that I wasn't going to get anywhere with girls unless I was involved with some kind of sport, and it turned out to be true. I may have been the worst person on the gymnastics team, but it was fun. Abbott taught me to drive and he lent me his car, which made all the difference on dates. I was probably the most careful driver anyone ever saw, because I really didn't want to get busted for driving with a forged license. When I was in tenth grade, Abbott came up to me and said, "Here, you'll need these," and handed me a pack of Trojans. He also liked to go fishing with my father, which took some of the pressure off me. I hated sea fishing; I'd get seasick in my dad's boat. My father gave me so much Dramamine one time that I just slept through the whole thing. Then he gave me Dramamine with Dexamyl, so I was high as a kite, watching the wake behind the boat and thinking it was the most fascinating thing I'd ever seen; the first speed I ever took was given to me by my old man. But Abbott loved fishing. When we went up to Mammoth Lakes with my father, he'd go out in the boat, and I could sit on the porch of the cabin and read all day.

2.

FIRST ENCOUNTERS WITH MUSIC AND ART

In junior high, I had dated Linda Pauling, the daughter of Linus Pauling. By the end of tenth grade, I had three girlfriends at once. It was a bit of a problem, but they stuck with me. There was one who was smart and nice, whom my parents would approve of: Elizabeth—Betty—Brunt. Her sister and brother-in-law lived near Balboa Beach, south of Los Angeles, and Betty and I would go there and swim on weekends; my parents felt that with her sister and brother-in-law there we were adequately chaperoned. But what my parents never knew was that her sister and brother-in-law were practicing nudists, and, although Betty and I didn't walk around nude, the two adults were always naked, in the backyard and around the house. It was a wonderfully exotic environment for a teenager in 1949. Then there was a nice girl from an Episcopalian family, Anne Richardson, who became my official girlfriend for about a year. That upset my parents a little, because her father played the organ and she took me to Episcopalian church. Although neither of my parents was atheist, or even agnostic, they were very opposed to organized religion. The third girl was called Marianne. She was the fast girl, the first high-school-age girl I ever got to feel up. She had a younger sister named Deedee. I brought them both home one time, and, while we were sitting listening to music or something, Deedee jumped my little brother. He was probably around thirteen at the time, but she was a wild girl, and she was on top of him on the sofa when my mother walked in. She took a very dark view of the proceedings. "What have you brought into our house?" she said. "Get these girls out of here and don't let them come over ever again." So Marianne became a less-than-official girlfriend, but she was terrific.

Betty Brunt loved opera and classical music, and we had a deal. On Saturdays we'd take a bus downtown to the Los Angeles Public Library—our

parents thought we were going to do our homework—but instead we'd go to musical events. One week we'd go to a symphony or an opera, and the next week we'd go to hear jazz. Igor Stravinsky once said that the only way he knew to avoid Hollywood was to live there, and one of the great delights of my life was getting to see and hear him conduct his own music at the extraordinary chamber-music society Evenings on the Roof (later the Monday Evening Concerts), which were founded by a man named Peter Yates, who held concerts at his home, a Rudolph Schindler house in the Silver Lake area. His wife, Frances, was a concert pianist and he was a poet and a critic for the original *Arts & Architecture* magazine. He worked for the county civil service, but he put all his spare money into this small-scale chamber-music group. The L.A. movie studios had some superb musicians on staff, and the best of them came to these performances to play the music they really loved: Beethoven, Mozart, and Bach, as well as some very modern music—Schoenberg, Stravinsky, and so on. One night, I saw the world premiere of a Stravinsky piece based on Dylan Thomas's great poem "Do Not Go Gentle into That Good Night." It was a gorgeous piece, and after he'd conducted it, Stravinsky turned to the audience and said, "I'd like to hear it again. Would you mind? Can we perform it a second time?" And, of course, everyone said yes. Those evenings were also where I first heard live music by John Cage and Charles Ives. And the audience, too, was fascinating: my crowd attended, but so did the older European expatriate world.

There was great jazz in the city then, too. Sometimes my interests were a little hard for Betty to take, but she put up with me. It was extraordinary what I got to hear in the late forties. The jazz clubs were all near the burlesque theaters and the porno joints. I would slip out at night with my friends and a camera and I'd photograph the musicians, some of it at very slow shutter speeds, because we were in dark places. They'd move and blur, and I liked that effect. I came up with a technique that I began to use frequently: I would cut some of my images into pieces and then fasten them down like tiles, some parts being whole and others more fragmented. A few of my works were rather non-referential; in others, parts of the night scene were clearly recognizable.

My father was a member of the Kiwanis Club, which had an auxiliary junior club for teenagers called the Key Club. I joined so that I could travel

to the meetings they held up in Oakland and San Francisco. I never actually went to the meetings; the minute I got to the Bay Area, I'd ditch the convention and go creeping around in the night to find musicians and see art. I'd stay at a hotel in Oakland, where the Key Club convention was, but from there I could take a bus across the bridge to the Ferry Building in San Francisco, and then take cabs. I'd use my fake driver's license, which said I was twenty-two, and even as a white boy I could go anywhere in those days before Dr. King was shot, so long as I was respectful of the music. I went to a big dance hall in Oakland called the Ali Baba, where you could hear Count Basie, and a club called the Burma Lounge, which, on one trip, was featuring a group I'd never heard of—the Dave Brubeck Trio, with Cal Tjader and the saxophone player Paul Desmond, who ended up meaning the most to me. Brubeck was an interesting piano player, but he was no Lennie Tristano, the blind Italian-American in New York, who was unbelievable.

In L.A., it was more of a challenge for me to get around. I had one particular friend who was a great jazz musician himself, a white guy named Jim Matheson, who played saxophone and oboe and went on to have a symphonic career. He was my best friend in high school and he'd often drive me to hear music or to record stores. He was a born-again Christian, and that sometimes made things a little difficult for us. He was always wanting me to talk to Christ, and I'd have to say, "Jim, you know, I just haven't seen the light." I once had to go to a Billy Graham meeting in a stadium just to keep him happy, but it was worth it because he really knew jazz and we'd go places.

Some extraordinary musicians ended up in Los Angeles because the head of the American Federation of Musicians—the national musicians' union—a man named James Caesar Petrillo, had a really bad attitude about musicians on dope. He'd revoke the cabaret license of anyone he suspected of using it. Those musicians would head west to California, where things were more liberal—and where, tragically for them, dope could be had. I was smoking marijuana before I ever smoked tobacco. I saw Charlie Parker play with the young Miles Davis—who wasn't much older than me at the time, though I didn't know that. (Soon after that, Parker was put into the Camarillo State Mental Hospital. When he got out, he wrote the piece called "Relaxin' at Camarillo.")

I got to hear Billie Holiday live on four successive weekends. She was playing at a club called the Tropical Village, on Central Avenue, near Watts, which was almost a free zone for narcotics then. It was where the movie colony went to get dope, and the corrupt LAPD of that time let it slide. They'd bust Robert Mitchum for marijuana possession in a little house on Laurel Canyon, but I never heard of them raiding Watts. Holiday was sort of wrecked by that point, but her genius was still all there. The third time we went to see her, I thought we were going to be killed. Jim Matheson, Betty Brunt, and I took a guy from high school named John Fitch. I wasn't very interested in drinking at that time, but you had to order drinks in a club to supplement the cover charge. Fitch grabbed my drink, which I was barely touching, and he got drunk really fast. During the second set, he ran up to the bandstand and wrapped his arms around Miss Holiday's legs. Everything stopped. The place was stone silent. We were the only white people in the club, and Matheson and I looked at each other and said, "We're going to die. Why did we bring this asshole?" The manager trotted up to the stage and peeled Fitch's arms off Holiday, who just stood there like a statue, with a What-the-shit-does-this-white-boy-think-he's-doing? look on her face. Then the manager walked Fitch over to our table and said, "I've seen you before and you are very respectful of the music. You will always be welcome in this club. But you have to swear that you will never bring this son of a bitch anywhere near this place again. And I think you should take him home now." I said, "Yes, sir," and I slipped him twenty bucks I couldn't afford, and he didn't say another word about it. He just took the money, and Matheson and I got on either side of Fitch and walked him out of that club. Fitch was persona non grata in my crowd from then on. But I made a point of going right back to the Tropical Village the next week and everything was fine.

When I was in high school, I read everything I could get my hands on about modern art—new art, postwar art—and I did my own research as well, because there was almost no contemporary art worth a damn in the local museums then. The vicious political war of the fifties was already brewing in Southern California in the late forties. It was centered largely around the

movie industry in Hollywood, where the primary targets were European expatriates, but the art world suffered, too. There were four art museums in the Los Angeles area then: the old Pasadena Art Museum, which had no modern art when I was a child; the Huntington Gallery, where the gardens were far more interesting than the exhibits; the fascinating Southwest Museum of the American Indian; and the original Los Angeles County Museum of Art. The L.A. County Museum was down in Exhibition Park then, and it had three divisions: the Art Division, the Natural History Division, and the Social History Division. The Art Division was where I saw modern art in a museum for the first time—thanks to the pioneering curator James Byrnes, who acquired the first Jackson Pollock to be shown in Southern California, as well as a beautiful early Josef Albers, *Homage to the Square*. (As soon as the Albers was installed, someone stuck a big wad of chewing gum right in the middle of it and it disappeared from view.) There was a very neoclassic, dull Rose Period Picasso at the L.A. County Museum, too. And, in the William Preston Harrison Collection, there were a few Max Ernsts that I liked. A Magritte and a powerful Picasso were given to the museum in 1949, but not long after that they also disappeared from view. I inquired after them and learned that they had been put away because the artists were "communistic."

San Francisco, on the other hand, was a liberal city in those years, with an art scene that was far ahead of L.A.'s. There were pioneering avant-garde art galleries there, and the old California School of Fine Arts, where Clyfford Still was teaching at the time. I didn't really know the East Bay then, but, thanks to the Key Club, I spent time at the San Francisco Museum of Art, which was the fourth oldest modern museum in the country. I saw extraordinary things there—the great Fauve Matisses, for instance, Paul Klees, some beautiful Georges Braques, and some of the newer people as well. I soon discovered that south of Market Street, in an old warehouse area, there were many amazing loft studios. Nine Mission Street, which was down toward the waterfront, was crucial: it was where so many of the artists I got to know later worked or had worked. On the first floor, there was a bar called the Seven Seas Club—with parrots in cages and so on—where sailors traded yarns and drank. A healthier place, where you could sit and talk forever, was the Sailors' Union of the Pacific cafeteria; it was clean

and well lit, with Formica tables, and you'd go there just to get wired, drinking endless cups of coffee. In the years after that, as the coffeehouses and bars of North Beach sprang up, things shifted. But 9 Mission Street remained a hot place for the older artists. Diebenkorn painted there at one time. Hassel Smith worked there before moving up to his apple orchard in Sebastopol. Frank Lobdell had a fantastic studio there. James Kelly did his most important paintings at 9 Mission Street. Even the poet Lawrence Ferlinghetti made some not-so-great paintings there. In the late forties, and the first half of the fifties, so much of what one saw, both in San Francisco and in New York, when I finally got there, was still in studios—not even in galleries yet, let alone museums.

By 1949, I'd seen enough of the Bay Area to realize that new cultural frontiers were accessible there in a way that they weren't in Los Angeles. Still, a few extraordinary things were happening in L.A. at that time. In 1948, I heard about Copley Galleries, on Rodeo Drive in Beverly Hills, which was owned by an artist called William Copley and his brother-in-law, John Ployardt. Copley was an artist—he eventually started signing his work CPLY so that he wouldn't be confused with other famous Copleys. He was also the husband of six wives, the father of three children, an amazing gallerist, a great collector of Surrealist art, and ultimately a major philanthropist. His gallery, in an area that is now choked with expensive boutiques and overpriced real estate, was actually a small bungalow, curiously outfitted for his exhibitions with six- or eight-inch-wide boards that didn't quite meet, so that you had these sort of see-through display walls.

Copley had been adopted as a baby by Colonel Ira C. Copley, a Republican Congressman and newspaperman, and his wife, who found him at an orphanage on Sixty-Ninth Street in New York. He always postulated that he was the child of some bounder who had got a girl pregnant by mistake; he liked to think of himself that way. But he was raised with a proper education at Phillips Academy Andover and Yale and a certain amount of financial ease. When he was drafted into the Army, he was bivouacked at an antiaircraft station in Central Park, and he would slip away from his post in the night and go to a nearby hotel bar to drink. He did see action overseas, and in 1951 he went back to Europe and worked for his father's newspapers, writing articles on life in Paris. But before that, he came to

California and used some family money to open his gallery in Beverly Hills. Copley's notion was that he was going to sell Surrealist art to California. He thought that his artists would be perfect for the wealthy movie magnates, but of course they weren't. The gallery was open for less than a year, during which time Copley put on six exhibitions: René Magritte, Yves Tanguy, Joseph Cornell, Man Ray, Matta, and Max Ernst. But he didn't sell much of anything. The only time the gallery was written up in the newspapers was when Copley's pet monkey got loose, ran down to Wilshire Boulevard, and got into one of the big movie theaters during a matinee, creating havoc. Eventually, Bill began to buy the work for himself, which was how the Copley collection began.

I was fifteen and still too young to drive when I first discovered the gallery, but I had a friend take me there for the Joseph Cornell show. I didn't know Copley, and I'd never heard of Cornell, but the show was just magical. I'd never seen art that even resembled that—I didn't know about André Breton's constructions or that extraordinary Miró piece with a parrot in it. I don't remember there being any Cornell parrot boxes in that show, but there were other boxes, and little sand fountains, and two different versions of *Paolo and Francesca*. These things were like poetry to me, visual poems. Not one of them sold. I think Bill bought them all for himself in the end, because they were so cheap. I started searching around for more of Cornell's work in books, but I didn't know what books to look at. I could have found it in Alfred Barr's great *Dada, Surrealism and Fantastic Art*, but I hadn't heard of that yet. I could have found it in a catalogue from the Wadsworth Atheneum, where Chick Austin first included Cornell in a museum show, but I certainly didn't know that. Eventually, I found a special issue of *View* magazine that was devoted to Cornell; that was the first real piece of writing about him.

The second show I saw at Copley Galleries was Man Ray. Man Ray's real name was Emmanuel Radnitzky, but people who knew him just called him Man; I don't think anyone ever referred to him as Mr. Ray. He had moved to Los Angeles in 1940, after living in France for twenty years. He made it out of Paris just before it fell, so he was able to save a lot of his art. In Hollywood he found a place at the Villa Elaine apartment complex on Vine Street, opposite the Hollywood Ranch Market, which was where he

met his last wife, Juliet Browner. But, like Copley, he made a tactical error. He assumed that movie people would buy his art. His career would have advanced much faster if he'd lived in New York. Copley, who was great friends with Man Ray—they had spent time together in Paris—put on a spectacular show of his work, with paintings and objects as well as photography. Man Ray did every kind of photography—abstract and imagist work, portraiture of a very high order, and some of the nastiest pornography I've ever seen, some get-the-camera-right-in-there hard-core views of penetration and close-up studies of the asshole, which are not hung on museum walls—but I'm of the opinion that he is vastly underrated as a painter. His paintings are imagist, very different from Duchamp's work. He had a unique ability to draw out images from the dream world and make them specific: para-figures running along and then turning into bricks or sinking into a wall. These are unlike the biomorphic Ernst pieces; they're unlike the biomorphic objects in Tanguy; they're unlike the fantastic insect-like creatures invented by Matta. They're real images—we know what we're looking at—but they exist in fantastic places, and we are haunted by the mystery of them. His masterpiece, *Observatory Time: The Lovers*, is a huge disembodied pair of lips floating in the sky, suggesting two figures in a sexual embrace; it's an image that you can't forget once you've seen it.

Man Ray also made some wonderful small sculptures; he prefigured Cornell in some of what he did with objects. He had a series called *Objects of My Affection*—for example, a little pipe rack, with curious things stuck into it, or a bottle full of ball bearings. My favorite was *New York, 1917*: he had some thin slabs of metal, clamped together with a C-clamp and sitting at a funny angle on a nickel-plated round base so that they looked like the stacked elements of a New York City skyscraper. It's a beautiful, refined, ingenious evocation of elegance. Man Ray had an acerbic sense of humor. Another classic piece of sculpture is his *Object to Be Destroyed*: a pyramid-shaped metronome with the image of a woman's eye paper-clipped to the top of the swinging bar. When it was in a show in Paris in 1957, a group of anarchist artists took the title literally; they broke into the case, took the object out on the street, and shot it to pieces with a gun. Man Ray subsequently made an edition of them and called them *Indestructible Object*.

The Copley Galleries were almost empty the day I went to see the

show, and Copley came over to me to discuss the work. We talked a little, and then he said, "You know, Man Ray is living here in Hollywood. He has more work over there on Vine Street, if you're interested." I said, "I'm very interested." Copley called him up and said, "Man, I have a Mr. Walter Hopps here. He's very interested in your art. Are you free?. . . O.K. He'll be right over." He gave me the address, and I went up there and rang the bell. Man Ray came to the door himself, a short man with a sort of pudding-bowl haircut, already turning gray, and big glasses. He stared at me for a minute, and then he said, "You're not Mr. Hopps, are you?" I said, "Yes, sir." He said, "Just what do *you* think you can do for me?" My heart sank. He'd thought a collector was coming over, but he'd opened the door to a schoolboy. It was typical of Copley to pull a gag like that on Man Ray, but crushing for me. I said, "I just wanted to see your work. Would that be O.K.?" He said, "Oh, yeah, take a look." So I stepped in the doorway, looked around a minute, and then I said, "Well, I have to go. Thank you very much." He said, "Yeah, O.K." But I really loved his work. Later, after he died, a show of his came to the Menil Collection, and I never worked harder to get an installation right.

Through Copley, I heard about a man named Mel Royer, who had an extraordinary Surrealist bookstore on a side street in West Hollywood—it was *the* avant-garde bookstore in L.A., and I began to get Surrealist literature there. It was the first place I saw Hans Bellmer books, and it was where I found back issues of *View* magazine. It didn't occur to me at the time that one wouldn't be able to make a reasonable amount of money selling Surrealist and Dadaist literature in an arcane corner of L.A., but Copley explained to me later that Royer subsidized the Surrealism with backroom sales of high-end pornography. This was at a time when you had to go to a very bad part of town to get anything like that. *Playboy* didn't exist; it was all under the counter.

One day I went in there, feeling kind of low because it was my birthday. I think I was a senior in high school. Royer wasn't there, but an Asian woman who worked for him was unpacking a crate from someone's estate and out came a perfectly fine copy of Marcel Duchamp's *Green Box*, a limited-edition collection of photographs and notes he made to explain the

development of his work *The Bride Stripped Bare by Her Bachelors, Even* (*The Large Glass*). I recognized it from the books I'd been reading. I said, "Oh, that's an interesting item. What would you take for that?" She said, "I don't know. Mr. Royer hasn't priced all this yet." I said, "I tell you what. It's my birthday and I'd love to get something. I'll buy that for, say, twenty-five dollars." And she said, "Well, I guess that's O.K." I wrote a check for twenty-five dollars, and she gave me the piece and I left. My phone number was on the check, and that night I got a call from Mr. Royer. He said, "Is this Walter Hopps?" I said, "Yes, sir." He said, "Happy birthday, indeed!" I said, "You're not going to make me give it back?" He said, "No, it's yours." He was a very nice man, and he and Copley were great friends.

What I'd learned at the Polytechnic, in junior high, was so far ahead of what was taught in the public junior high schools that, even though I'd missed ninth grade, I had a real running start by the time I started tenth grade at Eagle Rock High School. One day when I was in eleventh grade, the principal announced that a special experimental program was being started to encourage students who were good in math and science to get extra training in the arts and humanities. The organizers went through the schools and picked out some students, and I was on that list. Every Saturday morning, we'd go down to the basement of the old Los Angeles County Museum of Art, and a fascinating man named William Applebaugh would lead us through a discussion and assigned readings and take us on field trips. On our first visit, he talked about Greek and Roman art and walked us around the museum to see the pieces that were there. We went to the Huntington Library to see the Nazi treasures—Hermann Goering's trove of stolen art, which had been hidden in the salt mines in Germany and Austria and was liberated by General Patton's army. The Army shipped the artwork to the United States for a national tour, and then whatever the Nazis had taken from the great museums of Europe was sent back to where it belonged. In the meantime, I got to see some extraordinary things.

Another Saturday, we went to the Elmer Belt Library of Vinciana. Dr. Belt was a very successful urologist whose hobby and obsession was to collect everything that related to Leonardo da Vinci—books, documents,

and so on. At the library we were introduced to a small, older woman named Kate Steinitz, who was his archivist and librarian. She had a German accent, and she explained to us that she was from Hanover, that she'd had to leave Germany to escape the war because she was Jewish, and that Dr. Belt had helped bring her to the U.S. and given her a job. I already knew who Kurt Schwitters was by this time—I was fascinated by his work—and when I learned that Kate Steinitz was a Jewish refugee from Hanover, I asked her, "You wouldn't by any chance have known an artist called Kurt Schwitters, would you?" She lit up like a lightbulb and said, "We were very great friends." It turned out that she had a stash of artwork by Schwitters that had never been shown. (I didn't see it then, but I got back in touch with her in 1962, when I was doing a Schwitters retrospective at the Pasadena Art Museum, and she was a tremendous resource.)

The most astounding field trip of that program was to the home of the collectors and art patrons Walter and Louise Arensberg. I was fifteen when I went there for the first time, and the minute I walked through their front door it was as if I'd passed through the looking glass. I was just stunned. There was more modern art than I had seen anywhere. No museum in Southern California had anything like their collection. There were important artworks everywhere. They weren't used in any way decoratively and they took precedence over the furniture: chairs, desks, tables, anything associated with the normal activities of daily life was in second position. The art was hung edge to edge—it was everywhere and in every room. You could open a coatroom door and there would be pictures hung on the inside of that door. Or on both sides. All conventional rules went out the window. For kids to see that people even older than their parents lived in such a way was absolutely liberating. It was my own version of Frances Hodgson Burnett's secret garden.

I knew of Duchamp, but I'd never seen his work in person and suddenly I was in the world's largest and most complete collection of his art. The Arensbergs had three versions of *Nude Descending a Staircase*. They had a huge number of Brancusis. There was also a curious Magritte painting. I had a feeling that Magritte was trying to tell a story with it—there seemed to be some kind of symbolic narrative—so I asked Walter Arensberg if he could explain it. I didn't ask him what the Duchamps meant—they just were

View of the living room in the Arensbergs' Hollywood house, in 1945, including artworks by de Chirico, Rousseau, Picasso, and Duchamp. Photograph by Fred R. Dapprich.

absolutely what they were, fascinating and an amazing contrast to the beautiful refinement of the Brancusis. But the Magritte looked as if it had something to say that could be decoded, so I asked about it. Mr. Arensberg smiled and said, "Are you ready to really understand what it means?" I said, "I think so. I hope so." And then he gave me what is, in Zen Buddhism, called a hard lesson. He said, "You must look at this painting and understand that it means absolutely nothing." It was as if a master had asked me if I was ready for enlightenment and then thrown a glass of ice water in my face. For the next few days that was what constituted enlightenment. It became a laborious workout, intellectually: Why did he say that? What could it mean? I've never seen anyone teach a class more economically, with so few words. And the lesson I learned was not that the painting meant nothing but that there weren't going to be any easy answers about its meaning. I had to somehow sense or pick up on the curious poetry that Magritte was playing around with. I was thrilled.

I saw my first Mondrian at the Arensbergs', too, a difficult Mondrian in very severe colors, with a kind of crosshatch, and I asked about that, too,

and about the artist. That night at dinner, I tried to describe the painting to my parents. I turned to my father and said, "Dad, could you tell me what you think of Mondrian?" I expected my father to know of Mondrian, because he was intelligent, he was in charge, and I expected him to know everything. He said, "Who's Mondrian?" I never asked him another question about art. It became a kind of secret realm for me. And my father never set foot in any gallery or museum where I worked. The Pasadena Art Museum was twenty minutes east of my parents' home, but as far as I know, neither one of them ever went there while I was there. After my mother died, I had to sort out her things and I found that she'd kept a box full of clippings about my career. Years later, when I was working at the Smithsonian, I came home for a visit and, over brunch with my father, I said, "Dad, I have somewhere to take you." I drove him up to the Pasadena Art Museum and he just froze like a deer in the headlights. I went around the car and opened his door and took him by the hand and led him in. He tried to hang back, but I led him through the place, and he'd point and say, "What is that?" I'd say, "That's a Frank Stella, Father." I told him what each piece was, but he never said a thing, one way or the other, about what he thought of the work. It must have been a mind-blowingly strange experience for him, but it was very important for me to do it. I wanted him to see, while he was alive, what mattered to me.

At the end of that first visit to the Arensbergs, I asked if I could come back sometime. Walter said, "You'd be very welcome. Why don't you come Saturday morning and you can stay for lunch and we can talk more about this, if you'd like." Walter and Louise had no children, and they had nothing but leisure time, so back I came. I'd get a friend to drive me there and pick me up afterward, and my parents never knew that I wasn't going to my Saturday-morning class. Once I had visited the Arensbergs' house, that was it. There was a little library on the second floor of the house, and they'd let me read in there. A lot of what they had was in French, but I could make out what was going on, or just be with the art. They had a little Brancusi marble piece in the library called *The Newborn*. I was looking at it one day, when Louise Arensberg slipped in behind me. She said, "It's time for luncheon, Walter, but I can see you're really engrossed in that piece. Why

don't you bring it to the table?" So I very carefully picked it up, praying I wouldn't trip and fall, and carried it downstairs and set it on the dining-room table while we ate.

They were the most wonderful people, intelligent, serious, unpretentious. They weren't loud or declamatory in any way, but they had very strong individual personalities. Both of them had great style; it wasn't conventional or mannered or obviously eccentric. Walter Arensberg was a man of leisure, in the eighteenth-century sense. He was portly and distinguished but informal. He had no fetishistic attachment to the finer points of laundering and ironing. He had family wealth—his family was involved with steel in Pittsburgh—which counted as old money in America, and he didn't have to work, so he could pursue his own private research. He wrote poems. He devoted himself to the study of alchemy. He looked into the mystery of Francis Bacon and William Shakespeare; he was interested in puzzles of that sort, on a higher level. He was a great student of cryptography. Louise seemed far less palpable, more ethereal—she had a kind of lightness and charm—though she was obviously a practical woman. She was deferential to Walter, but I had the feeling that they cooperated on all sorts of levels. They were very close—each other's own best company, somehow.

Walter happened to see the Armory Show in New York in 1913 and was so blown away by the Duchamp and Brancusi works that he began a serious collection. He tried to buy the original, most famous version of *Nude Descending a Staircase*, but a man who ran a posh emporium of Asian art objects in San Francisco had already bought it for about $125. Duchamp did a second version for Arensberg, for which he had a photographic blowup made of the painting and then, using the most difficult tool he could find—a screwdriver ("It made it more interesting for me to use an intransigent mechanical tool," he said)—he painted what he called the "mechanical" version of it. Eventually, Arensberg got the original *Nude Descending a Staircase*, too.

He and Louise had lived in New York from 1914 until 1921, the grand couple of the vanguard on the Upper West Side. In their apartment on West Sixty-Seventh Street, in the Hotel des Artistes, they had established an extraordinary salon of people in the arts. It included writers such as William Carlos Williams and the very young political correspondent and pundit

Walter Lippmann; it included artists of all sorts, from Duchamp, who came to New York in 1915, to Americans like Joseph Stella, to Baroness Elsa von Freytag-Loringhoven.

At some point, Arensberg decided that he wanted a change of venue. I think the charm of the early days in New York had worn off and there were a lot of hangers-on. Much to the dismay of many of his friends, he decided to move to Hollywood in 1921. When they arrived, they stayed at first with a wealthy bohemian woman named Aline Barnsdall, who had bought an entire hill in the eastern part of Hollywood, below Hollywood Boulevard. She wanted to turn her land into a kind of art and theater colony, and she commissioned Frank Lloyd Wright to build a house there. Barnsdall was independent and single, and a great patron of Wright's. She had other buildings on the property—performance amphitheaters, a guesthouse—and I think she wanted to have an art school up there, eventually. But, after Wright had a quarrel with Barnsdall, and he brought Rudolph Schindler in to take over. The property has been chopped up since Barnsdall died, but the Wright house—Hollyhock House—became a property of the city and has been maintained as a landmark. And that was where Walter and Louise camped until they found a place on Hillside Avenue, up in Raymond Chandler land. On Hillside, they lived next door to a famous dealer of pre-Columbian antiquities, Earl Stendahl, and he prevailed on them to add some great hulking bits of pre-Columbian art to their collection.

In California, the Arensbergs lived much quieter lives. By the time I met them, people could come to visit only by carefully arranged appointment. But Duchamp often stayed with them when he was in town. For reasons I've never known, Man Ray—Duchamp's early coconspirator in New York Dada—was not welcome in the Arensberg house. He was a problematic person, and they'd had some bad encounter with him back in New York.

Around that time, the Museum of Modern Art in New York was beginning to get organized, and Walter had the idea to create a similar museum in the West. The Arensbergs were far and away the most important collectors ever in the Western United States, and theirs was the first really great collection of the advanced art of the twentieth century. As they envisioned it, the Modern Museum of the West would encompass their collection and the collections of Ruth Maitland and Galka Scheyer. Maitland was a wealthy

Louise and Walter Arensberg with Marcel Duchamp (right), in the garden of their Hollywood home, August 17, 1936. Photograph by Beatrice Wood.

woman who collected French art in a way the Arensbergs didn't—Braque and Picasso and Matisse, School of Paris, and that sort of thing. (Walter Arensberg had only one Picasso, a peculiar one; he wasn't that interested.) So their collections dovetailed perfectly. Galka Scheyer was a German woman who had moved to California in the twenties and lived on Blue Heights Drive, in a wonderful little house designed by the Viennese architect Richard Neutra. She represented the Blue Four in America: Wassily Kandinsky, Paul Klee, Alexej Jawlensky, and Lyonel Feininger, all artists associated with the Blaue Reiter group from Munich. She arranged shows for them, found collectors up and down the coast, and consigned their work to galleries. She owned work by other German Expressionists, too, and she had a Picasso. Those three collections would have been a great start for a Western museum of modern art, and they were offered to UCLA—there was an empty building there, which had held the Department of Education, and which Arensberg and the others thought could be refurbished to house the museum. The Pasadena Museum was too eccentric a structure, and it wasn't big enough for all three collections. But one of the regents of the University of California, a man named Edward A. Dickson, apparently had a wife who hated modern art and he blocked it. The building became the art and art-history center at UCLA instead, and it was named the Dickson Art Center, in his honor.

The Arensbergs never found another place for the museum. It would have changed the course of things in this country if they had. Ruth Maitland's collection was scattered all over the world when she died. Galka Scheyer died in 1945, and her collection was impounded as the work of "enemy aliens."

Later, after a series of legal actions, it was bailed out and awarded to the Pasadena Art Museum. And when the Arensbergs died, they left their collection to the Philadelphia Museum of Art. Fiske Kimball was the director of Philadelphia when they approached the museum to suggest the bequest. Kimball was famous for creating the period rooms at the museum. He also privately fought to save Thomas Jefferson's masterpiece, the house at Monticello. He hated modern art, but when he saw what the Arensbergs had he said something to the effect of "Although I find this art personally repugnant, I know that it will be important one day, and I am pleased to accept it." He devoted a whole wing of the museum to it, and it certainly was important. Kimball, unfortunately, went mad in the last years of his life, and after he was discharged from the museum he was often seen wandering through the place or just sitting and staring into space in the library, a lost soul. A sad ending. His tale was my first taste of the hazards of the profession.

3.

EARLY DAYS OF CURATING: JAZZ AND SYNDELL STUDIO

In high school, I was on a team of students who were strong in math and science, and I won a competition sponsored by Bausch & Lomb. My high-school physics teacher was hoping I'd go to Caltech; I got into Yale, and my parents wanted me to go there—no one in the family had ever gone to an Ivy League school—but the idea of going east was appalling to me. I wanted to go to Stanford, so that was where I went for my freshman year, in 1950. I was a physics major, and, to let my parents believe that I was preparing for premed, I also took biology. I worked on the Stanford humor magazine and was briefly suspended, with the other five editors there, after we ran a photo essay on some high-school students shacking up at a hotel. We also put together a parody of *Woman's Home Companion*: I created a "Dinner for Daddy" shoot, in which Daddy and the kids were being served dog shit on platters. It was pretty sophomoric stuff.

Getting into San Francisco from Stanford was an easy shot then, and I became very involved in what was going on in the Bay Area. Even before the beginnings of Beat culture, San Francisco had some of the best art in the country. It was second only to New York in terms of Abstract Expressionism, and the center of this activity was the California School of Fine Arts (now the San Francisco Art Institute), an art school that dated back to 1916. There was such an amazing spectrum of artists in San Francisco then, spanning almost three generations. Clyfford Still, who had taught for a time at the California School, had moved east, but his legacy was very much there. Still teaching was an artist named Clay Spohn, an absolute eccentric who came from a wealthy family and did Clyfford Still-like abstractions at one point, but also made a series of bizarre imagist works, based on war machines, and a sculptural tableau called *The Museum of Unknown and Little Known Objects*, which consisted of jars full of indecipherable things.

There were artists who, like Spohn, were born around the turn of the century. There were artists born in the teens and artists born in the twenties, including Richard Diebenkorn, who was a student at the CSFA. Diebenkorn, who had been in the active reserves, was part of the generation who'd served in the Second World War and come back to study on the GI Bill. Then there was a very interesting generation of younger artists, born in the later twenties or early thirties. There were also three museums that had begun to show modern art. The San Francisco Museum of Art was always a modern museum, and the Oakland Museum, in the East Bay, had a collection and a program devoted to art in California, which rescued work from the estates of somewhat forgotten artists. And at the Palace of the Legion of Honor, there was the pioneering curator Jermayne MacAgy, who was one of the first women in the country to get a Ph.D. in art history, and whose theme shows were extraordinary. I saw a crazy one called "Time," which had everything from old clocks and time devices to de Chirico paintings. Her husband, Douglas MacAgy, who later became her ex-husband, was running the California School of Fine Arts then.

At Stanford, I became friends with James Newman—Jim—whose family was behind the Hinky Dinky market chain in Omaha, Nebraska, and who was a jazz aficionado like me. We came up with a plan to book jazz concerts together, but when every attempt we made to book one on the Stanford campus was blocked by the school administration—they wouldn't have black musicians on the stage of the Memorial Auditorium—he transferred to Oberlin College. Meanwhile I, in my infinite wisdom, decided that I wasn't going to take any more money from my parents, and since I couldn't afford Stanford, I transferred to UCLA in the fall of 1951. I enrolled in life sciences, still thinking that I would complete that degree and fulfill my father's dream by going to medical school. I was very conflicted on that front. But at least I was supporting myself and didn't have to answer to my parents if I took a semester off to work on my own projects, which happened quite a lot.

Soon after I started at UCLA, Jim Newman and I formed a partnership, which we called the Concert Hall Workshop, to book serious jazz. To my mind, jazz was the greatest chamber music in America in the twentieth century, and I was sure that jazz musicians would become heroes and rake

in the fortunes they deserved. But I didn't think that the art I loved was ever going to go anywhere, really; there was no way the world would embrace it. I had everything absolutely backward, of course. The artists would make the money, and the jazz musicians would die off. Newman and I didn't make any money. A generation or two later, in Bill Graham's era, the serious money came with rock and roll; booking rock shows, we would have got rich. As it was, we couldn't even afford long-distance phone calls to each other, so we sometimes borrowed our friends' shortwave radios and did our business that way. We mostly covered the college circuit. Newman was booking shows at Oberlin and other colleges in the Midwest. I had my artist friends creating the announcements.

Dave Brubeck became a great friend of mine, as did Paul Desmond. I'd come to know Gerry Mulligan and Chet Baker. I double-dated with Chet Baker and his girlfriend, and it just terrified Anne Richardson, my girl-friend at the time, who couldn't handle the jazz thing or people who smoked dope. Poor Gerry Mulligan was still a heroin addict then, and so was Chet, and that scared the hell out of her. One night Jim and I set up a concert with Gerry Mulligan's quartet—Mulligan on baritone sax, Chet Baker on trumpet, a bass player, and a wonderful drummer called Chico Hamilton, the best drummer Mulligan ever had. They were at a small club called the Haig, across from the Ambassador Hotel on Wilshire Boulevard. In the middle of a song, Mulligan suddenly stopped playing. The rest of the band drifted to a stop, and Mulligan said, "Ladies and gentleman, we have just had the great honor of seeing Miles Davis enter the room." Everyone turned around, and there was Miles, smiling. He and Mulligan were friends. Gerry saw that Miles was not carrying a horn, and he said, "Mr. Baker, will you give your horn to Mr. Davis?" So the young man handed his trumpet over to the master, and they played the rest of the evening while Baker sat dutifully at one of the tables, listening. Not long after that, Mulligan had to go to the sheriff's honor farm; he was caught with marijuana or something.

I worked hard to book a Dizzy Gillespie show, but there was a terrible booking agency in the way and we never pulled it off. A few years later, I went to hear him play at the Fillmore Auditorium in San Francisco, and at the end of a number he noticed me standing down front near the band-stand, listening. There were probably five white people in the place, and I

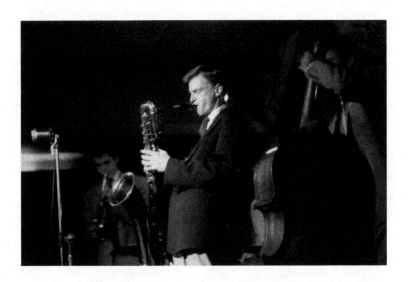

Gerry Mulligan. Photograph by Walter Hopps.

was one of them. He smiled and pointed at me and said right into the microphone, "Will somebody get that white motherfucker up here?" Just like that. So everyone was staring and somebody walked up and took me by the arm and led me onstage, where he shook my hand and embraced me. The audience didn't know who the hell I was, but they kind of clapped and I smiled like an idiot. He said, "See this white boy? He's all right." Then he turned to me and asked, "What would you especially like to hear?" So I named a tune and he played it. It was the most amazing public acknowledgment I ever had. He was a smart man, John Birks Gillespie, never a doper, and he died old.

While Newman was still at Oberlin and we were organizing shows long-distance, I also started booking concerts in L.A. with a guy called Jerry Perenchio, who came from an Italian-American family. He was ahead of me at UCLA and we organized some serious jazz shows together. He also booked bands for fraternities and sororities, and he had a scam whereby he'd charge them for a twelve-piece band in which at least two of the trumpet players and one of the saxophone players were just stooges holding instruments. The kids didn't know the difference. Jerry would pay the stooges twenty bucks a night and guarantee them free drinks and food and a chance to pick up college girls. Later he made a fortune with Jack Kent

Cooke, promoting the 1971 fight between Muhammad Ali and Joe Frazier at Madison Square Garden, and eventually he took over Univision.

By this time, I had become so enamored of the new art I'd seen in the Bay Area that I decided to put together a big independent exhibition in L.A. and I started gathering work. I'd hitch a horse trailer with a canopy over it, like a covered wagon, to my Chevy Coupe, and use it to haul down paintings from the Bay Area. It was on one of those drives that I met my first wife, Shirley Neilsen. Jim Newman and I had gone to Sebastopol, where the artist Hassel Smith was living, to see whether we could borrow some of his work for the show.

Smith was a wonderful man—he did wacky figurative paintings early in his career and then switched to delightful gestural Abstract Expressionist work. He'd been one of the younger faculty at the California School of Fine Arts, along with Clyfford Still, and he owned a great Still painting, which he kept in his barn. Some wasps had built a nest in the stretcher bars of the canvas, and when I went out there with a Coleman lantern to look at the work, I woke them up; those were truly the worst viewing conditions I ever had. It was hot driving back down, and we stopped off in Petaluma to visit a medical-school classmate of my parents, Melvin Neilsen. We were hoping that he and his wife would give us lunch and let us swim in their pool. It turned out that their daughter, Shirley, whom I hadn't seen since we were children, was home for the summer from the University of Chicago, where she was studying art history. Her parents were Scandinavian-American and she looked like a woman from a Bergman movie, blond and zaftig—while her father was like the grim old man in *Wild Strawberries*. We talked a lot about art, and after a while it became conspicuous that she and I were doing all the talking and ignoring everyone else. I really fell for her. We kept in touch—I'd call her up and write letters—and later I started visiting her in Chicago, where she was on the fast track at the university and went straight into grad school.

While I was up in the Bay Area looking for artists, I enlisted the help of a guide, a man named Relf Case, a painter himself, whom I'd met at one of the bars in San Francisco where there were art shows and poetry

readings—the Place, perhaps, or Miss Smith's Tea Room. Relf Case knew all the artists, and he took me around to meet them. In the course of my search, I kept hearing about an older painter who had fallen on hard times but who was very much adored by other artists. His name was James Budd Dixon, and I went to visit him at his studio in the Mission District. He had divided a big open loft space into separate rooms by hanging old Oriental rugs over pipe racks—the kind that hold clothing at commercial establishments. He was a very dapper elderly man, and I loved his paintings. They had areas of flat color, fierce color, but also, on the surface, webs and veins of paint. These didn't look anything like the beautiful applied webs of Pollock—they were something else. They had an intense linear quality, usually top to bottom, whereas Pollock's moved in a centrifugal way, across or out from the center. Dixon also did some works on paper, often colored craft paper or a kind of oatmeal paper, with metallic inks making tenuous, wavering linear forms that moved out from the center in strange X or H patterns. They were more subdued than the paintings, very subtle and quiet, but also beautiful. I took a look around and then Dixon came up to me and said, "Mr. Hopps, what is it that you want of me?" I said, "Well, I'm very interested in your work and from what I can see it looks terrific. I'd like to show it and see if I can sell some." He said, "Well, Mr. Hopps, are you interested in hearing what I want of you?" I said, "Yes." "All I want is all you've got and then some." He laughed. I thought that was the most honest answer I ever got from an artist looking to further his career. Sadly, I was never able to sell his work, and he died not long after that.

Back in L.A., I cashed in some bonds and, for seventy bucks a month, rented a place on Gorham Avenue, off San Vicente, on the edge of Brentwood, where I could store the work I was collecting. It was a storefront space, by the VA hospital and the seedy part of Westwood where veterans went to cheap bars to drink. There were some artists' studios on Sawtelle Boulevard then, not far from the space, and there was a famous bar nearby that I used to go to, called the Lucky "U"—a tough Mexican bar, with a big oblong counter in the middle and table service, though if you were smart you didn't eat the food. The walls were a greasy yellow-brown and painted on the ceiling in big red-and-black letters was the word "LUCKY," then the letter "U." The first time I was in there, I asked the bartender, "Why is that up on

the ceiling?" He said, "You get in some fucking fight, and they go-cart you, and you're on the floor and, when you open your eyes, you see 'LUCKY U'"—lucky you that you hadn't been killed for getting in a fight in that bar. But it had a mix of artists and musicians and working-class people from the neighborhood and a few old veterans. One time Johnny Cash came in and I bought him a beer.

The building I rented belonged to an eccentric old man named W. Briar Shorr, who had worked on the Panama Canal, bending pipes around trees with teams of horses—he was that kind of guy, a character from the Teddy Roosevelt era, a kind of independent anarchist himself. Afterward he'd settled in Brentwood and bought up land, and he'd built this strange one-story building. It had a concrete floor and the walls were made of pilings from the old Ocean Park amusement pier in Santa Monica, which had closed down after the war years. Shorr had set those pilings vertically in the concrete, like telephone poles, and filled in the cracks between them with more concrete. The ceiling, which angled down at the back, was made of varnished knotty pine. On the floor, he'd used tar to glue down the fuzzy brown felt you put under carpeting. It was the nastiest job in the world to get that stuff off and then paint over the concrete with gray deck paint. One wall was covered with leftover one-inch lumber, pillaged from construction sites, and nailed together in a crazy rectilinear jigsaw pattern. I called it the one-by-shit wall. I spent a lot of weekends fixing the space up, with anyone I could round up to help. My old girlfriend Betty Brunt, her boyfriend and future husband Ben Bartosh, and a friend of his, an artist called Michael Scoles, were all there from the beginning. And while we were preparing for the show, we decided to start a gallery first.

We needed a name for the gallery, and I remembered something that had happened to Jim Newman when he and a friend were driving to Chicago in his Oldsmobile 88. Somewhere in Ohio, on a clear morning on a wide-open highway, they noticed a truck parked by the road. Just as they came even with the truck, a man leaped out from behind it and fell under the wheels of the car. Jim's friend was driving, and he couldn't brake quickly enough. He hit the man and killed him. They were both aghast. When the highway patrol arrived, they could tell from the skid marks that it had been an accident. It seemed that the man had wanted to kill himself and, instead

Syndell Studio, exterior shot. Photograph by Walter Hopps.

of jumping off a grain silo or shooting himself, he'd chosen this method. He had a wife and a child, and an unusual name for an Ohio farmer—Maurice Sindel. It was such a beautiful name that I named the gallery after him— Syndell Studio (I didn't know at the time how his name was spelled)—and I decided that Maurice Syndell had been an artist and that we should come up with some interesting art for him so that he wouldn't just vanish unknown. So different people worked on pieces by him—Ben Bartosh and Michael Scoles and I, and later Ed Kienholz—and we included some of them in our group shows. There were very few art reviews back then, but Maurice Syndell is mentioned in one of them, which means that he'll be in the Art Index forever. I'm just waiting to meet the young art historian who tries to track down what he did. Most of it is destroyed now.

Once Syndell Studio opened, in 1952, people just started turning up. Critics in the conventional art world were not impressed, but it got the attention of the sort of people we wanted to attract; Jules Langsner, the critic for *ARTnews*, came in only once, but a lot of artists came for the first time and then kept coming. Generally, I did group shows and theme shows with the few Los Angeles artists I really liked and the San Francisco people. I'd cook

up the ideas while talking to Michael and Ben and Betty, whom I hired to man the place for next to nothing. When I learned that Alfred Stieglitz had shown children's art in his great modern-art gallery, 291, I started to collect art by children and include that in the group shows, too. There was a dreamy architectural designer named Sam Elton living next door to Syndell, with his wife, Lorraine, who supported him by drawing wallpaper patterns. They had a little girl, who made good art, so I showed her work. Some adult artists took offense. They said, "Why are you showing that crap by children?" I said, "Because I love it and it's wonderful. It's so simple."

The main people in my group shows were Sonia Gechtoff, Paul Sarkisian, Edward Moses, James Kelly, Julius Wasserstein, and Gilbert Henderson. It was the first time that many of those artists had had a window into Southern California. I also showed work by Michael Scoles, who was probably the brightest man I ever met—he topped two hundred on a Wechsler-Bellevue IQ test—totally dysfunctional but brilliant. He was a peer of mine, but he lived in a different world. He did strange drawings, like little Sam Francises, and he made these unusual portfolios that you had to tear open, and the way the paper tore would affect the way the image came out—different things and colors would be revealed. He was a genius as a mathematician, too. Scoles, Bartosh, and I were in some of the same math classes at UCLA, and our routine was to write our tests in ink. We'd do a perfect test in our blue books, then write in the grade—an A—and circle it. Another trick was to make interesting mistakes and then correct those mistakes in ink, just well enough that we'd still get an A. Scoles could always win at that game. He was like Seymour Glass in the Salinger stories, and, like Seymour Glass, he shot himself, sometime in the late fifties. He was the first friend of mine to die that way. Scoles had had a job working in the rare-book room at UCLA to support himself, and when he died, his wife, Carol, discovered that he had stolen hundreds of books. It was an eccentric collection. He had books of tables of random numbers—before computers were around to compile those things, there used to be books—and all sorts of other arcane and expensive volumes. He loved those things and he didn't have the money to buy them, so he'd been slipping them out. Bartosh and I boxed up the books as best we could and called the UCLA librarian, Lawrence Clark Powell, to let him know that there were a lot of books belonging to the

university at this address and someone could come and pick them up—which someone did posthaste.

Bartosh had quite a few eccentric friends. There was a person I knew only as Eli, who was Jewish, from a wealthy family; he and his friends would dress up in Nazi uniforms and cruise around L.A. menacing people with a machine gun. Why they didn't get busted, I'll never know. Then there was a man called Ron, who was one of the creepiest people I've ever met. One night I was at home in my apartment and I heard what I call the dead-man thump—a slow, rhythmic pounding—on my front door. I got up and opened the door and through the screen I could see Ron in a raincoat, his face bleeding down onto his clothes. I said, "Ron, what happened?" He said, "Hit with an axe, but not hurt." So I pulled him through to the kitchen, where he could bleed on the linoleum instead of the carpet, and I called for an ambulance. I never heard anything more about the incident other than that he was O.K. The only time I saw him after that, I was driving up Sawtelle Boulevard toward UCLA and I spotted him standing on the curb. He waved at me to pull over, so I did. My window was open. He walked up to the car, produced a jar, took off the lid, and shook a large black widow spider through the window and onto my lap. I was out of the car like a shot, asking him what the hell he was doing, but he didn't have anything to say. He was just carrying around a black widow and when he saw me he figured he'd give it to me. That was the kind of person Bartosh sent my way.

One time I had scheduled a group show at Syndell, and since I was in school I left it up to Ben and Betty to gather the work for it. But when I got to the gallery the day before the opening, they hadn't put anything together. I was really pissed. I was paying them what I could and covering the rent and the expenses, and they'd let me down. We went out for dinner, and I said, "Here's what we're going to do. We're going to spend the rest of the night doing the show." Ben said, "What the fuck are we going to do?" I said, "We've got to have something on the walls. The three of us are going to go up and down the alleys and streets around here, and we're going to collect the things that interest us and bring them back, staple them to the walls, and put them on sculpture stands. I don't give a shit what you bring back, but you have to bring back something. I'm going in one direction, Betty's going in another, and, Ben, you're going in another, and we're coming back

with stuff that will fit through the door. The faster we get it done the better." So that's what we did. We called the show "As Found," and it looked great. It was very interesting junk.

Syndell probably got two reviews in the course of its three-and-a-half-year existence and sold three or four artworks. It drained money, but I wasn't really looking to make money then. As well as cashing in my war bonds, I sold the stamp collection I had built up when I was bedridden as a child—I was selling it prematurely, but nonetheless I got a stash of money for it. So I had ways of picking up money on the side, though I never had much. I was still a bacteriology major at UCLA, and I went on taking all the art history and literature classes I could. I knew that if I ever finished my degree I'd face that terrible showdown with my parents about going to medical school, so I dragged it out forever.

And, not long after Syndell opened, I was drafted. You couldn't dodge the draft then—you'd have the FBI on you. I was in school, but that wasn't enough, at the tail end of the Korean War, to get me off the hook, so I started insisting that I didn't intend to kill anyone, not even Koreans or Chinese. The people at the draft board said, "Are you a pacifist?" I said, "Yes." They said, "What's your religious basis for this?" I said, "I don't have a religious basis, just a human basis." "Next." They pass you along. Finally, I got the attention of an officer, someone who looked like he might have the brains to understand, and I just yelled at him that I didn't intend to shoot anyone, "including you, sir." So he said, "I think you'd better go down to the base hospital and see Major Lahar." At the hospital I played it straight; I didn't try to fake anything. They gave me a series of tests, including the Wechsler-Bellevue. Some corporal was running the test, which involved reproducing patterns with a pile of blocks. He showed me a pattern, started a stopwatch, and I reproduced it with my blocks. I told him I was done. He said, "No, you're not." I said, "Well, come here and see it. I'm finished." He said, "Let's do it again. Now do it right." I said, "But you haven't looked." He said, "Just do it again." He gave me another pattern and I did it again, and I said, "I'm finished. Come over here and look." I wasn't trying to do anything weird, but, instead of laying the blocks out flat on the table, I was building them

into a vertical wall—so, though I could see the right answer, the corporal would have had to get up and walk around the table to see what I'd done.

This went back to Major Lahar, and he said, "Hopps, you're strange. What are you doing in here?" "I got drafted." He said, "Well, you don't belong in combat infantry basic training. Did you study any biology in college?" I said, "Yeah. I was doing some premed." "Good. We're going to make you a first-aid man. Can you handle that?" I said, "Sure. What am I supposed to do?" He said, "You do everything that everyone else does, but when there are people who have to be taken down on sick call, you'll bring them into the hospital."

God bless Major Lahar. He eventually wrote the report that got me honorably discharged, so instead of two years I had six months and twelve days of basic training, and even that wore me down to the bone. Fortunately, I was stationed at Fort Ord, near Monterey. One time when I was on leave, I was driving with some of the other guys down Highway 33, the highway where James Dean died. It goes through farmlands in the middle of the state, and you can drive fast and flat out—and when you get only a three-day leave, you want to get to L.A. as fast as you can. During the drive, I was so tired that I fell asleep at the wheel. Everyone else in the car was sleeping, too, and I went off the side of the road, into a ditch. Fortunately, the car just coasted to a stop and rolled over on its side. But this ended up on Major Lahar's report. He wrote, "Private Hopps must be honorably discharged from the Army. It is clear that he is absolutely unfit to operate motor vehicles and he would be a danger to himself and to other military personnel." That was fine with me—whatever it took to get me out.

Lahar was a young M.D. who wanted to be a psychiatrist. He was looking to get out of the Army, too, and go back to Michigan. When I was leaving, he asked me, "Are you going right back to school?" I said, "Absolutely." He said, "If you can, through the school, you should get some psychiatric counseling." It wasn't bad advice, and I took it. I ended up with a Jungian, Dr. William Alex, who was really into dreams. I remember him asking me if I ever had dreams that frightened me. I said, "No, I like frightening dreams." He said, "What about falling dreams? Do you dream that you're falling?" "Yes." "Does that frighten you?" I said, "No." "How is that?" "Well, I've learned how to tense up as I'm about to hit the ground. I hit the ground and

I bounce back up." "You bounce?" "Yes." He laughed, and said, "That's the first time I've ever heard that! Don't you have bad dreams?" I said, "I've had some pretty amazing violent dreams, but I'm interested in them." He said, "Like what?" I said, "There was a battle once in the front yard of my house—people with knives and swords and so on—and I was cut to pieces." He said, "Didn't that disturb you?" I said, "I managed to keep going, even though I'd lost an arm."

Ben and Betty had gone on running Syndell while I was in the Army, and we had also finalized our plans for the "Action" show—my first big independent show. I'd originally wanted to put it on in 1953, but because we were distracted by Syndell, and then I got stuck in the Army, it didn't go up until 1955. Our idea was to put a collection of vanguard art into a public place where people didn't expect to see art, and we looked into quite a few possible locations. Bartosh wanted to put it in one of those big do-it-yourself construction and paint stores—there was one in L.A. then called Paint City. I liked the idea, but it just wasn't practical; no retail space was going to give up the opportunity to do business in order to put on an art show. Then we looked at a defunct Chrysler dealership on Sunset Boulevard, across the street from Schwab's drugstore. It had a great modern-design showroom, but it would have been too expensive to rent. In the end, I came up with the idea of using the merry-go-round building on the Santa Monica Pier. The merry-go-round had closed down, and some people I knew were living in the space above it. We were able to rent the space for something like $250— an astoundingly small amount—for the entire run of the show. (The "Action" show was sometimes referred to as "The Merry-Go-Round Show," though that wasn't the official title.)

We wrapped canvas tarps around the entire cylinder of the merry-go-round itself and lashed them down with clothesline so that the horses were covered and we could hang paintings around the cylinder. Other paintings were hung on the exterior walls of the structure. The artists in the show were mostly San Franciscans—Jay DeFeo, Hassel Smith, Sonia Gechtoff, Roy De Forest, Julius Wasserstein, and others—and a few from L.A.: Paul Sarkisian, Craig Kauffman, Gilbert Henderson. The old merry-go-round operator was

there occasionally, and he would make the cylinder rotate very slowly and play all that wonderful old-fashioned mechanical music. We provided two other kinds of music as well. We played tapes from some of the jazz performances I'd been involved with, and we made our own version of a John Cage piece called "Imaginary Landscape No. 4." Cage had taken twelve radios, each tuned to a different frequency—some picking up music, some just static—and rotated between them for set periods of time to create a montage of a score. So we did that with our own smaller set of radios. It was a wild sound environment, which livened things up.

Because there was no admission charge, all kinds of people came. The pier was between Santa Monica Beach and the famous Muscle Beach and across the street from a gay bar, so we had this great clash of cultures wandering in—the bodybuilders and the homosexuals. Allen Ginsberg and his crew of San Francisco Beat friends came to visit—Jack Kerouac, Gregory Corso, David Meltzer, who was very young at the time and living in L.A. So did a number of critics and artists from Southern California, most of whom hated it, naturally. Sadly, I was in the Army for most of the time the show was up, so I didn't get to hang around and see who was there. I helped install it and saw it once while I was on leave.

Installation shot of "Action" on the Santa Monica Pier, 1955. Photograph by Walter Hopps.

It was around this time that I made my first trip to New York. It must have been in 1954 or 1955—not long before Jackson Pollock died. I really wanted to meet Pollock, so I headed out there. This was in the days before jet planes. You could fly as far as Chicago or St. Louis, and then you had to change planes to get to New York. When I got there, I booked myself into a cheap hotel in the Village called the Earle and went straight to the Cedar Tavern, which was the East Coast equivalent of Barney's Beanery.

I sat by myself at the bar, nursing any number of beers, waiting for Pollock to come in. Quite a few poets went to the Cedar Tavern then, as well as artists, but very few women—the women who were there were tough women, girlfriends, maybe, but no wives. It was a truly grungy place. After quite a few beers, I needed to use the men's room, and I saw that there was no door on it—you could look right in on the urinals. No one gave a damn, so I went in anyway. Afterward I asked the bartender why there was no door. In a gruff voice, he said, "Because Jackson tears it off. He comes in here, drunk and crazy, and he tears the men's-room door off. He's done it three times now, so we just gave up. We leave it off." That was the first direct report I had of how terrible life was for Pollock then. He was drinking enormously by that time.

There was a guy sitting by himself near me, a little older than me, and a poet, I think, associated somehow with the Black Mountain College, in North Carolina, where de Kooning, John Cage, Merce Cunningham, Robert Rauschenberg, and Cy Twombly had all spent time. The poet asked me who I was and why I was there, and then he told me, "I don't think you're going to see Jackson. He's been eighty-sixed from here. If he shows up, they'll throw him right out." I couldn't believe this. Throw out the great painter? Virtually all I knew of him was his work, though I'd heard about him, years before, from my family, too. My father's sister, Rosita, was a conservative woman, her sorority's delegate at the National Panhellenic Conference, and she had gone to Manual Arts High School in L.A. at the same time as Pollock. When I was still at UCLA, I was home one day, and I overheard Aunt Rosita talking to my mother. At the time I was having an illicit relationship with my first cousin, Aunt Rosita's daughter, Betty Rose, and I'd taken her to see an Abstract Expressionist show at the old Pasadena Art Museum; it was one of the very first Abstract Expressionist shows in a

museum, *the* first in Southern California, and I was so knocked out by it that I went every chance I could. So Aunt Rosita heard from Betty Rose that I had taken her to see all these weird paintings, and that there was this strange and amazing work by an artist called Jackson Pollock, and Aunt Rosita said, "Oh my God, I bet it's that guy I knew at Manual Arts High School." Now she was explaining to my mother that Pollock had been a real troublemaker at school. "But worst of all, Katherine," she said, "he was homosexual and we all suspected it, and it's just not wholesome for Walter to get involved with such things. You don't want him to be influenced that way." My mother cracked up. "Rose," she said, "I don't think we have to worry about that."

I told the poet at the Cedar Tavern a little about Syndell and he said, "There is an artist in here that you might want to meet. Do you know Franz Kline?" I said, "No, I don't know him, but I certainly admire his work." He said, "Well, he's sitting right over there," and he took me over to meet him. I told Kline that I had a gallery out west and he was perfectly charming. He bought me drinks, and then when it was getting to be closing time he said, "Well, I have to go to work now." It was quarter to two in the morning, and I thought perhaps he had a job as a night watchman. It didn't occur to me that he meant painting. I said, "Gee, it's a shame you have to go to work." He laughed and said, "My studio is just down the street and I go in there around this time and work for as long as I can and then I go to bed in the morning. Would you like to come along?" I said, "I'd be thrilled."

We set off down the street to his building and took a freight elevator up to a very large studio. He said, "Why don't you look around while I pack my lunch?" He always prepared a meal before starting work, so that he could eat as soon as he was finished, before going to bed. There was a kitchen and a kind of dining area at one end of the studio, and a bedroom somewhere, and, while he was making his food, I looked at the paintings on the wall. I had barely seen his work at that point—he wasn't very well-known yet—and it was just stunning to walk in and see a whole set of his paintings for the first time, black figures on a white or gray-white ground. He had a kind of easel rigged on the wall to hold the canvas up, and he marched back in, like a workingman, with a thermos of coffee, a sandwich, and a banana, and he went to work. He loaded his brush with the kind of

black he wanted and then, like a ballet dancer—he was beautiful in his movements—he moved slowly from one side all the way across the large canvas, one extraordinary, not absolutely straight gesture. No splash, no flinging paint, no attacking the canvas—it was just the most graceful and sensuous gesture I could imagine. I'd never seen anything like it. Some of the paint ran and he wiped it off, and then he sat down and looked at the work, smoked a couple of cigarettes, and got up and did another part. I was aware that those moments of just sitting there quietly and looking between gestures were a very important part of what was going on. I finally understood that what Harold Rosenberg so beautifully described as "action painting" wasn't throwing paint around, it was performing an act, contemplating it, and then acting again. Making it up, bit by bit, as you go along. After a few hours, Kline said, "You look kind of sleepy—you want a shot of coffee? There's still some in a pot on the stove." So I hiked down to the other end of the studio and got some. Finally, I saw light come up in the sky and he took me down in the elevator and said good night and I never saw him again.

It may have been on the same trip that I made it into Clyfford Still's studio. I knew his work from San Francisco, and I'd seen one painting at the Museum of Modern Art. It was actually a copy of another painting. He'd given them a painting for the 1952 "Fifteen Americans" show and they'd decided to buy it. He had it delivered back to his studio, made a copy of it, and sent them the copy. He didn't like the Museum of Modern Art. The original was still in his estate when he died. Almost everything in his studio was face to the wall, so I didn't get to see much. But I did go into the room where he was working, a side room where he actually did the painting. Stretched canvases were leaning against the far wall, ready to paint on, and he had a chair, a little table with a hot plate where he made coffee, a coffee cup, and some brushes and palette knives. There was no painting underway. But I saw that he had some playing cards spread out on a bench, and with a palette knife on the backs of those stiff little playing cards he had done some little oil studies of what he was going to do. They were extraordinary. He'd sit there, drinking black coffee, in a meditative state, doing these little studies and getting a sense of where he was going to go, and then he'd just stand up and do it. I told him how much I and a colleague of mine wanted to buy a painting. I wasn't sure we had enough money, but I thought we

could probably muster it. And he looked at me with a sort of a fatherly look and said, "Mr. Hopps"—it was always "Mr. Hopps," though I met him several times—"Mr. Hopps, even if you could get the money together, you're not ready for the responsibility of owning one of my paintings."

After I got out of the Army, I stayed with Shirley in Chicago on and off for a while. The art-history program there was extraordinary, thanks to the very progressive approach that Robert Maynard Hutchins had instituted, and I started attending the twentieth-century class and the graduate seminars given by Dr. Joshua C. Taylor. Taylor was an insightful man—he sized me up pretty quickly and arranged for me to audit classes. I remember one particular seminar during which we had to concentrate on three prints by Albrecht Dürer and think about how they worked and what they meant. We spent an hour and a half just looking at those prints. Taylor was probably the most knowledgeable person in America on the Italian Futurists, and when we got to Giorgio de Chirico, he spent the entire class and twenty minutes overtime on just one painting, talking about the contradictions of time—how you'd see a train going by in the background with steam streaming behind it, but then see little flags elsewhere in the painting flying in a different direction. It was about the way that de Chirico made time stand still—the train that will never arrive, the circus wagon with a little girl rolling a hoop—and how he was able to depict menace as something one doesn't see. Almost no one left at the end of the class. De Chirico was interesting, but Taylor made him absolutely compelling. Most of art analysis falls into one of two categories: there are the formalists, like Clement Greenberg and Michael Fried, and there are the iconographers, like Millard Meiss, a critic of Renaissance work. But Taylor loved both the matter and the stuff of art. He was an amateur artist himself, but he kept his work private. He had a place in Mexico, and he did most of his painting and drawing there.

Back at Syndell, meanwhile, I put on two one-person shows: Arthur Richer and Edward Kienholz. Richer did rugged Expressionist work, and he had an incredibly macabre sense of humor. He often wore a brimmed cap, like a yacht captain's, and when the artist Wallace Berman was designing

the announcement for Richer's show, he used an image of Richer in a Wolfman mask with his cap on as the illustration. It captured Richer's personality perfectly. When I met him, he was living over in Chavez Ravine, a neighborhood between Chinatown and downtown L.A. that was a sort of wasteland then, where various artists had shack studios. Richer lived in a cabin with his kids and his wife, Betty. (There were a lot of Bettys around then, named for Betty Boop, and a lot of Shirleys, named for Shirley Temple.) Richer had a stuffed raccoon sitting on his chimney, smoking a hash pipe. He had been a doper since way back, as a boy in New York. He'd grown up in the world of jazz; his father was a part-owner of the Cotton Club—the real one, in Harlem—and he would send little Arthur up onstage to sit on the piano bench next to Fats Waller.

In those days, when everyone was doing some kind of dope, there was a lot of bizarre behavior. One time Richer and a character actor called John Saxon and I were sitting in the front seat of my Chevy Coupe, and Richer suddenly flipped out. He pulled out a pocketknife and stabbed Saxon in the thigh. The knife went right down to the bone. Saxon screamed, and I drove straight to the UCLA hospital. Later, Richer was picked up with marijuana in San Francisco. It was a hard bust back then, and he went to jail for six months. While he was there, he wrote a treatise called "The Arthur Richer List of Cheap Highs." The last two entries were "sniffing stove gas"—without killing yourself, of course—and "the pinch-your-fingers-in-the-doorjamb high." The way he saw it was, if you're alone in your room and there's nothing to do, you can always go over and pinch your goddamn fingers in the doorjamb. He later killed himself with an overdose, but when he was around he was a funny guy. Only one painting sold at his show, and I bought it. I paid him for it, and then he broke into the gallery and stole the painting back. I have no idea where it is today.

I'd met Ed Kienholz not long after Syndell opened. Back then he was living over on the corner of Fairfax and Santa Monica and curating shows in the lobby of the Coronet Louvre—a film revival house and archive on La Cienega that was run by a guy named Raymond Rohauer—and at the NOW Gallery, in another space that Rohauer rented. At the time, there were three places in L.A. where the avant-garde hung out: a silent-movie theater on North Fairfax; Barney's Beanery in West Hollywood, which was frequented

Arthur Richer and Wallace Berman at Syndell Studio, 1957. Richer's art is in the background. Photograph by Charles Brittin.

by working-class people from the area, artists, poets, and fringe film-colony people; and the Coronet Louvre. The Coronet Louvre was a place where you could see strange classics like Leni Riefenstahl's *Triumph of the Will*. Rohauer had single-handedly saved Buster Keaton's films—he tracked down Keaton when he was a forgotten old man and began showing Keaton's personal copies of his movies. But Rohauer also showed the new underground cinema—that was where I saw Kenneth Anger's first film, a homoerotic work that was startling at the time. I also saw films by Stan Brakhage and Maya Deren. It was where Sidney Peterson, the first important film teacher at the California School of Fine Arts, showed his film *The Lead Shoes*—the story of a love affair between a woman in a wet nightgown and a guy in a deep-sea diving suit.

Kienholz had heard about Syndell, perhaps through people at the Coronet Louvre, and he came in to see what was going on. We went out and had a beer and talked about things, and we hit it off. We were very different people, but the minute I met him I knew he was the real McCoy, and when I first saw his art I was very interested. Not all the painters I knew at the time shared my enthusiasm; they were grudgingly impressed by the energy and the anarchy in Ed's work, but didn't think that he had the

intellectual credentials. How little did they know! Ed was a terrific artist. His first real gallery show was at Syndell, in 1956. We had some of his very early abstract work, painted wooden reliefs. While we were hanging one work, a vertical relief, about five feet high with a mix of rosy reds and yellows, he suddenly said, "No, I didn't get it right. Do you have sawhorses here? Give me some sawhorses." So we got him a couple of sawhorses. Kienholz always traveled with his own tools. He set the painting down on the sawhorses and carefully sawed off a strip at the bottom, about eight or ten inches wide. Then he put the frame back together, hung it back up, and said, "That's better." I couldn't believe it. He saw me looking at the part that he'd sawed off. He said, "Hmmm. That's interesting," and he scratched in his signature on the bottom right and gave it to me.

By this time, Shirley and I had decided that we were serious about each other, and she had transferred to UCLA. She moved in with me in Topanga Canyon, where I was living with Charles Mingus and some other jazz musicians, but we didn't stay long; Shirley couldn't stand the fact that there was no privacy there. We were completely broke, and we didn't have anywhere else to go, so I suggested that we move into the back of Syndell. I had built a wall about three-quarters of the way through the space, to create a storage area, and we moved in behind that wall. I put in a long pipe rack, for clothes that had to hang on hangers, and Shirley got an old trunk from a thrift store to use as a dresser, and a friend built us a sturdy double bunk bed—we slept on the top and occasionally we'd have a guest on the bottom.

So we lived there for a while and had the shows out front. After an opening we were always keen to get everyone out and the front door locked. Often we'd do that by taking all the stragglers to supper somewhere and then abandoning them. I liked to go to a cheap joint in Santa Monica called Pickle Bill's—a round restaurant with a giant pickle on the roof, where you could get sauerkraut or short ribs and all the pickles you wanted. Sometimes after openings and dinner at Pickle Bill's, we'd all be wired enough to say, "Let's go to San Francisco for breakfast!" We'd drive through the night to get to San Francisco. We knew exactly where to go—a place in North Beach called Mike's Pool Hall, which served food twenty-four hours a day. And

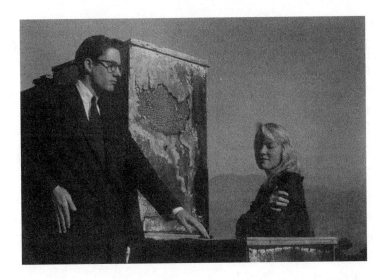

Walter and Shirley Hopps at Ice Boxes in Malibu, California, 1955. Photograph by Edmund Teske.

the first thing we'd do when we got there was put bourbon in our coffee, just to start unwinding. For energy, I'd have a waffle con carne—a waffle with a rare hamburger patty on it—and then put syrup on the whole thing so I'd get a sugar rush and a little protein. Then we'd crash at a friend's place. Four hundred miles for breakfast is a pretty good drive.

One night in early 1955, a few months before he was killed, James Dean came by Syndell with his entourage. He was taking classes at UCLA then, and he was quiet and deferential. He brought along one of his young acolytes—Dennis Hopper, who became a close friend of mine as the years rolled along. My relationship with Dennis developed primarily around art. At a time when fear of Communism was rife, he had a bumper sticker on one of his cars that said "The only 'ism' for me is Abstract Expressionism." Dennis once told me a story about James Dean, on the set of *Giant*: Dean was very anxious about doing the scene in the house with Elizabeth Taylor. He told Dennis, "I'm just so nervous with a major actress like Elizabeth Taylor—she is so beautiful, and I'm having a hard time." Then he said, "I know how I am going to handle it." Dennis said, "How?" "Watch me." There was a temporary fence set up to keep the onlookers away from the set. Dean walked over to the fence, unbuttoned his fly, and took a piss. All the locals

were watching. Smiling, he buttoned up and walked back to Dennis. He said, "If I can do that, I can do anything." Then he went in and did the scene perfectly.

The arrangement at Syndell was a little too bohemian for Shirley, and the Arthur Richer show was the last straw. It was an unbelievable opening— every Beat character in L.A. was there—and eventually we all went off to dinner. Later that night Shirley woke me up. There was a strange thumping sound coming from her trunk, and she made me get up to see what was going on. It turned out that Richer had somehow climbed into the trunk and passed out. The lid had closed, and at four in the morning he was trying to bang his way out. That was when Shirley decided we had to move out.

We got married in 1955, although none of our parents approved. We were both rebellious at the time, and we decided that we didn't want to be married by the church or the state. We wanted to get married at Simon Rodia's sculpture towers on 107th Street in Watts. (Rodia was still alive then, and he lived in a house down the street.) I asked Dr. George Day, an expert on the Soviet Union whom I'd known in Eagle Rock, to perform the ceremony. So Dr. Day came, in his academic robes; my brother was there as a witness; and Mr. Rodia, who'd heard what was going on, walked the half block from where he was living to attend the wedding. Years later, when Shirley and I were getting a divorce, I had a strange call from my lawyer. He said, "First, I have to tell you that you were never legally married. Dr. Day filed the papers and so on, but it was never recognized as a legitimate wedding." Of course, by then we had lived together long enough for us to be considered common-law married, so we still needed to get a divorce.

After the wedding, Shirley was accepted at Harvard to do graduate work, and we spent a year in Cambridge. To make some money, I got the best job I could—as a junior chemist in a private research facility. There were about seven of us on the job. The head man had been a professor at MIT. He was a good chemist and he set up his own company to do research and development for other firms. I was put on synthetic rubbers, which were the big new thing. In the old days, food jars had a rubber ring that had to be cranked on, and we were trying to come up with a synthetic rubber ring that would permanently adhere to the inside of the lid. My job was to get iron oxide into polyvinyl acetate emulsion, so that it would look red and the

customers would think it was rubber. I was working with another man, a black guy called Dave Earle, who'd come straight from Boston Latin. Dave taught me all kinds of things, and we became good friends. He was gay and also very shy. Shirley and I invited him to dinner once, and he was astounded. It was a really big deal for him to be invited by white people. This was in Boston, at the heart of the abolition movement. I couldn't believe the degree to which racial segregation still existed there.

I kept Syndell open while I was in Cambridge, and programmed the shows long-distance, calling Ben and Betty and telling them what art to put up. I'd have the announcements printed in Boston, address all the envelopes myself, then put them in a box, and send them west on a Greyhound bus, the cheapest way I could do it. So there were a couple of shows at Syndell that I never saw.

4.

THE FERUS GALLERY

By some insane miracle, Ed Kienholz won the bid to put on the 1956 All-City Outdoor Art Festival, an annual exhibition that was sponsored by the Los Angeles Municipal Art Gallery, and I proposed that we team up to do it. He liked that idea. Aside from his Syndell show, it was our first joint venture. The festival was held at Barnsdall Park, the gorgeous expanse of land that had been left to the city by Aline Barnsdall—the art patron who put up the Arensbergs when they first moved west. Barnsdall was long dead, but her house, designed by Frank Lloyd Wright, was still there, and so were the wonderful gardens she'd created. The festival was held outside in exhibition pavilions, with roofs over them but otherwise open to the air. Ed had a reasonable budget, something like $6,500, and one of the things he'd negotiated with the city was that whatever money hadn't been spent at the end would serve as his payment, so his challenge was to pull off the show and still be left with enough to make it worth his while.

One afternoon, while we were setting up, I noticed several people I knew lying around under trees. I think Wallace Berman was there, as well as George Herms, David Meltzer, and some other poets. I said, "It's great to see those guys, but why are they here?" Ed said, "They're working for us. I put them on the payroll, and they're getting two bucks an hour." I said, "But they aren't doing anything, Ed. They're just lying around." He smiled at me and said, "What do you expect them to do? They're poets. I don't want them anywhere near tools." So he was subsidizing them, in a way. It was like his own private WPA.

We didn't exactly curate the show. Entry was wide-open, and anyone who filled out a form could get in. Work would arrive, and Kienholz would organize crews to get it hung. But we came up with the idea that, as well as showing the three official categories—independent amateurs, independent

professionals, and children's art—we could also have booths from commercial galleries; this was, more or less, a ruse to get our own almost unseen, avant-garde galleries, Syndell and Ed's NOW Gallery, into the show. The city agreed, and we managed to get a few other galleries in on it, too. One of the Syndell entries was a really nasty Maurice Syndell piece that Kienholz, Bartosh, and I had worked on. We found a big piece of signboard, seven or eight feet long, that had been cut out in voluptuous curves, with a vaguely female shape. We turned it around so that the front was raw, dark-brown weathered plywood, and painted it as an abstracted reclining woman. We took some curly wood shavings—the kind that used to be used for packing crates before there was Styrofoam—and stuck them on with brown LePage's glue to make pubic hair. There were these brown drips of glue everywhere, and it was wonderfully disgusting. Kienholz loved it, but the show was under the auspices of the Parks Department, and when Mr. Parks Department and his committee inspected, they found two pieces of "obscene" work that they wanted removed. The Maurice Syndell woman was one, and the other was a very delicate piece of homoerotic art that had been entered by one of the adult professionals. It was a sweet, innocent work, really, a slightly erect male nude, and neither Ed nor I found it offensive in any way, but the city officials didn't like it and it had to come down.

That show included a piece by Bradley Pischel, an artist I first met when I was twelve or thirteen and staying with my grandmother in Laguna Beach. My grandmother had rented an apartment to a woman, Helen Pischel, and her son, Bradley—the father was in the Air Force and was killed in the war. Bradley and I would play on the beach, and, once, when I went over to the apartment to look for him, Mrs. Pischel invited me in and worked as hard as she could to seduce me. It wasn't something I ever told my grandmother about, or Bradley. But Bradley turned up, out of the blue, when I was living behind Syndell Studio and he was adrift. For the Barnsdall Park show, he made a little artwork on a post—a strange windmill-like thing, a kind of whirligig, with a clock face and clockwork. I don't know how he was living then. He'd served in the Korean War and had been wounded, so he had VA privileges. But he'd gone through some kind of hell and was now tragically disturbed. He'd bought himself a little English sports car called a Fairthorpe Electron and had attached a steel rod in the shape of an *E* to the

bumper. I asked him, "What does that 'E' stand for?" He said, "I represent Earth." At some point, he went up to the Atomic Proving Ground, in Nevada, with a hand grenade and somehow blasted off his right hand. As I heard it, after that he went up into the mountains in Colorado somewhere and built a wooden platform where he sat in the lotus position in some kind of meditation as winter came on. He was found in that position frozen to death.

Ed handled all the logistics for the All-City Outdoor Art Festival. I kept worrying that he wasn't going to have any money left over, but he managed to balance the books in his own way. At the end, there was $400 left over, which we split. He also had access to the Municipal Art Department's supply depot, and he was going in there regularly and helping himself to lumber, paint, hardware, nails—whatever he might need for his next gallery— and stashing it somewhere. He must have got several hundred dollars' worth of supplies.

When I decided to close Syndell down, later in 1956, I rented a space over on Sawtelle Boulevard, on the other side of the VA hospital, so that I could store things. Shirley and I had moved into a little two-story house on Colby Avenue in West L.A. and we were trying to soldier on with school and what have you. It wasn't the happiest time for me, with the gallery shutting down. Once I'd stored everything in the back room of the Sawtelle space, I let my friend the poet Robert Alexander—or Baza, as he called himself—set up in the front area. Baza was an ex-heroin addict who'd done time in a federal narcotics rehab hospital. Those hospitals were hard-core, much worse than prison—you either got clean or you died—and when he got out, he set himself up as a minister of something he called the Temple of Man. I'd heard about Baza from Wallace Berman, and one day he just showed up at Syndell with a beautiful miniature letter press and reintroduced me to the art of printing, which I think I had learned in school. He ran a press called Stone Brothers Printing, and I told him that he could use the space on Sawtelle rent-free, so long as he produced any announcements or posters or catalogues I needed.

Every Friday, we'd hold a reading or a performance of some kind. We

hooked up with Rachel Rosenthal, an independent drama coach, who, with the man in her life, King Moody, ran the Instant Theatre, which did wonderful improvisational work. Rosenthal brought some extraordinary people to Stone Brothers. She knew an old Chinese gentleman named Mr. Chang, who lived above the Greyhound station in Hollywood, and he put on a one-man version of *Hamlet* by shouting out all the parts himself and occasionally taking a break to run up and down the aisle with a basket of candies and knickknacks to sell to the audience. He was terrific, in an insane Chinese Dada kind of way. And we invited some poets to read. Baza himself would stand up there, with his wild hair and his big mustache and his chest bare, and recite poetry from any scrap of paper he found in his pocket. He'd just make it up as he went along. We were always trying to get him to write it down.

Ed and I had had so much fun working on the All-City Outdoor Art Festival that we decided to put on another show together, a kind of sequel to the "Action" show, called "Action²"—or "Action Squared." Ed hadn't worked on the first "Action"—wasn't in it and hadn't seen it—so I took him up to San Francisco to meet the Abstract Expressionist artists there: Jay DeFeo and her husband, Wally Hedrick; Julius Wasserstein; Frank Lobdell; and so on. The Coronet Louvre was closing, which meant that Ed's NOW Gallery shows were coming to an end, but he still had the space, and we set up "Action²" there and at a defunct theater down the street called the Turnabout. We included quite a few artists who'd been in the first "Action" show, and some new artists—Wasserstein, Lobdell, DeFeo, and Hedrick, as well as Hassel Smith, James Kelly, Sonia Gechtoff, Roy De Forest, and some Southern Californians, including Craig Kauffman. We had painting and assemblage work, and even a little bit of photography—an experimental photographer named Elwood Decker, and Edmund Teske, who had been a professional photographer for Frank Lloyd Wright in Chicago and now did very strange romantic montages. Baza put together the posters and mailers at Stone Brothers Printing, and he wanted to do his own installation, too, so we gave him a narrow little room, where he created an environment of his poems, mounted in collage-like ways. There was a kind of exterior alleyway between our building and the building next door, where some plants were

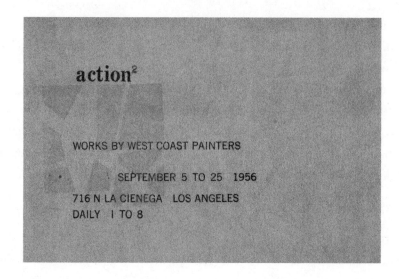

Announcement for "Action²: Works by West Coast Painters." Robert Alexander, designer.

growing that Baza liked, so he pounded a hole through the wall and pulled some vines and bougainvillea through the hole as part of his show. The landlord didn't much like it, but Kienholz could fix anything.

Like the first "Action" show, "Action²" was hated by all the official galleries and critics around town. Kienholz made a couple of pieces about one of those critics, Henry Seldis, from the *L.A. Times*, whom he really came to hate. One of them was his first television piece: it was a television set with one of Seldis's reviews in typescript on the screen, as if you were looking at a computer—though, of course, there were no computers then. The other was a vicious piece—a grotesque little figure bending backward in such a way that he's sniffing his own butt. Ed felt bad about it later when Seldis ended up taking his own life. He was a sorry figure and he was severely depressed, but he sure didn't like what we were up to and he said so. At least that didn't keep people from coming—they came to see what all the fuss was about, what the so-called terrible art looked like.

On the heels of the second "Action" show, Ed and I decided to pool our resources and open a gallery together, where we could combine what I'd

been up to with Syndell and what he'd been doing at the NOW Gallery and at the Coronet Louvre. One day we were having lunch at a hot-dog stand called Pink's, in West Hollywood, on the upper part of La Cienega, and Ed said, "Let's make a contract for our work together." So we drew up a simple contract on a hot-dog cozy—that stiff paper tray that a hot dog rests on. It said, "We will be partners in art for five years." We both signed it, and Ed kept it.

Then we started looking for a space. Kienholz found one, a big barn-like artist's studio with high ceilings and whitewashed walls, in the back half of a one-story building at 736 North La Cienega. He used the materials he'd requisitioned, shall we say, from the city of Los Angeles, and put in some extra plywood walls, mats on the floor, simple furniture, and a hanging wall that could divide the space in different ways so that we could do one big show or a couple of smaller ones. Some friends of Ed's, Camille and Streeter Blair, had an antique store up front. Streeter was a kind of primitive painter, and they showed Pennsylvania Dutch and country furniture. People coming to the gallery walked along a patio on the side of the building, where we had sculpture and ceramics, and entered through a side door. The space had been used before us by the filmmaker Arch Oboler, who'd made the first 3-D feature, *Bwana Devil*, in 1952, so as we were cleaning the place up we found all kinds of strange props. I cashed in some more bonds so that I could pay the rent and utilities—it was $200 a month, which was cheap even for then. Baza provided our printing for almost nothing.

We needed a name for the gallery, and again I thought of a particular incident from my past. In my brother's class at Eagle Rock High School, there had been a dwarf—a young man named Ron Anderson, who had the same bone disease as Toulouse-Lautrec. Miraculously, he got a car rigged up with extensions on the pedals, so that he could drive it, and he later went to UCLA for a while, where he got around by walking with leg braces. Everyone had shunned him at school—he was bright, but he was considered a freak—but when I ran into him on campus we hung out quite a bit. We'd go to his place back in Eagle Rock and smoke dope together and talk about music and poetry. He became interested in the art I was involved with, and he told me several times, "You've got to meet this guy I know who's a fan. He's seen Syndell Studio and he's heard about you, but he's very

shy." His friend, Jim Farris, had also gone to Eagle Rock High School, and Ron asked if he could show him some of my work—he'd seen some of my photographs at my parents' house. So I gave him some pictures. He came back and said, "Jim really likes this. He's very interested in you. I want to get the two of you together." And I said, "Great. When am I going to meet him?" But Ron kept putting it off, and I started to wonder why this guy was so shy. Then one day Ron called me, very upset, and said, "You're never going to get to meet him." I said, "What do you mean? Who?" "Jim. He shot himself." At the time, I wondered if Ron had made the whole thing up, but I checked and there really had been a James Farris at Eagle Rock High School, but before I got to meet him he shot himself with a rifle. So I realized that I had to do it again. Baza was doing our typography, and I told him the name I wanted. He said, "How do you feel about spelling it F-e-r-u-s?" "Why?" "Because it has more strength typographically." So I said, "Let's do it."

Ed and I put together the artists we'd worked with in our separate enterprises. So the San Francisco vanguard I'd gathered for the "Action" show and at Syndell Studio came in, along with a core of Southern Californian artists Kienholz wasn't in touch with—Kauffman, Moses, and so on. Then there was the Wallace Berman contingent, which Ed and I were both part of, and the artists Ed had been dealing with, many of whom were more isolated or more underground than mine. In March, 1957, Ferus Gallery opened up with a show called "Objects on the New Landscape Demanding of the Eye." We had the extraordinary Clyfford Still painting that Hassel Smith had been keeping in his barn—the first time a Still painting was shown in Southern California—as well as work by Sonia Gechtoff, Julius Wasserstein, Frank Lobdell, James Kelly, Jack Jefferson, Jay DeFeo, Hassel Smith, and other San Francisco artists. The only Southern Californians were Craig Kauffman and Gilbert Henderson. The Still painting was later bought by the Hirshhorn for more than $3 million; back then, we couldn't sell it to anyone for $125,000. All the work in that show was there on consignment; we didn't own anything. There was an enormous turnout for the opening. Still and Diebenkorn were there; the artists John Altoon and Billy Al Bengston showed up.

Ed had hired a crew of gallery assistants—including Dane Dixon, an artist who ended up being one of de Kooning's assistants back in

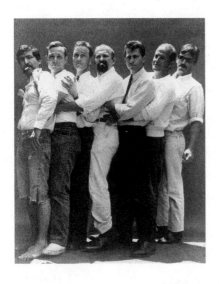

Ferus Gallery (John Altoon, Craig Kauffman, Allen Lynch, Ed Kienholz, Ed Moses, Robert Irwin, and Billy Al Bengston), Los Angeles, 1958. Photograph by Patricia Faure.

East Hampton. They were all friends and alcoholics, and Ed bought them enough tawny port to keep them going. Kienholz manned Ferus day to day, and he installed his own studio in the back, with a set of mirrors so that he could see if anyone walked into the gallery. If people who looked like potential customers happened to come in, he'd go up front and greet them. He was very scrupulous, though, about not showing his own work in the gallery. He had a very Duchampian attitude toward the commercial success of works of art. He mostly traded his work with other artists. He was a fast hustler for the buck in every other way, but he was reluctant to exploit his art for money in those days.

Things were always happening at Ferus. We held our own avant-garde movie nights and poetry readings, just as we had at Stone Brothers, and openings would bring enormous numbers of people—artists, writers, film people, and a few patrons of the arts. The openings lasted for as long as our jugs of not-very-expensive wine held out, and afterward we'd all go up to Barney's Beanery to eat and drink some more. Astoundingly little art was sold, but some was.

An interesting artist and poet called John Reed wandered into Kienholz's studio one day, through the back door to the alley. We never knew where he came from, but he was very young and had no money, and

Kienholz made him a bed on a heavy shelf underneath his workbench and took care of him. He lived there for quite a while, a sad young guy; he'd been a severely abused person, I believe, and he lived in a sort of dreamland. He ended up homeless, living under a bush outside the Pasadena Public Library for years.

One afternoon Ed Moses went to see a matinee of *Mutiny on the Bounty* and he happened to notice that Marlon Brando was sitting in the theater, watching his own movie, with whoever his wife was at the time. Moses introduced himself to Brando, and Brando asked him what he did for a living. Moses told him he was an artist and he had some work in a gallery nearby. By the time they got to Ferus, the gallery was already closed, so Moses decided to break the lock to let Brando in. Kienholz had a fit when he discovered the lock was broken. God knows what Brando thought. Another night, John Altoon broke in, took a painting of his off the wall, and started revising it on the floor. He hung it back up wet. We had concrete floors and we never managed to get out the paint he splattered on them.

Altoon was Armenian-American, and he had grown up among melon farmers in the San Joaquin Valley. He had dark skin and a hooked nose, like a Native American's. He had a terrific laugh and an ebullient manner, except when he was depressed. It was Kienholz who first introduced me to him. He kept telling me that I had to meet this guy who was just back from Spain and who did very interesting work, though maybe too much of it. The "too much of it" I encountered first: stacks of drawings and mixed-media washes and gouaches on paper. Everything that Altoon came across seemed to find its way into his work. You could see that in his first show at Ferus; hanging that show was when I really came to know Altoon's drawing. The opening night was one of the weirdest gallery openings I attended in L.A. at that time. John knew everybody or they knew him. I remember Bob Alexander and Arthur Richer stripping and wrestling to what they intended to be the death while my visiting mother-in-law watched.

Kienholz himself did some outrageous things. One day I was in the gallery and I went into the storeroom to look at something. In there, I discovered that the art had been moved and in stacks taller than I was were scores of cases of liquor. Scotch, bourbon, you name it. I went to Ed and asked him what the story was. He said, "Well, some people I know kind of

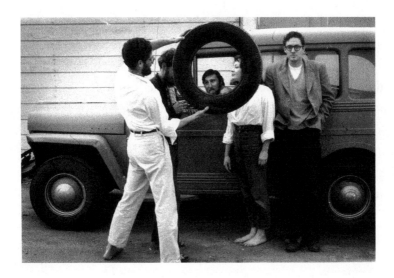

Robert Alexander, John Reed, Wallace Berman, Juanita Dixon, and Walter Hopps in the alley next to Ferus, c. 1957. Photograph by Charles Brittin.

got it off the back of a truck out on the PCH and brought it in here and are going to turn it over quickly. Let's not get into the details." I said, "Well, I'd sure appreciate it if it got out of here in a hurry. I feel nervous with it being in the place." He said, "Of course. By the way, it's near the holiday time. Wouldn't you like a case of good Scotch?" And he put a case of Chivas right in my car. I didn't know what that deal was, and I didn't want to know.

At Ferus in 1958, we did a solo show by Craig Kauffman, an artist I'd known since the third grade. There's usually one kid in the class who can really draw, and Kauffman was the one. In the third grade, he could draw a perfect realistic automobile; rather precociously, he occasionally drew nudes. His drawings got him into trouble and embarrassed some of the girls, but he and I became friends. His father was a hanging judge who bragged about sending teenagers to the chair, a bad man, and his mother was crazy. Once, when I went to Craig's house, she for no reason at all smashed her son in the head with an avocado and started screaming at him. I went and sat in the yard till it calmed down. Kauffman was nuts, too, but he could draw like an angel. He turned up again in high school, and I remember him entering an architectural contest for a big scholarship; it was judged by the

great old Viennese architect Richard Neutra. Craig sketched out a beautiful modern house, exquisitely designed, but he put one of those sling chairs on the deck next to the pool and drew a nude girl sitting in the chair, sexily curled up in the foreground; she set the scale for the house. Neutra got in touch with him and told him that it was clearly the finest work entered, but he could only give it second prize because of that nude. Kauffman had his first one-person show when he was twenty years old, at the Felix Landau Gallery on La Cienega. He went on to show at Pace Gallery in New York, and his work was collected by museums, but his life was mostly a sad one.

5.

WALLACE BERMAN

We did occasional group shows at Ferus, but more often we'd feature artists in one- or two-person shows. The artists we showed seemed to be about evenly divided between the dark-side-of-the-moon assemblage artists and the lyric abstract people. The one person who bridged both currents was Jay DeFeo. She was a truly versatile artist—sculpture, drawing, painting, you name it. She even made a collection of tiny sculptures; she'd been making some earrings for friends and she liked that so much that she started sculpting works that size. But the most important show we did at Ferus was the one and only one-person show of Wallace Berman's work in his lifetime.

Born in Staten Island, New York, in 1926, Berman came to L.A. when he was ten and grew up in the lower-middle-class Jewish stretch of Fairfax Avenue. He went to Fairfax High School, which eventually expelled him for gambling. We first met early in 1953, when Raymond Rohauer installed a show of my photographs in the lobby of the Coronet Louvre. One night I was there to see a film and I recognized Berman and his wife, Shirley. They were scrutinizing my photographs very closely, so I went up and introduced myself. I think he'd been to Syndell Studio, but I hadn't met him. We hit it off, and he invited me up to his house on the edge of a canyon on Crater Lane, above Sunset Boulevard, in Beverly Glen. It was a secluded little nest, hard to find unless you knew where you were going. He'd painted the house white inside, except for the bedroom, which was an olive drab, and he had all kinds of works by other artists around—things that he admired by Jay DeFeo and Jess Collins, the poet Robert Duncan's lover, and others— and he had still lifes set up, things he wanted to look at. But there was very little artwork of his own on view, initially. You had to ask to see it. Eventually he had his own little portable printing press, which he used to print his limited-edition journal of art and literature *Semina*. Every so often, he'd go

Wallace Berman, with a copy of
Semina No. 1, *in the Stone Brothers
Printing display window, 1957.
Photograph by Charles Brittin.*

out and get some ammunition cans from the Army surplus store; they were
about fourteen by twelve, and maybe twelve inches deep, and he'd put
everything he could into them—letters, still lifes, whatever was lying
around—and stash them under his house. That way, he could clear the
decks and start again. They were wonderful little time capsules. This was
well before Andy Warhol started doing the same thing.

Berman's world of music went from Bach to bebop, and we spent
countless hours lying around on straw mats or cushions at the Crater Lane
house, quietly smoking a joint and listening to music through the night.
Berman quickly became crucial to me as an interpreter of what was going
on in art and literature. He knew the San Francisco scene and the Black
Mountain poets. He'd also known the chemical engineer Jack Parsons, a
cofounder of Pasadena's Jet Propulsion Laboratory, who had died in a myste-
rious home lab explosion in 1952. Parsons was a kind of genius; he invented
the solid-fuel rocket engine, and he was involved, with his wife, the artist
known as Cameron, in the occult; they were in touch with Aleister Crowley
and L. Ron Hubbard, and they participated in strange sexual rituals. Berman
wanted to use a photograph of Cameron as the cover illustration for the first
issue of *Semina*, so I made a copy negative of it in my darkroom.

Berman also knew some of the jazz musicians who passed through the
West Coast—Charlie Parker and the young Miles Davis—and his work
from the late forties has a kind of bebop surrealism to it. In fact, the first

time I laid eyes on Berman was in a jazz club in the late forties, when I was a teenager. Parker and Davis were playing, and a peculiar hush went through the room. I looked around and saw a short, angular white man with dark glasses in a baby-blue zoot suit moving through the room with a blonde in a tight black dress, about a foot taller than him. I asked the people near me who he was, and they gave me a look that said, *Haven't you been around?* It was Berman, who made a bit of a living as a pool hustler and a card shark in the early fifties.

Semina was popular with the Beats, before they even knew Berman's visual art. He published poets like David Meltzer and artists like John Altoon, but he'd include earlier work as well—translations of Cocteau and Hermann Hesse, for instance. He published some strange poems under the pseudonym Pantali Xantos—declamatory free verse. When I asked him who Pantali Xantos was, he said, "He's a Greek anarchist," and kind of smiled. We all knew that it was Berman himself. He corresponded with many people and had a lot of visitors on Crater Lane. Orson Welles came by once. So did Judy Garland, and some Egyptian acrobats who were traveling with an enormous quantity of amazing hashish. One of Berman's favorite expressions was "Fuck nationalism." He was very much a We-should-all-be-together-in-the-world type.

Berman's early work was strange and powerful imagist art involving magic, angels, sex, death, and jazz. He once showed me a portrait he'd done of Frank Sinatra with a snake for a necktie and a microphone jammed into his head through one ear; his mouth was open to reveal a whole field of sores on his tongue. At that time, Berman was working at a furniture company in downtown L.A., where he'd beat tables with chains and so on to make them look antique. So he became ace at making things look old. When I met him, he had already begun making his assemblages, sometimes using leftover scraps from the furniture factory. He made a little jewel box for his wife—a sort of plaster saint mounted on an elongated lidded box. He had broken the head off the saint and reattached it backward, so that you looked into a face of hair. Then there was *The Panel*, a freestanding panel that was mounted on feet, about five feet off the ground, with some of Berman's early drawings collaged onto it. Other pieces were attached to it, most conspicuously in the upper-right-hand corner—a little box with a hinged door and a mirror in the back of the box, which Berman called a "soul-catcher,"

because if you looked into it the mirror would steal your soul. Then he made a curious little sculpture called *The Bead Game*, an homage to Hermann Hesse. It was on a polished-wood base about two feet square, with a couple of tall dowels like arms coming off the wood, and some little round pieces about the size of a man's thumb. It's the most abstract piece he ever made.

Kienholz was my partner, but Berman was my intellectual guide. Kienholz's motto was "Do it now and get it done." But Berman moved slowly a lot of the time. You'd ask him how something was coming along, and he'd say, "I'm waiting for a message to come in on the ether." If I asked him, "Who are you listening to on the ether?," he'd get a dreamy look on his face and say, "The dead poets are speaking to me." The two artists were very competitive with each other, but they had different ways of promoting their work. Kienholz was out in public, and Berman was the guru in the shadows. Kienholz knew that Berman, Mr. Natural, was the ultimate in cool, and he couldn't stand it.

Both Berman and Kienholz played pool at the level of a hustler. Up on Little Santa Monica Boulevard, near Barney's Beanery, there was a particular café, a workingman's café, which was a real hangout. Farther east, there was a better place to eat called the Four Star Café (though, in truth, we're not talking even three stars). The Four Star—or, as Ed liked to call it, the Foreskin—was a raunchy place. Nearby there was a pool hall, and one day Kienholz challenged Berman to a match. Word got out and all kinds of people came to watch. Kienholz said, "O.K., Wally, what game do you want to play?" And Berman said, "Let's play snooker"—which is harder than straight pool, because the pockets are smaller and there's no slopping around. They started to play and we all noticed that Berman had gone over to the scoreboard and written down "Kienholz vs. Winner." And, of course, Berman won. I'd never seen Kienholz more out of sorts. It was as if his favorite dog had died. That was, I think, the last time those two ever had any kind of congenial contact. Berman was just too spiritually misty for Ed, and Ed was just too bawdy and vulgar for Berman, though they had respect for each other.

Though I met Berman when I was still at Syndell, he didn't agree to let me show his work there. He wasn't ready yet. He finally consented to a show at

Ferus, which Kienholz and I mounted in 1957. There were three pieces of sculpture in the show: one was *Homage to Hermann Hesse*. Then there was another sculpture, *Temple*, which was an environmental enclosure, taller than a human being, with three walls, a floor, and a kind of peaked roof. Inside there was a mannequin of a man wearing a hooded monk's costume, draped to the floor and pulled close so that you couldn't see the man's face. On the face of that mannequin Berman had written "Schmuck." That was his own private joke—it was covered up. On the floor in the temple he had scattered a copy of the first issue of *Semina*. (The first *Semina* was printed as a commercial folder holding individual sheets of paper and cards with poems and artworks on them.) And he had stapled to the walls some curious rephotographed images he'd found that looked like angels flying through the air. The third sculpture, *Cross*, was a life-size Christian cross, mounted on a rough wooden base so that it was floating in the air. It was made of tough old timber, stained dark, and there was a ring on one of the arms, and hanging from that ring on an iron chain, right at eye level, was a six-by-six-by-four box with a glass front glued onto it. In the back of the box was a sepia photograph of a penis plunging into a vagina. Written across the photograph in fat ink letters was the Latin phrase *factum fidei*—"fact of faith." Also in the show were a set of little canvases, maybe sixteen or eighteen inches square, with scraps of brown shellacked parchment paper attached, on which there were Hebraic letters, which he told me were those messages that had come in "on the ether from dead poets." It was a very spare show, very handsome. Berman installed it himself, and I think he had the actor Dean Stockwell, who was a friend, helping him.

That was the only time that this body of work was shown together: the exhibition was shut down by the vice squad on the first day, after someone filed a complaint. Police officers stormed into the opening and arrested Berman. They found a drawing by Cameron on the floor of the temple, one of the loose pages from *Semina*, in which the Sun God was having anal intercourse with the Moon Goddess. It was obscured in the tableau by something else, so it wasn't even on view. But they got down on the floor and fumbled through the papers scattered there, and that image became the centerpiece of the trial.

Berman loved William Blake, the mad Christian visionary. (He'd gone

Contact sheet showing images of Wallace Berman's exhibition at the Ferus Gallery, 1957. Photographs by Charles Brittin.

to England only once, and had gone straight to the Tate Gallery to see the William Blakes.) At the trial, he testified that one day an angel of God had appeared before him and told him to marry a good woman and have a child—he and Shirley had a son named Tosh—and devote himself to goodness. That was all he would say, and of course it didn't work in his defense. He was convicted of obscenity. When the trial was over, he went up to the blackboard in the courtroom, grabbed a piece of chalk, and wrote, "There is no justice, only revenge." He was fined a huge amount, which I believe Dean Stockwell paid, and the show was shut down. But, of course, the vice officers missed the piece that had triggered the complaint—the photograph in the box hanging from the cross. They just didn't realize what it was. After he was convicted, Berman did two things. He gave me the box from the cross, with a funny inscription added on the back: "Dear Walter, L.A. is a fast city. Love, Wallace." And then he burned the cross and *Temple* and destroyed the mannequin as well. (Luckily, Stockwell had bought *Homage to Hermann Hesse*.)

Soon after that, Berman moved up to Larkspur, north of San Francisco, and continued his work there. He built a kind of crazy gallery with no roof, where he hung shows. He was in touch with Jay DeFeo and Bruce Conner and other San Francisco artists, and he spent a lot of time with George Herms, who was the closest thing Berman had to a protégé. Shirley Berman

had worked as a fancy hairdresser in Beverly Hills, so they'd amassed a little money, and they lived very simply. To get by, he sold some work to his friends—to some of the poets and to Stockwell and Russ Tamblyn.

Eventually, in 1961, the Bermans came back to Southern California and to Crater Lane. Berman got an additional studio, down the road from the house, and in 1964 he began to use an obsolete antique copying machine called a Verifax to make copies of photographs and manipulate them for his collages. Those collages were full of disjunctive images; they seemed to make no sense at all, except that they did make sense, visually if not narratively. Some of them were copied against an industrial-yellow ground, with sepia images. For others, he set the sepia against a more buff or white ground. And some were reversed, with the images in negative on a black ground. It was a very subdued palate—rich but muted. There were a few collages with just a single image—one of Marcel Duchamp, which was the only thing Berman ever did to acknowledge Duchamp. The Verifax copier sped things up for Berman. He could make all sorts of layouts and combinations on that machine. It was the only time that he was productive at a normal rate. He also started another series—of rocks and little boxes with Hebraic letters and kabbalistic symbols on them. There's a spiritual quality in all of Berman's work—or perhaps it's more mystical. He, like Barnett Newman, was very interested in the Kabbalah; he felt he was in tune with it.

And then disaster struck again. One day, after heavy rains, a terrible

Wallace Berman, Radio/ Aether Series, *1966/1974.*

mudslide took out his whole house. Everything in there was lost—his own art and the art he'd collected by other people. It was just a fluke that neither he nor Shirley was there when it happened. We managed to help him get a couple of grants, and he moved to a place out in Topanga Canyon, where he stayed for the rest of his life, which unfortunately wasn't long enough.

Once, in the seventies, when I was living in D.C. and was involved with Jean Stein, we decided to rent a house in California for the summer. We rented a wonderful little house up in Trancas, near Malibu, with a long stairway leading down to the beach, and we wanted to have a party for our various friends and constituents. She invited writers that she knew and Hollywood folk, and I invited artists. It was a really interesting gathering: there was Joan Didion and her husband, John Gregory Dunne; William Eggleston was there, taking photographs; Ed Ruscha was there, with his friend Joe Goode, who hit it off with Paul Newman. Jean had invited her parents, her father being Dr. Jules Caesar Stein, who had founded MCA and put Universal Studios on the map, and, along with his CEO Lew Wasserman, was one of the most powerful people in Hollywood. Everyone was moving about the party, except for two men who sat planted for the entire time in big easy chairs on opposite sides of the sitting room. On one side was Dr. Stein, and all the Hollywood figures came up to pay their respects to him. On the other side of the room was Wallace Berman. He stayed there the entire afternoon and into the evening, and the art-world figures all came up to pay homage to him. It was quite a standoff between these two men. I don't think Dr. Stein understood who Wallace Berman was at all. But I know that Berman understood who Dr. Stein was and decided that he was going to sit in the same power position as the old man.

For years I wanted to do a real retrospective of Berman's work, and I talked to him about it once. He said, "I tell you what. Do you think you could get it in the Tate, near the William Blakes?" I said, "Well, I could give it a try." I didn't really care where the show was—I just wanted to do it. He said, "The other thing is, you've got to wait and ask me on my fiftieth birthday. We'll talk again on my fiftieth birthday." He'd had a premonition that he wouldn't live past fifty, and he turned out to be right.

One day I was walking down the hall at the National Collection of Fine Arts, and my secretary came running out of my office, looking stricken. She said, "We just got a call. Wallace Berman was killed last night in a car accident out in Topanga Canyon." I said, "Oh, my God, yesterday was his fiftieth birthday." He'd been driving, and a drunk had suddenly veered into his lane and rammed him head-on. It was entirely the other driver's fault, but it was very eerie. One of his most unique Verifax collages shows a wrecked automobile.

6.

THE CREATION OF FERUS II

We had some success with Ferus, but the artists wanted more. By late 1959, it had become clear that things were going to change quite radically, in terms of the economics of art, and that artists stood a chance to survive on the proceeds of their work, but they couldn't do that with what Kienholz and I were managing to bring in. We just didn't have the same business plan as the vanguard New York galleries; we didn't have Leo Castelli's model. A lot of the artists were coming to us to complain about how little work was selling. Ed was becoming much more seriously engaged in his own art and didn't really want to deal with it, and I didn't, either, but I knew the time was coming. And Shirley and I had less and less money.

I'd been thinking of going into a partnership with Virginia Dwan, who was showing Kienholz's work by then. She had been orphaned and inherited millions from her father, who was a cofounder of 3M, Minnesota Mining and Manufacturing; she had more money than anyone else we knew who was interested in art. One day Ed Moses, who was a Don Juan all over the deck in Southern California, came to me and said that he had something very serious to discuss. He said that he was speaking on behalf of the artists in the gallery and that they all wanted me to capture the affections of Virginia Dwan and merge my gallery with hers. I said, "Well, what about Shirley, my wife?" But the word from the artists was "You live very separate lives anyway. She has to understand. It's for the sake of art." Frankly, I don't think she would have understood. Although our marriage didn't last forever, we were together for quite a long time, and she never had that much interest in the new art. Her field was Netherlandish painting.

But I was sort of beguiled by the ingenuousness of the idea. And then it almost happened, in a more straightforward way: Paul Kantor had moved the Kantor Gallery to Beverly Hills, and had begun to sell to Norton Simon

and other wealthy collectors, but his wife filed for divorce and slapped a restraining order on his bank account. There was a week when Paul Kantor was bankrupt and hamstrung. Virginia Dwan called me up one night and said, "We've got a partnership if we can take over the Kantor space in Beverly Hills." That idea was in motion for about three days, and then she got cold feet and backed off.

While all of this was going on, Shirley was still in graduate school, and I was taking classes, too. There were times when I'd sit out a semester and work at a place called Bioscience Laboratories, over in the western part of the city. We did medical tests that doctors and hospitals couldn't do for themselves. I worked on 17-ketosteroid analysis; I knew how to run a Beckman spectrophotometer and other laboratory equipment, thanks to my life-science classes. My friend Bernie Altschuler was in an adjoining lab that did forensic work for the police, boiling down car seats from crime scenes in order to find blood or semen. One day there was a big excitement in the lab because they had been given a specimen of Marilyn Monroe's blood to test. Word spread, and we all took samples of the blood and put it on slides as a souvenir. During that time, Bernie and I were often so strung out on speed that we had to find a way to calm ourselves down. Tranquilizers weren't easily available in those days, so Bernie came up with the idea of getting navel oranges and injecting them with pure-grain alcohol, which was readily available in the lab. We'd put the oranges in the icebox to keep them nice and cool, and through the afternoon we'd eat them, one section at a time, to stop the shakes.

I was also covering the graveyard shift at the UCLA psychiatric unit. I'd be there from eleven o'clock at night until seven in the morning. Then I'd sleep a little and go to school. At one point, I was one of four young male orderlies—Ed Moses was another—assigned to a private patient called Jane Garland, a very wealthy schizophrenic, who lived in a strange mansion on the beach in Malibu. She had a psychopathological aversion to women nurses, because she'd been brutalized by one. She lived with her mother, who was terrified of her, and would lock herself in her room. But Jane and I got along just fine. I'd lie down on a bed in my clothes, and she would some-times get loose and I'd wake up and find her staring at me in the dark.

So I was doing that, and I'd go into Ferus on weekends and try to see

what had happened during the week and look over the books, because I was getting concerned about how I was going to go on paying for the gallery. At the same time, I was becoming completely addicted to speed; it was the only way for me to make it through the days and nights on so little sleep. It was an addiction that lasted for eleven or twelve years, during which I needed a couple of Black Beauties a day, just to keep going. I often functioned for days on four hours of sleep. But I was exhausted, and I started looking around for a director who could run the gallery while I finished school and earned enough money to keep my life going.

One day I was in Ferus on a weekend, Kienholz was busy in his studio, and an older couple came in and walked around the gallery, looking at things very carefully. I recognized them from photographs: it was the artist Adolph Gottlieb and his wife, Esther; they were in town for an event at UCLA and they'd heard about Ferus and decided to check it out. Then another man came into gallery, a flashy guy in an Ascot tie and blazer, whom I'd already seen there once or twice but never spoken to. Suddenly, with a great expansive gesture and a booming Cary Grant kind of voice, he said, "Adolph, Esther, so good to see you! Isn't this a marvelous gallery?" And he started guiding them around as if he owned the place, singing the praises of the art. I didn't even know his name. He gave me a wink, and I just sat back and watched him strut his stuff. After he'd given them the tour and they'd left, he came over to me with a big grin on his face and said, "Let me introduce myself. My name is Irving Blum, and you're Walter Hopps. It's near closing time, and I think we should sit down and talk." Ed had already left; he'd go out the back way. So I closed up the gallery, and that was how Irving Blum entered the picture. He just insinuated himself into it.

Blum had gone to high school and college in Arizona, where his high-school teacher gave him elocution lessons and groomed him for the New York theater world. But when he moved to the city and tried to make it Off-Broadway, he hated the scene—he just wasn't about to suffer to try to make it—and he ended up working, instead, for the modern furniture designer Hans Knoll. His job, because he liked art, was to go around to galleries and find art that

would fit in the corporate settings Knoll was working on. Blum had a soft spot for Josef Albers and Ellsworth Kelly, and he bought quite a few of their works for corporate clients. After Knoll died in a car accident, he made his way across the country and moved into a little apartment in West Hollywood in 1957. By the time I met him, he'd done all kinds of work to make ends meet. Through a friend, he'd met Russ Meyer, the director of the first soft-core porn films. Meyer liked the sound of Irving's voice, so he hired him to write the script and provide the narration for *The Immoral Mr. Teas*, the first real crossover Meyer production. When we met, Irving was working for a company called Scalamandré, hustling fine fabric and wallpaper. But, no matter how little money he had, he always dressed well and had to live just right. He was clearly interested in what Ed and I were doing, and it seemed as though he might be the person to help move the gallery up a notch.

So I went to Kienholz and told him I wanted to buy him out. He said, "Why?" I said, "Well, the artists really want to sell their work. They're not selling. But here's the main reason: you don't want your work to be shown at Ferus. You don't have any idea how good an artist you are, or maybe you do. You've got to devote yourself to your own art, and you can really make a living from this stuff."

Ed was becoming a truly important artist, and I just couldn't see him spending more of his time as a partner in a gallery that didn't represent him.

Irving Blum, c. 1962. Photograph by Frank J. Thomas.

I wanted him to put himself behind his own career, and that made sense to him, too, though he was sad about it. He was particularly hostile toward and suspicious of Irving Blum. In the end, we settled on some small sum—a few hundred dollars—and two paintings he wanted (one was a Sonia Gechtoff called *Anna Karenina*). Ed insisted that I throw in a 1939 Studebaker station wagon he'd once sold to me for sixty dollars. He liked that car, and he wanted it back. The trouble was that it was a lemon—it was so undependable that I'd already given it away to some young artist and let him worry about it. So to Ed's last day I owed him a 1939 Studebaker station wagon. I'd say, "I don't have the Studebaker anymore." He'd say, "Well, you've got to get it back." He never gave up on that—never. The car was already scrap metal somewhere, but that went on being a gag between us.

And thus began the new Ferus Gallery, which we moved to the west side of La Cienega, in a smaller but very slick space. It had a gray-white Formica-tile floor, perfect white walls, and one beautiful big wall that would slide out, dividing the gallery into a smaller and a larger space, so that you could do one big show or two smaller ones. Irving was going to be the official director of the gallery. But when he looked at the budget I'd put together and saw his salary, he said, "I can't make only sixty-two dollars a week." And I said, "Irving, that's not a week, that's a month." That was all we'd have left after we'd covered our expenses. We were going to have to *make* some money, and we needed to find a backer, a silent partner, to buy stock in the company. I'd been teaching some art classes through the UCLA Extension, and among my students, who were mostly wealthy investors—the class was held at the home of the collectors Fred and Marcia Weisman—I was able to propagandize and gather together a kind of collector base. And I thought of a woman who had come to our avant-garde movie nights at the old Ferus, with Norton Simon's first wife, Lucille: Sadye Moss.

Sadye Moss had been a great sponsor of culture in Southern California. When I made up a list of possible backers for the new Ferus Gallery, I had a hunch about Mrs. Moss. We called a few other people, with no success, but she was genuinely interested. So we incorporated Ferus and divided the shares into thirds. Irving got a third. I kept a third. And we sold a third to

Sadye Moss for $100,000 or $125,000, which was enough capital to keep us alive. Probably the most we'd ever made at the old Ferus was five grand a year, so this was a big jump. Mrs. Moss was a lovely, extraordinarily generous woman, interested in the lives of the younger artists.

Irving and I wanted to use the capital that we'd got from her to explore a broader range of artists, including New York artists. We designed an elegant new announcement and opened up, in 1960, with a show of New York School artists. A few pieces we borrowed to flesh out the exhibition, and others we managed to obtain, by sheer guile, on consignment from galleries in New York. We'd go out to New York and stay, very inexpensively, at the YMCA. The first time Blum and I went out together, he was terrified that I would tell people where we were staying, but the money we had was spent on airline tickets and taxicabs and eating. And, in the end, the lineup of the show was impressive. I borrowed a Jackson Pollock from a Los Angeles collector—it was very hard to get a Pollock for sale at that point in time. He had died in 1956, and the prices were going up and up. We had a Rothko, a de Kooning, a Jack Tworkov, an Arshile Gorky, a Franz Kline, a Philip Guston, and a Robert Motherwell. Miraculously, I was able to borrow a terrific Barnett Newman as well. And I put in a piece of sculpture by Louise Nevelson, which I had bought in New York; she was doing her black works in wood then, which were better than what came later. It was a righteous show, but the only thing that sold was the Nevelson. We couldn't sell the Rothko or the de Kooning or the Newman.

7.

BARNETT NEWMAN

I was just brokenhearted that we didn't sell the Barnett Newman painting. Oddly, I'd first heard about Newman's work when I was still in high school, from my aunt Rosita, who'd been so distressed by the thought of Jackson Pollock. Rosita, who was living in New York at the time, was visiting us, and she mentioned that she had seen some inexplicable paintings that weren't paintings at all—just bands and blank spaces. They were paintings of absolutely nothing, she said. It was an outrage. Much later, I realized that she must have stumbled into the Betty Parsons Gallery, heaven knows why. Then, in 1959, John Altoon came back from a trip to New York just raving about a show of Newman's paintings that he'd seen at French & Company, a tapestries and decorative-arts establishment in Manhattan, where the critic Clement Greenberg was running a kind of gallery for the contemporary artists he admired—David Smith, Morris Louis, and others. Altoon, whose work was nothing like Newman's, was bouncing off the walls with excitement.

So somehow I managed to get to New York to see that show, and it knocked me out. The paintings weren't mechanical-looking; the handwork was very moving and very powerful. Some of Newman's canvases had longer horizontal formats that read from left to right, with the fields of color and the contrasting bands, which he called "zips," working in a rhythmic way, like a chord in music. Others worked vertically, with an incident at the top or the bottom and the rest of the space seemingly the same. Some of the vertical paintings were also divided horizontally, shifting the color, left side to right side, with an intense, subtly ragged union where the two colors met, so that they were palpably, physically different kinds of paint, and not just different colors. Newman seemed sui generis to me. I saw de Kooning and Kline as great painters, and David Smith as a great sculptor, but all three

were emerging in a way from the evolution of Cubism. Newman, like Pollock, Still, and Rothko—the four horsemen of the sublime—came from nowhere and traveled out into space.

At one point, Betty Parsons had shown all four, but then her gallery had changed and she'd lost them all. Pollock and Rothko went over to Sidney Janis, but Newman just dropped out of the gallery world and represented himself. He didn't play a lot of games and he didn't make deals, but he was tenacious, and he got along on his own. Later he showed with Knoedler & Company. But at the time of the new Ferus opening, he was listed in the phone book, and, if you wanted a Newman, you just called him up. He was living on West End Avenue on the Upper West Side, and he'd take you to the warehouse where he kept most of his work. Very rarely did he invite anyone to his studio. I was very honored to be taken to his studio a couple of times.

I hadn't yet met him when we were opening the new Ferus, but we corresponded and spoke on the phone, and he chose an extraordinary work for the show. It was about three and a half or four feet high and almost five feet across, a horizontal, with silver aluminum paint and orange-red lead zips. Newman had it crated and sent out, and he asked that I be on the telephone with him while I opened the crate. He had special instructions for how to handle it. It was the first painting of his ever to go west of the Appalachians, he told me.

I began to visit Newman and his wife, Annalee, when I was in New York. We'd drink coffee or vodka, depending on the time of day, and then we'd go and have a meal. If it was lunch, we'd go to Barney Greengrass, the Sturgeon King, over on Amsterdam Avenue. If it was dinner, we'd go to another seafood place or to a steak joint or to the Russian Tea Room. There was a kitchen in his apartment on West End, but nothing was ever prepared there except coffee. The oven was full of stored papers, an archive. The piano in the sitting room had so many papers piled up on it, you couldn't raise the lid. It was a very simple apartment with a foyer, a sitting room, a dining room, and a bedroom. I don't think there was even a second bedroom. One time at the Russian Tea Room, Newman suddenly asked, "Have you ever met Salvador Dalí?" And I said, "No." And he said, "Well, he's sitting right over there. I'll introduce you, if you like." I later asked him, "How on

earth would someone like Barnett Newman know Salvador Dalí?" He said, "Oh, in the early days, around Peggy Guggenheim, I got to know him." Peggy Guggenheim had never bought a Newman, but he'd gone to parties she threw. So he took me over and introduced me. Dalí was very polite and greasy-courtly, having no idea who I was. Sometimes unexpected things came out of Newman.

Newman was one of the only members of the New York School of Abstract Expressionism who were actually born in New York. Rothko started out in Russia, then moved to Portland, Oregon. Clyfford Still began in North Dakota. And Pollock was originally from Wyoming. But Newman was in New York for the entirety of his life.

I asked Barney once what was the first artwork he remembered making. He said, "I will try to remember," and he put his hands over his eyes so as not to be distracted. He seemed to be going into a trance. He took the question so literally. He said, "I'm a child, and I'm under the table, crawling about. I see legs with shoes, and that doesn't interest me so much, but there's a dog under there, too. I guess the first thing I ever drew was the family dog." At one time or another every American boy has drawn a dog or stick figures of Mom, Dad, and house, so I asked him what the next thing was. He thought about it and then he turned to Annalee and said, "Where is the tile? I haven't seen it in years." She looked startled. She said, "Don't get upset, Barney. I'm sure we can find it." "What on earth is the tile?" I asked. "I went to public school in New York," he said, "and we had a class called Industrial Arts. One of the projects was to make a single decorative hand-painted tile to be fired and glazed. I thought this was not a very exciting assignment. Everyone else was doing Art Nouveau designs or Maxfield Parrish imitations, and that didn't interest me at all. I had no idea what I was going to do. Then one day I was walking to school and I passed a construction site with a huge stack of I-beams. As I was walking by, I looked at the end of an I-beam, and it just thrilled me. I thought it was the most beautiful configuration I had ever seen. So I made a tile in two colors: the background of the tile was a deep maroon red"—which turned out to be a big color for him—"and, over that, a black outline of what an I-beam would

look like in cross-section. I was very pleased with it, but the art teacher gave me a hard time. He said that it wasn't a design at all. I didn't get a good grade, but he let me keep it and I gave it to my mother as a present. After she died, we packed up all her things and it must be here."

Newman was a self-taught artist, and he told me that before the war he spent a lot of time at the Metropolitan Museum. In those days, one could set up an easel and copy paintings in the collection, and that was how he learned to handle paint. One of the works there that intrigued him was a quiet monochromatic painting by the nineteenth-century American artist George Inness called *Peace and Plenty*. Everybody else loves the Albert Bierstadts and the Winslow Homers, but the Hudson River painters like Inness are so calm, so green-brown, and so "nothing happening," it's not surprising that they interested Newman. He used some of those colors later himself. In fact, he borrowed quite a bit from the American transcendental movement, and he paid tribute to it in a painting called *Concord*—as in Concord, Massachusetts (where Newman and Annalee spent their honeymoon), and Ralph Waldo Emerson, the sage of Concord. It's a green work with two vertical zips in a light beige-ochre—which are actually masking tape. Newman would sometimes use masking tape to keep the paint away from where his bands were going to be—long before Frank Stella and others started doing it. But, in this case, the color of the masking tape looked right, so he kept it, and he went to great pains to make sure that it was glued down correctly. They've had to reseal it over the years, and it's very fragile now, too fragile to move around. *Concord* is the finest painting ever to acknowledge the spiritual qualities of nineteenth-century American culture. It's really interesting that a New York Jew of Russian-Polish ancestry could get it so perfectly.

Newman was fascinated by nature, and the experience of nature. Having grown up in New York City, he didn't drive. Very few of the Abstract Expressionists did; they had women in their lives or friends who'd drive them. Pollock could drive because he was a Westerner, but, of course, driving was his downfall: he got drunk at the wheel and killed himself and a woman who was with him. When Franz Kline came into good money, he went out and bought a black Thunderbird; he just loved cars. But everyone around him panicked—they figured he'd kill himself in it because he was

old and had never learned to drive—and his dealer convinced him to return it. Instead, he bought an exquisite model of a black Thunderbird, which he kept in his studio; it was better than nothing. In any case, Annalee Newman could drive, and she and Barnett took a lot of trips into the countryside.

On one of those trips, Newman saw the berms and structures made by the prehistoric people known as the Mound Builders in the Ohio River Valley—forms in the landscape, covered with grass and other plant life, that are the ancestors to all earthworks. These became very important to his art. He called those mounds "declarations of space," and he'd say, "I declare space in my paintings," and raise his hands and make a kind of zip gesture. The mounds meant more to him than the Pyramids, though the Pyramids were important as well. He was very conscious of the Egyptian origins of two forms, actually: the pyramid, where you bury your great leaders, and the obelisk, a totem of power. He never went to see them in Egypt, but he used them both in his sculpture *Broken Obelisk*, which he said was an elegy about the tragic failure of power. Newman had the two shapes fabricated in Cor-Ten steel, then he took the power symbol and put it upside down on top of the tomb. It was quite something to see that sculpture in Washington, D.C., during the Vietnam War era. It sat by a corner of the Corcoran Gallery, with the real Washington Monument in the distance. (Later, it ended up at the Rothko Chapel, in Houston.)

Barnett Newman and Broken Obelisk, *in Washington, D.C., 1967. Photograph by Steve Szabo.*

Newman collected minerals and rocks. Once, on a trip to West Virginia, I saw some black basalt rocks piled up where a cliff had caved in, and I stopped and went over and found an amazing gray-black rock with a perfect zip stripe going through it, a vein of quartz. I saved it and took it to Newman. He looked at it and said, "See, deep in the earth this declaration of space exists, just as it does in my art." At some point, Newman decided that he wanted to go as far north as he could—he wanted to see the place where vegetation gave out and ice began. He wanted to see the tundra. It was an ordeal for Annalee, who had to drive, but they made the trip up through Canada and, in 1950, Newman did a painting called *Tundra*, an orange field of color with one vermilion band.

Newman was the most intellectual visual artist of the old New York School. He was a great reader and, of his generation, the one who was most engaged with younger artists. He would go out to openings, always looking distinguished in his best suit, with his monocle and his cigars and his brushed mustache. Newman, dressed to the nines, attended the opening of Rauschenberg's first retrospective, in 1963, at the Jewish Museum in New York. When he saw Rauschenberg, he went up to him—they had met somehow before then—and said, "Am I the only one here?" Bob said, "What do you mean are you the only one here? People are arriving." He said, "But am I the only one of my generation?" Bob said, "I guess so." Newman said, "Well, then, I want to represent my generation, and I want to ask permission to stand with you throughout the evening." Bob said, "Of course." Newman followed him through the whole opening; every picture, every encounter, Newman was by his side. As different as they were, Newman admired him greatly.

I'm sure Newman had dark moments of the soul. He was not manic-depressive, like Rothko, but he had difficult periods. When he didn't sell any paintings at his second Betty Parsons show, he withdrew from the gallery and didn't exhibit anywhere for the next four years. Annalee was a teacher in the public school system, and she supported the two of them for a long time. (Newman sold one painting from his first Betty Parsons show, thanks to Annalee's friendship with Rothko's wife: the women conspired to

each convince a friend who had some money to buy a painting from the other spouse's show—so Annalee found a customer to buy a Rothko and Mrs. Rothko found a customer to buy a Newman.)

While I was advising Fred and Marcia Weisman on their art collection, I introduced them to Newman's work, among others', and I urged them to buy a painting called *Onement VI*. I made an appointment for them with Newman in New York, and we rendezvoused with him on the Upper West Side. When we got out of the cab, he was already waiting on the street. We were planning to go to lunch, so Fred started trying to hail another cab to take us to the restaurant, and Newman said, "Wait! Wait! We must speak first." Weisman put his hand down, and Newman said, "Do you know why you're here?" Weisman said, "Well, we're here because Walter admires your work so much and wanted us to see it." He said, "No, that's not why you're here." Fred said, "It's not?" Newman said, "Walter is what he is because of many artists younger than I. I'll probably never know them or know who they are. Walter has been formed by artists. And that's why he is interested in the work that he is interested in, and that's why he told you about my work, and that's why you're here. So I want to salute the younger artists who brought us together." They said, "O.K., and now let's go to lunch." But I admired him so much for thinking that way.

After lunch, we went to the warehouse where he stored his work. He had taken *Onement VI* out of its crate, and they loved it. The painting was eight and a half by ten feet, a beautiful painterly ultramarine blue, not quite as revealing as *Concord*, but clearly there were brushstrokes, and a zip of a kind of lighter aqua-blue color, up the middle. They bought it, and it hung in their house for years. While we were in the warehouse, Marcia noticed a very early sculpture of Newman's that looked like a big Giacometti to her. It was about six feet tall, with one smooth vertical board and one rough one. She really wanted it, but he said, "I just won't sell that." And she said, "What'll you take for it?" She kept trying to get a price, $25,000, $30,000. Newman had never sold a sculpture. He didn't make that many. This was before he made *Broken Obelisk*. He was firm. He said, "I just can't sell that. It's very important to me." But later he got in touch with the Weismans and said, "I've got a proposition. You brought that sculpture back to life for me, Marcia. The name of the sculpture is *Here I*, and I'd like to have it cast in

bronze. We'll make two casts, an edition of two, and you can buy one of the casts, and I'll keep one. If you finance the casting of it, I'll give you a very good price." It wasn't a cheap or easy thing to get cast, but it did get cast, and he named it *Here I (to Marcia)*.

One day the Weismans' house was being painted while they were away. The housekeeper failed to have *Onement VI* taken down before the workmen came in, and they splashed wall paint on it. Worse than that, they took a turpentine-soaked rag and tried to clean it off. They made a terrible blotch in the lower section of the painting. The greatest restorer of color-field paintings at the time was a man named Orrin Riley. He worked at the Guggenheim Museum and also privately. When Newman heard what had happened he was very sad, and he asked the Weismans to ship the painting to Riley, who studied the situation. Finally he got Newman on the phone, and he said, "Barney, there's only one way to fix this painting. I first want to discuss the paint you used and I'm going to get it mixed up." Newman didn't use out-of-the-tube colors; he was a real colorist. "Then you're going to bring a bottle of vodka and the brush you used to make this painting, and we're going to drink and relax one night and you're going to go right back in there and paint that section again." So that's what they did and it came out perfectly.

8.

FERUS II AND JOHN ALTOON

Irving Blum and I ran Ferus together until 1962, but we were sparring part-
ners throughout. I was always disappointed that he wouldn't allow more of
the strong underground work to be shown there. Wallace Berman didn't
want to be shown in the new Ferus; he couldn't stand Blum. Nor could
Kienholz. He was very alienated by how quickly and efficiently the new
Ferus was set up. For a year or so, he wouldn't even enter the gallery. He'd
peer in the window and the front door, and he'd go into the alley and look
in through the glass door in the back, but he literally wouldn't set foot
inside. Eventually we had two shows of his work there—first a two-person
show with Billy Al Bengston, and then a one-person show in 1962, at the
same time as his Pasadena Art Museum show. But generally he showed
with Virginia Dwan in Westwood.

There were three galleries of real consequence in Los Angeles in those
years: Ferus, the Paul Kantor Gallery, and the Dwan Gallery. Dwan had

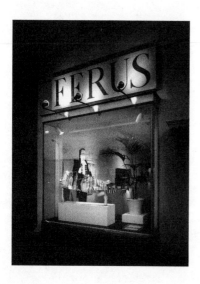

The Ferus Gallery, 1962. Photograph by
Seymour Rosen.

two different galleries in Westwood—a modest one at first, and then a very fancy one that she had built. In addition to Ed, Virginia supported the work of Robert Smithson, and she helped finance some of his great earthworks. She also showed Franz Kline, Yves Klein, Jean Tinguely, and Martial Raysse, who was a friend of Klein's. It was a hell of a lineup. Klein died much too young, in 1962, at age thirty-four, but before that he spent some time in L.A., and he and Kienholz became good friends, probably through Tinguely, who was also friendly with Ed. Klein had a wonderful show at Dwan in 1961, but he didn't sell anything. When the work was packed up to be shipped back, the handlers didn't screw the crates shut—they nailed them, and the nails were driven right through his monochromes, making little holes. Klein asked me to write a report for his insurance adjuster. He was declaring the works as a total loss—he couldn't just touch up the holes—and he wanted someone in the field to back him up. I had talked with him enough to understand the aesthetic of his work, so I wrote one hell of a report. (That letter is, I think, somewhere in the Yves Klein papers at the Pompidou.) It worked. He was paid the full value of those paintings, and he was so grateful that he gave me a little painting in return.

When Klein was in town, he'd meet up with me and Kienholz, and we'd go to the beach. Klein loved to look at the ocean. One day he asked if we could take him to Death Valley so that he could look for a place to make fire fountains. Kienholz said, "It's hotter than hell out there. Why would you make a fire fountain in Death Valley?" Klein said, "Because that's where fire should live." Later, Kienholz said to me, "We're not going to Death Valley. We're going to take him to the Mojave. He'll think he's in Death Valley, but it'll be about twenty degrees cooler and it'll be quite hot enough for him." Klein loved the Mojave—the more rugged and empty a place was, the more he liked it.

Apart from Berman and Kienholz, the new Ferus showed a lot of the same cast of characters as the old gallery, although Blum wasn't as enthusiastic about the Westerners as I was. We showed Richard Diebenkorn's wonderful figurative drawings and Bengston's new work, which had shifted toward a kind of emblematic abstraction. And some new, quite different artists came into the lineup as well. Sam Francis and Bruce Conner, Joseph Cornell, a beautiful ceramic sculptor called Kenneth Price, Ellsworth Kelly,

whom Irving admired, and Jasper Johns. We did an amazing two-person show with Johns's sculpture and Kurt Schwitters's paintings. Johns was in the front part of the gallery, with the lightbulbs and the flashlights and all those wonderful little sculptures, and Schwitters's collages were in the back. It was an odd pairing but it worked perfectly. I think we sold only two things. We were astounded that nobody bought more.

We borrowed a lot of work from Sidney Janis in New York. Sidney had taken over most of the Egan Gallery's major artists. His was the first gallery in New York to handle Schwitters, and he had also acquired some serious School of Paris work—Mondrians, Brancusis, Arps, and even Magrittes and some material of Duchamp's. Duchamp was sort of an advisor for the gallery, and he occasionally took a commission to keep himself going. He tried not to make any money on his own art; he didn't believe in mixing art and commerce. By 1959, Janis had Pollock, Kline, de Kooning, Guston, and Rothko, too. And we had a racket going with him. We'd fly there on a Friday, get a room at the YMCA, which was something of a flophouse at the time, then head straight to the gallery and make a deal. We'd write a check for something that we just had to have—which Janis wouldn't let us take on consignment—and then we'd get right back on a plane to L.A. We'd have the weekend to get the thing sold to cover the check. It worked several times, and then one time it didn't. We bought a Gorky. I wrote a check for something like $85,000; we probably had about $6,500 dollars in the account. We carried it back on the plane, hoping to get it sold right away and get a check in the bank before Janis could clear his. I knew that the collector Ed Janss was interested in Gorky, but something had taken him out of town. Janis called up on the Tuesday and got our young secretary on the phone, and said, "Will you ask those boys how many times I'm going to have put their check through the bank before it clears?" He was very nice about it, a real gentleman. Janss did buy the painting in the end, and we made good.

Ferus had three special shows of historical figures: Kurt Schwitters, Josef Albers, and Giorgio Morandi. Morandi was admired by certain of our younger artists, and I had always loved his work, so I found a gallery in

New York—a strange place called the World House, in the building where the Carlyle hotel is now—which had some exquisite paintings and a whole raft of drawings. We had designed a new look for the announcements at the new Ferus—we printed them on fine paper, about fourteen by twelve inches, and they became collectors' items. But, for this show, Irving screwed up. We'd chosen a Morandi drawing that we were going to print in line cut on the announcement, but he hadn't had it photographed. (Baza wasn't doing our announcements anymore; by this time, he was living in Venice, preaching his own private religion, and working on his poetry.) I was furious. I said, "Give me the drawing we picked out," and I took a piece of stationery, laid it down right over the glass, got the softest pencil I could find, broke it to make a fat point, and traced that drawing—made my own version of the Morandi work. Blum said, "What are you doing?" I said, "I'm making a Morandi, you asshole. Now, take this to the printer and have them make a line cut of this and print it on the announcement." So one day, somebody somewhere in the world, a graduate student or an expert, is going to go nuts trying to find the Morandi drawing I produced, because it isn't exactly the same as the original; there are slight variations. "Anything to get through the night" was our approach. It was a superb show, anyway. I was sure we'd sell one of the big still lifes to Norton Simon, but we didn't; we didn't sell anything. We sold Albers. We sold Schwitters. But we could not sell those Morandis. Twelve thousand dollars for an incredible Morandi, and we ended up having to send it back.

On one of my trips to New York, I met the actor Edward G. Robinson, who was a great art collector. To relax and clear my head between gallery visits, I stopped by the Frick Collection one morning, and I noticed Robinson sitting on one of the benches; I recognized him from the movies, of course. There was nobody else in the place, he beckoned me over, and we ended up talking. He said, "I like to just come here and look at this great art and rest." I said, "So do I." It was about eleven o'clock, and we walked around, looking at the paintings, then he took me out to a lunch counter nearby and told me about his collection—which, sadly, he ended up having to auction off because of a divorce dispute. He owned a great assortment of Impressionist and post-Impressionist paintings, as well as some later French moderns. He liked Nicolas de Staël, who was the best of that postwar French school of

Abstract Expressionists known as the Tachistes (from the French word *tache*, or spot), better than Pierre Soulages and Georges Mathieu. He said, "Do you know what I do? I have a study in my house." He lived alone at this point. "I have a chair and a special light, and I own a Cézanne. Do you know a Cézanne called *The Black Clock*? At night when I can't sleep, I go and sit in this comfortable chair, just looking at that painting, until I fall asleep." Robinson didn't collect the new Americans, but when he asked what I did I gave him the address of Ferus; not long after that, he was in L.A. and he came by one afternoon when John Altoon was there. Altoon was a wonderful artist, but you never knew what he was going to say or do. Robinson was looking at this ominous black-and-ochre Robert Motherwell painting, and Altoon walked up and put his hand on Robinson's arm and said, "Do you know what this painting means? It's about bulls, bulls in the bull ring before death. Do you see that big black form? It's death. Death. Death." Poor elderly Mr. Robinson rushed out of the gallery in sheer terror and never came back.

John Altoon was a handful, but his work sold. At the original Ferus, we hadn't made much money to speak of, and it was a good year at Syndell Studio if we made nothing. For the first year at the new Ferus, we got by on very slim pickings. But then the gallery did begin to make some money. We sold work by Billy Al Bengston, and John Altoon's gouaches and drawings sold like hotcakes. They were done on high-grade thirty-by-forty illustration board; he liked to work on a rigid surface so that he could move his pieces around. He also made both figurative paintings—big pieces, about six-foot-square—and Abstract Expressionist work, and he did pastels, too. He did a couple of really nutty things—including a pastel of a nude woman with a replica of de Kooning's *Woman I* on her belly. Often, when we couldn't sell anything else, Altoon was covering our overhead.

Altoon earned a living as a commercial artist, doing illustrations. He worked for one of the best ad agencies in L.A., and he'd go in with a pen point—no holder, just a nib in his fingers—and he'd pour some India ink in a little dish, and say, "What do you need?" They'd say, "Well, it's for the Bank of America. We need a young couple and a bank vice president, and they're signing up for an account." And in ten minutes, in wonderful flashy style, he'd whip it out and go waltzing off. In those days, you got paid by the

John Altoon in his studio, c. 1968. Photograph by Joe Goode.

job, not by how long you were in the office, and he'd drive the guys who were in there working at their drafting tables crazy.

Altoon sometimes stayed in my apartment behind the new Ferus, and he had some art stored there. One day I came home and John was sitting there with a guy I'd never seen before. There was a huge pile of money on my coffee table and, even worse, a gun. John bounced up and hustled me off to my little office area down the hall. I said, "What's going on?" He said, "You're not supposed to be seeing that. I'm sorry. That's So-and-so. He lives in South America. I knew him years ago and he comes into town from time to time, knocks over supermarkets and liquor stores and so on, and then he gets on a plane and gets out of here." Altoon had a wonderful boyish innocence. He said, "Don't worry. He just stopped by here to count his money. He's got a rental car downstairs and he'll be out of here in two minutes and on his way to the airport." I said, "John, for God's sake, don't bring people like that into my apartment." He said, "Well, he's an old friend. And actually he brought us a macaw. He loves tropical birds and while he was here he acquired one, just to make him feel at home. He lives in Brazil, and he can't take it back on the plane, so he's giving it to us. Don't you want it?"

Billy Al Bengston was living with me at the time, and he loved that macaw. He named it Susie. If you've ever heard a macaw screech, it's like a

Howitzer going off. And they eat everything—the moldings on the ceiling, the doorframes, and, as it turned out, paper. Altoon had a stack of drawings there, and this damn bird ate big notches in a bunch of his drawings. It looked as if rats had been gnawing on them. No one but Bengston could get near that bird, because she'd take your finger off. Finally, when Bengston moved out, I took the bird to a fancy pet store and got two hundred bucks for it.

One time Gilbert Henderson, Altoon, and I decided to go to New York for a weekend; by this time, there were jets and you could get back and forth in a hurry. So we flew out, checked into the Hotel Earle, which was one step above a fleabag, and went straight to the Cedar Tavern, where we drank too much, smoked too much dope, then found our way to a club called the Jazz Gallery to hear Art Blakey play. Somewhere along the way, we picked up some women and went back to our hotel. Henderson had more money than we did and he insisted on having his own room. He was one of the few Abstract Expressionists to come out of L.A. and he was a goofy kind of guy with a great sense of humor. He'd had some trouble in the service during the Second World War. Because he was a painter, they asked him to paint a mural in the mess hall or some such, where he was stationed, and he painted a giant cock along the wall, thirty-five or forty feet long; on top of the cock were the troops and the officers and so on, marching as if they were on a parade field. That prank led to his being kicked out of the Army. By this point, he was making contract art for a living, cranking out real paintings for hotels in Vegas and so on. His boss would go to the hotels with samples, and say, "Do you want it to look like Raoul Dufy, or do you want it like Georges Braque? Do you want it moody or abstract?" The clients would choose a style, and the artists would assembly-line them out. Henderson was an ace at that.

Anyway, John and I were sharing a room; it was one of those wasted nights, and the first thing I was aware of when I woke up was that I had on a collar, a necktie, and cuffs, but no shirt—my shirt had been ripped away. Whatever young women had been in the place had disappeared. It was the early hours of the morning, still dark. And then there was a terrible thump. I sat up and saw John Altoon squatting like an animal, then racing toward the

windows, one of which was open. He kept missing: he'd hit the wall between the windows—*ker-thump*—and then go back to where he'd started and get ready to make another run. Suddenly he adjusted his course and made it to the window. I jumped up and, as if I were moving in a dream, got hold of him on the ledge, just as he was about to go out. We were four or five stories up, and he was strong, but my own strength kicked in. I was doing everything I could to hold on to him and prevent him from going over the ledge and taking me with him; he was half out there, and he was naked, sweaty, and slippery. I managed to get one hand on a radiator handle and I held on to his leg with the other. What saved the day was the telephone: this hotel had old-fashioned candlestick phones that connected directly to the front desk. In the course of rushing across the room, I'd knocked the phone over, and, when the people at the desk heard us both yelling and screaming, they called the cops.

When the cops arrived, they didn't know what to do—one of us was naked, the other was a mess. They thought it was some kind of gay mayhem. I tried to explain, but they just hustled us both out of there. We were taken down and stuffed into the squad car, and off we went. I was riding in the front, and two guys were in the back trying to hold Altoon down as he moaned and raved. They took him straight to the psychiatric entrance at Bellevue Hospital. Then, as I was trying to tell the admitting staff what had happened and explain that this poor man had a history of attempted suicide, he broke loose and went racing off into the hospital, and they had to chase him down. You can imagine what the psychiatric entry at Bellevue was like in the middle of the night—total bedlam. Finally, the attendants found him cowering on the floor in a corner of the children's ward. It was very sad—he'd managed to scare all the children. That was the last I saw of him for a while. His wife at the time was Fay Spain, a third-string Hollywood actress and a really bad deal. She didn't even come to visit him at the hospital. He eventually got out of there and went back to Los Angeles, but he lived hard.

At some point, Altoon couldn't stand Blum anymore, and in a moment of depression he came to Ferus and got into the storeroom where his work was being held on consignment and tore all the gouaches in half and slashed up the paintings with a matte knife. He was selling and making money, but

he just flipped out. After that, he moved up to the David Stuart Galleries. He died a few years later, of a heart attack, at age forty-three, and his funeral at Forest Lawn was the largest gathering of Southern Californian artists I'd ever seen. Had he lived, he might have had the kind of reputation that Cy Twombly had. He was the Western version: where Twombly was monochromatic and subdued, Altoon was full of lush bright color.

9.

EDWIN JANSS

Surprisingly, there's a real tradition of art collecting in California, and the pioneers in the field were almost all from the movie world. One of the first people in Hollywood to have a serious collection was George Gershwin, who acquired some Cubist art. Then there was Charles Laughton, who knew the Arensbergs but collected more contemporary work. Billy Wilder had a fascinating collection; he bought all kinds of kinky things from the German vanguard, some work by George Grosz, but he also had a Balthus and a Cornell. The next collector who turns up is Vincent Price, who made his fortune in horror movies and was one of the spark plugs who tried to put together a modern museum to house the Arensberg collection in Los Angeles. He collected some wonderful things—Diebenkorns and others. I made a point of going to visit him, and he gave me a glass of iced tea and a tour through the house. In my own generation, Dennis Hopper was the first person in the film industry to get involved with the new abstract art—Frank Stella and others, and particularly Pop Art. He lost the bulk of his collection when things went haywire with Brooke Hayward, his first wife. And, of course, these days there's a whole new breed of art mogul—David Geffen and the TV and agency people.

Through Ferus, in the late fifties and early sixties, I came to know quite a few collectors, and some of them I advised personally: Dennis and Brooke; Robert and Carolyn Rowan; Taft Schreiber; Don and Lynn Factor; Michael and Dorothy Blankfort. I got the Blankforts interested in Kienholz, and they bought some important things. I hooked Betty Freeman up with Clyfford Still. And I got to know the critic Dore Ashton, who was in touch with Donald Peters, a fabulous collector in New York, who was dying, so there were some very significant works that we got straight from him to

other collectors—including an exquisite small Jasper Johns red-yellow-blue target, about twenty inches wide, which I persuaded Blankfort to buy.

One weekend I came back from working the night shift at the psychiatric unit, and I was in the apartment behind Ferus, trying to get a couple of hours of sleep. I told Irving, "For Christ's sake, don't wake me up before noon." Shirley had gone to Europe to work on her Ph.D. by then, so I was alone. But early that morning Irving banged on the door and said, "I'm sorry to wake you, but there's somebody here who wants to meet you. He's interested in Sam Francis and wants to see if we have anything." It was Edwin Janss, a real-estate developer, who had a collection of tribal art from the South Seas and Africa, as well as some Mexican painting, but had become more interested in modern art. He'd come across some of Francis's work while traveling but didn't yet own anything, and, while he was wandering around the galleries on La Cienega, someone suggested that he try Ferus. So I got up, put on a T-shirt and a pair of Levi's, and went out to meet a man who looked almost as rumpled as I did, though he was wearing a tie that he should have avoided. He was such an unpretentious guy; we instantaneously hit it off. And he bought several pieces from Ferus right away—some Altoon drawings and so on.

Pretty soon he proposed a deal. He said, "Do you own any of the art that's here in the gallery?" I said, "No, we take it on consignment and get a commission of a third of the selling price." He said, "That's not the best way to do business. Why don't you buy it cheaper and then hold it to sell?" I said, "We just don't have the capital for that." He said, "Walter, I like you and I'll make you a deal. I don't want to have anything to do with that weird partner of yours, but why don't we work together? You pick out stuff to buy for the best price you can get—whatever interests you. I'll put up the capital, then we split the profit when it sells. You can do whatever you want with the proceeds; if you put them into the gallery, fine." So that was how we worked. I didn't make any profit from our agreement—it all went into the gallery—but it was thrilling just to choose the work. I'd go east to see what was interesting in the galleries there, and I'd transport back whatever I found, which I'd pay for out of my special Janss account. Back in L.A., it would be hung in my apartment, not in the gallery, and Janss and I would divide the profits.

* * *

Janss was in his mid-forties then, only a little younger than my father, but youthful and eccentric and adventurous. He was the ideal uncle—a friend, a mentor, and a tough, unsentimental businessman. He kept his business small enough that he always had time for his own interests, which were art, chess, and philanthropy. He did some charity work in Micronesia, setting up a school so that the local people could maintain their own culture instead of ending up as servants at the fancy resorts that were being built up in that part of the world. And he was responsible for helping me at a couple of crucial times. In a way, he took the place of my father, who never understood what I was up to in relation to art. Ed was, intellectually, my graduate school. He put the voice in my mouth.

Ed was the grandson of a Danish immigrant, Peter Janss, a doctor who had the perspicacity to buy bean fields and other land over in what became the western part of L.A. When Ed was a boy, his uncle Harold and his father, Edwin Sr., were asked to give land to the University of California so that it could establish an L.A. campus. Ed's father said, "I won't give it to you. I'll sell it to you, but I'll give you a good price." The UC people were disappointed, because Ed Janss Sr. was very wealthy. They asked him how much he wanted for it. He said, "One dollar." (Ed always pronounced it, "J-u-a-n d-a-l-l-a-h.") They said, "A dollar? Why won't you just give it to us?" He said, "I don't give things away, but I'll sell to you cheap. It's a good cause." And he said, "I want all the escrow people. I want the lawyers. This transaction is going to be for one dollar." And he made them go through with it. That curious kind of anarchic do-it-my-way feeling was in Ed Jr., too.

Ed's father began to develop most of Westwood around the campus. He made so much money that he built himself a house in Holmby Hills, one of the richest parts of L.A., which the Janss Investment Company had developed, and took his family off on grand tours of Europe and Africa and so on.

Ed went to study at Stanford, where he met a girl called Virginia, whom he married and had three children with. After college, he ran the family company and took over the Westwood project. At first, he and Virginia lived out in Conejo Valley, at the eastern end of the San Fernando Valley, where the family owned ten thousand acres of what became Thousand Oaks, and Ed raised Thoroughbreds. But, as the investment corporation

Edwin Janss, with his airplane, c. 1946.

grew, he bought Sun Valley, Idaho, Snowmass in Aspen, Colorado, some agricultural land on Maui, and a big cattle-feed lot down in the Imperial Valley. He was making money in every direction.

At the same time, he was developing a wider-ranging interest in the new art than anyone else I knew. He paid attention to West Coast and East Coast art, he was open to young and oddball artists, and he had a penchant for assemblage work. He was a quick study, with great instincts. He started with an interesting but parochial attraction to Southwestern, Native American, and Mexican art, but quickly moved on to some of the most avant-garde contemporary art of his time. When he loved work, he didn't hesitate. He collected Kienholz and Cliff Westermann, on the one hand, and Sam Francis, on the other. He had a Morandi and he collected Guston. He owned work by de Kooning and Franz Kline, as well as by Johns and Rauschenberg and Pollock—the variety was just amazing. The fact that an artist was famous never kept him from buying something, but he also supported artists at the other end of the spectrum. He had some of the most obscene John Altoon drawings, and some exquisite Kenneth Price ceramics. Magritte did three nude figures that were separated into five parts: head, breasts, pubis, knees, and feet. The brunette is in the Menil Collection. The redhead was lost to the world—Jasper Johns had the breasts

and Rauschenberg had the knees, but the other parts were missing. Copley owned the blonde, and Ed bought it and hung it in his stairwell, so that you saw it bit by bit as you climbed the stairs. He had two Arshile Gorkys, and he also owned some strange antique paintings—a James Ensor and an early visionary work by an English artist who was in the Rosicrucian movement. Ed also collected chess sets, and he loved taxidermy and biological specimens. He made little tableaux around his house, sprinkling folk-art objects through the bookshelves. His sense of décor was tidy but genuinely eccentric. I don't know anyone who has lived more vigorously with his own collection.

In the end, there were only a few Californians I couldn't get him interested in—he bought Ed Moses and a good Ron Davis, but he just didn't take to Bengston and he wasn't keen on Pop. The two most interesting artists that we had on inventory at the gallery were Joseph Cornell and Bruce Conner. Ed bought all the movies that Conner had made up to that time. He got himself a projector, and whenever he had people to dinner he'd try to get them to watch Bruce Conner movies.

Janss traveled a lot and he often invited me to join him. He'd call me up and say, "Do you want to go to Venice for the weekend?" and he didn't mean Venice, California. Or we'd go down to Oaxaca, just to rest. He'd tell me to meet him on a street corner near the airport. I'd drive my Ford station wagon down there and park it, then he'd arrive in his pickup, wearing a sport jacket and a buttoned-down shirt, loafers, and unmatched socks. He always had a great wad of cash, which he used to buy tickets, and a little metal suitcase, about the size of a briefcase, for his clothes, plus a shopping bag full of books and magazines. And off we'd go. Most people can't afford to fly halfway around the world for a four-day sojourn, but he'd do it at the drop of a hat and he'd pay my way, too. On the plane we always talked about art. He'd bring a copy of *Artforum* or another art magazine, and he'd flip through it, asking me what I thought of whatever happened to be in it. He hated airline food, and he always traveled with a jar of peanut butter and some jelly and his own bread. He'd drink a couple of bourbons and make himself a peanut-butter-and-jelly sandwich and promise me we'd get a decent meal

when we got to where we were going. One time, when I wanted to talk to Janss about something, he was busy with work. He said, "Meet me—the usual routine—I'll be in my truck. I've got to go up to San Francisco, but we can take the shuttle and talk on the way up. I'll give you a ticket so you can turn around and come right back. It'll just take a couple of hours to fly up and a couple of hours to fly back. Can you spare the time?" So I flew up with him, we talked, and I got on the next shuttle and went right back.

Janss was an excellent pilot himself. Once, I flew down to the Palm Springs area with him to visit his brother, Bill—William—Janss, who was running the cattle end of the business there, and just to irritate Bill he buzzed the house in his airplane, terrifying everyone. It was hair-raising. But normally he was very careful. The first time I flew with him, he said, "Your job is to watch that whole sector of the sky." I said, "What am I watching for?" He said, "Planes coming at us. If you see anything that I might have missed, you let me know." So I watched, and eventually I said, "I think I see a little dot over there." He said, "Good. That's a plane." I said, "Is it coming toward us?" He said, "Yeah, but lucky for you, I know what to do."

We often went shopping for art together in New York. He'd give me a little warning and I'd line up some gallery visits. The first time we went, Leo Castelli arranged for us to visit Rauschenberg's studio, down on Pearl Street. All the Combines (works that incorporated found objects and media) were there—except *Monogram*, which was already at the Moderna Museet, in Stockholm—and Ed was knocked out by them. He said, "These are really terrific. Can we get a couple of these?" I said, "Ed, why don't you just get one?" I couldn't imagine that anyone seeing them for the first time would want to get two. Of course, I should have said yes. He said, "Well, which one do you think?" And I chose an untitled one from 1953–54—a four-sided work with a hen under a porch and a man in white buck shoes. It was shipped out to Conejo and he installed it in his house, and that, all of a sudden, made his collection. Then one day Janss came home from work and discovered that his wife, Virginia, had had some workmen come in and move the Rauschenberg into the garage. He called me up and told me that he was so disgusted he didn't want to fight about it, and asked if I could take the Combine to my flat. So I lived with that piece in my La Cienega apartment for a while. But it broke Ed's heart, and that was, I think, when

he decided that the marriage was over; from then on he referred to his wife as "Aunt Virginia."

Ed was trained in scuba diving, and he loved to do underwater photography. Eventually he bought two more Rauschenbergs, both of which had references to the sea. One was a color silk screen, about twelve feet wide, that dealt with the *Apollo 11* landing pod falling into the ocean. Rauschenberg was interested in the space program, and Ed snatched up the best of his works relating to that. The other piece was one of the strangest sculptures Rauschenberg ever made. In the seventies, he found a bleached, weathered plank that was curved—it was wider at the bottom than at the top—and it had a beautiful salt glaze on it from having been in the sea. It was about seven feet high, and suspended from a little thong attached to the top was a wooden rod, about three inches in diameter, that went down almost to the floor and was covered in a bright ultramarine silk. It was a simple piece of sculpture to pay a lot of money for—there was so little to it—but it was beautiful, and absolutely redolent of the sea. Ed loved it.

At one point, we headed back to New York in search of a Jasper Johns. Ed had acquired some Cliff Westermanns by then, and a gorgeous Sam Francis. Francis had moved to Santa Monica, and he and Ed had become friends. Sam was a very urbane man, with a great spirit and sense of humor. He was a Jungian, and he liked to talk metaphysics. Ed resisted that, but he absorbed a lot more than he'd let on. He and Sam made a deal over the painting he bought: if Ed died first, it'd be given back to Sam—and that was what happened, in the end. Now Ed decided that he wanted to consider a really major Jasper Johns painting. I said, "I know the one. He's been working on it for some time, and it's up in his apartment on Riverside Drive." That was where Jasper was living at the time, and I'd stayed there with him. "It's called *According to What*." So we flew into New York and headed over to Jasper's apartment. He wasn't there, but the doorman knew me. I didn't try to persuade him to let us into Jasper's place, but I said, "This man's got to see the painting up there. Can we get up onto his floor and go out on that balcony outside the big room? We'll look in through the window." So the doorman got us up to the balcony somehow and we peered in through the window at it.

Ed said, "That's really an interesting painting. Let Castelli know I'll

take it." We were heading back down when he said, "By the way, how much would that painting be?" "I think it's a hundred and fifty thousand or more." Ed said, "Would that be the highest price ever paid for a Johns?" I said, "I think so, up to now." He said, "That's all right. I can handle that." So he bought it. The painting was huge, and it was complicated to disassemble for shipping and then put back together. Ed made a stipulation that whenever that painting was borrowed for an exhibition I had to travel with it and be the person to supervise, in exchange for my transportation costs and a per diem. That gave me a chance to tour with the 1977 Johns retrospective, which was at the Whitney, then at the Whitechapel in London, the Wallraf-Richartz-Museum in Cologne, and on to Japan.

The next time Ed and I went to New York, we stopped in at the Leo Castelli Gallery while Leo was showing one of the great early Pollocks, a poured painting from 1947, which he'd bought from Jackson and held on to. Robert Rowan, the head of the board at the Pasadena Museum, who was my boss at the time, and his wife, Carolyn, were sitting in the back room, looking at the painting, and Rowan was negotiating to get it. I don't remember exactly what price Leo was asking; in today's world it seems ridiculously low—$350,000 or so. Rowan said, "Leo, can't you just come down some?" Leo said, "Bob, this is a very reasonable and fair price, a good price. You have to know that, and I can't come down." Rowan said, "Well, I've got some pre-Columbian objects. Can I throw them in? They're worth such and such." Leo said, "Bob, I don't deal in pre-Columbian objects."

This crazy haggling went on and on, and Carolyn, who was a wonderful person, was getting more and more embarrassed. Janss was just gnashing his teeth. He leaned over to me and asked, "Is that Pollock as good as I think it is?" I said, "Yeah." Ed fished around in his pocket and came up with a check—he just stuffed money and checks in his pants pockets. He wrote out the amount, signed it, and started walking toward Leo. Just then Rowan said, "Leo, I'll throw in my wife." And she burst into tears. Janss turned to me and said, "This is too grotesque. Let's get the fuck out of here." He tore up the check and dropped it in the wastebasket, and out we went. So he had to wait a few years to get his Pollock painting—a different one.

In the meantime, I was just desperate for someone to buy the Pollock

that Rowan had wanted. At some point, I called up Norton Simon. Whoever answered put Norton right on the phone, and I mentioned this great Jackson Pollock painting. There was a terrible noise and the phone was disconnected. I said to Irving, "I guess that one didn't go anywhere." Later, I heard from Sadye Moss, who'd heard it from Lucille Simon, that Norton had been at dinner and was so taken aback by the idea of buying a Pollock that mashed potatoes shot right out of his nose. He hated the idea. It became a multimillion-dollar painting, and it was selling for just a few hundred thousand then, the price of a good drawing today. In the end, Taft Schreiber, the MCA executive, bought the painting and hung it over the sofa in his living room. After he and his wife died, it was donated to the Museum of Contemporary Art in L.A.

I also introduced Janss to the world of Berman and George Herms. Ed slipped them money and bought their work. He had set up a special foundation to buy art beyond what he could keep at home; he'd buy it through the foundation and then give it away to museums. There's a great George Herms sculpture in the Menil Collection, *Greet the Circus with a Smile*, which Ed's foundation bought and donated, and he bought some sculptural objects from Berman—rocks with Hebraic lettering, which are quite rare. He also bought a terrific early Bruce Nauman from me so that I could fix up my house; he later gave it to the Menil. And he bought Kienholz's 1959 sculpture of me, *Walter Hopps Hopps Hopps*.

At some point, Ed decided that he wanted to buy a Klimt or a Schiele, and he thought maybe we could find something in Vienna. He booked us into the Imperial Hotel, where, it turned out, we stayed in the suite that Hitler had lived in. That was the first time I ever saw a bathroom with heated towel racks. We didn't find a Schiele or a Klimt—they'd all been swept up and sold to other places—but the city was fascinating. From there, we flew up to London, where we found two great works. At the Marlborough gallery, Janss saw Francis Bacon's "Van Gogh" paintings and loved them so much that he bought one on the spot. Then we went to the Hanover Gallery, which was run by a woman called Erica Brausen, and Ed bought the extraordinary

Richard Hamilton 1956 collage work *Just what is it that makes today's homes so different, so appealing?*

On one of our trips, Ed and I were flying from New York to England, when the pilot discovered a problem with the plane. We had to make an emergency landing in Dublin. They let us get off the plane and walk around while the plane was being worked on. I was out there on the tarmac, and the next thing I knew I was waking up on the plane with a terrible headache. I'd passed out. Ed was sitting next to me, and he'd called ahead to have a doctor meet us at our hotel in London. I was still sort of shaky when we got there, but the doctor examined me and found nothing wrong. I took a warm bath and went to bed and the next day I was fine. I was still seeing my Jungian analyst, Dr. Alex, at the time. I talked to him when I got back, and he said, "Do you have any Irish ancestors?" I said, "Yes, a lot." And that meant something to him. A Freudian would never have asked that, but a Jungian would. He said, "Perhaps you were haunted—you had a spirit come over you."

Ed and I went to Venice together a couple of times: once for Christmas— Ed couldn't stand being at home for the holidays—and then for the Venice Biennale in 1964. It was curated that year by Alan Solomon, who had been the director of the Jewish Museum in New York and had put together the first retrospectives of Rauschenberg and Johns, at a time when the Whitney and the Modern were simply not touching these people. For the Biennale, Solomon had brought over work by Rauschenberg and Johns, as well as Morris Louis and Kenneth Noland. He also had a small amount of work by Claes Oldenburg, Jim Dine, and Frank Stella. I think that was the first Pop-oriented work in any Biennale. There was a John Cage and Merce Cunningham performance, which didn't thrill Ed, though he dutifully attended. While we were there, the director Michelangelo Antonioni, whose films I just adored, showed up with his actress Monica Vitti. Antonioni loved Morandi's work—in his early black-and-white films, set in strange, bland apartment houses, you can often see a Morandi painting on the wall, and it fits the aesthetic perfectly. At the Biennale, he was very taken with these white stuffed works by Claes Oldenburg, and he invited Oldenburg to do the décor for an experimental film he was planning. We were all shocked when Oldenburg said no. He had no idea who Antonioni was or

what an interesting project it could have been. Ed and I were thrilled when Rauschenberg won the grand prize. His works were in a pavilion on the island, and, when the news came that he'd won, they couldn't get a vaporetto to come over, so he had to carry one of his paintings back to the mainland in a gondola for the ceremony.

In 1965 or so, Ed and I took a long trip through Europe. By then his marriage to Virginia was falling apart, and he'd fallen in love with a younger woman, Ann Howe, whom he'd met while skiing in Aspen. He decided to take a last trip with Virginia before ending their relationship, and he invited me to join them. We started off in Paris, at the old Meurice Hotel, where Ed arranged for one of the chefs at Lapérouse to come and cook for us. I was separated from Shirley by then, and I had two different girlfriends: Eve Babitz and Beverly René. Ed asked me if I'd mind if Ann addressed her letters for him to me while we were traveling so that Virginia wouldn't see them and be suspicious. I remember Virginia saying, "My, Walter, you certainly get a lot of mail. You must be popular!" It was a sad but beautiful trip. From Paris, we went to Florence and Milan, and Virginia would look at cathedrals while Ed and I went around looking at art; we'd meet up in the evenings and eat superb dinners. In Milan, we went to Beatrice Monti della Corte's gallery and Ed bought a nude woman by Yves Klein, who was dead by then. Ed and I also went to the studio of Lucio Fontana, one of the artists who had supported Klein. He was a grand old man by then. He'd lived in Paris and Argentina, and he'd gone through several phases in his art, but in his old age he was doing monochromes with slashes. At his studio, there were racks of monochromes that went on forever—thirty-five or forty feet—all organized by color. We were polite and we looked through them all, but it just appalled Ed. He said, "Don't you think this man is a little oversupplied?"

After that trip, Ed let Virginia know that it was all over. She eventually married a doctor and, I think, moved to La Jolla. Ed moved in with Ann. First he lived at the Chateau Marmont, and then down in Marina del Rey, in a little condominium near where his boat was anchored. Then they got a big apartment on Wilshire. He could have lived anywhere, but he lived very modestly. The Janss family mansion was still in Holmby Hills, but he never chose to live there. Eventually he decided to build a place for himself, on Purdue Avenue in West L.A., in a neighborhood of Japanese gardeners. He

drew up some simple plans for a house, and then he commissioned an unknown Southern California architect to clean up the drawings so that they'd pass code. The architect was Frank Gehry, but Gehry never put the house in his portfolio, because it was really an Ed Janss design. It was plain as a stick from the outside, white stucco, but the inside was airy, open-plan, leading to an exquisite Japanese garden, with a fishpond and a waterfall and so on.

In 1989, when he was seventy-four years old, Ed had a stroke. It devastated him physically, and one morning he tried to take his own life. Ann was out playing tennis, I believe, and he took some pills. But someone got into the house and rushed him to the hospital and saved his life. He told his former son-in-law, the gallerist Jim Corcoran, that he couldn't play chess anymore, he couldn't play gin rummy, and he just didn't want to live that way. One day, after he came home from the hospital, he got himself in his car and drove down to his doctor's office, which was on the twelfth floor of a building in Santa Monica. There was a window at the office, which looked over the back alley, and Ed chose to jump out of that window, where no one would see the mess and he wouldn't hurt anyone who was passing by.

I was in New York at the time and, when I called in to check how he was doing, I got the word. I went numb. It was as big a loss to me as when my mother died. Kienholz was in Düsseldorf, getting ready for a show at the Städtische Kunsthalle, and I called him to say that I was coming over for the opening. I had some money and a credit card, and I got on a flight. We went to the opening, had some kind of post-opening dinner of bratwurst and so on, then we went back to the director's office at the museum to talk, and I told Kienholz what had happened. He was very upset—he was close to Janss, too. That was the end of Ed Janss. He'd arranged for his collection to be auctioned off after he died, and Jim Corcoran dealt with it, along with Ann, who kept a fair number of things for herself.

10.

FRANK STELLA AND ANDY WARHOL

Toward the end of the fifties, the art world had begun to divide. Abstract Expressionism was still alive and well, but some of the new artists were starting to look for different ways to proceed. Rauschenberg emerged, inspiring two of his contemporaries, Johns and Twombly. And then we began to encounter the next wave: a new form of image-based art that would eventually be called Pop, and a new era of abstraction. While looking for artists to show at the Ferus Gallery, Blum and I had met an art dealer named David Herbert, who had worked for the Poindexter Gallery and Betty Parsons and Sidney Janis and was setting up his own gallery in New York. To save money on one of our trips, in 1960, Irving and I stayed at Herbert's apartment in Manhattan; afterward Herbert complained bitterly that Irving had hung his socks on a Louise Nevelson sculpture, to air out overnight. Herbert was handling Nevelson at the time. The Nevelson work in the first show at Ferus II had come through him. In fact, I took two from Herbert for the show, but my car was broken into and one was stolen; it was probably trashed—it was in a crate, a beautiful unique piece, and I had paid real money for it. But the other one survived and it was sold to Joseph Hirshhorn. (Hirshhorn did a lot of art shopping in L.A., because his daughter lived there, and he'd always try to chisel you on prices. On La Cienega, the galleries had a regular price list and a Joe price list. Dealers would call one another when he popped up, so that they could quickly set higher prices, because they knew he'd try to argue them down or say, "If you sell it for a quarter of what you've got on that damn price list, I'll buy half the show.")

Herbert was charming and lively, and he knew the whole scene. He was also representing an imagist artist called Stephen Greene, whose work I knew from art magazines back in the forties and fifties. After the war, he'd painted some dark, lumpy, bodylike things, missing arms and legs, a kind of

grotesque Philip Pearlstein. Now he had moved into Abstract Expressionism. Irving had never heard of Greene and he couldn't have cared less, but I made an appointment to meet him at the Art Students League. He was an intense, nervous kind of man, surprised to see that I was younger than he was, but we hit it off, and I explained to him what we were up to. I took several of his drawings on consignment; I liked the work and I liked him. While we were talking, he told me that he'd been privately teaching a grad-uate student from Princeton called Frank Stella. He said, "He's very bright and he's very shy and nothing's happened with him yet, but I know it will. He has a studio in New York now, and I bet you'd be interested in what he's doing. I'm not sure I understand it myself, but I think you should see it." The Museum of Modern Art show "Sixteen Americans" hadn't happened yet, and Stella wasn't yet with Castelli—no one had ever heard of him. But, on the strength of Greene's recommendation, I went to meet Stella at his studio.

It was a first-floor entrance, and, when I walked in, the room was pitch-black. At first I couldn't make out the paintings, but I could see a spotlit piece of crumpled paper on the wall. It was a page torn out of an art magazine, with a color reproduction of a de Kooning on it; it had been wadded up and then semi-flattened out, and one big vicious nail was driven through it, attaching it to the wall. I was sort of taken aback. I turned to Stella, who was a short, dark, curly-haired young man with very intense eyes and an ironic sort of smile, and said, "I take it you don't really care for de Kooning's painting?" He said, "On the contrary—he's a great artist. But I want a reminder in this studio of what I must not do." What he was doing were the extraordinary black paintings, bands of strange, greasy black paint that sat on the surface, rather than soaking in, not allowing any depth, and little unpainted areas between the bands. The paint was very palpable and objective; there was no real texture or impasto to it, but it had a material presence. It was totally unlike the paint surface on a Rothko, where there are washes and layers, and it was different from the black on a Franz Kline, less material; it had matter but it was a different kind of matter. You can see the strokes on a Franz Kline. But the gestural quality of the application was not essential to Stella. The symmetry of it all, of course, was astounding.

In 1953, when I was in the Army, I'd had a time of very vivid dreams,

Frank Stella in his studio, from "The Secret World of Frank Stella," 1958–61. Photograph by Hollis Frampton.

and one of my dreams was of the black Frank Stella paintings, including the bands. They were so strange that when I woke up I drew them so that I'd remember them, and I kept that drawing. That was what really struck me when I saw the Stellas—I had seen them six years earlier, before Frank had made them. He was still painting like Richard Diebenkorn in those days.

Stella and I became friends, and we showed him at Ferus—some works that came a little later than the black paintings. But we took one black painting for our inventory, and we sold it much too early. Frank sold me a copper painting very cheaply—so cheaply that we made a deal that, if he ever wanted it back, I'd have to sell it back to him.

Socially, Stella was practically mute, he was so shy, but, when you were with him one-on-one or in a small group, he was very smart. And I believe that he was the greatest abstract painter since the era of Pollock, de Kooning, and Newman. He had a great appreciation for Newman's works; he saw them as complicated and gorgeous and full of subtlety. He also loved David Smith's work, and I think it ultimately had an effect on his own. He often saw colors out in the world and knew that he needed to use them. I asked him once about a green that he was using and he said, "It's U.S. Post Office city-mailbox green." He didn't mean that the work had anything to do with a mailbox, but he'd seen that color out in the world and he liked it. Stella may have been taciturn, but he had a sly sense of humor, too. Once, I was in his studio when someone asked him why he didn't make paintings about

what was going on in the world—why hadn't he painted something to protest the Vietnam War? And he pointed at a painting he was doing in a sort of sickly green and said, "Look at that one. It's Mekong Delta green. Isn't that enough?"

He also knew how to keep evolving. At one point, he kept a kind of notebook in which he sketched out everything he needed to do for the rest of his career—he understood the visual logic of what he was up to. I saw pages from it in the late sixties. He said, "I'll have a great career and I'll be known as a great artist. All I have to do is what's in this notebook." But what was interesting was that the notebook didn't include any of the wild things to come—those freeform, painted-metal extravaganzas. One day he just decided to turn his plans inside out and go the other way as well.

David Herbert's other recommendation was Andy Warhol. Both Blum and I had heard of Warhol. He had graduated from the Carnegie Institute in Pittsburgh and moved to New York, where he was a roommate of Philip Pearlstein's, and he'd been showing surprising illustrative work at the Gotham Book Mart, which handled Surrealist and Dadaist literature and occasionally put art on display in the front window. He'd found work in commercial illustration and design—drawing for *Harper's Bazaar* and doing ad work and so on—but he wasn't with a gallery yet, so in 1961 we decided to go and meet him. We went to the townhouse where he lived and worked on upper Lexington. He buzzed us in and we climbed the stairs to the first landing, where we found all kinds of strange things and Americana he'd collected in thrift shops and elsewhere—big enamel signs from gas stations, gumball machines, a barber chair, and the pole from outside a barbershop with its red-and-white spiral. Andy met us at the door and ushered us in. He was a quiet guy with an ethereal look, so pale that he looked as if he lived in the dark.

We went into a huge room, like a meeting hall; at the far end, there was a stage. The floor was awash with art magazines, fashion magazines, and fanzines, an endless sea of imagery, and you practically couldn't walk without slipping on something. There were some large easels set up on the stage and several paintings on view: *Telephone*, I think, and *Dick Tracy and*

Sam Ketchum. Some of the paintings were in black-and-white and very neatly painted, with hard edges. Some were more expressionistic. There was the painting of Superman in full color, blowing out a fire. There was *Icebox,* with some odd food in it. (Warhol had a strange attitude toward food, and he had a terrible diet. He starved himself when he went to parties. He couldn't bear to be in a social situation and eat at the same time. He went on record saying that eating was like pissing and shitting; it was shameful and he couldn't do it in front of other people. He once said that he'd like to open a special restaurant where everyone would eat alone in a private booth. I said, "Wouldn't it be lonely?" He said, "Oh, no. I'd have a television set in there, so you could watch television.")

Alice B. Toklas said that when she was in the presence of genius a bell would ring in her head. A little bell rang that afternoon in Andy's studio. He was just a natural. I'd never seen any paintings quite like these. There was no such thing as Pop Art yet; none of that had come out. Once it did, you could see it prefigured in work that Rauschenberg and Johns had been making. You could see, on the West Coast, how certain things by Berman and Kienholz had also anticipated what was to come. But something new was going on in Warhol's studio, and both of us were fascinated. I asked if there were any other works, and he brought out one that I have never seen since. It was beautifully, precisely painted, about a six-foot square on nice linen, and he rolled it out on the floor. It was Superman shooting through the air, holding Lois Lane in his arms. As far as I know, that painting has never appeared anywhere; I don't know what happened to it. (I suspect that Warhol dropped comic-strip characters from his work when he found out Roy Lichtenstein was using them.)

What was interesting about Warhol that day was that he talked more and asked more questions than I ever heard him do later. This was the time in his life when he had the most to say. He asked if I knew Rauschenberg or Johns, and we talked about the two of them. Did I think they were any good? Yes, I did. But did I think they were *really* good? He talked like a very young person. Yes, I thought they were terrific. What pictures had I seen? The flags and the targets and other things. He'd seen them at the Castelli Gallery. He visited galleries and museums a great deal. Later, when he had money, he collected everything, not just art. I was at his house once, during

the time of the second Factory, and the dining room was full of shopping bags: he'd go on expeditions for collectibles, Fiestaware, cookie jars, clothing, and it was all just sitting there, waiting to be unpacked.

After we'd looked at the work, Andy took us down to the lower floor of the building, where we met an old woman he introduced as his mother. And he gave me one of his little books, 25 *Cats Name Sam and One Blue Pussy*, which he autographed. We discussed the idea of showing his work at Ferus. He said, "Where is the Ferus Gallery exactly?" Irving said, "It's in West Hollywood." Of course, the idea of Hollywood appealed enormously to Andy. So we agreed to keep in touch and see what came along. And what came along, in 1962, were the thirty-two original *Campbell's Soup Cans*, which were part stenciled, part hand-painted. When I first saw them, I thought of the wonderful stylization that went on in the paintings of Stuart Davis, whose work I'd always admired. I remember asking Andy how he'd describe the paintings. He gave me a funny smile and he said, "I think they're portraits, don't you?" It was an interesting, ambiguous answer—as though he didn't distinguish between people and things.

We made a spectacular announcement for that show. I loved the way Castelli did his folded-poster announcements, so for the Warhol show we used eight-and-a-half-by-eleven-inch stock and printed one of the soup cans on it; those are collectors' items now. And Irving had an interesting idea for the installation: he made little one-by-two-inch planks, neatly painted white, and set them as shelves that ran across the gallery; the paintings were spaced evenly along the shelf, sitting there like real soup cans in a supermarket. Very simple and very stark. We'd both thought that the show would be a sensation, but it was ridiculed in the press. The *L.A. Times* even ran an op-ed cartoon in which some scruffy-looking fake Beatnik characters—totally inappropriate, since that wasn't Warhol's world at all—are looking at the show, and one says, "Frankly, the cream of asparagus does nothing for me, but the terrifying intensity of the chicken noodle gives me a real Zen feeling."

The paintings were very reasonably priced at a hundred dollars each. I was guest-curating at the Pasadena Art Museum by the time the show went up. I still had my stock in the gallery, but I wasn't there on a daily basis anymore, so I'd call Irving up to see how it was going. He told me that nothing was selling—he'd sold only one painting and put four on hold. One of the

Installation view, Campbell's Soup Cans, *Ferus Gallery, 1962. Photograph by* Seymour Rosen.

ones on hold was for Dennis Hopper, who really loved Pop Art. Irving was crushed. "It's a disaster," he said. I said, "Well, I have an idea. Can you give back the money on the one you sold and cancel the sale on the other four?" He said, "Wow. That's a great idea. Then I've got nothing!" I said, "Here's the deal. Why don't you tell Andy that you've decided to buy the entire set? You can negotiate a price for the group and ask for some time to pay it off." I said, "Talk to Andy. See if you can't come to a deal. You won't regret it."

So that's exactly what he did. Warhol bought it like a hungry trout; the idea of keeping all the paintings together really appealed to him. Irving paid almost nothing—a thousand dollars, a hundred dollars a month for ten months—to buy the set of thirty-two, then he hired carpenters to come in and make a false wall and he sealed them in. That way he knew he wouldn't be tempted to sell one of them individually, just to make money. In 1996, he sold them to the Museum of Modern Art for $15 million.

For me, the three major figures in American Pop Art were Warhol, Lichtenstein, and James Rosenquist. Lichtenstein was more of a narrative artist. Rosenquist was very much a visual poet. Sometimes his poems were

epic—vast in subject or in scale—but they were still poems, not narrative. With Warhol, it was just the icon presented—no story. Perhaps that had to do with his having grown up in the Orthodox Church. I kept in touch with Warhol over the years and visited his studio in New York on any number of occasions. He was pleased by my interest in his work and he gave me small things, including a wonderful Verifax print, a crazy-looking self-portrait. He also made one of his video portraits of me. One time I was visiting his studio—I was in a summer suit and tie and I picked up a hammer and was balancing it on my finger. Warhol arranged to have a film done of me dancing with that hammer on my finger. But the main thing he gave me was *Orange Car Crash* image, about a thirty-inch square. Sadly, I was sued later, and I had to sell it to pay my legal bills. I hated having to give that up.

I also went to the Factory, the first one, the second, and the third. I remember feeling very tired at the Factory one time. I needed to sit down, and the only place I could find to sit was a rolled-up rug. There was a party going on, and it was very crowded. Everyone was doing drugs. So I sat down on that rolled-up rug, and all of a sudden it started squirming. I realized that someone, wasted, had rolled himself up in the rug, and I was sitting on him. The Factory parties were really something else. They were blatantly terrific or terrifically blatant, depending on how you looked at it. Everyone was there to be seen; there was not the slightest pretense about being there to have fun or to have any intelligible exchange with anyone.

But Andy and I talked a lot about art. He was very interested in Man Ray—not just his photographs but the sculpture and the painting, too. He owned a big abstract painting by Man Ray, an unusual one. We talked about movies as well, and I helped introduce him to Dennis Hopper and other people in that world. I think he liked movies more than music, although he went to clubs and so on. And I introduced him to Jean Stein, who became very involved with him when she was working on her book on Edie Sedgwick.

I followed Andy's career from the beginning all the way through, and I think of him as our great icon painter. In the eighties, I was able to see a very early work of his. I was in Memphis, Tennessee, visiting the photographer William Eggleston, and one night after dinner he said that there was a little soiree he wanted to go to. So we went to a house in a respectable part of Memphis. There were young people there getting wasted, and Eggleston

immediately joined in. I wasn't in the mood to drink and take quaaludes, but I met a nice young woman—it was her parents' house—and she took pity on me. She said, "I hear you work in a museum. My father has something I bet you'd like to see." I said, "What's that?" She said, "Well, he went to college with Andy Warhol, and we have this really early painting." So there I was in the middle of a stupefaction night in Memphis, looking at one of the earliest surviving Warhols. It was interesting—some figurative people on a porch. A cleanly done, competent representational painting that you wouldn't associate with Warhol or Pop unless you knew how neatly he could work.

But by the seventies there were two clear poles in his art: on the one hand, there were the portraits of specific people—Marilyn Monroe, Elizabeth Taylor, Elvis Presley, and so on. All of those paintings have a certain currency because of the subject matter, and because he found a wide variety of ways of presenting them. And, on the other hand, he did some very fascinating, more abstract work. He made more than a hundred paintings of shadows, of different sizes. He also made a series of Rorschach patterns. And then there were the oxidation piss paintings: Warhol would coat a canvas with wet copper paint and literally use urine to oxidize it, splashing it in different kinds of patterns.

I never met another artist who was so good, aesthetically and historically, and yet so acutely engaged with disengagement. That was a very curious thing about Warhol: he drained the juice out of any sort of existential confrontation. But whatever American Pop Art was, Warhol embodied it more than any other figure; no one was more central than Andy, in his choice of subjects, in his manner of making the work, and in his take on consumer culture. He left the modernist traditions behind and opened the door to the postmodern generation.

11.

EDWARD KIENHOLZ

In 1959, not long after Thomas Leavitt became the director of the Pasadena Art Museum, I began doing freelance work there. Leavitt was a young Harvard Ph.D., a quiet, terrific man, fully professional in his way. I went to the museum one day and introduced myself to him and we immediately hit it off. He was interested in what I'd been up to, and he invited me to collaborate with him on a few things.

In 1961, I curated the first museum show of Ed Kienholz's work—tough assemblage imagism, including some of the particularly controversial early pieces. We had a hell of a work, titled *They Took the Boss and Tied Him to a Cross* (1961). Kienholz was a hunter, but he loved and had great respect for animals. He'd found an old bearskin rug—the kind with the head still attached, teeth bared—and he posed it in an anthropomorphic position against a Christian-style cross, so that the head of the bear was where Christ's head would have been and so on, and lashed it tightly to the wood with leather straps. The cross was leaning at about a forty-five-degree angle, so that it looked like a kind of torture rack. Ed sawed off the top of the bear's head, just above the eyes, leaving a sort of hollow, bowl-like shape where the brain had been. He filled the skull pan with a bunch of walnuts that he'd painted gold—he thought they looked like little brains. There was also a work called *A Bad Cop (Lt. Carter)* (1961): Lieutenant Carter, the bad cop, had a police-band radio inside him, which gave off staticky police calls and so on. We showed a piece that Irving Blum later destroyed. It was in storage at Ferus and, before Ed could recover it, Irving had it hauled away in a Dumpster; the installation views of the Pasadena show are the only record of it now. It was the rear end of an automobile, without the tires, but with the trunk open and filled with lollipops. There was one piece I don't know how we got away with. Most people living in Southern California

then were aware that Walt Disney, the beloved cartoonist, also happened to be a terrible bigot: Mickey was a white mouse in blackface; Donald Duck, the noisy, pushy, bad-tempered character, was a caricature of a Jew; and so on. Kienholz took a piece of sheepskin and stretched it out like a canvas— maybe three feet by five—and he sheared off the outline of Mickey Mouse's head. A kind of smiling, leering Mickey, which he painted in, like a cartoon, and titled *Mickey Mouse as a Spade* (1961). Ed later destroyed that work himself. (I know of only one other work that Ed finally found so offensive he had to destroy it. Once I was in his studio behind Ferus, and he showed me something he'd made: it was one of those big, lifelike baby dolls, about eighteen or twenty inches high, with legs and arms and blond hair. He had taken his hunting knife and slashed it between the legs to create a vagina, and then he had buried a nasty-looking rubber rat up to its hips in the orifice. He asked me, "What do you think of this?" I said, "Jesus, that's horrendous." He nodded and said, "I think it's just too terrible," and he took a hatchet and chopped the thing to pieces right before my eyes.)

Kienholz's childhood played a big role in the way his art developed. He was born in 1927, into a close-knit Swiss-American ranching family, and grew up on the family farm, about forty miles from Spokane, Washington. Being born in 1927 meant that he, at a sentient age, experienced the full effects of the Depression in the United States. He also experienced the four crucial wars in American history. He had relatives serving overseas in the Second World War, and caught the full aftermath of that. He saw America, after its great victories in Europe and Japan, descend into the Korean War; by that time he was of an age to be drafted, but, although he never shrank from violence or confrontation, he took a pacifist position and dodged the draft. He worked in a mental hospital instead, an asylum, where he learned all sorts of brutal things about humanity. He always considered it quite a feat to have outwitted the FBI. He lived, of course, through the Vietnam War. And he was subject, from his formative years on, to the Cold War, which was, in some ways, the biggest of all four.

Kienholz's family was very hierarchical. His parents were serious, sober Protestant workaholics. His mother was a wonderful but nervous and frail

woman who cared very much about her family. She was constantly busy and she kind of wore herself out. The father was a very sober, intelligent rancher who had aspirations for Ed to become a doctor. Ed was intelligent enough, the only male child in the family, and they were always pushing him not to become a slave of the land. I suspect that the mother may also have had some secret desire to see him become a minister. But Ed tended to regard most organized religion as a fraud. He had a kind of native intellectual streak in him, but the idea of spirituality was not there.

Because he was a husky, bright child, farmwork started early for him. He developed the skills in mechanics and carpentry that would inform his art all his life, and that taught him a kind of resourcefulness in solving problems. In Ed there was always a curious mixture of the liberalism of FDR, who aided the farmers and small landowners in that era, the more anarchistic self-reliance of John Wayne, and the pragmatism of John Dewey. Like many people who owned their land and were able to grow their own food, Ed's family did pretty well during the Depression, bartering and conserving what little money was flowing around. Trading and bartering became native to Kienholz's nature. Even at the very end of his life, he preferred trading an artwork for a new Mercedes to paying cash for it. Small watercolors and so on were good for buying hand tools. In fact, he invented a kind of conceptual art where the watercolors he was painting were, in effect, stock certificates. He made a whole series to use as small bills. In the center of a nice abstract background, he'd paint "for $5." Before he died, to help his wife raise money, he ran those watercolors up into the very high denominations. He did one that says "for $10,000." But he figured that the most ubiquitous, useful bill was a twenty, so there are lots of twenties. Then, later, the people who owned them could sell them for whatever the market brought.

The people in Ed's community were not people who liked to buy on time, and they didn't like to take out bank loans, because they didn't really trust the banks. Ed didn't, either; he'd seen so many people lose their land and their possessions during the Depression, because they couldn't stand up to the bank, and he had a real terror of being taken advantage of by big companies. He liked to pay off any serious debt with cash on the barrelhead—no

fooling around with a check. There were times when he actually went to the bank, pulled out ten thousand dollars in cash, and briefcased it over to someone he owed it to. This could be disconcerting in modern times. He liked to repeat a funny saying from his part of the country: "What are the three biggest lies? The check's in the mail, my pickup truck is paid for, and I don't have a mortgage."

Part of the John Wayne side of Kienholz was that he believed in being armed. It was the Western tradition. The ethic was that, if you owned land and had paid for it and worked it and gone about your business in an honorable way, nobody should be allowed to fool with you. You fought the government when you had to, whether it was a matter of taxes on your land or the game warden. People who owned their own land out West tended to believe that the game that lived on it and fed off it belonged to them. So they would regularly hunt deer, ducks, and other birds on their own land, regardless of what the seasons or the game laws were. Interestingly enough, Kienholz had a good streak of conservation in him, too. He knew firsthand what could be lost.

Sometimes I went deer hunting with him. I carried a rifle but I certainly didn't shoot a deer. I didn't want to. He thought that was sort of sissy of me, but he admired the fact that I would at least come out with him—getting up in the wee hours of the morning and sitting through it. In an odd way, he also respected my reluctance to shoot an animal. Of course, he chided me when I had no compunctions about enjoying a great meal of venison. He'd say, "Aren't you glad that I, at least, am able to shoot this game so that we can eat it?" I'd say, "Your efforts to provide food for all of us are more than enough. For your family, mine, and several others," which was true.

The last time we were out hunting together, in the mountains above Bakersfield, near Tehachapi, we were walking when he suddenly whispered, "Freeze!" I froze in my tracks, staring at him. I watched his head slowly move up and that was a cue for me to look up. There was a squadron of giant condors soaring overhead. It made the hair stand up on my head—it was thrilling beyond belief. I knew that I was seeing something extraordinary

that I would never again see in my life. And that turned out to be the case. The condors are all but extinct now. They've managed to breed some in captivity and reintroduce a few into that part of the world. But, for Kienholz, seeing them was as close as he got to having a religious experience.

Ed's interest in art began early on, and he knew somewhere in his heart that he was going to end up being at odds with his father over it. His mother was the one who was most sensitive to his art, who saved his childhood work and so on, and when he made a tableau about her later he used a lot of that childhood paraphernalia in a room he made for her. He went to a good high school in Fairfield, Washington, where he studied art to the extent that it was taught there, and he learned drafting as well. He was a natural at it. When he began making art, he did some drawing and painting, but he soon realized that what he wanted to do could really only be done through sculpture. Drawing for him was a practical matter, rather than an aesthetic one. Diagrams and schemes and blueprints were conceptual plans for the real work. He rarely showed them as works of art in themselves.

After high school, he made a couple of attempts to enroll in an art school or in college, but they didn't stick. He was on the run from the draft, and he was more interested in learning what was going on in the world—which meant going on the road through most of the western half of the United States. He was very keen not to take money from his parents. And he was resourceful. So, like Joseph Cornell, another exceptional assemblage artist of the twentieth century, he ended up being almost wholly self-taught. Kienholz was relatively well-read, and he had strong reactions to what he read. He was very interested in Edgar Allan Poe and the dark side of American Romanticism in Poe's work. And at the other end of the spectrum was Mark Twain—he fell for the robust vernacular quality of Twain's realism. You see both of those qualities in Kienholz's work—Poe's creepy darkness and Twain's bawdy humor.

In his travels, I think he got as far east as Nebraska. He developed a crazy mythology about a nowhere place called Pender, Nebraska, which he must have passed through in his travels. At some point, he ended up in Las Vegas. He was a good gambler, terrific with numbers, and he tried to get a

job running a blackjack game, but instead he was hired by a small-time club to remodel its interiors. So, until he got restless and moved on, he worked as a contractor in Nevada. There may also have been a brief marriage at that point—he apparently got a woman pregnant and figured that the honorable thing to do was to marry her. It didn't last, and I have no idea what became of that woman or that possible child.

He passed through Los Angeles sometime around 1950 and then traveled on down to El Paso, Texas, right on the Mexican border, where he set up his studio in a storefront. El Paso—hot, parched, windswept, rocky, rugged, practically treeless—was about as different a physical environment from the Pacific Northwest as you can get and still be in the U.S. The very name of the place—"the pass"—contradicts the idea of anyone settling there. On the other side of the border was Juárez, a rough-and-tumble town that made Tijuana look like heaven. But I think that it was important for Kienholz to feel that he could handle himself on his own in a place far from the nurturing environment of home. He earned some money doing odd jobs, the start of a pattern that held for the rest of his life: get in, get paid, get out, never sign on for the long term.

Also in El Paso was a very fine Depression-era artist called Tom Lea, who had gone through the Art Students League in New York; he was a well-trained artist of the Thomas Hart Benton era and a natural in his own right. He made imagist murals in a very Western vein—horses, animals, mountains, and so on. Kienholz invited Lea over to his studio to see what he was doing. Lea looked at everything very seriously, and at the end he said, "Young man, I've got to tell you: you've got to leave El Paso." Ed was discouraged, but Lea explained, "I'm not criticizing you. It's just the opposite. For what you're up to here and what it's going to lead to, you need to be in New York or Los Angeles as soon as you can. You're not going to be understood around here." It was remarkable advice.

For someone as Western as Ed, going to New York was unthinkable. What he always said about the East Coast cities was "How can you live in a place where you can't just walk out of your house and take a piss in the backyard?" So he chose Los Angeles, and by the fall of 1952 he was settled into a place in the San Fernando Valley, which felt less cityish to him than central L.A. Once he got the lay of the land, he moved to Santa Monica

Boulevard, an unpretentious blue-collar area below Hollywood, where he could get the kind of work he wanted and live cheaply. He loved living off what other people threw away. He said that he could furnish an entire house with the furniture people threw out. It was a pragmatic mode of survival; he was like the European Gypsies who live on the fringes of cities and scavenge. It also enabled him to find the kinds of materials that would end up in his art.

Ed was a sizable man who looked like a rugged, meaner version of Burl Ives: long hair, bearded—you could easily mistake him for an outdoorsman or a ranch foreman. He had a sly, decisive way of taking charge of any situation he found himself in; he was a natural leader. And he took it for granted that in our era, if you wanted to be an artist, you had to earn a living in other ways, so he became a kind of handyman. He bought a pickup truck, and on the side of it he painted his name, his phone number, and the word "Expert." To make money, he'd drive around town in the mornings and park the truck in fairly prosperous neighborhoods. People would come out of their homes and say, "What are you an expert in?" He'd say, "Well, what's your problem?" They'd say, "We have a plumbing issue we can just never fix." And Ed would say, "I can handle that. I charge so much an hour and I can take care of it right now." He did good work. He had every kind of tool. He also knew cars. He carried a stack of business cards with him, and he would wander around various neighborhoods looking for problem cars. He'd write a note on a card saying, "I'll pay you X amount of cash for this rolling piece of junk. Call Ed," then he'd wait for the calls to come in. He'd buy the car for cash, then take it to one of the used-car agencies he knew and sell it for a profit. When he was really desperate for money, he'd go to a used-car lot somewhere far from where he lived and act knowledgeable and interested, as if he really wanted to buy that prewar Chevy or whatever was there, and take it for a little test drive around the block. Once he was away from the lot, he'd open up the trunk and take out the spare tire and stash it somewhere. Then he'd go back to the lot and say, "No, this isn't the car for me," and he'd make a little cash selling the tire at a junkyard on the other side of town. He was just scrounging around. But he lived very simply in those days.

Even in his art, Ed was a fix-it man, a *bricoleur*. He was probably the

first and most prominent artist to bring all the various physical skills necessary for farm life to bear on his work. He saw no practical reason that any of the techniques he was using professionally—plumbing, woodwork, metalworking, and so on—shouldn't also be used in his art. In fact, he took a certain perverse satisfaction in using proletarian techniques for things that were aimed at the higher realms. He was never directly influenced by the Dadaists, but he had some of the same tinker spirit. Duchamp also thought that it was too limiting for an artist to restrict himself to paint. He used an old French expression: "dumb as a painter." The interesting irony was that Duchamp was actually a beautiful painter. Even Kienholz had a great command over the painted passages in his work, but one never thinks of that. (Incidentally, when I talked to Duchamp about Kienholz once, he actually leaned back, laughed, slapped his hands on the table, and said, "Marvelously vulgar artist. Marvelously vulgar. I love the work by that vulgar Californian.")

When Ed got to L.A. there was one artist living there whom he wanted to meet: Man Ray. The sad part is that by the time Kienholz got his feet on the ground and a car to run around in, it was 1953, and Man Ray had gone back to Paris. He never did get to meet him. But something else happened that was wonderful: one day Ed was wandering around La Cienega, looking in galleries there, and he saw a big red barn on the west side of the boulevard, a few blocks below Sunset; it was a kind of folksy emporium full of art books and rare prints and engravings that was run by a man called Jake Zeitlin. Zeitlin was one of the great hustlers of West Hollywood. He sold to decorators and he often had some fine things. Ed went in there and discovered a Man Ray print for sale for only thirty-five dollars; it was a reverse linocut or a litho offset, with white figuration on a black ground and some words—maybe a poem. Ed kept it his whole life—it was his only piece of historical art. I think he liked Man Ray far more than he liked Duchamp, strangely.

Essentially, Ed made three kinds of art in his lifetime. His work in the mid to late fifties, which was shown at Syndell Studio, was abstract—often made up of little blocks of wood, which he used as major parts of the

composition and then painted over. He had an ingenious way of making these reliefs, usually shallow reliefs—there was no great depth from the painting or the board he worked on. One work from that era is *Construction for Table* (1957), a woodblock construction in beautiful black, gray, and olive-green tones. He liked to work on hard board, like plywood or Masonite. He knew where to get the lumber. He had a real knack for solving material problems, and he would often do daring, surprising things. There was a period in 1954 when he bragged that if he was in a good mood he could do an acceptable painting in one day. (The painting *One-Day Wonder* is an example from that year.) There's another painting from 1954 that is curiously shaped, with some strange painterly aspects as well as geometric lines. I asked Ed where that one had come from, and he told me it wasn't going to make sense to me but he'd admired some work by Miró and it had been suggested by that. Only rarely did Kienholz refer to a historical artist.

Ed's first show was at Vons Café Galleria, a sort of Beat-era hangout where people could get beers and food—there was a little market there—in Laurel Canyon, in the western part of L.A. The owner, Von, let Ed hang a show on the walls of this place. His first gallery show was at Syndell, and in the days of the first Ferus Gallery, some work that was less abstract and more literal started to turn up; Kienholz's imagist work began in 1957, and it overlapped with the last of the purely abstract works. There was one piece called *They Tarred and Feathered the Angel of Peace*, from that year, which included an angel-like form. Incidentally, that was Ed's first piece to go into a museum. Tom Leavitt and I got it into Pasadena; later Norton Simon, who hated contemporary art, dumped it and it was put up for auction at Sotheby's or Christie's. Ed happened to be in New York at the time and he walked into the auction house, picked it up, and walked out the door with it, just as normal as can be; the guard even opened the door for him. He was halfway down the block before some girl came rushing out and said, "Excuse me, Mr. Kienholz, you can't just do that." He said, "Why not? This was supposed to be in a museum collection. It wasn't supposed to be sold off." Somehow she convinced him to go back and talk to Robert Rowan on the telephone. It wasn't auctioned that day, though it was later.

Kienholz was the most willful person I've ever known. He just did what he wanted to do. He wasn't out looking for trouble, but if trouble came

he could dish it out more than anybody else. I've never seen anyone work so hard for retribution when he felt he was wronged. Once, in the mid-sixties, he was on the East Coast and he found an old Tiffany lampshade, which he liked a lot. He was a good packer and art handler—you had to be with his kind of art—and he wrapped that thing up very well in a wooden box he built so that he could take it back with him on the airplane. But TWA wouldn't let him carry it on and he had to check it. They assured him that they would take care of the box, but at the end of the flight in Los Angeles he opened it up and discovered that the lampshade had been broken. Kienholz had paid pretty good money for it, and he was just seething. But he took his time. A week later, he drove back to LAX and went to the airline's ticket desk. He said to the man behind the desk, "You owe me this much money for a lampshade of mine that was smashed and I need to speak to someone about it." The man at the desk tried to get rid of him, so he took out his tape measure and measured off a section of the desk, made some estimates, and showed his notes to the man. He said, "You smashed my lampshade, which was worth this much. Now I want you to stand back because I'm going to take out the same value in your desk here." He had a friend with a camera with him. He said, "I'm going to document this and I'll send you all the papers, but for now just stand back." And he took out an axe and proceeded to chop out a section of the desk. No one could believe it. "Here's my name," he said. "Here's my card. You can be in touch with me, or I'll be in touch with you." He never heard a word from them. Report went in: Insane man comes in and chops up our desk. They didn't want it in the newspaper. Ed had a particularly graceful aggressiveness. No one else could have gone in there with an axe and coolly chopped out a portion of a public facility without ramifications. We all suffer from that kind of rage from time to time, but only one in a million can pull off revenge in that way.

The first important piece of this second phase was *George Warshington in Drag* (1957), in which Kienholz depicted the father of our country as the mother of our country. There is a little figure with breasts centered on a panel. The uppermost part has the shape of the eighteenth-century wigs that the founding fathers wore, but it also suggests the cap that Washington wore as a general. Kienholz was very antiwar, and this piece demonstrates his innate displeasure with all things military. It's also a robustly impudent

comment about the father of our country. At the same time, it sets his agenda as an American artist. It is kind of hilarious, in its way. That was the beginning of his real imagist work, along with another piece called *Leda and the Canadian Honker* (1957), a Pacific Northwest version of the classic theme. (You know what goes on between Leda and the swan, and it's certainly going on between her and the honker.) On a panel going from left to right, you can see the lower extremities of a female figure, somewhat abstracted in wooden relief; the negative space between her legs is shaped like the neck and beak of a large bird diving in. I saw these pieces when Kienholz first made them. I remember watching him finish *George Warshington* in his studio behind the old Ferus. He was living up on Nash Drive then, at the top of the hill, in Laurel Canyon, and he was with his third wife, Mary, a hippie girl who had drifted into L.A. (He said to me once, "You know, I was so dumb, I thought you had to be married to have sex.") I was sort of astounded by the piece, with its bright-yellow background, a sudden shift from Ed's Abstract Expressionist look—which *Leda and the Canadian Honker* still had, in its way—in the surface and the handling of the paint. *Leda* related more to *They Tarred and Feathered the Angel of Peace* and certain earlier works that were quite abstract and nonobjective. But the humor and the figurative elements that were buried in *Leda* were right in your face in *George Warshington*. I said, "I want that piece." He said, "It's not quite finished yet." And then he took the tip of his brush and scratched the title into the still-wet paint, spelling "Washington" with an *r*. He very much wanted the word "war" stuck into Washington's name. He said, "People are going to get confused. I want them to really understand what it is." And he laughed about it.

Around this time, Kienholz's work also became more three-dimensional. Some things simply came down off the wall, and, from then on, everything is essentially imagist, in one way or another. The first set of stand-alone three-dimensional pieces come in 1959, which was a very productive year for Kienholz. The most famous work of that period, *John Doe*, has the torso of a male mannequin mounted on a baby stroller. Ed kept that piece in his studio and liked having its company. One day I went in and it had a big rent in the side of its head. I asked him, "Where did that come from, Ed?" He said, "The son of a bitch is always staring at me, and I got tired of it, so I

gave him a whack upside the head with a tire iron." To this day, that gash is there—a strange part of the creative process.

In 1960, he made a companion piece, *Jane Doe*, a sort of tragic figure. Kienholz was an extreme libertarian, who would take the law into his own hands if he felt it was necessary. But curiously, even though he had no formal religious background, he was very anti-abortion. He thought a lot about how to portray the sadness of women. He said, "Her husband, John Doe, is a pretty good guy, but he's insensitive or dumb. And Jane is often wanting, so she's sad. And she has this other problem that John will never know the way she does—these babies that are stillborn or that she has to abort." Hidden inside drawers in Jane's skirts are lots of little unborn babies.

When Kienholz made *John Doe*, he also made *Mother Sterling*. He knew Bertolt Brecht's play *Mother Courage and Her Children*, about a woman who lost her children one by one as she protected her merchandise. *Sterling* was meant to imply that this mother was a sterling example of womanhood. Ed used a dressmaker's dummy, life-size, and on the top, where the neck would join the head, he put a woman's mask, beaten down, flush with the shoulders, but looking heroically skyward. At the base he has a bunch of little baby-doll children trying to get under her skirt. On an old piece of furniture, he found a symmetrical piece of wood, which made a great medallion or medal that he put on her chest and painted a rough gold. He liked that woman. When I first asked him about the work, he told me that it was based on *Mother Courage*, and I asked him how he knew about Brecht. He said, "What do you think I am, totally illiterate?"

Another of the early three-dimensional works was *Conversation Piece*, which has the legs of an Indian woman sticking way out from the support structure. He told me that the work was based on the story of an Indian woman who had been raped and killed by non-Indian scouts. What he said was "They might as well have mounted her legs the way you'd mount a slain deer."

Then there was the portrait he did of me, *Walter Hopps Hopps Hopps*. Actually, it wasn't just a portrait of me. Ed was thinking in general about the kind of things that art dealers or curators can get themselves into—how these characters are mediators, even hustlers, who enter into the lives of artists and affect the work, for better or for worse. There were two reasons

for the repetition of my last name in that title: it always amused him that I was Walter Wain Hopps III, but he also used to tease me about the way I'd jump around between projects, and the title captures some of that hopping motion. He found himself one of those plywood Bardahl oil-additive signs that were around gas stations then, in the shape of a man in a hat, and he reworked it and painted it to look like me. He picked up a few of my attributes. The wristwatch says "Late," because he was always waiting for me to get to his studio. The eyes are bloodshot—I generally made it on just four hours of sleep a night then. And he depicted me holding my coat open, the way someone trying to sell dirty French postcards might—those postcards were a gag between us—but what I was hiding in my coat like dirty postcards were images by three East Coast artists I was always trying to convince him were good: de Kooning, Franz Kline, and Jackson Pollock. The work was freestanding, on a metal base, but it rotated around, and the back had all sorts of strange little compartments. Ed managed to steal and put in a little leather pouch the corporate seal for the Ferus Gallery. There were also several lists, of important artists and other people, which he made me write out in my handwriting, a lot of the names purposely misspelled; that was a comment on my love of lists, among other things. I once called him an "itinerant barn builder," as in "When are you going to settle down and really focus on your career?" He resented the word "itinerant," so on the back of the sculpture he managed to put down every phone number where I'd either lived or shacked up with someone when he needed to reach me. Up by the head he used some bones from the spinal column of an animal—I don't know if it was a deer or a cow or what—and off to the side was a strange little box. There was no obvious entrance into this box—it was one of those trick boxes. If you knew where to apply a screwdriver, it would spring open and a sliding drawer would come out and whack the spinal column. In that drawer were various drugs—the real thing. Some that I used and some that I didn't use, as a matter of fact. He was aware of my particular addictions back then.

Kienholz was one of the great visual philosophers of our time. By that I mean that he was a humanist who reflected on the human condition and its

dark corners. From early on, he was dealing with the themes of child abuse and sexual perversion. There are political and heroic figures in his work, and issues that are deeply disturbing—war being a major theme. And not since Edward Hopper had we seen the theme of isolation and loneliness portrayed so thoroughly. *The Illegal Operation* (1962) is one of the toughest of his works to look at. It's clearly about abortion—the tools of the trade are present, in a particularly nasty way, in a bedpan and in an enameled kitchen pot. There is a kind of bucket meant, I think, to receive the aborted fetus. There's a little hooked rug, a low stool, where the abortionist would have sat, and a lampstand with the shade pulled back and a glaring lightbulb to illuminate the scene. But what is curious about this work is that there's no aspect of human figuration. Kienholz used mannequins and human figures in a variety of ways, but what we get here is a shopping cart with the sides removed, so that it looks like a chaise, holding a disturbing object—a sack of gray cement, split open and oozing. It doesn't resemble any normal after-birth; it has a generic disgusting quality that doesn't seem to go with the tawdry abortion tools. It's a strange visual metaphor. Ed's third wife and the mother of his children had apparently had an affair, become pregnant, and had an abortion in her kitchen, and Kienholz made the piece in a state of overwhelming anger, influenced by that. But at the same time there are a couple of elements that just don't make sense. Why a shopping cart? Everything else suggests an at-home, in-the-kitchen abortion. For me, there's an overtone of *other* abortions—of bucket-shop activity—but, even less literal, of shoddy activities, dubious goods and practices. Kienholz was a great stickler for fair practices; he may have horse-traded people down to their socks, but he wasn't sleazy. He gave you a good product, and he expected the same in return. He was always pissed off when he got less than that, and he sometimes enacted a harsh form of justice.

The piece was shown back then at the Dwan Gallery. I thought it was fantastic—one of the most powerful he had made up to that point. But one evening I got a call from Kienholz, and he said, "You know that *Illegal Operation* that I made?" I said, "Yes, what about it?" He said, "Well, I'm going to destroy it." I said, "What do you mean?" He said, "I don't want to discuss it. I'm going to destroy it." I said, "That's crazy. You shouldn't be doing that." And this went back and forth for a while, then he said, "Well, I'm not

talking about it. I'm going to destroy the piece," and hung up. Two things occurred to me. First, I knew how willful he was: if he said he was going to destroy it, he meant it. Second, he'd said "going to"—he hadn't called me up to say that he *had* destroyed it. He had tipped me off. He was telling me that if I was so determined and the piece meant enough to me, I could do something about it. And he was right. I immediately got hold of a younger artist I knew called Jim Eller, who had always admired Kienholz's work. He said, "We have to save it. I'm your man." In the middle of the night, we drove to the Dwan Gallery. I was a little concerned as to whether they had a sophisticated alarm system there. But I took a few tools and cased out their storage quarters, which were a little separate from the gallery, in the back, and, as far as I could determine, there wasn't one. We managed to break in, get the piece, put it in the trunk of Eller's car, using timber to prop up the lid of the trunk as best as we could, and then we very slowly drove out to the San Fernando Valley and put the work in Eller's mother's garage. The whole thing was done by perhaps three in the morning.

The very next day, I got a call from Kienholz. "All right. Where is it?" "What are you talking about, Ed?" "You know what I'm talking about." We went back and forth, and finally I said to Ed, "Look, I trust you. And if you swear to me you're not going to destroy it, I'll tell you where it is." "Well, bullshit. Fuck you." He slammed down the phone. I called back. Finally, he says, "O.K. I swear to you I'm not going to destroy it. Now tell me where it is."

By that time, I felt that the whole thing was a setup, that he'd been testing me to see if it meant enough to me to save the thing, and if it did he'd go along with that. So I told him where it was and Ed was out to the San Fernando Valley like a shot to reclaim the piece. He never did destroy it. Of Kienholz's smaller pieces, it is probably the most difficult to move around. It isn't exactly a tableau—it's a freestanding sculptural assemblage. It is not a piece that makes sense sitting out nakedly in the middle of a room. Eventually it was bought by collectors in Southern California, Monte and Betty Factor.

The great breakthrough for Kienholz came when William Seitz put on "The Art of Assemblage" at the Museum of Modern Art in 1961. It was in the same year as Ed's Pasadena Art Museum show. Seitz came to California

Clyfford Still, *1947-J*, 1947. 68 x 62 inches. Oil on canvas.

Craig Kauffman, *Still Life with Electric Fan and Respirator*, 1958. 51 x 41 inches. Oil on linen.

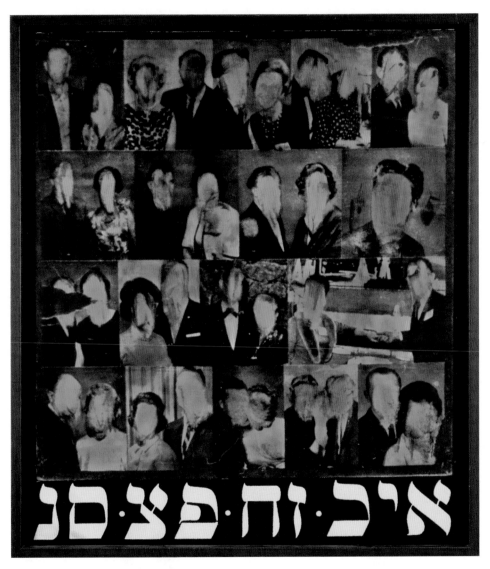

Wallace Berman, *Untitled (Faceless Faces with Kabbalah)*, 1963–70. 29 7/8 x 28 11/16 inches.
Verifax collage with transfer lettering.

Barnett Newman, *The Name I*, 1949. 48 x 60 inches. Oil on canvas.

John Altoon, *Ocean Park Series*, 1962. 72 x 84 inches. Oil on canvas.

Frank Stella, *Union III*, 1966. 103 3/4 x 173 3/4 x 4 inches. Fluorescent alkyd and epoxy paints on canvas.

Jasper Johns, *According to What*, 1964. Oil on canvas with objects (six panels).

ANDY WARHOL
FROM MONDAY, JULY 9TH, 1962
FERUS GALLERY
LOS ANGELES, CALIFORNIA

TOP: Announcement for Andy Warhol's *Campbell's Soup Cans* show at Ferus Gallery, Los Angeles, in 1962. BOTTOM: Edward Kienholz, *Roxys*, 1960–61. Mixed media, dimensions variable.

Kurt Schwitters, *Merz Picture 32A. The Cherry Picture*, 1921. 36 1/8 x 27 3/4 inches.
Collage of cloth, wood, metal, gouache, oil, cut-and-pasted papers, and ink on cardboard.

Jay DeFeo, *The Rose*, 1958–66. 128 7/8 x 92 1/4 x 11 inches. Oil with wood and mica on canvas.

Marcel Duchamp, *Étant donnés* (interior view), 1946–66. 7 feet 11 1/2 inches x 70 inches.
Mixed-media assemblage: wooden door, bricks, velvet, wood, leather stretched over
an armature of metal, twigs, aluminum, iron, glass, Plexiglas, linoleum, cotton, electric lights,
gas lamp (Bec Auer type), motor, etc.

Frank Lobdell, *March 1954*, 1954. 69 1/2 x 65 1/2 inches. Oil on canvas.

Joseph Cornell, *Untitled (Aviary with Yellow Birds)*, c. 1948.
Wood, corks, paint, and mixed media in glass-faced wood box.

William Christenberry, *Walker Evans in Front of Brick Wall with Commercial Signs, Alabama*, 1973.
4 13/16 x 3 1/8 inches. Chromogenic print.

William Christenberry, *Red Building in Forest, Hale County, Alabama*, 1994. 17 1/2 x 22 inches.
Chromogenic print.

William Eggleston, *Untitled*, from *Los Alamos*, c. 1974.

William Eggleston, *California, 1974 (Walter Hopps in Phone Booth)*, from *Los Alamos*, 1974.

Sam Gilliam, *April 4, 1969*. 110 x 179 3/4 inches. Acrylic on canvas.

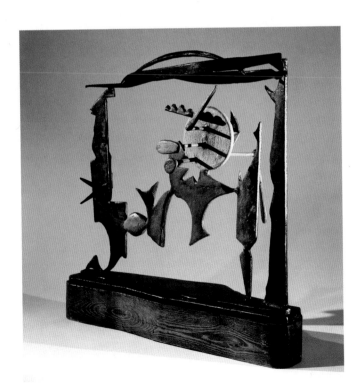

David Smith, *Helmholtzian Landscape*, 1946. 18 1/4 x 19 x 7 1/2 inches. Painted steel on wood base.

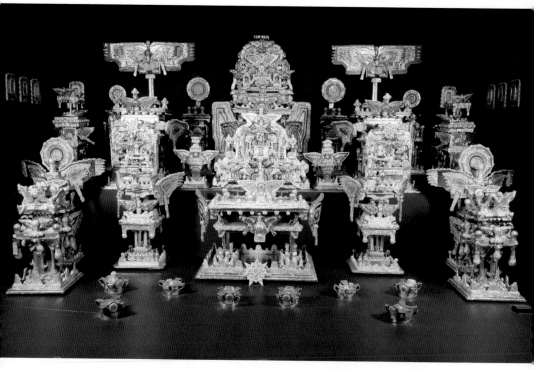

THIS PAGE: James Hampton, *The Throne of the Third Heaven of the Nations' Millennium General Assembly*, c. 1950–64. Dimensions variable. Mixed media.

FACING PAGE: Robert Rauschenberg, *Untitled (Man with White Shoes)*, c. 1954. 86 1/2 x 37 x 26 1/4 inches. Oil, pencil, crayon, paper, canvas, fabric, newspaper, photographs, wood, glass, mirror, tin, cork, and found painting with pair of painted leather shoes, dried grass, and Dominique hen on wood structure mounted on five casters.

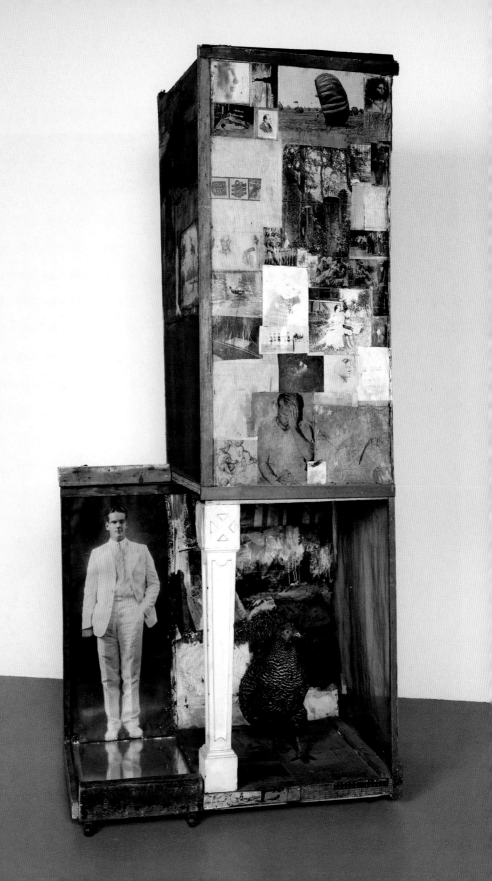

Max Ernst, *Portrait of Dominique de Menil*, 1934. Oil and graphite on canvas.

and I introduced him to some things; he was crazy about Kienholz and he took *John Doe* and *Jane Doe* for the show. I adored William Seitz. We hit it off right away; he even had me help install part of the show. Once the show went up, Kienholz started to be recognized in Europe and around America, where the show traveled.

In 1972, Ed met and married Nancy Reddin, but their life together really began in Berlin in 1973. He had received a DAAD (German Academic Exchange Service) grant to work there, and that extraordinary city became very important to him. Originally, Ed and Nancy planned to be in Berlin for just a year, but while they were there they started working on a piece called *The Art Show* and they found that it was easier to move themselves permanently to Germany than it was to move the piece. It took five years to finish the work, and after five years Berlin was home.

I visited Ed a few times while he was there. He was living in West Berlin, but we'd go over to the Eastern side, which an American could do. The beer halls were filled with men in knee boots, and when they came in everything got silent and grim.

The first time I went to see Ed there, he said one night, "Come on. We're going out to a club to play pool. I have something special in mind." I said, "You're a much better pool player than I am, Ed." He said, "That's just what I have in mind. There are these young Germans and they have a lot of money." This was in West Berlin. He said, "I'll explain to you how we're going to handle it. You're going to go up and you're going to bet some money and play as well as you can, but you're going to lose." I said, "How do you know I'm going to lose?" He said, "I know you're going to lose. And then you're going to pick up this other American in the joint—these people have never seen me. And we're going to be partners, and then we'll play a couple of them together and I'm going to win big." And that was how it worked. It was a hustle he had in mind. It wasn't serious money. But the idea of winning was important to him.

The third phase of Kienholz's art, which really got rolling in the early seventies, just before he met Nancy, and continued on from there, involves the big tableaux. There's *The Middle Island No. 1* (1972) and *Five-Car Stud*

Ed Kienholz, in Hope, Idaho, 1975.
Photograph by Paul J. Karlstrom.

(1969–72), which he showed at the 1973 Documenta. *The Middle Island* involves a man and a woman, strange, mournful figures, sitting on the floor. There are three chromed racks from the tops of station wagons, lined up so that they separate the couple on the floor. It's about divorce, of course: those two have been through it all, and there's no way that they can go on. Then you get *The Art Show* (1963–77) and *The Merry-Go-World or Begat by Chance and the Wonder Horse Trigger* (1993). *Roxys* (1961–62)—a room-size 1943 Nevada whorehouse—started off as a smaller piece, an individual woman called *Zoe*. Virginia Dwan bought it from Ed and then he went over and asked for it back. She said no. So he said, "Well, could I borrow it?" So he took it home and reproduced it exactly, except that it has a different leg. One has the right leg of a mannequin and the other has a left leg. Virginia never knew whether the one she got back was the original or the remake. *Zoe* ended up in *Roxys* and the other one, *A Lady Named Zoa*, is at the L.A. County Museum. *Roxys* was shown first at Ferus. At that opening, Ed insisted on serving boilermakers. He and I got so wasted that we just curled up in the whorehouse at the end of the night and slept it off. When *Roxys* traveled, Ed would go to the new city and go out and buy a lot of crummy old rugs and chairs and couches, so that the work would change according to the space—it was just too expensive to ship all that stuff around. The figures were set, but the rest he'd pick up as he went. Originally, you could walk into *Roxys* and make one of the whores, "Five-Dollar Billy," jiggle up

and down. Later he took more control and made sure that everything was screwed in place.

Kienholz was an unlikely feminist, but he made the decision to put Nancy's name on the work that was produced while they were together. She was a collaborator from a certain point, but he even went back in time a little and put her name on works that he'd made before she had a major impact on the work. When I asked him about that, he said, "Well, she has to put up with me. She helps me with everything I'm doing. She deserves to have her name on it." During his period of working with Nancy, some new themes came into play. Women became prominent, and so did children, who were often in harm's way. A different kind of painterly quality also shows up. One of my favorite pieces that Ed and Nancy did together is *Man with Blue Shirt* (1989): there's an easel and a headless man in a blue shirt, holding a horse's skull. I've often thought of it as a kind of self-portrait of Kienholz.

The Kienholzes moved to Idaho after the Berlin Wall came down in 1991. He said, "Once that wall comes down, I'll never get a parking space again." They settled in Hope, just east of where he grew up in Spokane, Washington, and near Lake Pend Oreille (French for "hangs from ear" or an earring), a beautiful lake with clear, cold water and big rainbow trout. It was the land of the Unabomber and the survivalists, and Ed had no trouble fitting in there. He certainly didn't look like a fancy artist, and he made no secret of the fact that he was armed. At the same time, he acquired an old schoolhouse and outfitted it for a summer artists-in-residence program. He'd always wanted to run a workshop for women, with carpenters, electricians, and plumbers, to teach them how to build things. The first thing he did when he bought that schoolhouse was take the heat out of it. There were old radiators, and it was heavy work to get them out. That way he designated what time of the year artists could be there—it was very clear what months were available and what months were not.

The first time I went to visit, I was alone with Ed. He usually got up early and fixed breakfast; breakfast was a very important meal for him. But one day he was working, and instead of making lunch he said, "Listen, take one of the cars and go into town, where there are some bars with restaurants." He gave me directions, and then he said, "Now, there are three bars

Walter Hopps, Nancy Reddin Kienholz, and Ed Kienholz, in Idaho. Photograph by Caroline Huber.

you must not go to." And I said, "Why is that?" He said, "They don't like strangers in there and you're going to stick out like a sore thumb. I suggest you go to some other place." So I went up there and, of course, I went into each of the three bars to check them out. And in one of them I had my lunch. When I came back, he was smiling, and he said, "Which one of those places I told you not to go into did you have lunch at?"

When Ed died, in 1994, I was in the hospital, recovering from a brain aneurysm. I was getting reports about how his funeral was being planned in Hope, and I knew I wasn't going to be able to go. I was having very vivid dreams at the time, some of which involved a kind of disembodied voice—a sort of stage manager, like in Thornton Wilder's *Our Town*—who would explain things to me. One night the stage manager was there, and he said, "You miss Kienholz, and I know you know that he is buried in his Packard coupe up there in Idaho." And then I was flying through the sky like a little paper airplane or Captain Marvel and, in what felt like five minutes or so, I was all the way up in Idaho near the Canadian border, where Ed was buried in a 1940 Packard coupe. I was fascinated that Nancy had chosen this sort

of Egyptian way of burying him, on his own land, in his own car, with the various things he might turn out to need in the underworld—a bottle of wine, a deck of cards, and so on. But when I got there I realized that he was underground and I didn't have a way to get down to him. The stage manager said, "You can go right through this earth; you just have to think about it very carefully." So, like a kind of boring machine, I went down through the earth, feeling my way in the darkness until I hit that car, which was in a sort of pod cave: Ed had somehow known I was coming and had hollowed out a space for me. When I got there, I peered through the window and saw Ed sitting in the car. I spoke his name and he sort of roused himself and said, "Oh, good, you're here." He opened the door and came out and we sat on the running board and talked for a while. He asked me what kind of day it was aboveground, and he told me that he could make his little Packard coupe fly right up through the dirt and into the air, where he could navigate it. Then he said, "I've got an idea. Let's go for a spin out west together, over Vancouver and Puget Sound." But I was worried that taking this trip with him would mean crossing over into his world—I might die, too—so I told him that I couldn't go, I had to get back. He asked me why I was being so wussy—he used that word—and I said, "So be it. I just can't do it right now." He was a little annoyed. He said, "O.K. One day we'll do it. And now I guess you'd better get going." So I flew off the same way I'd come, with a strange mixture of disappointment and relief, and I was somehow back in the hospital in time for morning rounds.

As usual, Ed was asking of me more than I was quite ready for. With him, it was always, "Come on. Just one mile farther . . ."

12.

THE PASADENA ART MUSEUM

I'd always thought that the San Francisco Museum of Modern Art was where I wanted to work. But it seemed as though I'd be able to do good things at Pasadena, too. In 1962, Tom Leavitt invited me to be the museum's first official staff curator, and I agreed. He said, "Do you know anything about registration? We don't have a registrar, either." I said, "I think I can handle it." So he gave me a handbook on registration, which the Museum of Modern Art had published, and I studied that. Robert Rowan, whom I'd met as a collector, was on the board, and he put up the money for my salary—$6,000 a year, which was barely enough to get by on, but more than I'd been making at Ferus, and I could take the summers off to teach art history. By this point, I'd decided that it was time to put college behind me. My marriage was falling apart. I was seeing Eve Babitz, and Shirley had a boyfriend who was living upstairs in our house in West L.A.

My only concern was my relationship with Ferus. Not long after I started full-time at Pasadena, I was sitting with Leavitt, and I said, "Look, Tom, there are artists who are shown in the Ferus Gallery whom I want to show here." He said, "Oh, yeah, great." I'd already shown a few of them there in my freelance shows. I said, "You know I own a third of the stock in the gallery, and I'm concerned that it could shape up as a conflict of interest. What do you think I should do?" He looked at me and smiled and said, "Walter, don't worry about it. Just do whatever you think is the right thing." He wasn't concerned about it—he knew I wasn't profiting from it—but I felt that I needed to get things straight. So I called up Irving one day and said, "I'm coming over after lunch." He said, "Good. I'm just sitting here, popping my knuckles. What are we doing?" I said, "You'll see." I went over with my share certificates in my briefcase and I took them out and laid them down on his little Formica-topped desk in the back office. He said, "What are you

doing? Why are those here?" I said, "Irving, I'm signing these shares over to you." I signed them all over, and he said, "What do you want for them?" "Three things. First, I want you to run an honest gallery and always treat the artists well. I want you to be decent to Sadye Moss. I want you to run a good gallery." He said, "But what do you want for yourself?" I said, "Well, one day, I'm going to claim an artwork—a painting or a sculpture." He said, "Oh, well, pick it out now." I said, "I don't mean for me. One day I want to come to you and ask you to give an artwork of my choice to the museum of my choice." "Oh," he said. "You got it. Absolutely." And I said, "I want to get the things that I own, that are stored here, out of here." Because he'd sold off a couple of my things—a good Bengston painting from the fifties, which he'd sold to Hedy Lamarr, and a Ken Price. I had no way of getting them back.

I'll never give away more money in my life. I owned a third of the Warhol soup cans, and I signed them away. I never did get that artwork I asked for, either. And, in the end, Blum didn't treat the artists very well. Kienholz had left a few pieces at Ferus, and Blum told him he'd destroy them. Years later Ed got a catalogue from the San Diego Museum and in the collection was a gift of a work of his—one of the pieces that had supposedly been destroyed—which someone had bought from Irving Blum. Ed was in the midst of instigating a lawsuit against Irving when he died.

In any event, Blum was annoyed that I was leaving. He didn't get along well with Sadye Moss. The artists weren't very happy with him—the Southern Californians, particularly, but he'd alienated most of the Northern Californians, too. After I left, he pretty much got rid of everyone from the San Francisco School and all the artists of the Beat era.

Historically, Pasadena was the first wealthy high-society part of the city; before there was a Beverly Hills or a Bel Air, there was Pasadena. A lot of rich people settled there, and they commissioned some extraordinarily progressive architecture; there's a Frank Lloyd Wright house, and the great Richard Neutra and Rudolph Schindler worked near there. The museum was founded in 1924, in a large frame house in Carmelita Park, which was landscaped by the famous John Muir, on the western side of Pasadena, just

before the arroyo. But the house turned out not to be an adequate space. In the thirties, the museum moved to the east of the original site, to a crazy building on North Los Robles Avenue. It was kind of a Chinese villa: two stories in the back, but the rest was just a square doughnut on the first floor. It had been an emporium of Asian and Native American goods, run by an eccentric woman named Grace Nicholson, who traveled in the Orient and imported all sorts of fancy *objets* and sold them to the wealthy people of Pasadena. She fell on hard times in the Depression and made a deal with the city of Pasadena that if she could live the rest of her life in the living quarters of this place—on the second floor in the back—she'd give the building to the city.

So I went to work in the Chinese Grace Nicholson building. It had a central courtyard with a wonderful garden, and a layout that made it possible to do a variety of things. There were showrooms already set up, and you could string galleries together to make the shows bigger. I loved working at Pasadena. Leavitt let me get away with murder. He had a laissez-faire but focused style. Whenever I proposed an exhibit he had two questions. He'd say, "Do you think we can afford it?" and "Do you think we can pull it off?" What a boss! Then he'd push it through with the board. I'd often work

Exterior of the Pasadena Art Museum, 1962.

through the night, and Leavitt was quite relaxed about my finding artists to come in and help for a couple of bucks an hour.

Leavitt and I did a fair amount of work on the museum's permanent collection. We were putting together our own modest version of the antecedents of contemporary art: we had Van Gogh and Gauguin graphics; one of the late Degas monotype landscapes; an extraordinary Ensor painting; Edvard Munch's *Girl Under Apple Tree* and the great Munch print *The Sin (Woman with Red Hair and Green Eyes)*. We had a terrific Picasso painting and works by Lissitzky, Schwitters, and so on. So there were pre-Second World War works in the collection that meant something, plus some works from the Blaue Reiter: Kandinsky, Feininger, Jawlensky, and Klee. No Matisse, but there was enough there to make Pasadena *the* modern museum in L.A. at that time.

Over the next few years, I had the opportunity to curate some of the most important shows in my career. I put together a show of drawings by Richard Diebenkorn and Frank Lobdell, and in 1962 I worked on a Robert Motherwell retrospective, which was, without a doubt the most beautiful show Motherwell ever had. It predated the later, more vacuous works. He was very popular in Southern California in the fifties, and the new collector establishment poured into the opening, along with dealers and artists. There was an overflow crowd for his lecture, so we rigged loudspeakers to play it down in the galleries. The show opened a few years after Motherwell had married Helen Frankenthaler, and I remember the two of them arriving in Pasadena very shaken. They'd gone to the airport in New York, but they'd missed their flight and had to take a later one. As it turned out, the plane they were supposed to be on crashed, killing all the passengers—a real tragedy. Motherwell was particularly upset by this. I remember Helen stalking through the museum, saying, "Oh, Robert, I've never seen this one, I've never seen that one," while he just stood there stunned. The next day we learned that a shipment of Arshile Gorky works had been on the plane, headed to a gallery show in L.A. Gorky had already lost a lot of work in a fire in his studio.

Leavitt and I developed a sort of plan: we were going to try to give half of the contemporary American artists at the time, from both the East and the West, a serious presentation. After Motherwell, who was a major East

Coast figure, for instance, we'd turn to someone from the West who was perhaps less well-known—Emerson Woelffer or Richards Ruben. I did a show of Hassel Smith's work and the first museum show of Robert Irwin's work, pure and painterly lyrical Abstract Expressionism; this was before his ethereal disk paintings. Leavitt liked photography, and he had already shown people like Ansel Adams. One day the photographer Frederick Sommer, who had a sense of our programming, came by the museum and said that he'd like to do a show. I didn't know his work then, but I was very impressed by what I saw, and I learned that he lived out in Sedona and was a friend of Max Ernst. He was doing some strange experimental things with light, but I especially loved the shots of the desert, with cacti and rocks. He was an exacting printer, and the prints were incredible. We did a big show, and Sommer liked it so much that he said to me, "I want you to choose a print for yourself, any one you like." On top of that, he gave twenty-five or thirty prints to the museum.

I also ran children's and adults' art classes upstairs, at the back of the museum. I had John Altoon teaching there at one point and various other people. That was how I got to meet the physicist Richard Feynman—he came in to learn how to draw. Rowan and I took him to lunch the day he

Thomas Leavitt, Llyn Foulkes, and Walter Hopps at the opening of Foulkes's exhibition at the Pasadena Art Museum, September 18, 1962.

won the Nobel Prize. He said, "The phone's ringing off the hook, and I don't want to talk to those people. Let's just go to lunch." He was a crazy man. He loved to hang out in go-go bars and so on, and he became very proficient at drawing nudes.

While I was at Pasadena, I looked for every chance I could get to jury exhibitions in other parts of the country. I liked to get out to the heartland, or to Chicago, or New Orleans, or Oklahoma City, and just see what was going on. The first exhibition I ever juried was in Bakersfield, California. Somehow the organizers had latched onto me. The competition had categories for adult amateurs and adult professionals and children, and I spent a weekend jurying all three, then presented the awards at a grand banquet at some godforsaken restaurant in Bakersfield. While I was there, I was approached by a man who had been at Berkeley with Sam Francis. Francis had come to Syndell Studio when he was passing through L.A., so I'd met him once. I said that I admired his work very much. The guy said, "You do? I couldn't stand him. Couldn't stand him. He was a smart-ass." I said, "What was the problem?" He said, "You know, we had a class where we were supposed to do still lifes. There'd be a still life set up, and Francis would come in and do the blue version, the green version, the red version, the yellow version, while the rest of us were struggling just to get at what it looked like." I was fascinated to hear that Francis had been trying to do those suffused-color still lifes back when he was still a student.

I got terrible laryngitis while I was there. Handing out the prizes, I awarded a first, second, and third in each category, but there had to be a grand prize. The grand prize went to a little girl's painting of a big yellow cow, which I really adored. And, of course, the hosts of the competition were outraged that I had given the grand prize to a child, and I could barely croak through the microphone to defend my choice. My first attempt at jurying and I was practically run out of town on the rail.

Before I ever got to the Pasadena Art Museum, I'd decided that there were three artists I was absolutely determined to address in my lifetime: Joseph Cornell, Marcel Duchamp, and Kurt Schwitters—the American, the Frenchman, and the German. Schwitters was the first of the three that I

managed: in 1962, I did a retrospective of his work. I had shown him at Ferus, but there had been no retrospective at that point and there was no Schwitters work in any museum in the West.

Schwitters was born in Hanover in 1887, and that city was his home base until shortly before the Second World War. He was adopted by the German Dadaists and was part of that world, though interestingly in his early work there are some quite realistic portraits and still lifes. He became most famous for his assemblages and collages in a synthetic Cubist mode; he was a master of that kind of composition. He also did some conceptual art. He had a poem entitled "W," which he would recite for fifteen or twenty minutes, a riff on the letter; he'd shout it, yell it, whisper it, repeat it fast, draw it out long. In 1953, when I was living behind Syndell Studio, I loved the fact that there was a market across the street called Westward Ho, which had a huge W on its sign: I always had my own Kurt Schwitters poem at home. There was another conceptual performance he conceived in which a curtain would rise on a vast stage and all the audience would see was a railroad track, then suddenly two locomotives would roar toward each other at full speed and collide center stage with a great explosion. I've always wanted to see that performed, but I guess I never will.

Schwitters was very interested in the vanguard art being made in the rest of the world, and he had friends among the De Stijl people in Holland, and in the Russian Constructivist movement, particularly El Lissitzky, who would visit him in Hanover. Theo van Doesburg and Hans Arp were both friends of his. In his house in Hanover, Schwitters began to build a fantastic collection of memorabilia connected with art activities—announcements, posters, and other ephemera—which no one else in Europe was saving systematically, as far as we know. At the same time, he made up a word for his own art—*Merz*—which was part of the word *Kommerz*, or commerce. Schwitters wasn't very interested in *Kommerz*, which was such a desperate concern in Germany between the two World Wars, and I think it amused him to use a piece of that word for his own approach to art. In his house he constructed a gigantic three-dimensional structure out of wood, which he called the *Merzbau*—the *Merz* environment. It was a crazy construction that went from room to room, with little passageways. There are very few photographs of it left. His friend Kate Steinitz, whom I had met when I was

in high school, told me that Schwitters had kept pet guinea pigs in the structure—they ran wild inside it and it stank. He considered them part of the work.

Schwitters's wife, tragically, was sympathetic to the Third Reich, which Schwitters was not. His work was considered "degenerate" by the Nazis, and in 1937 he fled to Norway with his son, Ernst, having shipped out as much of his work as he could and leaving behind his wife, who wanted to stay. A British bomb destroyed the whole house, and the *Merzbau*, as well as his elaborate archive, was lost. In Norway, he tried to build a new *Merzbau* out of rocks and stone, but then the Germans invaded and he had to evacuate again. Miraculously, he had enough money to get to the United Kingdom, where he was held in internment camps for some time. At the end of the war he moved to Ambleside, in the Lake District, and he lived modestly there, along with a young woman called Edith Thomas, whom he nicknamed Wantee (pronounced, by him, "Vantee"). In Ambleside, he made one last *Merzbau*, a cavelike structure in a barn, which he called the *Merz Barn*. Only part of that is still around.

While I was at Pasadena, I discovered that the Museum of Modern Art had proposed circulating a batch of Schwitters works that Alfred Barr had acquired. I said to Leavitt, "Let's grab that material and borrow all the other Schwitters pieces I can get my hands on and do a major show." As usual, his response was "Do you think we can pull it off? Do you think we can afford it?" I said, "I'm sure we can." So, working with almost no budget at all, I pulled together the MoMA works, and I borrowed two from the Phillips Collection in D.C. and others from private collectors. Kate Steinitz lent me some extraordinary material, including a late work that had never been shown. It was called *For Kate*, and it had American comic strips in it. I asked Steinitz, "How was Schwitters, living in England, able to get American comic strips?" She explained that after the war he was very poor and she sent him care packages with food and razor blades and so on, which she wrapped in newspaper. She often used the Sunday supplement with the comics as wrapping paper, and he liked that even more than the food. In return, he sent her the work, which was, without question, the first piece of pure Pop Art to be made. When I saw it, I was just thrilled. Steinitz also had a tiny collage called *The Lust Murder Box*; it was just a few inches high

and wide, a strange little box, with a kind of baby-doll figure inside, wrapped in gauze and dabbed with mercurochrome. A creepy piece.

One thing I did at Pasadena was to pair historical and contemporary exhibits. I paired the Schwitters retrospective with a show in the adjoining gallery called "Collage—Artists in California (Directions in Collage)," which featured more than a hundred contemporary artists, from the Muir Woods to the Mexican border, including William Dole, who wasn't very spectacular, but was the classical entry—abstract and tasteful and Schwitters-like—Bruce Conner, and the San Francisco artist Fred Martin, who was a key player in the Berkeley vanguard. On the west wall, I had the collages arranged geographically, floor to ceiling, with the northern artists at the top and the southerners at the bottom. It was like wallpaper—a collage of collage. In the middle, hung high, was an absolutely pornographic work by Ben Talbert. Talbert was a Southern California Beat artist who was closely allied with the Berman world. He did extraordinary drawings and graphic work as well as assemblages. (In one work, *Clean Up This Mess*, he took a postcard of a Cézanne still life and attached a word bubble to it that says, "I told you once, I told you a thousand times, clean up this mess.") The work in the collage show was a little box with a very graphic photograph of a woman giving someone a blow job, and a real ivory-handled, open straight-edge razor, positioned right near the private parts, which created some anxiety. I hung that up high in such a way that no one could open the little door to the image. There was also a great assemblage by Bill Copley: a paper plate painted pink and covered with lace, in the center of which was an artificial rose with a hypodermic syringe plunging into it. The whole thing was mounted in a little shadow box. In the George Herms section, there was a work called *Macks*; it was a shallow box with a reproduction of a Renaissance lady, a tire iron, an old rubber inner tube, and a crumpled, tattered American flag.

I got into trouble with that show. First, the Health Department came in and confiscated the Copley, because of the syringe, and we had to go through all sorts of legal rigmarole to get it back. Copley himself loved the fact that his piece went to jail. After it was released, he modified it; he put

little black bars across it. That scandal made the museum's board nervous, and they looked more closely at the collages, but fortunately they never opened the Talbert box. The big trouble was with the Herms assemblage. One night the museum was broken into. The alarm system was so weak that it wasn't even turned on. We were being picketed by the American Legion, and someone got through a door and took the Herms piece off the wall and stole the flag. That made the papers. Herms kept the piece in the show, but where the flag had been he put a note that said, "This piece has been raped by a madman and despite this degradation the forces of creation will go on. Love, G.H." Somehow we weathered it. Leavitt stood by me. We had a wonderful old attorney on the board who was a First Amendment conservative. He saved the show and Leavitt's job and mine.

In the fall of 1962, I put on an exhibition called "New Painting of Common Objects," which turned out to be the first Pop Art show in America. It included East Coast and West Coast artists: Warhol, Lichtenstein, and Dine from the East (I hadn't yet heard of James Rosenquist; I didn't see his work until Sidney Janis's "New Realists" show later that year); and, from the West, Ed Ruscha, Joe Goode, Phillip Hefferton, Robert Dowd, and Wayne Thiebaud. (I've since come to consider Wayne Thiebaud essentially a kind of realist, who shouldn't have been in that show, but at the time—this was his breakthrough early work—that was the context he was in.) I didn't use the term "Pop Art" to describe the show; the term wasn't really current in the U.S. yet, though it later floated across the Atlantic from Britain.

Paired with "New Painting of Common Objects" was an exhibition of lyrical abstraction from the West. I wanted to juxtapose what was considered the major vanguard in American art with this new thing. So I had a Sam Francis—a beautiful painting that we'd managed to acquire, which is now in the National Gallery—along with Diebenkorn, Hassel Smith, and some other Western Abstract Expressionists. Sam Francis came to the opening to see his work hung, and I remember Phillip Hefferton, who had a crazy sense of humor, came over to him from the adjoining show and said, "Sam Francis? Phil Hefferton's the name, common objects are my game." Sam laughed, and Phil added, "I hate to tell you this, Sam, but space died

yesterday." Phil was doing these flat pictures of money and other objects, and meanwhile Sam's works were just glorious abstract space. Sam thought it was hilarious.

Hefferton was never shown at Ferus; he just turned up one day at the Pasadena Museum and asked if I'd take a look at his work, so I did. It was very interesting. And Hefferton became an important person in my life. I had a friend then who worked for Pacifica Radio and he suggested that I do a talk show on art. I asked if I could bring Hefferton with me. I had the idea of doing an oddball kind of show—like those old Carl Reiner and Mel Brooks routines. So we did a series of dialogues on art, in which I was the straight guy. I'd say, "Phil, what do you think of Duchamp?" And he'd say, "He's a two-bit Leonardo da Vinci, isn't he?" I think our audience was both bemused and intrigued. It was through Hefferton that I met Jim Eller, a strange and truly brilliant artist whom Hefferton had met somewhere downtown. He made little toy assemblages, and he was probably the fastest learner I ever met. As a young man, he went through four or five different stages of art, and then he dropped out of the art world for years to join a Christian cult. Then he started making art again and trying to find a way to work Christian iconography into it. I showed his work to William Seitz at the Museum of Modern Art and Seitz offered him a show, but Eller turned it down—he was just too young and too shy.

I also curated a show called "New American Sculpture," with a mixture of people—Kenneth Price, John Chamberlain, Lee Bontecou, and Edward Higgins, who made beautiful cement-and-steel sculpture and later disappeared from the art world. It was the first show I ever did that had H. C. Westermann's work in it. Chamberlain was living mostly in New York then, and by that time I was going to New York every chance I could get.

13.

MARCEL DUCHAMP

Tom Leavitt knew about my friendship with the Arensbergs, and he encouraged my desire to do a retrospective of Duchamp's work. No retrospective of Duchamp's work had been mounted yet, and Bill Copley was able to put me in touch with Marcel to arrange it. I'd met Duchamp for a minute, back when I was a teenager visiting the Arensbergs: one day in 1948 or '49, I was in Walter Arensberg's little study, sitting next to Duchamp's absurd and charming work *Why Not Sneeze Rose Sélavy?*—a little rectangular birdcage filled with perfectly carved marble cubes, with a thermometer stuck into it—and looking through some books, desperately fishing around for something in English on modern art, when a man in a blue-purple silk or satin dressing gown wandered into the room. He said, "Oh, I beg your pardon," and backed out and closed the door behind him. That was my first sighting. So when I met Duchamp again in New York, in 1962, the first thing I said was "I think we once began a conversation and I hope we can finish it."

I never worked with a more agreeable or cooperative artist in my life. William Seitz used to say he couldn't decide if Duchamp was an idiot savant or a genius, but it was perfectly clear to me that he was hugely intelligent and he was helpful in every way. He called up Henri Marceau, the director of the Philadelphia Museum of Art, and said, "There's this young man coming over. He's doing an exhibition of my work and I'd really appreciate it if you could lend what he asks for." He was such an efficient man. When someone once asked him what he thought was his greatest accomplishment, he said, "Learning how to use my time." If he was asked "What do you do?" he answered, *"Je suis un respirateur"*—"I am a breather." "We're all *respirateurs*," he said.

When Duchamp came to California in the forties, he often stayed with the Arensbergs. But when he was going to be involved with a

woman—he was a famous bachelor at the time—he sometimes shacked up at the Hotel Green in Pasadena. He didn't want to bring a lady friend into the Arensbergs' home, for propriety's sake. There was a woman he used to see in the years before he married Teeny (Alexina Sattler, the former wife of Pierre Matisse), a retired actress who lived over in San Marino. (She came into the Pasadena Museum at the time of my show and told Leavitt that one day Marcel had been looking out the window at some trees and turned to her and said, "Do you realize that these are just overgrown fungus? They should all be pulled down.") Because he had stayed at the Hotel Green before, Duchamp sent me a telegram asking if he could stay there during the show. I couldn't believe he knew it. We'd meet for lunch often—never breakfast, though he was up early and he'd walk to the museum from the Hotel Green and speak French with an alcoholic poet I had hired as a gardener.

I would work up presentations for what I was planning in the show, and he would look at them and say, "Oh, that's interesting," or "Fine. Let's do that." I'd never had an artist be so engaged but still supportive. I could go on about the dimensions of the rooms for two hours and that seemed to him a perfectly reasonable thing to do. There was no minute detail this man

Marcel Duchamp and Walter Hopps at the opening of the Duchamp retrospective at the Pasadena Art Museum, 1963. Photograph by Julian Wasser.

wouldn't listen to. He made only a couple of suggestions for the show; one was to include a little readymade of two pot holders in the shape of a man and a woman, which I hadn't even known existed, and another was about where something should be located in the installation. It was a bizarre little landscape called *Moonlight on the Bay at Basswood*, a 1953 work on blue blotting paper with chocolate, pencil, and talcum powder, the strangest materials for a painting anyone had ever heard of back then. *Moonlight on the Bay at Basswood* was inspired by an American woman named Mary Hubachek, with whom Duchamp had been involved in Paris and who had died in 1950. (She was the widow of a man named Reynolds; Hubachek was her maiden name.) Basswood Lake, Minnesota, was a place she used to visit in the summers. She was Duchamp's first great love, and she had all the wit and grace of a female Fred Astaire. (Brancusi loved her, too; he used to make dinners for her.) Duchamp told me to position that work so that when you looked at it with one eye, your other eye was looking right through a door at *The Bride Stripped Bare by Her Bachelors, Even*—also known as *The Large Glass*. I said, "My God, these things are related!"

Duchamp loved the fact that I put the readymades (signed found objects) in the same area as *The Bride Stripped Bare by Her Bachelors, Even*, since several of them referred, in a kind of street-talk vernacular, to the more highfalutin ideas that were in *The Bride*. I arranged them as they were arranged in the *Boîte-en-Valise*, Duchamp's box of miniature versions of the readymades: the urinal on the bottom, the typewriter cover in the middle, and the little vial of Paris air up in the air. I did that instinctively, and he was charmed by it. The vial of Paris air was up where the virgin was; the Underwood typewriter cover, which seemed to correspond to the section of *The Bride Stripped Bare by Her Bachelors, Even*, called *The Clothing of the Bride*, was in the middle; and the urinal, a male device, was down on the bachelor level. I said, "Is that the right thing to do?" "Yes, of course it is," he said. This was typical of our exchanges.

A group of Pasadena Art Alliance women came in to look at the installation and reported to Harold Jurgensen, the museum board president, about that urinal, *The Fountain*. Jurgensen was a self-made wealthy man. He'd started as a butcher and now ran gourmet markets in Pasadena, Beverly Hills, and so on. He came over to me and pointed at the urinal and

Installation shot from the Duchamp retrospective at the Pasadena Art Museum, 1963. Photograph by Frank J. Thomas.

said, "I want to know your statement. Is that art?" I said, "Mr. Jurgensen, that is art." He said, "Fine." And he went back to the Art Alliance people and dispatched them. I never had more support in a museum.

Of all the early moderns, no one was more cosmopolitan than Duchamp. Born in 1887 near Rouen, he affected the course of modern art throughout the world, and he was an inveterate world traveler. At the time that he painted *Sad Young Man on a Train* (1911–12), he himself was the sad young man on the train, going down to Munich. While there, he became so interested in reading Kandinsky's *On the Spiritual in Art*, which had been translated into German for a show there, that he holed up in his hotel room with dictionaries. From early in his career, Duchamp also had a fondness for America and Americans. When he was coming over for the first time, in 1915, a couple of years after his *Nude Descending a Staircase* caused a scandal in the Armory Show, he studied English on the ship and made a wonderful little conceptual work called *THE*, which I found in his files and included in the retrospective. The title is up at the top, with a little star next to it. Then there's a piece of text in English and every time the article "the"

comes up he uses a five-pointed star instead of the word; it's a conspicuously American star, an allegory of war, of the U.S. flag, and of George Washington, melded together in a strange way. Many of his readymades were absolutely American—the urinal, particularly. As the artist Beatrice Wood, who was a friend of Duchamp's, wrote in defense of that urinal, "The only works of art America has given are her plumbing and her bridges." It was more than just an ironic remark. For Duchamp, these were two very different realms, plumbing being the low road, and bridges, soaring above life, the high road. That elevated level of engineering really appealed to him. His biggest ready-made, of course, was the Woolworth Building, which was the tallest building in New York at the time. He signed the building somewhere—though the signature was never found—and then he signed a photograph of it, too, to document it.

Duchamp's first home in New York was on West Sixty-Seventh Street. I once said to him, "The Armory Show was downtown and the Stieglitz gallery, which you dealt with, was way down at the foot of Fifth Avenue. How did you get down there?" He said, "The subway. It was new and clean and perfect." In his apartment on West Tenth Street, where he moved in the late fifties, he had a wide range of artwork—Tanguy, Brancusi, Balthus, Braque, and Matisse. (The latter two were likely there by way of his wife, Teeny, but the others represented special interests of his.) But he had only two American pieces on display. One was a wonderful little red-and-black stabile by Alexander Calder, which sat on a rough-hewn Pennsylvania Dutch bench. It has always been assumed that Duchamp invented the mobile for Calder, but Duchamp told me that that wasn't the case. He said that one day he had visited Calder's studio in Paris, during the era when Calder was making his wire portraits. "This crazy American was there, whom I enjoyed very much, named Clay Spohn," Duchamp told me. Spohn was a kind of conceptual *brico-leur*—the grandfather of all Californian assemblage art. "And he suggested to Calder to take the little parts and balance them, making these little contraptions." He told me, "It was this man Spohn, from San Francisco, who invented the mobile. All I did was to name it." The other American artist whose work was on display at Duchamp's apartment was Joseph Cornell. Duchamp had two Cornell boxes on a little shelf next to his bed: *The Pharmacy*—one of the three versions of that work—and another small box. It has to mean

something that the first thing he saw when he woke up in the morning was a Cornell box.

One day I was there trying to work out the show with him, when a reporter from, I think, the *Village Voice* came to interview him. Marcel had, uncharacteristically, mixed up the appointment times, and he was very annoyed with himself. He said to me, "Do you mind? Let's deal with him and I'll get rid of him." So I was able to witness their conversation. The reporter was in over his head, and at some point he said, "Mr. Duchamp, can you talk to me about what it's like to make really far-out art?" Duchamp sort of leaned back and took a drag on his cigar. He always smoked a cigar when he was in a less-than-perfect social encounter. "Far out," he said finally. "Far out." And the reporter started fumbling to explain what "far out" meant. Duchamp said, "No, no. I understand 'far out.' I'm going to show you something really far out." He said, "Walter, could you go to the bedroom and get one of the Cornells to show this young man?" So I came back and held the piece up, like Carol Merrill on *Let's Make a Deal*, and Duchamp started giving the guy a lecture on Cornell in the most elementary terms—Cornell for Idiots. Finally, he concluded, "Well, *that's* far out." The reporter just didn't get it.

Duchamp had met Cornell in 1933 or 1934, probably at a show of Brancusi's work that he organized at the Brummer Gallery, in New York. When Duchamp moved to the U.S. in 1942, he needed help producing his edition of the *Boîte-en-Valise* and he asked Cornell to run the assembly line to put the work together. Cornell was used to working in miniature, clearly, and Duchamp knew about his handiwork and his appreciation for finesse. It's interesting that Duchamp had other people doing his work. He wasn't a lazy man. He was always up and about, a light sleeper. But he was impatient with some of the physical tasks. He wasn't a great carpenter. You can see a lot of bent nails poking through the woodwork and the armatures in his work. But I think Marcel would have thought of Cornell as a kindred spirit—a man of great privacy and discretion. Both men were out in the public world, going to exhibits and openings, but they shared a great secrecy about their own work. They never had people around to watch them work, unless it was an assistant or a collaborator. Teeny, whom Duchamp married in the fifties, was also very fond of Cornell. She'd known him in her days

with Pierre Matisse. And she spent time with him on her own; Marcel was not the guy to meet at a department-store café for cakes and tea, the things Cornell lived on.

Duchamp and Cornell, of course, were the two major artists of the twentieth century who made artwork using found objects. Duchamp was a superb draftsman, as evidenced by his Cubist and Futurist paintings. But he also invented, for all practical purposes, the art and aesthetics of the readymade. In his writings in *The Green Box*—a collection of almost a hundred notes, theorems, postulates, and sketches that he made between 1911 and 1934—he describes the three kinds of readymades. There are the found objects that he simply signed—*The Bottle Rack* (1914), for instance. Then there are the adjusted readymades, made up of several off-the-shelf parts: a bicycle wheel mounted on a stool or *The Ball of Twine with Hidden Noise* (1916). And Duchamp also postulated the reciprocal readymade, in which you take a work of art and do something practical with it—use a Rembrandt painting as an ironing board, for instance. (When I was at the Corcoran, there was a Rembrandt painting so questionable that it was never really shown. I could have got it out of the vault and put it on a pair of sawhorses with some breeches and an iron on it. I wouldn't have turned on the iron, but it would have made a great photograph. I would have titled it *This One's for Marcel*. I regret terribly that I didn't get around to doing that.)

Duchamp had a way of dislocating objects, changing what they meant to us by changing their position. At one point, he had *The Fountain* suspended from a rope in his studio, a kind of curious flying object or chandelier. He had a cast-iron coatrack, with a number of hooks, screwed into the floor of his studio, much to the distress of some of his visitors. It was a hell of a thing to trip over, and what good is a coatrack mounted on the floor? He gave it the title *Trap*.

Duchamp was intensely conceptual. In an interview he said, "I propose to strain the laws of physics," an interesting pun, which I think he was aware of. Other times he referred to his own "silly physics." I asked him what he meant by that, and he said, "Oh, just workaday amateur physics." Before he came to America, to earn a little extra money, he worked in the mathematics and physics section at the Bibliothèque Nationale in Paris; of

all the jobs that he could have done, that was the one he chose. (That job was also one of the reasons that he didn't come to the U.S. in time for the Armory Show.) There's a kind of technical phenomenology in his advanced work. Certain of his later notes concern themselves with the concept of "infrathin" phenomena: the idea that certain two-dimensional objects may be "slices" that accommodate the three-dimensional world within them. Like Walter Arensberg, he was interested in cryptology and codes, as well as the idea of alchemy: alchemists use everyday materials from the real world, but their goal is transformation. It's incredible that Marcel lived into a time when real physical alchemy took place—at the cyclotron in Berkeley, and at the linear accelerator in Stanford.

Duchamp could be quite concrete. If someone had told him that he had to get down to brass tacks, Duchamp would have gone out and bought some brass tacks, put them on the table, and said, "O.K. Now that we have our brass tacks, what are we going to do with them?" At the same time, he was looking for ironies, paradoxical ways in which something that was literally one thing could also portend other things.

Duchamp's interest in broken glass began as an accident. After *The Bride Stripped Bare by Her Bachelors, Even* was shown at the Brooklyn Museum in 1927, it was packed up and shipped off and it somehow broke in the process. Rather than rework it, Duchamp sandwiched the broken shards, which appealed to him in a curious way, between other panes of glass. When we talked about it, he said, "That's part of life. I'm sorry. I wish it hadn't happened, but it has its own sort of beauty." And when his smaller glass, *Nine Malic Moulds*, also broke, he kept it that way. When he made a facsimile of it for the Pasadena show, he went to some pains to have the glass broken to resemble the original.

When Duchamp chose collaborators, he was very clear about whom he wanted to work with. At one point, he worked on several things with André Breton; he also worked with Enrico Donati. Another coconspirator was Francis Picabia, with whom he had a complicated relationship that included Picabia's wife, Gabrielle—perhaps some kind of ménage à trois. Marcel loved to travel in fast motorcars with Picabia, and I think that there's a lot of

Duchamp in Picabia's early so-called Dada machine works. Duchamp was very involved with getting his friend out of the French Cubist movement. I also think that he had his hand in a crazy headdress by Baroness Elsa von Freytag-Loringhoven that looks like the great-grandmother of all Jean Tinguely's sculpture. At times a collaboration simply meant having someone else meticulously carry out Duchamp's plans, as when Man Ray photographed *Dust Breeding*.

With patrons, collectors, and gallerists, Duchamp helped build collections and organize exhibitions. He singled out works for Walter Arensberg, Katherine Dreier, and Sidney Janis, among others, to buy or show. He chose not to profit very much from his own art; instead he traded. Most of the Duchamp work that Arensberg had he got in exchange for the cost of Duchamp's studio on West Sixty-Seventh. Duchamp took commissions on the sale of works by other artists so that he wouldn't feel the pressure to make money on his own. He was also very generous when it came to giving things away. He was one of the first people on the advisory board of the Copleys' foundation—the William and Noma Copley Foundation, which was later called the Cassandra Foundation—and the very first grant went, at Marcel's urging, to Joseph Cornell. Years later I was on the board as well, and at the time of the Pasadena show I recommended Larry Bell. I showed Duchamp some pictures of his work and he said, "Oh, I'd love to meet him." So we drove out to Larry Bell's studio in Venice, and the two of them immediately started talking about glues and adhesives, fiberglass, silicone, and what have you. Occasionally, Marcel would look at a work and say, "This is so marvelous. If only I'd had epoxy." He made most of his work at a time when these things just didn't exist. All he had was rubber cement—which he used rarely—and LePage's glue in tubes. One of his readymades was a LePage's glue box. It's signed and it's adjusted—Duchamp added the word "gimme" above the word "strength" on the LePage's box; he knew that was a slang phrase in America.

Once, late in life, Duchamp made an exception to his normal ethics and produced something purely for sale. He knew that he'd die before Teeny, and he didn't want her to be under pressure to sell any of the important works in their collection, so he made some limited-edition replicas of his readymades, with a dealer named Arturo Schwarz. He had a very sour

view of Schwarz, but he made those editions in order to have some money in the bank. One time he wanted to give me something, and he went fishing around in the closet off the bedroom in his apartment on West Tenth Street. Suddenly I heard him saying *"Merde, merde!"* and he said, "Well, here, you take this one. This is one more extra proof that Arturo asked for and I'm tired of giving him extra proofs." It was a wonderful etching of a drawing of a readymade that Duchamp never actually made. It was inscribed, *"Pour Arturo Schwarz, ap Marcel Duchamp,"* and he said, "Here, I apologize, just erase his name." I never did erase it.

Duchamp told people that he didn't save things. It turns out that it wasn't true. At certain times in his life, he would throw away a lot of things, but the work that was important to him he saved very carefully. It was just that if you tell people you don't save anything they stop bothering you to show them things. It was like when he told people that he was no longer an artist—it simply got them off his back. They'd say, "What are you doing these days?" And he'd reply, "I'm playing chess" or "I'm retired." But all that time he was working away on several things, including *The Clock in Profile*, which was a curious kind of readymade. I didn't see the work itself, but I saw a kind of cardboard maquette in which a standard round clock face was set up so that it was seen from the side. It was telling the time, but you couldn't see the time. It was doing its job, but the spectator couldn't perceive the results. Duchamp was also working on some other conceptual things, like the stereopticon. People would come in and see this strange thing over the fireplace, and he'd claim that he was just trying to make a fireplace hood. He could have his work out in plain sight and people would not necessarily see it as artwork, which was just fine with him. His life in his studio was very private. Almost no one got in there between 1946 and 1966.

One night in Pasadena, we had arranged to go out for dinner. When I went to pick him up at his hotel, he chose a restaurant by looking in the yellow pages; it was called the Pepper Mill, and its logo—which appeared in the phone book—was a pepper grinder that looked just like Duchamp's chocolate grinder of 1913. When we got to the restaurant, while we waited for our table, he went fishing around to see if there was any printed matter

Teeny Duchamp, Richard Hamilton, Betty Factor, William Copley, Monte Factor, Walter Hopps, Betty Asher, and Marcel Duchamp, in Las Vegas in 1963.

with that image on it. At dinner I said to him, "Over these last years, you've supposedly stopped making art, but, if you happened to have been making something important in secret, would this be the time to show it?" There was an unusual silence. Then he smiled and said, "Were it the case that I had been making such a work, no, this would not be the time to show it." As soon as he said that, I knew there was something. I didn't know what, but I knew there was something. At some point around then, Duchamp was asked what would happen to the serious artists of the future, and his answer was "They will go underground."

Duchamp died quietly, at his home in France, in 1968. Not long after that, I got a call from Bill Copley asking me to come to New York. I flew in, had dinner with him, and then he said, "Now we have to go somewhere." I knew then, knew what it was, and we went there—to Duchamp's secret studio—and it was absolutely astounding. As we entered the studio, we were looking at a false brick wall with a set of doors that didn't open. There was a peephole in one of the doors, and through it you could see a reclining nude lying on her back, her legs spread, her head hidden—you could see her blond hair and a bit of her cheek, but not her face. The only thing to indicate that she wasn't dead or sleeping was the fact that her arm was

extended: she was holding a gas lamp up to the landscape. Behind her was the flicker of a waterfall. It was so overwhelming that I looked away and started looking at the worktables and other things around the periphery of the room. That's what Ed Janss called "the Israeli strategy"—building on the edge of things while everyone else focuses on the center. I picked up a piece of paper from a table, and it turned out to be the title of the work, for heaven's sake. The complete title of *Étant Donnés* is written out as a theorem: "Given: 1.) The waterfall. 2.) The illuminating gas." I had no idea what I was picking up. *Étant Donnés* was his magnum opus. Some people have assumed that the figure in *Étant Donnés* is a rape or murder victim. My answer to that is: "How is she holding this gas lamp up in the air?" She's alive; she's just reclining.

For the Pasadena show, I had designed an invitation—a sheet of green paper, folded, envelope-size. When you pulled it out of the envelope, you saw a die-cut hole with an eye peeping through it. You opened it, and there was a photograph of Marcel—a photograph I took of him—standing next to his readymade wooden door. The eye was my idea. I don't know where it came from. Perhaps it had to do with the mystery of his work. When Frederick Kiesler installed Duchamp's *Boîte-en-Valise* at the Art of This Century gallery in 1942, you viewed it through a peephole, and perhaps I was thinking of that. When Marcel saw the card, he gave me a very funny look. I said, "Well, what do you think?" He said, "That's very nice. Why did you choose that photograph?" I said, "Well, I love the paradox of the door. When you open it, you close it, and when you close it, you open it." "Oh," he said. "And what about the peephole?" I didn't really understand why he reacted in that way until I finally saw *Étant Donnés*. It has occurred to me that Duchamp's decision to make *Étant Donnés* the way he did may have had something to do with Cornell's influence and his love of boxed assemblages. He began working on it in 1946, at a time when he was thoroughly imbued with certain elements of Cornell's work.

In any case, it thrilled me the moment I saw it, and over time I realized that *The Green Box* and *The Bride Stripped Bare by Her Bachelors, Even* were just a stop on the way to the three-dimensionality of *Étant Donnés*, a trompe-l'oeil tableau. The number three was very important to Marcel. There are three versions of *Nude Descending a Staircase*: the famous one

in Philadelphia, the version that he made for Arensberg, and a miniature one that went into Florine Stettheimer's dollhouse. Duchamp went out of his way to come up with this system of threes. When you make two, you have a classical dialogue in duality. With three, you've invented the law of chance.

The night after I saw *Étant Donnés* for the first time, I went back to Bill Copley's apartment at the Imperial House on East Sixty-Ninth Street but I couldn't sleep. I was up and walking around all night. I wondered who could have seen or known about the work before Duchamp's death. The three women in his life, possibly: Mary Hubachek, who figures in there somehow, as a subject or part of it, whether she knew about it or not; Maria Martins, with whom Duchamp had an affair in the forties (they shared a studio in New York, but it had to be kept very secret, because she was stepping out on her husband, who was the Brazilian ambassador in Washington); and, of course, Teeny Duchamp, who worked with him in the final stages, especially to make the body of the woman holding the gas lamp. On the male side, there was Robert Lebel, who was a great collector and who wrote the first serious monograph on Duchamp. He was one of Duchamp's favorite people, and he owned an extraordinary drawing for *The Bride Stripped Bare* which showed an electric pole and wires hooked up to it. *The Bride Stripped Bare* doesn't require electrification, but it's absolutely essential in *Étant Donnés*. And then we have Copley, who was a close friend. Duchamp knew Copley had money, and he wanted him to buy the work and guarantee that it would go to the Philadelphia Museum—and that was what happened. So Copley knew in advance, probably shortly before Marcel died, and made the arrangements. It's possible, too, that Cornell knew about it.

I know firsthand that Duchamp was not the least bit concerned about having a biography written about him. He thought it was beside the point. When the Archives of American Art asked me to interview him, late in his life, he said, "Well, I've done so many interviews by now. Wouldn't you rather just get together in New York, have a good supper, and talk about whatever we like?" I said, "That would be terrific." And I think that was the last time I was with him. He smoked his cigar, and we talked about whatever we liked.

14.

THE PASADENA ART MUSEUM, PART II

Just before the Duchamp retrospective went up, in 1963, Tom Leavitt resigned from Pasadena. I became acting director and, shortly afterward, director. I just dug in and kissed goodbye the idea of ever going back to school. I also brought in James Demetrion, a colleague who was teaching at Pomona, to be chief curator. When I first tried to hire him, he said, "Why?" I said, "I need you." He said, "That's not enough of a reason. What else?" I said, "You don't know it yet, but you were born to be a museum person. There are a lot of people who can teach art history but there are damn few who are any good in a museum." He said, "How do you know that?" I said, "I just know." He said, "I'm not convinced." By this point, I was getting irritated. "O.K., when I collapse or they throw me out of there, I want you to be able to take over. I'm choosing you as my replacement." He looked at me and said, "That isn't going to happen." I said, "Jim, I know it is." I knew about my own addictions—I was addicted to amphetamines and I knew that I was going to crash and burn at some point. In any case, he finally agreed to come aboard.

Demetrion wrote the catalogue introduction for the Alexej Jawlensky show I was working on—an important retrospective in 1964, which was only at Pasadena, sadly. Jawlensky was a beautiful painter and at that time probably the least recognized of all the painters in the Galka Scheyer collection. He was far better known in Europe. Demetrion and I also worked on a Paul Klee show. There were two versions: one to tour America, which would open at Pasadena, and one to open at the Guggenheim and then tour Europe.

At Pasadena, we were in the lucky position of being able to outmaneuver the twentieth-century department at the old Los Angeles County Museum of Art and bring in several of the important modern surveys that

were done on the East Coast. We brought in the great Kandinsky retrospective from the Guggenheim and we took on a Magritte show from the Museum of Modern Art. We also brought in an Emil Nolde retrospective from the Museum of Modern Art. Among the German Expressionists, Nolde was one of the most interesting; he made some of the most powerful woodcut prints of the twentieth century, and he did some exquisite watercolors as well. Nolde worked up on the North Sea, near Hamburg, so there are some wonderful seascapes. His paintings sometimes seem a little lurid and strident, and are quite Christian in their iconography, but Nolde did something very special late in life. At first, when the Third Reich came in, he supported the cause. So when he found his name on the Nazis' list of degenerate artists, he was shocked. He built a chamber in his house where he could work in secret—a hidden room with only a little faint light—and in there he made some small pastels in chalk. Figurative things, very delicate and magical, with a special intense color. I was so moved by how he'd made these works that I created a special room for them, behind a curtain, in the middle of the show, a kind of replica of the room where they had been drawn. People could go in two at a time; the room was very claustrophobic, with the works spotlit, but I wanted them to be seen that way.

I was able to experiment with installation techniques at Pasadena—whether it was doing a whole wall of collages or a salon of drawings or just isolating and spotlighting certain works. I tried to think about how to reestablish the artist's physical situation vis-à-vis the work in a very different public space. Schwitters, for instance, always had lots of work around him—I was thinking of the way he'd installed his *Merzbau*—so when I hung his show I organized things in sets. I came up with a little repertoire of configurations—three or four configurations—so that it wouldn't be just one damn thing after another on the wall. There could be three or five works in a row. Or a cross of four works—two in a vertical line and one on each side. Or an H configuration of five works. Each set was spaced at a certain distance from the next set, and when it was hung right it didn't call attention to itself or look mannered. With small works that you look at intimately, you can simply isolate them, one at a time. Later, if I moved a show, I had to remember each of the sets in order to reconstruct them. With

Kandinsky, I did something that would have horrified the Guggenheim. I had certain of the freeform cosmology paintings simply floating in space: I put cardboard on the back and some kind of a wood frame on the floor, so that I could just suspend the paintings in the air, with the front lit and the back in shadow, and they looked terrific.

At one point, when we had a hole in the schedule looming and not much of a budget, I came in one morning and said to Demetrion, "I know what we're going to do and it's going to be a great show." He said, "What is it?" "It's called 'A View of the Century.'" He said, "'A View of the Century'? What a pretentious title. How can that be a simple show?" I said, "We're just going to do our own survey. One work by each great artist, Museum of Modern Art–style, from Southern California loans. We'll get a Cézanne and a Monet, a Picasso and a Matisse, and we'll just keep on going right up to Jackson Pollock; I know where we can get a great Pollock." We pulled it off in the end, but it made him nervous as hell. We didn't have any of this in the museum—no museum in L.A. did then. So people loved it. Not everything was a masterpiece, but it worked.

I also did a large show of pre-Columbian art. Rowan had collected some and I knew some other people who had as well. The great pirate of pre-Columbian art in Southern California was a man called Earl Stendahl, who lived next door to the Arensbergs on Hillside Avenue. As a matter of fact, his family took over Walter and Louise's house when they died and did the job of packing up the Arensberg work to ship to the Philadelphia Museum. Stendahl's son-in-law, Joe Dammann, worked with him. They used to bring the work up from South America by boxcar, packed in straw. They had a gallery and they helped me meet up with some extraordinary collectors around Southern California. In the course of working on the show, I heard about a blacklisted Hollywood writer, Dalton Trumbo, who had gone to live in Mexico for a time and had brought back some amazing things. He was living in Highland Park, south of Eagle Rock, where I'd grown up. One afternoon I drove to the end of a street and took a dirt road through eucalyptus trees and brush until I got to a house and some outbuildings. The front door was obviously not used, so I knocked on a screen door

in the back for a while. Finally I heard a voice off in the distance say, "Come on in." I walked through the house calling, "Hello, hello?" Finally, I heard the voice say, "Come on in here." In the bathroom was a strange little man sitting up in a big old-fashioned bathtub full of water, with a board set across the tub. On the board was a typewriter, and he was typing away. He said, "Excuse me, but I like to work in a nice warm tub. Why don't you go in the kitchen? There's some coffee and milk and cookies. Get yourself a snack and I'll join you in the sitting room shortly."

Around this time, I brought down to Pasadena Jay DeFeo's great masterpiece, *The Rose*. I first saw *The Rose* in DeFeo's top-floor apartment on Fillmore Street in San Francisco. It was in a bay window—the only thing in the room—and the windows on either side of it were spattered with paint, so that light came in softly. Paint encrusted the floor and the walls, giving the impression of a kind of primordial cave, in which the painting was an apparition, a flower, a great female symbol. The power of the work was overwhelming. DeFeo worked on that painting for years and years. She just couldn't let it go. Dorothy Miller wanted to include it in the "Sixteen Americans" show at the Museum of Modern Art in 1959, but DeFeo didn't think it was finished; it appeared in the catalogue but it wasn't at the museum. The galleries that had been interested in DeFeo's work gradually faded away while she worked on that piece.

In 1965, I heard that DeFeo was being evicted from her apartment. Although it raised a few eyebrows, I arranged for *The Rose* to be taken out of the building in San Francisco and trucked to Pasadena. There was so much paint on it by then that it weighed more than a ton. It was more than ten feet high and a foot thick. We actually had to cut a hole in the wall and have a forklift lower it down. I didn't have budget authorization to do this; I just did it and Demetrion covered for me. Then we cleared out a storage room in the southwest corner of the museum—a room that was already, felicitously, painted black—and we installed the painting there. DeFeo made me promise that she could come down to Pasadena and access the painting, because she had "a little more work" to do on it. She stayed at my house for about three months. When I came in to work in the mornings, she'd come, too, and go into that room to work on the painting. Finally, I had to tell her that the painting was finished and send her back to San Francisco. It was

one of the hardest things I ever had to do. I took her to the Huntington Hotel, where she could catch the airport bus, and she was lying on the street, next to the bus, crying. I had to pick her up and put her on that bus. Sadly, I left the museum before the painting was ever shown publicly. One of the first things Demetrion did when I was gone was to open that gallery.

At Pasadena, we did concerts as well. There was a chamber-music society in residence that performed from time to time in our little flat-floor auditorium in the back. And I brought in the contemporary music that I liked: Morton Feldman and John Cage, whom I admired enormously. We generally got a pretty good audience—enough to fill the hundred or so chairs we had there. The afternoon that Cage was due to come, Clyfford Still was in town and came to the museum to see me. I had a work of Still's hanging in my office—on loan from Hassel Smith—which I was trying to get the museum to buy. I also had a Jasper Johns red-yellow-and-blue target painting hanging there, which I wanted the museum to buy as well. Neither was bought, in the end. (Demetrion later bought the Still for the Hirshhorn, where he had a budget to buy everything we'd passed on in Pasadena.) In any case, when Still arrived I was tied up with the concert, and he decided to join me. I was very worried about this. Still was such a distinguished older man, and Cage at the time was doing some very difficult avant-garde things. He'd grind vegetables in a blender with a contact mic on the blender, so you'd hear a terrible roaring noise, and then a gurgling sound as he swallowed whatever he'd liquefied. Cage had the pianist David Tudor with him, and some percussion, and he had the blender and the carrots and celery and so on. The concert began and Mr. Still, who happened to like the great piano music of Beethoven, was sitting there very stiffly, listening for an hour or so without an intermission. When it was all over, he said, "Mr. Hopps, this was a very interesting concert. Please convey my compliments to Mr. Cage, even though our aesthetics are committed to their mutual destruction." He took his leave, and I went up to Cage and delivered this message. He said, "Oh, that's too bad. I don't wish him any harm at all."

*　*　*

By the time I was at Pasadena, I already knew and admired the work of both Robert Rauschenberg and Jasper Johns. I'd first seen Johns's work at the Leo Castelli Gallery in 1958, the same year that Tom Hess, the editor of *ARTnews*, put Johns's *Target with Plaster Casts* (1955) on the cover of the magazine and launched Johns's career. I wanted to do shows of both Johns and Rauschenberg, but Johns turned out to be the easier to arrange. The work of his that had been in the 1964 Venice Biennale was being packed up, and I was able to borrow that as the core of my show. There was also some new work that hadn't been seen in a museum yet—the extraordinary piece that Ed Janss bought, *According to What* (1964), was the climax of the show. And I borrowed the painting *Tennyson* (1958), as well as some things that were owned by other collectors in the area at the time. I also loved Johns's drawings. I called him up one day and said, "Look, I've got a wall in one of the galleries that's covered with monk's cloth and I want to feature studies and drawings in there. I'd like to have it covered practically floor to ceiling. Can we work it out?" He hadn't seen the museum at the time, but he promised to bring over a couple of portfolios full of drawings. We had them framed and did the wall that way—all in pencil and ink and arranged chronologically, right to left, as you walked through the gallery.

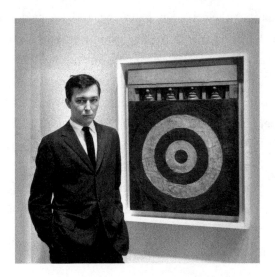

Jasper Johns, standing beside his mixed-media painting Target. *Photograph by Ben Martin.*

Just before the show opened, I was finishing a last-minute installation. I had the drawings partially up and I saw a better arrangement. This was the middle of the night, and I told Hal Glicksman, whom I'd hired as my chief preparator—he was involved in the very early days of the Merry Pranksters—that we had to redo the wall. He said, "It's two in the morning, and the guys working here are dying." I said, "Well, we have to redo it. There's nothing I can do about it. Here's what we'll do. They've got to rest. There are some mattresses in the basement and I'm going to let the guys go down there and sleep for a while. But, before they go down, I'm going to give them some Coca-Colas and I'm going to lace them with a hefty dose of speed." And off they went. I went to my office to take a little nap, and, not long after, Hal came by and said, "They're up and they're raring to go." In they came, and they had no trouble taking it all apart. "Want to arrange it this way? Anything you say, boss." So we got it done.

The next day, everything was ready. The press came in for a preview. Then there was an early dinner at Rowan's house before the opening. All of a sudden the lights in the back of the museum went out. An entire section of the show was in darkness, and people were going to be arriving in a couple of hours. So, instead of going to Rowan's dinner, I stayed there with Glicksman and we went through the yellow pages trying to find an emergency electrician. An electrician came by and he said, "It's old wiring burned out in the walls. We don't have time to dig in there for tonight." I had an idea. I said, "Let's make a deal with the old hotel next door. Can we shack onto their juice and override this?" He studied the situation and said, "If you can get permission from them, I think we can do it. I happen to have some big jumper cables." I said, "This isn't going to burn down the building, is it?" He said, "You don't have a building here that'll burn very easily— that's why it's so hard to get into the walls." So we hooked in a live line and lit up the show, but there were these strange cables hanging off the side of the museum all night. That poor old museum—so many times I got shocked by the lighting system I had to work with. One time I was knocked right off my ladder. But the proportions of the rooms were wonderful.

15.

THE 1965 SÃO PAULO BIENAL

In 1965, I was offered the chance to be the commissioner for the American pavilion at the São Paulo Bienal. Alan Solomon, whom I knew, had been the commissioner for the Venice Biennale in 1964 and had recommended me. I accepted like a shot. I was dying to see Brazil. The Bienal was handled in those days by the United States Information Agency. There were some real rough customers buried away in that agency; it was a cover for a lot of CIA agents. The Bienal fell into its cultural category, a kind of benign propaganda program.

The general format was to choose one major figure and then add works by several lesser figures. For the major figure, I decided to go with Barnett Newman, who was my friend by then. Of all the old New York School artists, he was the one I was closest to; I spent time with him whenever I was in New York. I decided that there would also be three younger New Yorkers and three younger people from California. From New York, I chose Frank Stella, Donald Judd, and Larry Poons. I liked that period of Poons— he was doing little elliptical dots on a color-wheel canvas. From the West Coast, I decided on Robert Irwin; Larry Bell, who was doing immaculate glass-box sculptures; and Billy Al Bengston, who was doing sprayed lacquer paintings that were startling and brightly colored and symmetrically patterned. Irwin, at the time, had some subtle convex paintings, seven- or eight-foot-square canvases, with tiny little dots in the center—this was before he made the disks with lights—that created a sort of hallucinatory optical effect, so that you'd see pulsing color out in front.

At first I thought of commissioning each of them to design an architectural structure. Newman was going to show his synagogue; Stella was going to do a water garden, with patterns in colored concrete; Bengston was going to do a birdhouse with an outer shell and an inner structure with glass—the

outer structure was all foliage and birds, and below you had a tunnel, so that you could walk through it all without the birds shitting on you. But Irwin and Judd never got around to figuring out what they wanted to do, so I abandoned the idea.

It was a long trip to São Paulo; you had to fly into Rio first, then change planes. I think I got to make one trip down there to meet people and see the space before it was time to make final selections. São Paulo is a huge and daunting city, very modern, very cosmopolitan. I left Washington, D.C., in winter, and suddenly I was seeing string bikinis on Ipanema Beach. The space for the Bienal was in a park called Ibirapuera, in an enormous building where they produced not only the Bienal but expositions of agricultural machinery and you name it. It was a couple of football fields long. I learned a few Portuguese words and sentences, and otherwise I got by with some Spanish and English. Our ambassador at the time was Lincoln Gordon. I ran into trouble with him right away, because his wife was an amateur painter and she gave him a lot of grief because I hadn't chosen Edward Hopper. I said that I loved Hopper's work, but he wasn't living and this show was supposed to be for living artists.

I knew there'd be problems there, and there were. The consul general in São Paulo was a terrific man named Niles Bond, and he was a great supporter of what I was trying to do, helpful in all sorts of ways. After I was chosen, I was briefed by State Department people, who explained that I could give talks in addition to doing my show but that I should not get involved with the local artists. I said, "Why not?" They said, "There's a lot of political unrest in Brazil and you never know who you're dealing with." But, of course, I did get very much involved with the local artists. During the time I was there, there was a nonviolent military coup, and the liberal government of João Goulart was overthrown. That was when Frank Stella made his great remark to the press. He said, "I like your two-party system here." They said, "What do you mean by two-party system?" He said, "Well, you have the Yes Party and the Yes, Sir Party."

While I was in Brazil, I was assigned a United States Information Agency officer—a cultural-affairs officer—named Al Cohen. I asked Bond what was so cultural about Al Cohen, who was always turning up and watching what we were doing. I said, "Don't get me wrong, he seems nice.

But why is he here? What does he do?" Bond said, "Don't you understand? He's Agency." I said, "What do you mean 'Agency'?" He said, "He's our CIA plant." But Cohen did me a great favor. I was in São Paulo when the Watts riots took place in Los Angeles. I was a long way from home and I wanted to know what was going on in L.A. I tried to phone my parents, but I couldn't get a call through. Everyone was trying to call. Al Cohen heard about this. He said, "Walter, come over here. I can get a call through for you." He said, "Can we take a walk that you'll swear we never took?" I said, "Sure," not knowing what was going to happen. So we took a cab into the city and we went into a big modern office building and up to a floor where there was a door with a keypad. Al punched in a number and the door opened and we went into a room with the most amazing array of communications equipment I'd ever seen, no windows, guys sitting at radio and telephone banks. This was the communications point for the CIA in São Paulo. Al pointed to one man and said, "Give this man the number you want to reach, and he'll put through the call for you." So I gave him my parents' number and the call went through and my mother was on the line. The man said, "Just a moment, please. It's Walter Hopps calling." She said, "Where are you? Aren't you in Brazil?" I said, "What's going on with the riots? Is anything happening near you?" She said, "Oh, we can see the smoke, but it's not near us." We chatted for a bit, and that was that. I think I bought Al Cohen lunch.

In terms of packing, this show was something else. The paintings were so big that we didn't want to take them off the bars to roll them, so they were transported in huge crates. We got everything to New York by truck, and then it was packed and went by ship to Santos Harbor in the state of São Paulo, and then by truck again to the city of São Paulo. It was quite a procedure. I designed the packing for the Larry Bell glass boxes. He had never been able to ship them without some getting broken, but I came up with an idea: I had some heavy plywood boxes made and lined with felt that would slip like a tight skin over the glass box, and then a top and a bottom, also lined with felt, screwed onto those, so that each glass box now had a hard skin. The boxes were maybe one or two feet square. Then I had a big outer

box in which the smaller boxes were suspended by ethyl foam chips so that they could just float around. Not one thing broke—they made it all the way from the West Coast to New York, onto boats, and into the harbor and onto trucks in Brazil without anything even getting cracked. It was all very expensive, but the government was paying for it.

I took Hal Glicksman with me, and his wife, Gretchen Taylor, who was the registrar for the show. Ed Janss wanted to contribute money so that his daughter Dagny and a college friend of hers named Christine could be docent guides for the show. Glicksman said, "Boy, what a terrible idea." I said, "Why, Hal? It's nice that he's doing this." Hal said, "If those girls get pregnant while they're in Brazil, Ed Janss will kill us." Well, they played around a lot but they didn't get pregnant, and my staff had a great time. We had rooms in a hotel, but a couple of nights we were so tired that we just made a little nest of packing materials in one of our big crates and slept there. In the morning, we'd go to the café and get something to eat. I think I spent two months in Brazil, and in the midst of it I got pneumonia and needed shots of penicillin.

While we were hanging the paintings in this huge pavilion, I'd stand a certain distance away to see if things were right, in terms of the long vista.

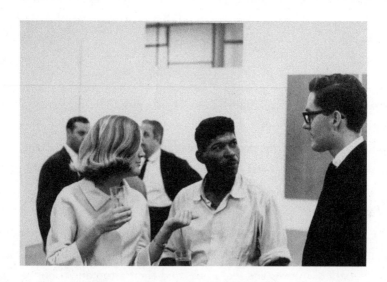

Dagny Janss and Walter Hopps (far right), with unidentified guest, at the São Paulo Bienal, in 1965. Photograph by Hal Glicksman.

Whenever it looked good, I'd give the workers the O.K. sign, but I saw some funny reactions. Later, somebody explained to me that for a Brazilian that sign means the same thing as giving the finger. So I said, "Let's agree on thumbs-up. When it's all O.K., I'll do the thumbs-up," because I couldn't shout from that distance, and we had no walkie-talkies.

I don't remember if Larry Poons and Robert Irwin came down, but everybody else did. Newman insisted on going. Annalee, his wife, was very nervous about it. Barney was older and he'd had heart trouble at one time. There was a whole year in his career when he didn't do any painting at all—a year or a year and a half in the late fifties is just a blank. But he had canceled a retrospective at the Guggenheim in order to do this, and he loved the idea of younger artists being involved. He was genuinely interested in their work—Bell's, especially—and both Stella and Judd were great fans of his. Newman told me, "I'm delighted to be the engine in this really great train we're pulling." When he arrived in Brazil, reporters asked him, "What's the meaning of this art?" Newman gave one of his incredible answers. He said something like, "I can tell you this. When all the boundaries of nationalism fall, and the world is one people, the meaning in my art will be perfectly clear." Depending on the slant of the particular newspaper, he was reported every which way. "This man is a strange radical wanting all the nation-states to fall!" and so on. The press didn't know where to go with that response. It was an astounding antinationalist statement, and it didn't make the embassy happy—Lincoln Gordon's wife was saying, "I told you so," and we were getting grief from the embassy in Rio. But Niles Bond was just fine with it; he backed me up on everything. One day I was at the show, standing near Newman's *Vir Heroicus Sublimis* (1950–51), which we had borrowed from the Modern, and some guy was walking by with a two-by-four balanced on his shoulder. He was holding it with one hand and he turned and the end of that two-by-four missed whacking the painting by so little, I almost passed out. Fortunately, Newman didn't see that. I went to quite a lot of trouble to have people posted, guarding that painting.

At the press conference, the reporters also asked Newman whom he most wanted to meet in Brazil. He said, "I want to meet the greatest Brazilian

of all." They said, "Who is that?" He said, "I want to meet Pelé and see him play." Pelé was the greatest soccer player in the world at that time, so the press loved that, and it was arranged for us to go to a game. Pelé was instructed to come over at halftime and meet this American artist. I just sat and watched: the white-haired American and Pelé, the superb black Brazilian athlete, shaking hands and smiling at each other. Pelé's team won the game, of course, and afterward there were mobs of people; Barney was sweating and Annalee wanted to get him back to the hotel, but we were stuck in traffic. (Her refrain, from that soccer game forward, was "Walter, if Barney has a heart attack and dies, I'll never forgive you.") Finally, in whatever language possible, I indicated to the driver that we had to get out of there. He just drove up on the sidewalk and held down his horn. People were leaping out of the way, and we went most of the way back to the hotel on the sidewalks. Newman loved it.

The show was one of the best surveys of Newman's work that had been done up to that time. There hadn't been one like it since the French & Company show that Clement Greenberg arranged back in the fifties. But then came the next crisis. Newman had insisted on being hors concours, and made a big point of saying that all the artists who participated in the Bienal were honored just by being there. He didn't believe in competitions. He said, "This is not a sporting event." So there was a whole brouhaha about that. The French commissioner was elected head, and he chose French as the language for the proceedings. Pontus Hultén, who was there representing Sweden and who spoke French, made a point of saying, "Let's sit together and I'll translate for you." He had to explain to the jury that it wasn't an insult for Newman to decide to be hors concours. Then the Frenchman nominated the terrible Victor Vasarely, who was representing France that year, for the grand prize. We all insulted him by vetoing that. Then I said to Pontus, "What about Alberto Burri from Italy? He's a good painter." So we started a groundswell, and got others behind it, and Burri won the grand prize.

We saw some interesting things while we were there. Lasar Segall, a Lithuanian artist who had settled in Brazil, had died a few years before, but his house was preserved as a museum. Stella was very intrigued by the

work, and I could see that it affected him; certain colors turned up in his own work afterward. I also met a fascinating younger artist named Frederico Jaime Nasser, who hung out sometimes in my hotel room with his friends. The room had the usual desultory hotel prints hanging on the walls, and Nasser and his friends took them apart and made these fantastic collages, right on top of them, then put them back in the frames and hung them up. I've often wondered what happened to those. They may be hanging in that hotel room to this day. I spent time with that group, which could be why I got pneumonia, because after dinner they'd go out to the clubs until late morning. It was the time of Astrud Gilberto, and there was music everywhere.

After the Bienal was over, I was invited to bring the whole show back to America and present it at the old National Collection of Fine Arts, which was in the Natural History building of the Smithsonian, behind a huge stuffed elephant. I remember Bengston complaining that when you left the show you had to look right at the asshole of the elephant. The show was redesigned, translated back into English, and installed there, but there were problems with the walls—they couldn't hold the big Newman paintings— and we needed to do the construction work all over again. Sadly, an art handler dropped and broke a Larry Bell box. Those boxes went all the way to Brazil and back without a scratch, and then an art handler broke one. The Irwins were hung in a strange place where there was molding on the walls. He came to check out his installation and saw that there were shadows around the edges of his paintings, where the molding was. So he did an extraordinary thing: he worked night and day to make a reverse trompe-l'oeil painting. He painted the molding so that, if you stood in the normal place to look at these works, you couldn't see it at all. He painted the shadows out. He was one of the most obsessive people I've ever known.

At the NCFA, they didn't have many guards. One day a guy came in, a respectable-looking man in a business suit who must have had a fight at home or too many Martinis at lunch, and he freaked out on Donald Judd's big galvanized-sheet-steel boxes that were hung on the wall. He went up and started pounding on them. *Boom, boom, boom!* They had to be remade.

It was crazy: everyone had treated the show respectfully in Brazil, and in America we had an art handler who dropped a Bell and a nutcase who pounded on the Judd. That was my first encounter with the Smithsonian.

Back in Pasadena, I talked to Robert Rowan about doing a Newman show there. I told him that there was an extraordinary series of new works that I wanted to pair with some earlier work called *The Stations of the Cross*. We hadn't had those in Brazil. Rowan refused. He said, "We can't feature *The Stations of the Cross*. That's a Christian theme, and we're going to get in trouble with the churches. We just can't have controversial work like that." So I didn't get to do a Newman show.

16.

FRANK LOBDELL AND JOSEPH CORNELL

In 1966, I put on one of the first museum shows of Frank Lobdell's work. Of all his important Western contemporaries—Bischoff, Diebenkorn, Francis, and Thiebaud—Lobdell is still, for some reason, the least known, nationally and internationally. There are a few possible reasons for this. One is that he was uniquely indifferent to public exhibitions. Another is the challenging nature of his imagery—it's dark and primordial—which makes the work difficult for collectors. His paintings have a haunted air to them; they're like William Blake turned Abstract Expressionist. They must be among the least decorative works of my time. (It's interesting to me that when I introduced Kienholz to the art in the Bay Area, back in 1954, Lobdell was one of the artists he liked the most; when we started Ferus together, Ed absolutely wanted to represent Frank. There was a toughness to the work that he loved. We couldn't get anybody to buy it, though.) Third, Lobdell dedicated years of his life to being a vital teacher of art, at the San Francisco Art Institute and at Stanford. He wasn't the kind of teacher who turned out clones of himself; he was simply an artist's artist. He himself was one of the artists whose careers flourished under the GI Bill, which covered his tuition at the California School of Fine Arts.

Lobdell's earliest work, which involved a palette of reds, yellows, and greens, may have been inspired by Cameron Booth, the Midwestern pioneer of Abstract Expressionism. Sometimes Lobdell worked monochromatically—in black, brown, or a putty color, or in incredible acid greens, orange, and red. Later he went into a phase of doing black and gray figures drawn against the surface of a stone-like background. His drawings from the late fifties look like imagined cave paintings—they're seemingly simple, troubling works. After that there are some more whimsical, joyful works that, if anything,

relate to Miró. His work is full of biomorphism. Not a lyrical biomorphism, like Gorky's, but something more blunt and atavistic; there's a sense of ancient cultures, right on the edge of abstraction. Lobdell never had the figurative literalness of Diebenkorn or Thiebaud, but he often had the tone of a forbidding late Goya. There's an untitled painting from 1958 that shows something like a long-necked bird, a terrible-looking thing with a lump on its neck, against a heavy sea-foam-green ground. I told him once that that painting gave me the willies. He laughed. "It's pretty strange, all right," he said. "Nobody ever wanted that." These things are built into the paint, so deeply that they're almost hallucinatory. Are you really seeing them? Yes, you are, but . . .

This was toward the end of my time at Pasadena, and my state was deteriorating. Lobdell was a heavy drinker, and the two of us together were a difficult combination. Frank hated going to openings. Once, when I was in New York, he was having a show at Martha Jackson Gallery. He was staying with a friend in Hoboken, and I took a taxi all the way over there, not knowing then how to take the PATH train under the Hudson River. I got to the apartment and tried to get Lobdell to go back to the city for the opening. I was standing at the window. I said, "Come over here, Frank. There's Manhattan, just over there. That's where your show is going on." But he just stared out the window, and I don't remember how I got home.

The night of the opening in Pasadena, I went to the hotel where he was staying to pick him up. He was already soused. He wasn't an ugly drunk, just a paralyzed one. In those days, I was taking speed, and on top of that I was drinking his bourbon right out of the bottle and saying, "We've got to go. They're going to kill me if I don't get you to the opening." So we got in the car. We were driving through a suburban neighborhood, north of the museum, and I said, "Christ, this is really a rough ride. What's wrong with these streets?" And Frank said, "Walt, you're not on the streets. We're driving across lawns." I said, "Really?" And he said, "Yeah, people have had to run out of the way." He turned the wheel and we bounced back over the curb and onto the street. Apparently we'd gone two and a half blocks across people's front lawns.

A few months later, in December of 1966, I put up my last major show at Pasadena: a retrospective of Joseph Cornell's work.

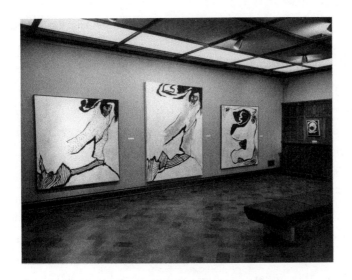

Installation shot from Frank Lobdell show at the Pasadena Art Museum, 1966.
Photograph by Frank J. Thomas.

Cornell was born in Nyack, on the Hudson River, and he lived his entire life within a hundred-mile radius of New York. His ancestors were Dutch— another family name was Storms—and he was proud to be the descendant of a sea captain, but he himself never traveled anywhere, except in his mind. I think he went up to the Wadsworth Atheneum in Hartford, Connecticut, and maybe to the Philadelphia Museum. But he never went to Europe, was never even west of the Allegheny Mountains. Nevertheless, he was an enormously cultivated man. From the twenties on, he haunted the libraries and bookstores, the galleries and museums, the theaters and public spaces of New York City. This was all part of his very rich self-education. He lived like an eighteenth-century prince, on very little money, availing himself of all that the city had to offer culturally. I am convinced that the parrots in his work signify beautiful people, and that many of his boxes are a surrogate for what, in his day, would have been called "café society," an idea he adored. He collected Baedeker guides from Europe and used engravings from them for his collages. I suspect that he would have known exactly where in Paris to get Proust's favorite madeleines. He had a passion for French and Russian ballet. He probably had more empathy for the world of French Symbolism than any other American artist had. He liked Duchamp,

and Surrealism, too, though he once acknowledged that he found some of it—particularly Max Ernst's work—frightening. I asked him why. "Well, it seems as though it involves a kind of black magic," he said. "I'm interested in white magic." He used that phrase a lot.

Cornell relied almost totally on found objects. He did not sculpt; he did not paint. He is perhaps the most important twentieth-century artist who did not draw at all, in any classical sense. He referred to his aggregates of three-dimensional material as his "sketchboxes"—sketches and ideas made of found objects, instead of pencil or ink. The only thing he did in that regard, as far as I know, was a series of Rorschach-like patterns on paper—using ink and folding the pages—that anticipate the large paintings of Andy Warhol several decades later. Cornell not only worked with things; he transformed them. He created a cosmology from everyday parts, a whole reality that is both quotidian and somehow, mysteriously, other; there is an ineffable resonance between things. It was a kind of unselfconscious alchemy. If he had been a more physical person, Cornell would have been a choreographer. He had the soul of a Balanchine. His boxes seem to me a kind of simulacrum, a sublimation of what one could do as visual theater. When I asked him once which abstract artist of his time was his favorite, he said, "What do you mean my time?" Then there was a long, thoughtful silence, and finally he said, "I think Mark Rothko's paintings are very beautiful." And when you look at the backgrounds of his collages, with all those blended and stained colors—rose, blue, blue to black—they do look more like Rothkos than anything else.

There was not much irony in Cornell. It's clear that even small experiences could be virtually overwhelming for him. The critic Nicolas Calas told me that he had once spotted Cornell alone in a department store, examining a slice of cake with a magnifying glass. He was studying all the little craters in it, as if he were exploring the surface of the moon. Cornell was interested in very subtle things. He made tiny pillboxes. He could stare at a little box of pink sand as though it were a whole universe of events. He was also a profoundly gentle man. He loved and collected films, especially early French experimental animation, and he thought of movies as the new medium for poets. For a time, he held film evenings at the Julien Levy Gallery, and one night he screened *Rose Hobart*, a wonderful poetic-surreal

film he'd made by editing and rearranging clips from a Hollywood melo-drama called *East of Borneo*. Salvador Dalí happened to be in the country at the time—this was in the thirties, when he was working on his own bizarre Surrealist films—and he was at the gallery that night; he flew into a rage, screaming that Cornell had stolen his ideas. People who knew what a gentle man Cornell was were just appalled. It was bad behavior on Dalí's part—and it was sad, because Cornell had been one of the first people to buy a small Dalí painting. Dalí fascinated him, but he was so hurt by this behavior that he took the painting somewhere in the neighborhood and buried it—gave it a funeral.

I had first become aware of Cornell when I saw William Copley's show of his work back in 1948. Then, when Shirley and I were living on the East Coast in 1955, I took what little money I had and went to the Stable Gallery to look at some of his pieces. Eleanor Ward pulled out some of the hotel boxes, which she'd shown, and I kept asking to see more. Suddenly she brought out the 1943 *Habitat for a Shooting Gallery* and I was astounded. It cost considerably more than everything else—$750—but I bought it. That pretty much wiped out our bank account at the time, much to Shirley's irritation. Cornell later described to me how, in 1942, he had made a "bullet hole" in the glass for that work. He didn't use a gun, of course; the idea of firearms was abhorrent to him. Instead he drilled a hole through two pieces of Masonite and clamped the glass pane between them. He had a bolt set in the first hole and hit it with a hammer until he had punched a hole through. I asked him, "How many times did you have to do that to get it right?" He said, "More times than I care to remember." To get a clean hole, with no shattering, he did the same thing, but I think he used an ice pick. (After he died, we found several ice picks in his studio and wondered what on earth they were for.) When I bought the work, an idiot in the back room at the Stable Gallery used a Cy Twombly drawing to wrap it up—it must have been just lying there, unframed. I returned it to the gallery, all bent, but Eleanor was grateful.

A few years later, while I was still at Ferus, I got Cornell's address from Eleanor and wrote to him. This was at the time when I had my deal with

Ed Janss, and Cornell was one of the first artists I turned to. I went out to his house in Queens, a turn-of-the-century, two-story, wood-framed house on Utopia Parkway. It had an attic, at least four bedrooms, a sort of enclosed porch, and a sizable basement. It was full of things—photostat drawings by his brother, Robert, who had cerebral palsy, toys, china cabinets, bric-a-brac—very neat, but full. I'm sure it had been neater when his mother was living there, but it was not the kind of house you'd normally expect a man to be living in. On that first visit, I arranged to buy some work. He said, "Come back the day after tomorrow and I'll have some things for you." When I got there, he had some works packed up in newspaper and brown paper bags. I was a little concerned. I said, "Do you think these things are safe?" "Oh," he said, "sometimes I just wrap them up like groceries. I think they'll be all right." Later I had a foam-rubber-lined case made, with straps and a handle. It could hold three boxes or two boxes and a bunch of collages. The first time Cornell saw it, this black thing with straps, he shuddered; it sort of scared him.

When I visited, we would usually sit at his dining-room table or at the breakfast table in the kitchen, and he'd make tea and toast with honey. He always had cookies around. I could never get him to go out for a meal. I never had a meal with Cornell anywhere other than his house, and that meal was, in essence, always made up of sweets. Sweets were literally a passion for him, and I think it's fair to say that his inordinate love of sugar was partially a sublimation of erotic impulse. He was a quiet man, serious— he sometimes seemed to be almost in a trance. For him to smile was a rare event. You really noticed it when it happened. He seemed sort of other-worldly. At the same time, he was charming, very courtly, especially with his assistants and with young women.

He asked a lot of questions. He wasn't big on giving answers himself— he was very reticent. And he'd been hurt by a good many people; some of his young assistants had robbed him. One of the women he'd had a real crush on had died of a drug overdose. But he always wanted to hear about my life. The fact that I had known the Arensbergs, had met Duchamp, was an important entrée for me. I had, somehow, the right kind of credentials to be of interest to him. One time, when we were talking about my childhood in California—he was interested in physics and was excited to hear that I'd

Joseph Cornell, in Flushing, Queens, in 1967.
Photograph by David Gahr.

gone to a school connected to Caltech—he asked me if I knew about the observatories up on Mount Wilson. Well, it happened that my mother was very interested in them. Sometimes, when she was too hot or couldn't stand it at home, she'd take my brother and me up there and we'd stay in a cabin. We got to know the people who worked the big telescope, were allowed to go in and watch them work at night, and ate the marvelous banana cream pies in their commissary. She managed to talk her way in there, and it was wonderful. So, when Cornell asked, I started to tell him about Michelson and Morley, who were the first people to measure the speed of light directly, and, while I was talking, he pulled a book about them off his shelf and began flipping through it. I stopped talking. He said, "Go on, Mr. Hopps. I'm just following the story here as you're recounting it."

Another time, he brought out a copy of Susan Sontag's first novel, *The Benefactor*, and asked if by any chance I knew her. I told him that I had known her as a girl and he practically swooned. "Could you arrange an introduction?" he asked. I said, "Of course." And then he had to go upstairs and lie down, he was so emotional. The book itself disturbed him, but he loved the photograph of her on the dust jacket. Eventually, he gave me a collage he'd made that was an imaginary portrait of Susan as a young girl, holding a sheep; it had an inscription from Verlaine on the back. Cornell loved beautiful women, ballet dancers especially. He'd buy standing-room-only tickets to the ballet, then get himself backstage to meet the dancers.

He even took little snippings of their costumes, which he put in his talisman boxes.

Cornell had never had a museum show, and he liked the fact that I had done Duchamp and Schwitters, so he worked with me to put things together. I'd already had a show of his work at Ferus—one of the last I worked on before leaving for Pasadena. While that show was up, a guy came into the gallery with a Cornell work that he'd bought for $35 at a used-furniture store on Santa Monica Boulevard. "Is this by the same artist?" he asked. Blum said, "Yes, I think it is. What would you take for it?" "Well, could I have a hundred bucks?" Blum snatched it up. It was worth something like twenty thousand at that point. It turned out that Copley, after his 1948 Cornell show, had given his secretary one piece as a bonus, and it had somehow disappeared.

I put the Pasadena show on the north side of the museum, where the galleries were more intimate than the ones I usually used. Of course, it was inconceivable that Cornell would come to the opening, but he was wonderful about making all the arrangements. I made a special room with built-in glass cases for the early works, and then I put certain things on pedestals and others in freestanding glass cases. For the final work in the show, I blocked off another room and had its walls and a sculpture stand painted black, and I set one beautiful night-sky box in there, a big one, spotlighted in the middle of the room. I barred the entrance to the room with a black-velvet rope on stanchions. The way it was set up, it seemed as if the whole box were floating in air, in dark space. Because you couldn't get closer than about six feet, you couldn't see that it was sitting on something.

A few years later, I got to work on another Cornell show. At that point, Henry Geldzahler was the newly appointed curator of contemporary art at the Metropolitan Museum in New York, and the museum was marking its hundred-year anniversary with an enormous exhibition. Geldzahler was in charge of the contemporary section, *New York Painting and Sculpture: 1940–1970*. He allotted a separate room for each artist that he chose for the show—there were fifteen or so—and he invited me to put together the Cornell room. (I also ended up working on the Franz Kline room.) Geldzahler offered to pay me $25 an hour while I was working on the show. I said,

"Here's how you're going to have to pay me: the hours start when I walk out of the Corcoran"—where I was the director at that point—"and get on a shuttle to come up to New York. I'm going to lay out plans and so on, and when I get into the installing I want to be able to work right through the night there in the Met. When I come up, I want to stay at the Stanhope Hotel across the street—and, by the way, I'll need an assistant, whom I'm going to choose and hire." He was desperate to get the show done, so he signed off on the whole thing, and Cornell was totally cooperative.

So I came up with an installation that had platforms, like islands, that were higher than a table—there were counters around the edge of the room, and then there were three islands in the middle. I had the entire room painted black and I had black felt covering all these islands, so that it was a totally nocturnal environment. I put little spotlights on the pieces, and strip-lights on the floor, so that people could see their way around and wouldn't get confused as to where the pathways were. It was a real workout getting all this built and installed and getting light into some of the boxes without casting strange shadows. I had reflective strips made and positioned to bounce the light up into the boxes, like footlights in a theater. When you were standing looking at the box, you didn't see the mirror, but it shot light up into the work in a nice, soft way. None of the Cornell boxes were in cases; they were all just there. I figured out ways to fasten them down so that no one could walk away with one. Hilton Kramer wrote a review saying that the room looked like a cocktail lounge, but I got a wonderful letter from Cornell saying that he liked the installation very much. He didn't come to the opening but he eventually saw the show.

When Cornell died, in the winter of 1972, I learned that the law firm of Greenbaum, Wolff & Ernst was handling his estate. It was an august old firm—it had handled James Joyce's obscenity case and had negotiated the tax-import duty on Brancusi works coming into the country. (The government had tried to tax the work as kitchen utensils or hospital supplies, and it had to be argued that these strange-looking bronze objects were actually art.) Cornell had chosen the firm on a friend's recommendation, after having made innumerable attempts to come up with an ideal vision for what he

wanted done with his work. Part of the firm's job was to figure out where Cornell's work was in the world. He had a habit of loaning pieces to people, rather than selling them, and he kept no normal sales records, so it was a nightmare to unravel.

In 1973, the firm got in touch with me and I was brought in to appraise and catalogue the works—and, above all, to determine which were finished and which weren't. In addition to the artworks that were known, there was the ephemera, the leftovers, the working parts of Joe's art—there was so much of that. The first thing I did was to take one of the attorneys, Richard Ader, to the house. I had been down to Cornell's basement workroom when he was still alive, but I'd never been up to the attic or out to the garage, where he stored all kinds of things.

In the basement, I found a box labeled "mouse matter," and I wondered what on earth it could be. Ader said, "That's disgusting. Don't open it." I said, "Please. Just calm yourself. I have to look at this." And I opened it up and I said, "Oh, dust bunnies." He said, "What?" "You know," I said. "Everyone has their own nickname for them." Cornell called them "mouse matter." I call them "dust bunnies." The little things that collect under beds and couches.

When I saw the extent of what was there, I knew it had to be saved. It was an unprecedented opportunity. I convinced Ader of this, and then I got on the phone with Joshua Taylor, whose classes I'd attended in Chicago and who was now the director of the National Collection of Fine Arts, in Washington, where I was working at the time. I told him that it was urgent that we pack all these things up and create some kind of center for them. It was going to cost some money to get everything boxed up, I said, and it would take time, and we were going to have to store the works until we found the space for them. Taylor had only one question for me. He put it very succinctly. He said, "If you don't do what you're suggesting here, is it the furnace?" I said, "I'm afraid it is." He said, "Well, I don't know what it all entails, but I authorize you to go ahead." So all these boxes of incomplete dossiers and unfinished work went to the Smithsonian and ultimately became part of the Joseph and Robert Cornell Study Center, which was as close to following Joe's will as we could get.

Eventually, as I was sorting through things, I realized that I would

need to go through the books as well. In the dining room, there were simple bookshelves, up to counter height, all the way around the walls—just cinder blocks and boards. It was a wonderful library. I explained to Ader that I wanted to record the titles of all the books, so I would have to look at every single volume before it was boxed up. I was hoping that the books would come to the study center as well, but they ended up going to relatives, who sold them off. I photographed the title page of each one. But there was another reason that I wanted to go through them: I happened to know that Cornell did things inside books—cutting secret compartments into them. So I opened every single book to see what was in there, and I found two extraordinary things. The first involved volumes V and VI of a set of French agricultural journals, which had little compartments cut into them, containing a poetic portrait of Marcel Duchamp. It was an extraordinary thing—everything was there, the *Mona Lisa*, and so on. (Even the choice of the journals was an inside joke: Duchamp had once referred to himself as a horticulturalist, the proprietor of a "dust-breeding farm.") And the second was a whole Duchamp dossier. Cornell's dossiers were boxed collections of clippings and other material surrounding a given subject, sometimes a place, but more often a person, or the idea of someone—Ondine or the Medici children. Some, like the dossier on Ludwig of Bavaria, were considered finished artworks; others he worked on till the end of his life. The Duchamp dossier was housed in a *Boîte-en-Valise* case that Cornell must have saved from the time when he was working with Duchamp. He had given the case a sort of lavender color, a wash of ink, and had initialed it. Inside were various bits and pieces from Duchamp's studio, some small readymades that Duchamp must have given Cornell—including the adjusted LePage's glue box—and other things that Cornell may have fished out of waste baskets or bought, like the copy of *Vogue* that has a model posing next to the *Large Glass*. There was no way to tell whether it had been made in collaboration with Duchamp, or whether Duchamp knew about it at all, though Cornell seemed to have started working on it in the forties.

17.

LEAVING PASADENA, AND THE INSTITUTE OF POLICY STUDIES

At the time of the Cornell show at Pasadena, I was going through some difficult things in my personal life. Shirley had left, and I had met a young woman named Helen Goldberg at a party at the Factory in New York. She was even more of an addict than I was, but of course I didn't know that then. Her father, a psychiatrist, had committed suicide, and she had a very difficult stepfather, who worked for the Federal Reserve Board. Helen had gone to high school with Barbara Rose, who was married to Frank Stella, and now she was living in New York and doing a Ph.D. in cultural anthropology at Columbia, studying favelas and the poor people on the margins of urban cultures. Eventually, she became involved in a big antiwar protest on campus, dropped out, and came to live with me in Pasadena. But things were tough with her, and I was in a bad state—doing speed, running around trying to get things done at the museum. When you're young, you think you can stay up all night and live two different lives—the night life and the day life. But it's the dope that's getting you through the day life, and it can get pretty bizarre. I was exhausted. And, in the course of putting together the Cornell show, we had two real disasters.

I had been very happy in our old Chinese building on North Los Robles Avenue, and Demetrion and I had talked about buying the hotel and parking lot next door and expanding there. However, the museum had an option to reclaim the land in Carmelita Park, where the original Pasadena Art Museum had stood in the teens and twenties, and the board wanted to commission a new building there. I was hoping that they'd hire what was left of Richard Neutra's architecture firm or Charles Eames or Craig Ellwood to design it, but instead they hired Edward Durell Stone, who had become a terrible architect by then. His proposal was a piece of crap. A sizable chunk of money was spent on it—some hundred thousand dollars of

investment—but eventually I got the board president, Harold Jurgensen, to fire Stone. I convinced him that it'd be cheaper in the long run to have an architect from Southern California, and that we could get someone even better. But then, tragically, Jurgensen discovered that there was a society architect in Pasadena named Thornton Ladd, whose mother was rich and was willing to cover the entire architectural fee if her son and his firm, Ladd & Kelsey, got the commission. Suddenly, all our plans went out the window, and we were having to work with this Thornton Ladd, whose ideas were no good at all. I felt absolutely betrayed.

Years later, John Coplans, my pal at *Artforum* magazine, ran an article on the situation, and Ladd & Kelsey filed suit—against the magazine, against Coplans, and against me, because I was quoted extensively in the article. So then we had to go into depositions—it was a multimillion-dollar lawsuit. Ed Janss jumped right in to my defense. He said, "You can't pay for all that. My law firm will be your law firm and I'm going to cover it." He paid for my defense up front. It was a grueling ordeal. Finally, when the case got to court, it was thrown out, but it had already cost a huge amount of money by that point. To pay Ed back for some of it, I sold the car-crash painting that Warhol had given me for my thirtieth birthday.

I went to New York a few months before the Cornell show opened and had to rush back to make it to the board meeting, where the plans for the new building were being discussed. By this time, I was just sick at heart. I hadn't slept normally in days and I couldn't. When I landed in L.A., I started walking through the airport to the baggage claim, but I could barely move. I suddenly looked at my watch and saw that an hour had passed. I was startled and frightened. I sat down for what seemed like five minutes, but when I checked my watch again I saw that another hour had passed. I knew that something was wrong. I went to a pay phone and called an artist I knew who lived near the airport, but he wasn't home. So I called my friend Judd Marmor. Marmor was the head of psychiatry at the UCLA Medical Center, later Cedars-Sinai, where I'd worked the graveyard shift as a psychiatric attendant. He was also an art collector. Miraculously, I got him on the phone.

He said, "Walter, you sound tired. I want to bring you into my place for

a rest and we can start from there." He asked, "Is there a place where you can sit down or even just go to sleep near you?" I said, "Yeah, I see some seats over there." He said, "Tell me exactly where you are. I'm going to have someone there to pick you up. Just take it easy." So I waited there and finally someone tapped me on the shoulder and said, "Are you Walter Hopps?" I said, "Yes, I am." He said, "Good. I'm here for Dr. Judd Marmor, and we're taking you into the hospital tonight." I didn't make it to the meeting, of course, and the trustees' building was approved in my absence.

When I got to the hospital, I was given some medicine and I slept for a day and a half. I ended up staying there for a month or more. This was when some of the Cornell works were shipping and waiting to be installed. Rowan was appalled. Harold Jurgensen came to see me. He said, "We've got to get a budget written. If I send a secretary over, is there somewhere that you can work on it here?" I said, "Mr. Jurgensen, I'd love to do a little work." I was so grateful. When I got out, Rowan was calling for my resignation. I said, "I'll tell you what. I'm going to write out a resignation and sign it, Bob, and I want you to talk to the other board members and see what they think. If they back me, tear it up, and, if they don't, you have it." But he didn't even try. He just accepted it. Later, I learned that his mother had gone nuts and insanity was a terrible thing in his life—anything psychiatric terrified him.

I saw him again years later, in the eighties, at a society party in San Francisco. This was after the museum had moved into the terrible new building, gone into debt, and been picked up by Norton Simon, who threw out most of the old board members, put all the modern art in the basement, and featured his own collection. Rowan loped over to me and said, "Walter, I want to shake your hand. Turns out you and your boys were right." I shook his hand and said, "Bob, thank you. But don't forget there were a few girls, too." He gave me a funny look, and that was that.

So I started trying to get another job, but in the meantime I had to finish putting together the Cornell retrospective. Demetrion, who was now acting director, had been visiting Edwin Bergman, the great collector of Cornell works in Chicago, to borrow pieces and carry them back for the show. It was winter—Cornell's birthday was December 24th and it meant a lot to

him to have the show open around that time—and the taxi driver who was taking Demetrion to the airport missed the exit, tried to back up on the freeway, and got into a terrible fiery crash. The driver pulled Demetrion out of the wreckage, which was why he survived. He had two packages of Cornell works with him, and as he was pulled out he managed to hold onto one, which held four boxes, but he didn't get the other, which had a collage and one of Cornell's great swan boxes; they ended up burning in the car. There was insurance to pay for it, but the work was lost, and Demetrion was badly injured and in a hospital in Chicago.

I had the shakes, because I'd just come out of the hospital, I'd lost my job, and I had to finish off the show in Demetrion's absence, which I did. I just focused on the show, and the installation was beautiful. I had all of Copley's Cornells, which were superb, several from Ed, and a large batch from Joseph himself.

I continued to look for another job, but whenever people found out that I'd been in the nuthouse, the job opportunities dried up pretty quickly. So eventually, at Ed Janss's suggestion, I decided to spend a year at the Institute for Policy Studies, a left-wing think tank in D.C. The institute was founded in 1963 by Marcus Raskin, who had been an aide to McGeorge Bundy in the Kennedy cabinet, and Richard Barnet, a disillusioned former member of the State Department. They were the best and the brightest. Ed joined their board and helped to arrange a one-year fellowship for me there, which changed the course of my life. I moved east with Helen, to a little apartment on Mintwood Place, in Adams Morgan, and I left my house in Pasadena to a group of artists who tore up the downstairs, drilling holes in the floor and building partitions. Someone dug up the front yard and turned it into trenches—a kind of earthwork. Eventually, an artist called Richard Jackson, a friend of Kienholz's, moved in as a kind of caretaker and fixed things up. He brought in Bruce Nauman, who was a college friend, and Nauman and his family stayed there for a few years. (When he moved out, he gave me one of his earliest works, which I sold to Ed Janss so that I could afford to fix up the house.)

I spent an extraordinary year at IPS. It was a kind of graduate school for me. I sat in on the general seminars and I gave some lectures about art—showing the other fellows things like Bruce Conner's *Black Dahlia* and

Sam Gilliam and Rockne Krebs, 1984. Photograph by Carol Harrison.

Wallace Berman's work, and speaking about how I thought art and public policy should meet. I did a lot of reading about what FDR had done on that front, and about Thomas Jefferson, whom I adore—like JFK, I've always thought that the greatest dinner party in America would be Thomas Jefferson dining alone. I also started to get to know some of the artists in the area—including Sam Gilliam and Rockne Krebs—and had them visit the institute.

While I was there, I worked on a chapter of Raskin's book *Being and Doing*—a response to Jean-Paul Sartre's famous *Being and Nothingness*—in which Raskin argued that nothingness was not a meaningful concept for Americans: We exist, and the question is what are we going to do? What is it meaningful to do? His theory was that the business and corporate structure of America is a "Plantation Colony" in which we don't all share in the wealth; we work for the man. Artists form the "Dream Colony," which isn't considered a real part of society. They float around like someone else's dream: for some, they're a good dream; for others, they're a nightmare. Often, they're just the highbrow end of the entertainment industry, entertaining or decorating America. Jackson Pollock was a unique mind and Barnett Newman was a true intellectual, but how many people took them seriously as such?

During this time, Helen and I got married, and we were both very politically active. Raskin was trying to set up something called the New Party, with Dr. Benjamin Spock as the presidential candidate and Dick Gregory as vice president. He also helped to organize the 1967 March on the Pentagon, at which Allen Ginsberg and Abbie Hoffman planned, through meditation and chanting, to levitate the Pentagon. There were various dinners beforehand, and some presentations at an old theater in the Adams Morgan district. Some extraordinary people were involved—Raskin and the IPS people; Norman Mailer; and Paul Goodman, who was a brilliant poet, novelist, and essayist. Anyway, the day came for the March on the Pentagon, and there was an enormous gathering of people in a procession going across Washington; many people joined along the way, and eventually we had completely surrounded the Pentagon. President Johnson had given orders to let us do our damage before sending in the troops to round us up and arrest us—just so that the country would see these nasty demonstrators doing bad things. I think that was the logic, at least, but it was also a time when the national sentiment against the government was beginning to sway people. I took several cans of black spray paint on the march with me, but once I got to my spot by the Pentagon I decided that I wasn't going to write any message. I was just going to paint a black flag, a huge black flag, for anarchy. It was about six feet across and five feet high, with some detail in the edges, to show that it was waving. I got that paint on densely. They must have had a hell of a time getting it out of that surface, which was some kind of concrete aggregate. When I heard that the troops were coming, I ducked out. I had a board meeting that I didn't want to miss. So I hid in some bushes nearby, then made my way to where I could get a taxi back to my apartment. I ran into Ginsberg again a while later at a fancy Washington dinner party, where he was trying to convince a big shot from the CIA to smoke dope or meditate or both. He said, "For all our sakes, for humankind, you've got to meditate, and you should be stoned while you do it." And he was right; that was just what you'd want a hawk from the CIA to do.

Around the time of the March on the Pentagon, I was in touch with a group of young radicals who had got their hands on some defoliant chemicals and were determined to defoliate the cherry trees down on the tidal basin. I talked that over with Raskin, and he and I agreed that the American

public would never forgive someone who destroyed the cherry trees, which had been given to the U.S. by Japan as a gesture of peace. He said, "Convince them not to do it, Walter." It was difficult, but I got them to leave the cherry trees alone and to work instead on the lawn on the Mall, which could be replaced. So they put big peace signs and slogans on the Mall grass, none of which did any lasting damage.

Washington in those years was one of the five places in the country, urban centers, that were contributing new art. New York was in a class of its own, then there was L.A., Chicago, San Francisco, and, in Washington, the Washington Color School, a small set of extraordinary pioneers in art: Morris Louis Bernstein, Benjamin Abramowitz, Jacob Kainen, and Leon Berkowitz. Ancillary to them, and somewhat younger, were Anne Truitt, Kenneth Noland, Gene Davis, and then, younger still, Howard Mehring, Thomas Downing, Paul Reed, Mary Pinchot Meyer, and others.

While I was at IPS, I proposed a workshop program for artists. I felt that it was important for young contemporary artists to be subsidized—to be given studios and forums in which they could share their work with others. I thought of it as a kind of guild. There was a wealthy trustee on the board of IPS named Philip Stern, who had served in the Kennedy administration.

Walter Hopps, c. 1969.
Photograph by John Gossage.

He came from a family of Jewish philanthropists in New Orleans; his grandfather had been a chairman of Sears, Roebuck, and had donated millions of dollars to building schools for black students in the South, and his father was the president of the New Orleans Cotton Exchange at age twenty-seven. His mother still lived in the Garden District, which was the Bel Air of New Orleans at the time. I flew down there once for a visit. I arrived at night and was greeted at the house by a butler in uniform. "I'm sure you're hungry," he said. "May I prepare a dinner for you?" The house had a huge walk-in refrigerator, and he prepared a superb meal with wine and all the oysters I could eat. Then he took my bags up to my suite. In the morning, I woke up and opened the curtains and saw that I was looking out over a garden that went on forever; the desk in my room actually had color postcards of the view.

Anyway, I got to know Philip and his wife, Helen, known as Leni, who was also very involved with art. She was a mainstay on the board of a small museum—an exhibition hall—called the Washington Gallery of Modern Art, which was directed then by a very nice guy called Charles Millard. Millard was a kind of aesthetic elitist, and the turmoil of everyday events in the late sixties gave him migraines. He invited Barbara Rose, an important historian and critic, to guest-curate a show called "A New Aesthetic," with work by Larry Bell, Donald Judd, and others. Barbara and I were old friends, but I knew there were problems when Millard called me up to say, "My God! Barbara Rose is shipping in more art than fits the building!" I came in, with some preparators and art hangers from the NCFA, to try to help with the installation. There was massive bad karma behind the scenes. Everybody connected with the show was angry—the board, the director, the curator, and the artists were all as sore as wet hornets—but it was a very important event for showcasing new directions in abstract art.

Not long after that, I saw in the newspaper that the Washington Gallery of Modern Art was closing its doors. Raskin, at IPS, came in with the paper and said, "Did you see this? Why did it happen? What should they do? Do up a paper and let's discuss it." I came up with several ideas for how the WGMA could survive—including merging with an existing institution or university. Leni Stern held some forums to discuss the possibilities, and she was taken with my idea for a workshop program. She raised

some money privately, through the Stern family foundation and others, to support it and keep the WGMA going.

So I went straight from the IPS fellowship to running the WGMA, and I did wild things there. First, I established the workshops. The idea was to commit to the here and now in art by sponsoring five different areas—painting, sculpture, photography, graphics, and architecture—and to give a grant to workers in each one of these areas, with no stipulation other than that they be encouraged to stay and work in Washington. If they needed studios, we'd help find space. If they wanted to teach, they could teach. If they wanted to get involved with public art, they'd get more of our budget. Lou Stovall, a great silk-screen printmaker, ran a printmaking workshop. Rockne Krebs ran the sculpture workshop, and Sam Gilliam ran painting, and I got them set up in studios in the same building in an alley off Fourteenth and U—not a great neighborhood, but they got good space and a lot of important work was done there. The photography workshop was run by Joe Cameron and John Gossage, a tough guy from Staten Island who knew Bruce Davidson and was the first person to tell me about Diane Arbus's work. They brought in other photographers and helped to curate some shows at the WGMA. Finally, there was an architecture and design workshop, run by two young architects, Robert Feild and Doug Michels. One of our trustees, Hugh Newell Jacobsen, a society architect who'd gone to Yale, objected to this. He said, "They're professionals; they should be out doing their work, not getting money from us." Being an architect himself, he resented the fact that these young architects were going to get grants to play around. But the Sterns backed me up, and I had the support of the board, and, as it turned out, Feild and Michels did a very interesting project: they proposed a redesign for the Georgetown waterfront, with models and plans. (One of the stipulations for the artists involved in the workshop program was that they devote themselves to Washington, D.C., but Michels eventually ran off with his chunk of money and went west to form the Ant Farm with Hudson Marquez and Chip Lord.)

Meanwhile, I was also curating shows at the WGMA. The president of Antioch College, in Ohio, was a member of the board of IPS, so I went to visit the school with Raskin and to consult with the art department, where I met a photographer called C. J. Pressma, whose work impressed me. I

Lou Stovall, Washington, D.C., 1999.
Photograph by Carol Harrison.

gave him a show, and hung some Walker Evans photographs at the same time, as a kind of ancillary historical reference. I liked the format of doing one younger artist and one older one, so I repeated that idea in many other shows. The two most important shows I did at the WGMA were a 1967 show of Kienholz's work and a Frank Stella one-man show with some major works—wonderful paintings—though it was a bitch getting them through the doors and into the building. One afternoon when I was up a ladder, trying to arrange the lighting for the show, I called to my assistant, "Hey, hey, where are you? Hand me another hundred-and-fifty-watt bulb and a canister." I heard a voice say "O.K." and someone handed me a bulb, but the voice wasn't my assistant's. I turned around and it was Philip Johnson, who'd wandered in to preview the show. I think I'd met him once before, at the Museum of Modern Art. I said, "Oh, Mr. Johnson." He said, "Please call me Philip. Carry on. I'll help you." So he hung around looking at the paintings and helping me light them.

For another show, I wanted to draw on art from Washington, something that went against the grain of the Washington Color School, so I chose Lloyd McNeill, an interesting black artist who was not part of the abstract establishment. A poet, an important jazz musician, and a fine artist, he was interested in doing an experiment in multimedia participatory art. In those years, there was a strong black separatist movement in Washington, centered around the New School for Afro-American Thought on Fourteenth

Street, which was run by a street-smart, irrascible figure called Gaston Neal. I had come to know Neal and Stokely Carmichael; they were welcome at IPS, but the separatism had become so extreme that a white person couldn't really go to the New School for Afro-American Thought. The only way I could see the art shows there was if Neal slipped me in at night when no one else was around. McNeill, for the most part, lived in the white culture, but he was very concerned about the black, and he wanted to stage an event that didn't use "white" words like "environment" or "happening." He planned a continuous 152-hour work that would involve performance and multimedia exhibits on all floors of the WGMA space, and I pitched it to the board. But when I mentioned that McNeill wanted to title it "Intercourse," the board went crazy. Of course, McNeill meant human intercourse and exchange of all kinds, but I was, very grudgingly, charged with getting rid of that title. So I asked McNeill to change it, and he said, "No way. This is absurd. It has to have that title or I won't do it." I went back to the board and there was a lot of wrangling and finally Leni, who was the chair, backed me up. She threw up her hands and said, "O.K., do it." She was responsible for most of the funding for the show, which was, in a way, an unhealthy thing. Leni got the show approved on principle but at the same time subverted the democratic process of the board; to save one principle, another was violated. That kind of thing is so often swept under the rug in institutions and it shouldn't be.

The McNeill event was staged in 1968, with both local and nationally successful jazz musicians and classical musicians, including a group of percussionists from the Buffalo Academy, who played an overture with windup toys. The first floor was like an environment for children, with a big drawing board and Magic Markers, where the sounds of play and drawing were amplified and fed through speakers; the second floor was set up for the musicians and performers; and the third floor had an area with television sets tuned to every channel, and a room full of murals that McNeill had painted, with a sitting area where you could sit and listen to the sound collage: children, musicians, TV, and other noises (there was even a microphone hanging outside the building, so some street sounds blended in), all in one overlay. It was an idea that was very much ahead of its time. It brought in the most mixed audience the WGMA had ever had: black and

white, younger and older—and truly engaged. In the end, it was an extraordinary public success. So were the Stella and Kienholz shows. Interestingly, Kienholz had the greatest public attendance and response. Paul Richard, who was the new art critic for the *Washington Post* then, loved it. There were some controversial pieces—including *The State Hospital*—but it was a major event for everyone on the leading edge, and it led to some important things for Kienholz, who had never spent much time in Washington before that. He became fascinated with the Iwo Jima monument; it was a kind of focal point for him. He began to gather found objects and junk, as an assemblage artist does, and started studies for what became *The Portable War Memorial*.

For my last show at the Washington Gallery of Modern Art, we were running out of money and the staff were depressed. I said, "Let's see how interesting a thing we can do with almost nothing. We've been showing abstract art and realistic imagist art, but there's something we haven't done. Let's do representational figurative art." They said, "But there isn't any in Washington." I said, "We haven't looked. Let's just see what there is." We made phone calls and sent letters and got the word out that we were looking for as much representation of the human figure as we could get. Then we started trucking it in and hanging it all over the museum, like in a kind of French salon. I think there were more than a hundred artists in the show, which we called "All Kinds of People." Not everything was of the highest order, but it raised spirits.

18.

THE CORCORAN GALLERY OF ART

The Stern family was running out of gas and money, and they decided that they couldn't continue to support the Washington Gallery of Modern Art, so I tried to come up with some solutions to keep it going, one of which was to affiliate it with a university and turn it into a training ground for art historians. I couldn't get that arranged quickly enough and we ended up moving ahead with my other suggestion, which was to merge it with the Corcoran Gallery of Art. The vice president of the Corcoran, Aldus Chapin, a mild-mannered, sort of ineffectual, decent man, had gone to Harvard and had worked for the CIA; his family went all the way back to the Pilgrims. He liked what I'd done at the WGMA, so he took me on at the Corcoran and kept the WGMA building in Dupont Circle as a separate exhibition space. I became the director of the Dupont Center and was able to keep the workshops going. James Harithas was the director of the Corcoran then. He was kind of a wild man, who acted irrationally sometimes, but he did interesting shows. Then, one day in 1969, Harithas got into a blowup with Chapin and resigned; after he left, I became the acting director and then the director.

Being at the Corcoran was like doing a tour of Southeast Asia; it was so crazy all the time, and I was always getting into trouble in one way or another. On the other hand, you could do some amazing things. Along with a very bright younger curator, Nina Felshin, I did the most pornographic show that any museum in America had ever done. While we still had the WGMA building as a branch, we put on a show of underground comics there, called "Comix." We had Gilbert Shelton's *Wonder Wart-Hog*: a comic in which Wonder Wart-Hog is fucking Lois Lamebrain with his snout and has this big orgasmic sneeze and blasts her off into the sky. We had an R. Crumb comic, in which a couple of bad guys are forcing Angelfood McSpade's

head into a toilet bowl full of turds and treating her very badly. This was rough stuff. I installed the show in two rooms on the top floor and just prayed that no trustee would wander in there. I gave the show an X rating and hung a sign that said something to the effect of "Hey, Mom and Dad, check out what's in the next two rooms. It's not for everyone. You may not want your kids to go in there." So, of course, the kids just raced in there. But we somehow never got blamed.

For the Corcoran's Biennial of American painting in 1971, my idea was to choose a certain number of artists and then ask each of them to choose another living artist to include in the show. We had a wide variety of people, from abstract to figurative, but no women. There wasn't a single living woman artist that I was interested in choosing at that time who hadn't already been in a Biennial at the Corcoran; I couldn't stand the world of Judy Chicago, and Jay DeFeo was already dead. I chose Frank Lobdell, Roy Lichtenstein, Richard Estes, Richard Jackson, Sam Francis, and Franklin Owen. I included a really exuberant, vicious, loud anti-Vietnam painting by Peter Saul, and I got grief from the trustees over that. Peter Saul chose Alex Katz, which was interesting. One of the painters in the show, Robert Gordon—a very strange man and an obscure artist—who was chosen by Lichtenstein, was the most impossible artist I ever had to deal with. He refused to let anyone into his studio and failed to acknowledge that he was being invited. Roy had seen his work somehow and it *was* interesting—a kind of geometric patterning, with stripes and diamonds and strange forms. But we couldn't get him to answer the phone. At the WGMA, I'd had a member of the staff named Kasha Linville. She and her estranged husband were CIA operatives; their job in Washington was to take note of people at demonstrations. She was a real Mata Hari, up for anything. I got in touch with her and said, "Look. For a hundred bucks plus expenses, there's this artist in New York City—you've got to get a painting out of him for this Biennial, at least one. Lichtenstein has chosen him, and Lichtenstein can't get through to him. Can you go to New York, get to where this guy lives, select a painting, and arrange for a truck to get it down here? Do whatever you have to do to get this guy to let loose of one." She liked the idea. She went up, and three days later—I have no idea what went on and don't want to know—I got word that she'd flown back to D.C. She told me, "Truck's on

the way and you've got a painting in there and it's pretty interesting." So that was one hassle solved.

Another problem was that I mixed up Sam Francis's artist choice. I asked him whom he wanted, and he said, "I want Ed. Put Ed in." The best-known Ed at that time was Ed Ruscha, so I contacted Ruscha and said, "You're in." Later, I was talking to Sam and I said, "Ruscha said he'd love to be in the show." Sam said, "I didn't mean Ed Ruscha. I meant Ed Moses." So I invited Moses, and then, to finesse things with Ruscha, I asked him to choose another artist himself. He picked his pal Joe Goode, which was fine. Then I had a crisis with Frank Lobdell. I was assuming that he'd choose one of the other Bay Area artists in his age group or younger. But he took a long time to respond and, when I finally got him on the phone, he said, "Well, Walt, the only other artist I want to have in the room with me is Clyfford Still." Lobdell had studied under Still at the old California School of Fine Arts. There was a terrible silence on my part. He said, "Is that a problem?" I said, "Well, Frank, you know he has just totally disavowed group shows. He doesn't do group shows. He's a recluse in Maryland now and he doesn't want to talk to anybody." Frank said, "I know, but that's my choice." I said, "Well, can *you* talk to him?" He said, "Oh, no, Walt, you've got to get a hold of him. Don't you know how to get a hold of him?" So I tracked Still down, took a deep breath, and explained Frank's request. He said, "Lobdell, Lobdell! How is the boy? I admired him." This gave me hope. He said, "I haven't seen his work in quite a while." I said, "He's doing terrific work." And he said, "Well, it's nice that he asked me to be in the room with him. I'm honored. I'll tell you what—let me think about which painting." In the end, he chose one owned by a woman named Betty Freeman in L.A.—I'd helped her to buy it. I was hoping that he'd come up with a new work—he had tons stored away—but he chose that one and Betty was perfectly willing to lend it. So there it was—a gorgeous painting, all by itself. One great Still and, on the other side of the room, a set of, I think, four crazy Picassoid Lobdells—gray grounds with black dancing figures drawn in.

Jim Harithas had made plans for a show of Paolo Soleri's work at the Corcoran, and when he left I had to take it over. Harithas had worked for a

time at the Phoenix Art Museum and had come across Soleri's work in Arizona. Soleri was born in 1919 in Italy, where he studied architecture. He came to the United States in 1947 and worked for a while with Frank Lloyd Wright at Taliesin in the West. Then he had this kind of Messianic break-through: he believed that the fate of the earth depended on ecological balance and that the terribly inefficient energy waste of suburban sprawl was going to poison and choke us. He hated every tract development in America. He based his project on the hill towns of Italy—he wanted to build struc-tures, or "arcologies," in which living units and working units, and so on, were ecologically balanced and energy-efficient. He had all kinds of models as to how this could work. In 1956, with practically no resources, he started, in Phoenix, the Cosanti Foundation, where he lived with his wife and two daughters, and had quarters for student apprentices who would come and work with him. They got room and board in exchange for their work in the drafting rooms, building models and so on. They had virtually no pay; they just had to be devoted to him. The project coincided with the era of hippies, so he was able to ride the counterculture wave. To make money, as a cottage industry, Soleri made ceramic and bronze bells, those little wind-chime bells that are all over the world. That put food on the table. Everyone ate communally, and Soleri's wonderful wife would prepare meals.

Of course, he was way ahead of his time. At the Cosanti Foundation, he built structures out of earth with very simple techniques that were low-tech but sophisticated in design. The complex began to look like something out of *The Planet of the Apes*. It was either futuristic or retro; it just didn't connect with any contemporary architecture. You could call him a visionary, but he hated that word. When I had to title the show, to give people a clue as to what they were coming into, I called it "The Architectural Visions of Paolo Soleri."

When Harithas and I first went out there to see Soleri, we had a very difficult meeting. Harithas was a big cannabis smoker, and he managed to get me thoroughly stoned beforehand; I was just in outer space and hearing ideas that were out there, too. Harithas loved the work but had no practical grasp of how to show it. I inherited all that. There were huge models made of cardboard and wood, whole sections of theoretical work, some of it depicting what Soleri had built, some of it purely hypothetical—models

Paolo Soleri's office and drafting studio, 1959. Photograph by Stuart A. Weiner.

with structures that were fifteen, twenty feet, in plaster and cardboard, and fragile, but less fragile, thank God, than they seemed. And there were drawings on pieces of paper so big you couldn't even frame them. You just had to mount them on the wall. Selecting the work was a matter of figuring out what would fit. The largest show ever done at the Corcoran was a retrospective of the work of Daniel Chester French, who had done the Lincoln Memorial and made more models and studies than anyone can imagine. Soleri's was the next biggest.

I managed somehow to get a budget hammered out. What I came up with, with Soleri, was a plan to rent trucks and have his corps of apprentices drive the whole thing into Washington themselves; it was the cheapest way possible. And then they'd stay to work on the installation. As for how to handle them in Washington, I proposed that we bivouac them in the basement of the Corcoran. There were showers and a kitchen down there—the old living quarters, where staff people had actually lived in earlier days. I told the apprentices to bring their sleeping bags, and we got a bunch of mattresses from thrift stores, and I just prayed that no trustee would walk in and see all these boys and girls living down there together. It was the only way we could afford it.

For the catalogue, which Soleri worked on with Donald Wall, an art-history professor at the Catholic University of America, who was a fan, Soleri wanted large printouts of some of the drawings; the drawings were

huge—about twenty feet long. So what we eventually designed was a cubic box, twelve or fourteen inches square, with a lid that came off, and a series of rolled-up scrolls inside, which you could pull out. There was a regular bound book with text and pictures as well. It was an unwieldy thing, but somehow I managed to justify the cost by explaining how much money we were saving by putting Soleri's whole staff to work for us. The installation period was tighter than we needed, and it was just hell to get set up. I had our carpenters make some wheeled carts to carry our tools. I had the Soleri people bring their tools as well—and thank God I did, because as people were coming in for the opening we were still rolling tools out to the elevator. It was an incredible strain, but it came off and it looked great. Afterward, it traveled to the Whitney Museum and then up into Canada. By that time we were so exhausted and burned-out, Soleri was on his own. It was among the most difficult shows I've ever done.

So many bizarre things went on at the Corcoran. My office was in the front of the building, on the west side, near the boardroom, which had the bathroom that was closest to me. One night I was working late and went into the board room to use the toilet, and Chapin was in there with some woman. He saw me and I backed out hurriedly; I never saw who the woman was. Rockne Krebs got caught doing the same thing up in the skylights once.

One day I was walking through the atrium of the Corcoran and I saw a man sitting on a bench, staring at a Josef Albers painting. It was a beautiful orange and light yellow, a pretty good Albers. But it was still strange to see someone sitting there just fixed on it. I wondered who he was and what he saw in that Albers. Another day I came in, and the same man was there, sitting on the same bench, staring at the Albers. So I went up and quietly introduced myself. His name was Raymond Price, and he was a speechwriter for Nixon. He worked at the old executive office across the street. I often suspected that he was Deep Throat, because he turned out to be a really good guy. He loved abstract art, and he found that Albers painting very soothing when work got too intense. One day, after I'd become director, I got a call from him, and he said, "You know, our Secret Service have people watching your building twenty-four hours a day, because you're in our line

of sight. And I have to tell you something. I think it's the students from the art school—they're up on the roof screwing all day, assuming they can't be seen by anyone." He said, "It's not illegal or anything. It doesn't concern us, except that it's distracting our Secret Service men. What do you think we can do about it?" So I convened all the students in the building for a mandatory meeting. I announced that everything that happened on top of the building was under twenty-four-hour surveillance by the Secret Service and asked everyone who was there to spread the word to the other students. Later, I talked to Price and he told me that it had worked. "Apparently, you don't have any exhibitionists," he said.

Price helped with two other things. When I took a big David Smith retrospective from the Guggenheim, he helped get us permission to put the works in the President's Park, right across the street from the Corcoran, which was under White House jurisdiction. Later, I did the same thing with Alexander Liberman. The Smith went off without a hitch. But H. R. Haldeman, Nixon's chief of staff, apparently hated the Liberman, and we suddenly had to move it.

My favorite trustee at the Corcoran was a very intelligent and cultivated man named David Lloyd Kreeger, who was the chairman of the Government Employees Insurance Company (now known as GEICO). He was a great patron of music and theater. His dining room was decorated with Monet paintings, and above his chessboard he had a wonderful Man Ray painting about chess. He was a very good trustee who backed me up on any number of occasions. There were some terrible old trustees at the Corcoran, ancient people who were not in tune with what was going on in the world at all, but I got along very well with Mr. Kreeger.

In September, 1969, the White House was planning a dinner for Golda Meir, who had apparently said that she was interested in the arts and music. For some reason, they were having a hard time finding Republicans who would make good guests for that dinner. Kreeger was very much a Democrat, but he was a distinguished member of Washington society, so he was enlisted to help and he arranged for Chapin and me to be invited. We had to fill out forms and have our pictures taken. It was very unusual for a

boatload of Democrats to go to dinner at the White House under Nixon, but it was relatively early in his regime, and I wasn't going to pass up a chance to see what the place was like on the inside. So Chapin and I took a taxi up to the main gate and showed our papers and were checked all the way along the line. We finally got inside and got into the receiving line. A man was standing behind Nixon, whipping through a little book of photographs; as I approached, he whispered in the president's ear, "Hopps," and the president said, "Good evening, Mr. Hopps," and gave me a dead-fish handshake. Then I came to the first lady, Patricia Nixon. I had hair down below my ears—I looked like a hippie in a tuxedo—and she was taken aback, clearly wondering how I'd got in there. She just said, "Hi," and I passed on—no handshake. Dinner was terrific. The service couldn't have been better, and afterward we all retreated to the East Room for the entertainment. Kreeger had arranged for Leonard Bernstein and Isaac Stern to perform. When you get asked to entertain at the White House, you accept. But they had something up their sleeves. For the first number they played something very sedate. Then Stern said, "In honor of Madame Meir, we have a very special number called 'A Survivor from Warsaw.'" I thought, *Oh, my God*. It was Schoenberg—fierce, atonal modern music—with Bernstein smashing all the keys on the piano with the pedal down, like a terrible explosion, and Stern's violin sounding like screaming, like people being tortured to death. I couldn't see the Nixons—they were sitting up front with Golda Meir. But H. R. Haldeman was near me. His face was contorted—he obviously hated it—and I thought he was going to break the arms of his chair. And then the music came to an abrupt end, and there was dead silence. No applause. I didn't know what to do. Suddenly, bless her, Golda Meir jumped up and hugged Isaac Stern. She got it. She got the art of it; she knew the subject. She had probably never heard such a piece of music, but she understood the meaning of it. And then everyone limply applauded and vanished into the night. But it was a sensational moment.

When Chapin left the Corcoran, he was replaced, as chief executive officer, by a man called Vincent Melzac, who was just an SOB to deal with. One day he called me into his office and said, "Hopps, you've got to stop doing all

this weird, avant-garde stuff and do a popular show and I've got something in mind." I said, "What do you have in mind?" He said, "Norman Rockwell." I said, "Let me think about that." I didn't want to do a Norman Rockwell show, no matter how popular it might be. So I thought about it, and I came back with the idea of doing a show of major American illustrator-artists. I told him I'd include N. C. Wyeth (whom Melzac confused with Andrew Wyeth)—some of the Winslow Homer-like paintings and woodcuts and illustrations that he had done for books like *Treasure Island*—and Maxfield Parrish, who did some very romantic and dreamy paintings, as well as *Saturday Evening Post* covers, long before Norman Rockwell. Then we could have Norman Rockwell, too—especially the *Saturday Evening Post* cover where a man is contemplating a Jackson Pollock—and Saul Steinberg and Andy Warhol; I was thinking of Warhol's early illustrations for *Harper's Bazaar*. Melzac said, "No, that's no good—you're back in the avant-garde." So I said, "Well, let me think again."

And I came up with another idea. Melzac wanted people lined up around the block; his mention of Andrew Wyeth had given me a clue. So I went back to his office. He said, "What do you have today?" I said, "Three famous artists from World War II." He said, "That sounds interesting. Who are they?" I wanted Dwight Eisenhower, who did these stiff realist paintings, sort of in the style of Andrew Wyeth, and Winston Churchill, a serious amateur painter, who painted a little like Bonnard, still lifes and floral things. Then I hesitated, and he said, "Come on. You said there were three." And I said, "Adolf Hitler." I was thinking of his drawings and illustrations, which are collected in Vienna. I figured that with some effort one could borrow a few drawings. Melzac took the knife that he used to clean the bowl of his pipe and stabbed it right into the oak table and shouted, "Get out of this office! Get the fuck out of my office!" And that was where the whole matter was dropped. But I still think that that show would have had them lined up around the block.

19.

THREE PHOTOGRAPHERS

One day, I was in the atrium of the Corcoran, when a lanky, shy-looking man approached me and said, "Are you Walter Hopps?" I said, "Yes, I am. Who are you?" He said, "I'm Bill Christenberry, and I just want to thank you for that poster you gave me." Then he reminded me of something that had happened back in Pasadena in 1963, when the Duchamp exhibit was up. My assistant, Elizabeth Elliott—Betty—was opening the mail one morning and she said, "Here's a strange one. Somebody in Memphis, Tennessee, has written a very formal letter requesting a catalogue and has sent a check for fifteen dollars." The catalogue didn't cost that much. I said, "Memphis, Tennessee? Who on earth in Memphis, Tennessee, would want a Duchamp catalogue? Tell you what, throw in a poster from the show and send it all off to him." She mailed it and I forgot about it until that day at the Corcoran. I said, "You're that guy from Tennessee?" He said, "Well, actually I'm from Alabama. I just happened to be teaching in Tennessee at the time. Now my wife and I have moved up from the South, and I have a teaching job here at the Corcoran." I said, "Well, what do you do?" He said, "I draw. I make some sculpture. I take some photographs." I said, "Can I come over to your place sometime and see what you're doing?" He said, "Yes, sir, I'd be pleased." So I went over to the modest apartment where he was living with his wife and his first child and looked at all his work, but the minute I saw the photographs—both black-and-white and little ones in color—a light went on in my head, and I thought, *This is special.*

Christenberry had gone to the University of Alabama, where he was taught by Lawrence Calcagno, a sophisticated artist who'd enrolled in art school on the GI Bill and then taken this teaching job down South. Calcagno had opened up all kinds of things for Bill that he wouldn't have known about otherwise, and when Bill graduated, around 1962, he went up to New York

Walter Hopps, in Washington, D.C., in 1978. Photograph by William
Christenberry.

to work. First he got a job at Bella Fishko's gallery. When that didn't last,
he went to work at Norman Vincent Peale's church—cleaning the church
or something—but that was too depressing. Then he was a guard at the
Museum of Modern Art, but that was too boring. He told me, "All I got out
of that job was a good pair of black shoes that I had to wear." Eventually, he
heard that Walker Evans, whose photographs he'd always loved, was
working as a contract photographer for *Fortune* over in the Time-Life
Building. So Christenberry went there to meet him, and Evans was fasci-
nated to hear that he was from Hale County, Alabama, just a quarter of a
mile away from the families that Evans had photographed for the book *Let
Us Now Praise Famous Men*. The Evans subjects were sharecroppers, and
Christenberry's family was one step up the ladder—they actually owned
their own land. But, aside from one uncle, Bill was the first in his family to
get a college education. He and Evans became good friends, and Evans got
him a job in the photo archive at Time-Life.

Christenberry introduced me to Evans, and we really hit it off. I loved his
work. The first photograph I ever paid real money for—serious money, it

seemed to me—was one of his, which I bought at the old Robert Schoelkopf Gallery in New York. It was a curious still life from the early thirties, of a cactus plant with a little American flag stuck into it and, on the wall and mantle behind it, some family photographs.

Evans was living in Old Lyme, Connecticut, when I knew him, and Christenberry and I stayed at his house there. Evans was single then. He had three or four great loves in his life, never any children, and at this point he had just broken up with his wife. It had been a difficult marriage, the wrong marriage for him, and his career was somewhat declining as well. Christenberry stayed in a guest room, and I slept on a narrow cot in Evans's studio. It was almost winter, and it was cold. I tried to get as much blanket around me as I could. (It was cold enough that I'd arrived there wearing a raincoat with a liner, and when Evans was hanging it up in the closet he noticed a magazine sticking out of the pocket. I'd been reading an underground comic, one of the Zap Comix, which he looked at and immediately loved. He asked if he could keep it, so I had to give it to him.) During the night, as I was thrashing around, trying to stay warm, a stack of photographs about a yard high that were piled up at the end of a worktable fell over onto me. And I remember waking up in the morning to the sound of Walker Evans laughing—he had a very distinctive low voice—because I was lying under a blanket of his photographic prints. I was embarrassed and said I hoped I hadn't hurt any. He said, "Oh, you can't hurt those old things," and he scooped them up and stacked them again. It was that kind of chaos in his studio.

Not long after that, John Szarkowski put on a great retrospective of Evans's work at the Modern and I got word out that I wanted it at Corcoran. Szarkowski had mounted it thematically, with big blowups to announce each theme, but I didn't think that made sense. It was serious photography, and John was worried about how some of it was going to go over with the public—he worried more than he should have in those days. I got permission not to have the thematic arrangement. I worked with a couple of assistants and laid Walker's images out chronologically, period by period, in different groupings, and it was a beautiful show.

There were three distinct periods in Evans's photography. Early on, in the twenties, he did some extraordinary modernist photography, ingenious

and surprising geometric compositions. Most of these were taken in New York City; the most famous sequence is of the structure of the Brooklyn Bridge. But there were other things that were exquisite—images of signs, ironwork, and so on, often from behind. Some of these look startlingly like Pop Art icons. Others are very simple. It's an underappreciated area of his art. The images he took when he went south during the Depression and began shooting for the Farm Security Administration are the most celebrated. There are images from Alabama, Mississippi, and Louisiana, and some amazing ones from the coal-mining towns of Pennsylvania. He did all kinds of photography in the South, not just the iconic shots of farmworkers. There are gorgeous images of the plantation houses. He'd get the white boss standing up against a building, or have a family pose with their house. He'd get the interiors, how they lived. He took a couple of photographs of the graves of children. There's one beautiful photograph of a worker's boots. He even did a whole series of eroded earth. Between the all-but-abandoned plantation houses and the rural cabins, he saw both sides of the situation.

Evans was a one-exposure man. He didn't do a lot of shooting; he'd get it right and, if he hadn't got it right, he'd maybe do one more. When he was down south, being subsidized, he'd sometimes try to do one negative for the program and one for himself. All those negatives ended up at the Library of Congress, and one day, years later, Evans went there with Christenberry and stole some of them back—stuffed them in his coat and walked out with them. He said, "Some of them are better exposures than the ones I have," and he carefully chose the ones that he wanted to print from. I think that Christenberry quietly let his contact at the Library of Congress know that Evans had them and promised to get them back—and he dutifully returned them after Evans died.

Evans took more interesting portraits than most people realize. In 1933, he did a series of photographs from Cuba, showing conditions there, for a book by an American journalist, Carleton Beals. This was in the days of the dictatorship, before the Second World War. In New York, he took a photograph of a black woman in a coat with a fur collar under the El. He shot people at a lunch counter through a window. He even shot some strange photographs of trash in the gutter, cigarette butts. Irving Penn did those very mannered pictures of cigarettes and cigarette boxes, but Evans's were

different—just pictures of nothing. He had images of heartbreaking beauty, but he also took some more comical shots. There's an early picture of two men loading onto a truck a big sign that says "Damaged." It's just an absurd picture—he had a very wry sense of humor. He also did some curious work in color, especially when he was working for *Fortune*. The last stage of his photography, in the early seventies, involved color Polaroids. Late in his life he revisited certain areas and even traveled with Christenberry in the South. Christenberry took some wonderful pictures of Evans with his view camera taking pictures of Christenberry subjects; there are Evans versions of Christenberry scenes, and pictures of Evans taking the pictures.

Evans was a collector. In the days before the pop top stayed on the soda can, he collected those tops. They'd get bent into different shapes, and instead of throwing them away he had them all lined up on a sideboard in his house in Old Lyme, a crazy array—he played with different arrangements for them. He also, like Christenberry, collected signs. They used to discuss the best ways for getting signs off posts and so on. I remember that Evans was delighted to learn of something called Liquid Wrench, which would loosen rusted nuts quickly.

Evans could drive. Unlike painters, all photographers drive—they've got to get to their subjects. The automobile changed the course of photography. Can you imagine what it was like in the nineteenth century? William Henry Jackson and Carleton Watkins and Eadweard Muybridge, heroically hauling all the big, heavy equipment and glass negatives around? Evans used some 35mm cameras, but mostly he liked a view camera. Generally, he wanted a longer exposure, with a very small aperture, so that he'd get depth of field, which added a narrative quality to his images.

Once when I was visiting him, I asked how he first took up photography, and he said, "You know, I always wanted to be a writer. I thought I was going to be a writer. I read a lot and I love American literature." I said, "What do you especially like?" He said, "I love *Gatsby*. Fitzgerald. I love it. I practically have it memorized. Do you want to hear the last three pages?" And he sat there and, in his deep voice, recited the last three pages of *The Great Gatsby*, including that incredible enigmatic ending: "So we beat on, boats against the current, borne back ceaselessly into the past." He obviously knew Hart Crane's poem about the Brooklyn Bridge when he was working

on his Brooklyn Bridge series. And he had a very productive collaboration with James Agee, who was a terrific writer. They came up with an ingenious way of working together on *Let Us Now Praise Famous Men*. Evans said, "I'm not going to illustrate your writing and you're not going to write about my photographs." So the photographs are a suite unto themselves. It was an amazing relationship.

Evans was always such a gracious man. There were two things he'd often say when looking at his own work: "Jesus Christ, I can't print like that anymore" or "I think I got that one right." Sometimes he'd tell stories about the work. Once, we were looking at an image, and he said, "Do you see that little girl standing back there, in the shadows? I had to wait for her. The whole thing was good and these guys are standing around, waiting for me to take the shot, and I took it twice. And then this little girl appeared. I made everyone hold still so I could take it one more time, because that was the real shot." About another one, he said, "Do you see that cat hanging through the banister up there? I thought I'd have to wait till hell froze over before that cat would reappear."

Photographers have to know how to wait and where to stand. They don't, in a synthetic way, invent the imagery; their signature is in where they stand to take the pictures. Paul Strand has superb diagonals. His famous photograph of a white picket fence is on a diagonal. His masterpiece, *Wall Street*, is a trapezoidal shape. Edward Weston, in some of his best photographs, has a way of positioning himself so that you're disoriented as to the space. He gets below, or above, or in some strange juxtaposition to the subject. I love his *Nude on Dune*. He's shooting from above, or from an angle that you can't quite understand. Evans, on the other hand, has a way of very frontally and iconically setting up a building or a scene—he'll put a doorway right there to settle the image. Christenberry's photography is like a simplified color version of what Evans does. Evans was his great influence.

One day Christenberry told me, "There's this photographer from Memphis I know, who works in color. His name is William Eggleston. He's very good and you've got to meet him. He's major." I agreed, and soon after that Christenberry showed up at my office at the Corcoran with Eggleston in an

immaculate beige cotton suit, a clean white shirt, and a thin, conservative necktie, carrying a box full of color prints. No one had heard of Eggleston at this point; he was in his early thirties. Christenberry nervously introduced us, and Eggleston gave me a strange smile and said, "Here." That's all: "Here." So I opened the box and started looking through the photographs, one by one, in silence. He didn't say a word about the images. Sometimes he would look along with me, if something caught his attention; the rest of the time, he just stood patiently, smoking and looking out the window. This endeared him to me right away. I studied the photographs carefully, and they were amazing; they didn't look like anything I'd seen before. There was one of a cigarette machine with some trophies sitting on it; there was one of the back of the head of a woman with a beehive hairdo, sitting in a green chair. I got about two-thirds of the way through and I looked up and said, "What can you tell me about what you're doing?" He smiled and said, "Well, I think I'm working on a novel, don't you?" That's all. I said, "Those are wonderful pictures. And I expect we're going to know each other from here on out." He smiled and said, "I hope so." We shook hands and he left.

Eggleston and I did have quite a bit to do with each other. When Helen and I were having terrible times in our marriage, his home on Central Avenue

William Eggleston and William Christenberry, at the Corcoran Gallery of Art, in 2008. Photograph by Carol Harrison.

in Memphis became a place of sanctuary for me. I'd go there and just go to bed. His wife, Rosa, was quiet and nice, and, because there was family money, nobody had to work. Eggleston's family goes way back. He once took me to Black Hawk, Mississippi, and showed me family graves dating back to the seventeen-hundreds. His grandfather owned Mayfair Plantation, at the top end of the delta, near Sumner. Rosa would watch out for money and try to keep the family together by not letting Bill go hog wild. I don't know how she put up with all the other women in his life. There were times when she was out of the house and topless go-go dancers from near the Air Force base were there.

Eggleston was a real traveler. All photographers must have that—it's inherent to the medium. You have to go to the material; you can't bring it to you. He spent a lot of time driving around Memphis and the Mississippi Delta—that was his world—but he also went west, all the way to the Santa Monica pier, and we did that together. One time, in 1973, we flew to New Mexico and drove up to see Dennis Hopper, stopping at Los Alamos, the site of the clandestine development of the atomic bomb. That was when Eggleston came up with the idea for his "Los Alamos" project. He wanted to put together an encyclopedic set of bound volumes containing two thousand original prints. You see so many images in the course of a month—more than two thousand—and Eggleston wanted to make an artwork that was somehow an analogue to that experience. The photographs would include Memphis and the delta but would also trace his travels west, from New Orleans to Las Vegas and Southern California. It was an extraordinary concept (and the title acknowledges, with some irony, Eggleston's belief in its possible aesthetic consequences). As he saw it, the photographs would be of a manageable size, numbered, but with no other commentary. He wanted Christenberry to design the bookcase where the volumes would be lined up, and the table and chair where you'd sit to look at them. I loved the idea.

Eggleston is a fluid kind of photographer. He began with black-and-white photography, but when he and Christenberry met and he saw Christenberry's little color photographs, he dove into color, and he did it in a unique way: instead of looking for iconic images, he was looking up, down, around, up close, and his orientation got stranger and stranger. There are

extraordinary pictures of people in their own settings—a cast of characters, many from his own family and others around the Mississippi Delta. These are always posed with a kind of torque. Sometimes I'd joke with Bill, saying, "What's wrong with this picture? It looks as if the woman's about to twist her ankle or fall off a chair." Then there are his hyper-simple landscapes: his clouds series, for instance, the best looking-at-sky pictures since Alfred Stieglitz's "Equivalents." Just white clouds and blue sky. There's absolutely no orientation and they're in gorgeous color. When he did the series called "Election Eve," down in Georgia in 1976, he went to Andersonville, the site of the Civil War prison Camp Sumter—the most vicious prison ever in America, just a sump of death. And he managed to find a wrecked tree beside it, which tells the story in a way, just *speaks* it. So there are identifiable and beautiful or ominous landscapes, but there are also photographs of things that no one would ever photograph. A shot of footprints and tire tracks in sand and a tiny little strip of a car's license plate—there seems to be nothing there: he's taken a picture of nothing. Eggleston has a very special quality of indifference, a sort of transcendental indifference that's Duchampian.

Eggleston never uses a light meter. All that setting the shutter speed, factoring in the speed of the film, judging the light that's out there is built into his head; he can do it without ever thinking about it. Put him in a darkened room or staring up at a blue sky—it doesn't matter. He has a kind of kinesthetic knowledge; the camera is almost part of his body. I've never seen anyone less self-conscious about what he's pointing a camera at. It's like a card trick, a sleight of hand almost, or the seemingly passive, instinctual mastery you'd associate with martial arts.

In my early days of knowing Eggleston, I asked him once, "Are there any photographers you admire?" He admitted, without too much diffidence, that Cartier-Bresson had impressed him very much when he was a young man. "To tell the truth," he said, "I wore out two copies of *The Decisive Moment*." He smiled and added, "As you can see, what I do doesn't look anything like that." Of course, that was true. Where Cartier-Bresson would catch people running, jumping, at the decisive moment, Eggleston catches that moment where everything seems curiously at rest, when people stop and look around, whether in exhaustion, confusion, or just at an ordinary

moment of change or transition. Think of the guy, the ominous, hippie-looking guy sitting in the back seat of a car; he's just got into the car or is about to leave it. It's an in-between moment in some ongoing drama. The old man in Morton, Mississippi, sitting on his bed with a colorful quilt on it and the pee pot next to it: he's been telling strange tales, showing off his old gun. The man in the red room, standing naked, scratching his head in bemusement. But the idea of being very flexible in one's movements—almost a spy, as Cartier-Bresson described it—very much not part of the scene that's going on: Cartier-Bresson and Eggleston have that in common. However radical Eggleston's work might seem, he appears in his own work much like an omniscient narrator in a good nineteenth-century novel.

I asked him, "Was there anyone else?" He said—making it clear that this person was not strictly a photographer—"I've seen some pictures of gasoline stations taken by an artist named Ed Ruscha." "Oh," I said. "That's someone I know." He was referring to a wonderful and curious book that Ruscha had put out in 1963, *Twentysix Gasoline Stations*. It had the most ordinary snapshot photographs in the world, which Ruscha had taken, of gas stations and garages along Route 66 between Oklahoma City and Los Angeles. That book occupied a very special place for Eggleston, and for Ruscha, too. When I asked Ed what that work meant and why he'd made it, he said, "Well, I don't really have a Seine River. I don't have a boat to float up and down while I make paintings of haystacks. I just go between here and Oklahoma in my work." He wasn't being facetious. The highway and the car were his river, really, a place to explore and sketch, and photographs became an important mode of sketching for him.

Several years later, Eggleston happened to be in Los Angeles, and the chance for him and Ruscha to meet came about. The closer Eggleston got to meeting another person, the more silent he became. He could get so quiet at times like that that you could almost hear his heartbeat. There were several people over at Ruscha's studio on Western Avenue, and Eggleston wandered into a part of the studio where Ed had a large view camera set up facing a kind of crimson velvet drapery, on which something was being arranged by an assistant. Ruscha joined in and Eggleston peered over his shoulder, like a surgeon in an amphitheater. I was amazed to see that

packaged steaks were being arranged into some kind of still life. Ruscha was creating a suite of prints that would end up being silk-screened as part of a series called *Sweets, Meats, Sheets.*

When I was at the National Collection of Fine Arts, now the National Museum of American Art, in the early seventies, I proposed to my boss, Joshua Taylor, that we do a show of Eggleston photographs. We talked about it with John Szarkowski at the Museum of Modern Art, to whom Bill had been showing his photographs. Szarkowski asked if we could hold off. I said, "Why?" And he said, "I want to have his first museum show here. It will astound people." I said, "O.K." So I didn't show Bill. And the MoMA show in 1976 did astound people. He'd shown at the Carpenter Center at Harvard, at Jefferson Place in Washington, and at a little gallery in Memphis, but he hadn't had a gallery show in New York at that point. And suddenly, out of the blue, he had an exhibition at the Museum of Modern Art, with a hardcover catalogue. It just enraged the world of "art photographers" in New York. A lot of people were obviously wondering why this guy was having a show and they weren't; they'd never heard of him. While the show was up, Eggleston was invited to give a lecture, in some auditorium away from the Modern—at the International Center of Photography, perhaps. He got up onstage and showed his slides, with a good three minutes for each one, in total silence. There was no lecture.

While Eggleston's show was at the Carpenter Center, he was a visiting faculty member at Harvard. One night he was having dinner at the faculty club, whacked out of his mind, and he suddenly got paranoid. He picked up his butter knife and whirled around and tried to stab a guy from the German department who was sitting at the next table. Luckily, the knife was blunt and it didn't break the skin. But Eggleston's fellowship was, as they say, cut short. There was one incident after another. Soon after the MoMA show, he hooked up with Viva, Andy Warhol's former model, and they had a tempestuous relationship. One night they were visiting Yale and, between the fucking and the fighting through the night, they completely destroyed the guest quarters they'd been put in. Viva said, "We just passed out and the next

morning it looked like one of the Rolling Stones had been in there with groupies." Another time I was in New York and I was trying to find Eggleston; all I had was an address somewhere uptown, and when I got there it was a town house, and I could see down into a basement room, where Eggleston was passed out in a big plate of spaghetti. He was wearing, of course, a suit, a necktie, and a white shirt, but he had passed out with his face buried in that plate of spaghetti.

20.

THE 1972 VENICE BIENNALE

In 1971, I got word from the United States Information Agency that I'd been chosen to be the U.S. commissioner of the Venice Biennale the following year. Henry Geldzahler had been involved in 1966, and Alan Solomon had curated the famous one in 1964, with Rauschenberg and Johns, and I had been recommended by them. My museum affiliation was arranged through the National Collection of Fine Arts at the Smithsonian. So I took a leave from the Corcoran to work on this, and met up with Joshua Taylor, who was the director of the NCFA at the time. The Biennale was held on an island—you had to travel there by vaporetto. I studied the plan of the place and got a sense of the American Pavilion, which was like a little neoclassical Monticello, though that gives it far too much credit. In São Paulo, I had been very precise about Barnett Newman's being the star, and the other artists the supporting cast. But I wanted to do a different type of show in Venice, an eclectic exhibition with relatively new and younger people, and I was determined to include photography. In the early days of Alfred Stieglitz, there had been a strong push to consider photography art, but in the thirties much of it was treated as documentary, even when that wasn't the intention of the photographers; in the sixties, photography had reemerged very strongly, and I wanted to acknowledge that. So I chose two abstract artists (Sam Gilliam, with his draped and suspended canvases, and Ronald Davis, who made acrylic paintings), two image-based artists (Richard Estes, whom I thought of as a solid realist, and Jim Nutt, who was a flat-out crazy imagist), and two people working with photography and video (Diane Arbus and Keith Sonnier, whose strange video installation *Channel Mix* was one of the first to use a split-screen montage). I thought I was going to get some grief about Jim Nutt, because there are genitalia in his work. He did an installation

for the show, for which he painted and stenciled funny little things directly onto the walls. Estes, of course, was very chaste and clean.

In the midst of the preparations for this show, Diane Arbus committed suicide. The Biennale was meant to include only living artists. So there I was, already fielding criticism because this would be the first time that photography had been included in the Venice Biennale as fine art, and suddenly I was in trouble for featuring a dead artist. I was really angry. I told them, "She's a great artist. She was alive when I began this project. What do you want me to do? Pull her out of the show?" and I walked out of the room. It was all so sad.

I had hired an artist—Jennie Lea Knight, who was a sculptor—to be my chief preparator in Venice, and Joshua Taylor was able to get a budget to pay her. She was really dedicated to the job: she carried a toolbox during the day and an attaché case for meetings at night. She could handle whatever went on with the artists. When Sam Gilliam fell out of a gondola and was bobbing around in a filthy canal, she managed to get him out of the water. When Keith Sonnier showed up with two girls wearing nothing but see-through slips and told me that all three of them had a bad case of crabs, Jennie Lea found the medicine they needed.

The most interesting pavilion that year was actually the German pavilion (which was originally designed by Albert Speer). The entire show was by Gerhard Richter, but it felt like a five-person show. In the rotunda, hanging unusually high, was a series in grisaille of forty-eight portraits of famous men of the twentieth century, many of them Jewish: Einstein, Freud, Kafka, philosophers, scientists. In the other four rooms, he hung four different kinds of work: his color charts, some expressionistic city scenes, and so on.

While I was in Venice, I got a call from the *Washington Post*. Did I want to comment on my dismissal from the Corcoran? The newspaper got to me before anybody at the museum did. I talked it over with Taylor. He said, "Well, if it is true, and you are going to leave that place, how would you like to come and work with me?" He offered me a job right on the spot, and I took it.

I had been fingered as a labor agitator at the Corcoran, and this was how it happened. As soon as I became director, I could review what people were paid. There were two black women working there, making coffee and so on. I looked at the staff list and saw that they were listed as maids. I said, "Maids? Well, what do they do?" I was told, "They bring us coffee when we want it in the boardroom, and they clean the women's restrooms." I said, "But they're full-time." They said, "Yeah, we're full-time, and they need to be on call for us." I said, "Something's wrong here. What does this number $4,200 mean?" "That's what we're paying them a year." Four thousand two hundred dollars a year. I said, "But they're here eight hours a day or longer." "Well, they don't have to do much and they're glad to get it." That was when I said to myself, *We're all being fucked here and there should be a union.* I wouldn't have joined the union; I just encouraged it. But someone I'd hired ratted on me. I'd met Peter Dworkin in the psychiatric ward at Cedars-Sinai, a smart but sociopathic young man. He came up to me one morning in the dayroom and said, "Hopps?" I said, "How do you know my name?" He said, "Oh, I've heard about you. I've read about you. You're a big deal in the art world, aren't you? Did you ever think you'd be sitting around the dayroom of a nuthouse?" He went out of his way to befriend me. And later, when he got out, he tracked down where I was and looked for a job at the Corcoran. He ratted everybody out, and it didn't do him any good. He got fired. I got fired. Everybody who was connected to the union idea got fired. Gene Baro became the Corcoran's acting director for a few months, until he and Melzac got into a fistfight at a black-tie opening, and then they were both fired, too.

21.

THE NATIONAL COLLECTION OF FINE ARTS

In 1970, S. Dillon Ripley, the secretary of the Smithsonian, chose Joshua Taylor to direct the National Collection of Fine Arts, which was later known as the National Museum of American Art. The NCFA was a sort of step-child of the Smithsonian facilities, a strange spillover collection, while the important historical American art was at the National Gallery. Taylor was hired to put some order and meaning into the NCFA and he was deter-mined to make it a serious museum of American art, giving full weight to both the nineteenth and twentieth centuries. The Smithsonian owned quite a lot already, and Taylor was charged with acquiring more. For years, the NCFA had been located in the Smithsonian's Natural History Building. In its new quarters—half of the wonderful old Patent Office building at Eighth and G—Taylor laid out galleries to accommodate the collection, much of which hadn't been seen in years, and he began to add to it. He had a curator for the nineteenth century and one for prints and drawings and, from 1972 to 1980, I was the general twentieth-century curator.

The NCFA was far more constrained than the Corcoran. Taylor was terrific, but we just didn't have the same kind of opportunity to put on free-wheeling, eccentric shows; the strictures were much greater. I was at odds with Ripley's values, his behind-the-scenes policies on the Cold War, and any number of things, and I found that quite a strain. The Smithsonian should have been as apolitical as any university, but, as far as Ripley was concerned, it was not. Still, the institution had to transcend whoever happened to be heading it. One of the first shows I did there, in 1973, had the unwieldy title "Divergent Representation"—Taylor's name for it. The goal was to span from clearly representational work to different kinds of imagist figurations. I wanted to include some nonliteral, nonrepresentational work, from the Expressionist to the decorative. I included four painters and

one sculptor, none of them well-known. The sculptor was Darryl Abraham, a backcountry guy who'd gone to school in Virginia and North Carolina and made fascinating little three-dimensional tableau scenes that were better than Red Grooms's. I'd discovered him in a group show in New York. Two of the painters were also of particular interest to me: Gage Taylor, one of the San Francisco psychedelic visionaries, whom I had met and made a book with, *Visions*—which sold more copies than anything I'd ever done— and Robert Gordy, from New Orleans. Gordy made these sort of stylized imagist paintings in the decorative or pattern-painting mode; he was a real pioneer of that approach, which become prominent in the seventies. I'd come to know him on my visits to New Orleans, where his companion taught ballroom dancing to ladies and he lived in a grand old building in the Quarter. When I stayed with him, we always had to make three stops in the evening: he knew the right place for pre-dinner cocktails, the right place for dinner, and the right place for dessert and brandy. He had an interesting way of describing his own ambition: he said, "I want to paint paintings that are as beautiful as fine French wallpaper." He had studied with Weeks Hall, a very bizarre figure in the South, who was missing a

Joshua Taylor, in the 1950s, when he was a professor at the University of Chicago. Photograph by Joan Kohn.

hand—he used a hook—and collected antique children's costumes. Gordy was the first person I knew to die of AIDS, and when he was sick his work took an odd turn, becoming very strange and grim.

In the fall of 1975, I did a show at the NCFA called "Sculpture: American Directions, 1945–1975. I included three pioneers, real pioneers who were born in the nineteenth century: Alexander Calder, Reuben Nakian, and Saul Baizerman. The three of them were as different as they could be. From Nakian, I chose the early cast-bronze work. Baizerman worked with freeform, hand-forged shaped ribbons of steel and hammered copper and made very strange totemic figure-like works. He was known to Barnett Newman's generation, but not really to younger artists. Taylor was delighted that I had rediscovered him. And, since the show was sponsored by a big copper company, we were happy to have some pioneer work in copper. I also had two Isamu Noguchis. Noguchi was younger than the other pioneers, but precocious—a pioneer of curvilinear biomorphic forms, very active at a young age, back in the thirties. He did things that looked like Gorky before Gorky got around to doing them. Then I had a full array of Abstract Expressionist sculptors. I missed the wonderful later sculptures of de Kooning—they hadn't come up yet. But I had some fantastic early David Smiths. Smith was one of my great loves in American art—the greatest abstract American sculptor of the twentieth century—and I felt that he deserved two works, especially one in color, so I included one of the earliest polychrome pieces, a steel-and-painted small tabletop work. (I hated the scandal of Clement Greenberg—who was a trustee of Smith's estate— taking the primer off the later works, because he believed they would look better in raw steel. He also suppressed Smith's paintings.) I borrowed a piece of Theodore Roszak's from the Art Institute of Chicago; he did hard-edged Constructivist work before switching to Abstract Expressionism. *Whaler of Nantucket* (1952–53) is a fantastic piece. I included Jasper Johns's most famous piece of sculpture—*Painted Bronze* (1960), the Savarin coffee can and paint brushes. He gave it a very abstract title because he didn't want it to look like a coffee can with brushes; he insisted on what it actually was, as an object. My sense is that it's a kind of self-portrait—there's a color that appears only once on the sculpture and that's orange, which he used to put his thumbprint on the side of the coffee can. I also had an early Louise

Nevelson, which had some little found carved objects in it, quite different from her later work. Near that, I put a beautiful early Joseph Cornell. (There were three in the show.) I tried to make unusual juxtapositions like that. Also on that shelf I had a wonderful intimate piece by David Hare. And, on the more contemporary end, there were works by Ed Kienholz, Richard Serra, Bruce Nauman, Tony Smith, Alexander Liberman, Sol LeWitt, Rockne Krebs, Lucas Samaras, Ellsworth Kelly, Anne Truitt, Eva Hesse, Donald Judd, and Claes Oldenburg.

I also worked on "America as Art," Taylor's big show to celebrate the hundredth anniversary of the Smithsonian, which went all the way from colonial times to the present. I was in charge of the Abstract Expressionist section, and I had one incredible work each by Pollock, de Kooning, Kline, Rothko, Still, Newman, and David Smith. Miraculously, I got one of the great poured Pollocks, one of the last ones. I didn't have a Gorky, sad to say.

While I was at the NCFA, it was very important to me to get the museum involved with photography. I suggested to Taylor that photographs be incorporated into the department of prints and drawings. He agreed and I was able to start shopping. I bought some wonderful work by Carleton Watkins and Timothy O'Sullivan, major nineteenth-century American photography. I almost got one of the most valuable American photographs, Paul Strand's *Wall Street*, but couldn't round up the $20,000 asking price. I can't remember if I got any Stieglitz or not, but I was going for the major figures whenever I could. There was no board committee that had to approve purchases there; they just had to fit within the overall budget parameters. Occasionally Taylor would have to go up to "the castle"—the headquarters of the Smithsonian—and get special dispensation for signifi-cant acquisitions. There was a great early Thomas Cole painting that Taylor wanted—*Falls of the Kaaterskill*—but he wasn't able to get approval for it. That broke his heart. The National Gallery has some Coles, but this would have been the finest one in the capital.

I acquired very little contemporary art. I got an important Sam Gilliam painting and, I think, an Anne Truitt. But I don't think I added a single major contemporary New Yorker to the collection. I was able to start the NCFA's collection of American folk art, though. I knew that the museum's deputy director, Harry Lowe, personally owned James Hampton's *Throne of*

the Third Heaven of the Nations' Millennium General Assembly. James Hampton was a black man from South Carolina, who had served in the Second World War and then got a job as a janitor at the General Services Administration. He lived very modestly in a boardinghouse, and he had visions of Christ coming back to Earth. In an unheated garage space that he rented, he built this enormous structure—about two hundred square feet—with a platform, a back wall, and side walls, using furniture from thrift stores and an endless amount of silver and gold foil; it was a kind of baroque altarpiece, with chairs and crowns, and everything covered with foil. He had strange plaques with what looked like encoded cryptic writing on them. Later, some government people worked on it to see if they could break the code and translate it, but they couldn't. There was no encrypting; it was just a visual effect. Hampton worked on *Throne of the Third Heaven* for fourteen years, from 1950 until 1964, when he took ill and died in a VA hospital. The work just sat in the space he had rented until the owner realized that he wasn't receiving the rent. Then there was something in the paper about it and Harry Lowe jumped in and paid off the back rent and collected the piece. He had come to me at the Washington Gallery of Modern Art, wondering if I would like to use it as a centerpiece for a fundraising party. I couldn't believe he owned it; I'd heard of the work but didn't know what had happened to it. It was an extraordinary work—not something to use for decoration at parties—so I went to Taylor about it. Taylor, who had great respect for folk art, was astounded to learn that his deputy director owned this piece and he went to Harry and arranged for it to be partly bought and partly donated to the museum. Thus, the folk-art collection began. I was able to buy a few other things, too, and it has grown into a vital part of that museum now.

22.

ROBERT RAUSCHENBERG

The most important exhibit I did at the NCFA was a Robert Rauschenberg retrospective. I'd always wanted to do a major show of his work. I had done the Johns show in Pasadena, which was a fluke of opportunity, but I hadn't done Bob. I'd seen Rauschenberg's first retrospective, which was put on by Alan Solomon at the Jewish Museum in New York, in 1963, and I'd seen all the Castelli shows over the years and visited Rauschenberg's studio and so on. In 1974 or 1975, I went to Taylor with the idea. We had only one work by Rauschenberg in the collection, and it had come in through a strange route: a cleaning-products company, S. C. Johnson & Son, had been buying contemporary American art and happened to own a Rauschenberg. When the company was looking for a place to donate its collection, someone contacted the Smithsonian, and the Smithsonian said, "Give it to the NCFA, where the American art is," so there it ended up.

I knew that the Bicentennial was coming up in 1976 and that Rauschenberg was involved in various political and ecological causes. So I said, "Can't we pitch Rauschenberg as a great American citizen-artist, our Bicentennial Man? Let's get some Bicentennial money." And Taylor said, "Well, he's a wonderful artist. Why don't you explore it?" So I built a case for Rauschenberg as the living artist who was the most engaged in public discourse, who was a benefactor and a philanthropist and reflected Thomas Jefferson's concerns for the country. In fact, Rauschenberg's personal favorite of the founding fathers was Benjamin Franklin, an inventor, an experimenter, and a publisher. The experiments that Franklin performed just thrilled Rauschenberg. He said, "Can you imagine getting out there and flying a kite in a storm to prove that lightning really was electricity?" He used to talk about another experiment of Franklin's, which he said was the most beautiful he'd ever heard of: Franklin, thinking of Newton and Goethe's

concerns about color and light and absorption, took a set of little pieces of cloth that covered the whole spectrum of color out to a snowbank on a sunny day and placed them very carefully in the snowbank at a precisely level position and waited. And, as he predicted, the darker end of the spectrum sank deeper into the snow than the lighter, because it was absorbing more light and heat. Bob loved that. He loved the idea of experimental devices as a kind of elemental sculpture. He had works in which a string hangs down from the ceiling, suspending a rock one foot from the floor; that was his demonstration of gravity. And he made different setups with those hanging rocks: some could be used to make a circle; others could swing like Foucault's pendulum and demonstrate the rotation of the earth. Those are probably the most underappreciated, stupefyingly simple works that Bob ever made.

Anyway, a short time after I spoke to Taylor, a group of American art-world people were invited to Stockholm for a special occasion organized by the Swedish government and by Pontus Hultén, the director of the Moderna Museet. It was kind of a cultural goodwill trip, and Rauschenberg and I both went over. There were so many artists on that plane; if it had gone down, the whole course of American art would have been changed. Rauschenberg was sitting in first class with his companion at the time, Bob Peterson, and I went up and sat down next to him and told him about my idea. He said, "I think we could pull this off. Let's do it," and then we discussed where the show could tour—to MoMA, to the Albright-Knox, the Art Institute of Chicago, the San Francisco Modern, and so on. And it was that simple. Eventually, we did the whole tour, just as we'd planned it on the plane that day. When I got back to America, I picked up the phone and made a few calls. So: a very complicated show, but after one conversation with Joshua Taylor, one conversation with Rauschenberg, and five phone calls, it was virtually set.

I'd first heard of Rauschenberg in the early fifties through Wallace Berman, who'd heard of him through the poet Robert Creeley. The e-mail of that time was delivered by poet couriers: writers were itinerant in the Beat period, and we'd hear about art from them before it was reproduced in art

magazines or anywhere else. Berman thought Creeley's description sounded interesting, and he made a point of saying to me, "If you're ever in New York, check this artist out and let me know."

The whole thing came tumbling out of the trunk when Rachel Rosenthal turned up in Los Angeles in 1955. She worked as a theater coach for movie people, and she founded the Instant Theatre, the first sustained performance-art company in L.A. She had had a fling with Jasper Johns and was friends with him and Rauschenberg, and she brought with her work by both artists. She had what was arguably the first Combine painting—Rauschenberg had put a shelf below and a light box above one of his red paintings. Collage in a painting was one thing—that wouldn't have looked alien at the time—but if you add to a painting a piece of ornamental stained glass and a shelf from the studio, which paint cans have been sitting on, you've got a different kind of animal.

Rauschenberg had started his career as a collagist and a collector very young. He grew up in a poor family in Port Arthur, Texas, in the thirties. As a child, he slept on the back porch; his sister had a room of her own, but Rauschenberg's father made him sleep out there, as if he weren't quite part of the family, as if he were the dog. Thanks to the intervention of his mother, by the time he was ten or so, he had a room of his own, and in that room he created his own little museum in milk crates stacked up to form shelves. He saved all kinds of things—spiders in a bottle, rocks, bits of wood, shells, toys in various states of travail. He liked things that had been worked on by people or by nature just as much as he liked a pristine sample. Even as a child, he told me, he used to cut things out of his mother's old magazines and stick them up on his wall. "I'd put them all together," he said, "and it just grew larger until I had this interesting amorphous shape, with all these images layered on." Rauschenberg continued to do this all his life. Every bedroom of his had a great set of cupboards or baskets or a wall of shelves filled up with this sort of material. I'd walk into his room and find on top of his dresser a collection of artworks given to him by different artists and small objects that he'd picked up—stones or foreign coins. He'd have a wonderful Cy Twombly object alongside things he'd picked up on the street: he didn't make any distinction at all. He even had an Egyptian mummy case in his Lafayette Street studio in New York. He was instinctively carrying

on the tradition of a wonderful early American artist, Charles Willson Peale, who established a museum in Philadelphia, with a portrait gallery and a huge cabinet of curiosities: mastodon bones, mechanical devices, and other artifacts—a practical American version of the *Wunderkammers* that barons and princes kept in Renaissance Europe.

As a young man, Rauschenberg was drafted and chose to serve in the Navy, which took him to San Diego. Once he was out of the Navy, he returned to California, where he met a woman called Pat Pearman, who encouraged him to go to art school and lived with him in Kansas City, while he attended the Kansas City Art Institute on the GI Bill. Then he studied at the Académie Julian in Paris, where he met Susan Weil, another painter from New York, whom he later married. He and Weil went to Black Mountain College, because he'd heard that Josef Albers was there. They worked on some photographic blueprints together. At some point Pearman came to visit and she was the nude in his blueprint work. What a wonderful, indulgent life: the old girlfriend comes in and strips down and he and his wife make a blueprint of her! Susan Weil was an absolute saint. Even after their son was born, in 1951, and Rauschenberg ran off with Cy Twombly, she was part of his family, attending openings, staying in touch. Rauschenberg traveled to Europe with Twombly—to France and Spain and Italy—and to North Africa. They also went over to Cuba, pre-Fidel. They informed each other's work in very important ways. Neither of them was really known yet, and I think Twombly always felt a great debt to Bob. But then they split up. Twombly went back to Italy and met a rich woman, Tatiana Franchetti, and married her, and Bob met a younger artist, Johns, and fell in love with him. Someone once asked him, "What was your relationship with Jasper?" He said, "We gave each other permission to do what we were doing." They were an audience for each other; they had studios near each other.

Rauschenberg's first solo show was held at the Betty Parsons Gallery in 1951, when he was twenty-five. In 1950, he'd taken some smaller paintings into the gallery to show to Parsons. Parsons set them out and then sat there quietly. After a while Rauschenberg said, "What do you think?" She responded, famously, "I think I could show you next spring." He hadn't been asking for a show—he'd just wanted a professional opinion. But he kept his

Robert Rauschenberg working on a solvent transfer drawing in his Front Street studio, New York, 1958. Photograph by Jasper Johns.

mouth shut; he was stunned and exhilarated. Interestingly, Parsons had Clyfford Still go to Bob's studio and help to pick out pieces for the show. Nothing sold. The rumor was that Rauschenberg then destroyed all the work out of disappointment. Wrong: Never believe an artist when he says he has destroyed his work. It was dispersed and lent around.

The first time I saw Rauschenberg's work in a gallery was at Castelli, in a group show, in 1957. I was very, very excited it by it, so Castelli said, "Let's call him up and you can visit his studio." Ed Janss was with me, and he and I went to Rauschenberg's studio on Pearl Street. I couldn't believe what he had there. I became very engaged with Rauschenberg's work and with Johns's. We were friends, and whenever Rauschenberg was in California he'd come over to my place, behind Ferus. Once, when he was there, he noticed a little Kurt Schwitters drawing collage that I had bought—a very simple one, a pencil drawing with one little red-and-white gum label stuck to it. At the top was the word *"Hinterhaus"*—"behind the house"—and, below, an elaborate annotated diagram showing the back wall of a house and a floor plan. I'd bought the work by mail, in a German auction. It was the only Schwitters I owned then, and it looked like one of the drawings that Bob was making at the time. He took it off the wall and started walking out with it. I said, "Wait a minute. I love that drawing, and, uh, you know,

it's the only one I have." He said, "I love it, too, and I don't have one." I said, "O.K. I'll loan it to you, on condition that one day you'll make me a frame for it." The frame it was in was cracked. He said, "A frame? What do you mean a frame?" I said, "Well, let's define 'frame' however you want to, in any way you come up with." Bob said, "Aha. All right. You've got a deal." I didn't get that piece back from him until sometime in the late seventies, when I saw it hanging in his office on Lafayette Street and thought it was time for the work to come back to me. He never did make me a frame. But he had given me some little odds and ends in the meantime, so I figured those would serve as rent for the Schwitters.

By 1962 or so, Rauschenberg had become a real presence in Southern California. I didn't show him at Ferus, because I was showing Johns at the time, and they had split up at that point and couldn't be in the same gallery. Virginia Dwan showed Bob at her gallery in Westwood. He had made some prints at the Gemini print workshop. And he plunged into lithography with ULAE—Universal Limited Art Editions—the wonderful Tatyana Grosman enterprise on Long Island. The first major museum show to include Rauschenberg was William Seitz's great "The Art of Assemblage," at the Museum of Modern Art in 1961. It was a groundbreaking survey of works that Seitz didn't want to refer to as "mixed media," an explosive show that covered the whole twentieth century up to that point, from Picasso and Schwitters on. Rauschenberg was represented by a masterpiece of his, *Canyon*, from 1959. *Canyon* is a wall-hanging assemblage with a stuffed eagle perched on a box, its wings spread as though ready to fly. A pillow hangs from the bottom edge of the painting. On the surface of the painting there's an astronomy chart jutting out into space. The title implies that there's some kind of canyon to be crossed—a risky leap for a human, but something that an eagle can cross with ease. In the upper-left section of the painting there are two images collaged to the surface: a small reproduction of the Statue of Liberty, and then beyond the Statue of Liberty is an image of a child raising his arm in the air, echoing Liberty's gesture; it's Rauschenberg's own photograph, of his son, Christopher. He was thinking of his dreams for Christopher, hoping that his son would safely cross the canyons of life, riding on the back of a great eagle. (Interestingly, his son became a photographer and cofounded an alternative space for photography

in Oregon called the Blue Sky Gallery.) When I asked Bob why there was a pillow hanging from the painting, he said, "For a soft landing, in case he falls."

It was around that time that Rauschenberg started becoming interested in the silk-screening process. It was coming into Warhol's work at the time, too, but they didn't really know each other then. Rauschenberg had been working, since the late fifties, with "transfer drawings"—transferring printed images, through a sort of solvent-and-pressure transfer process, onto paper. Those images became monoprints—one-of-a-kind works from assembled media. It wasn't a cut-or-tear-and-paste technique, à la Schwitters; it was a new kind of technology, working on a flat surface, which was why Rauschenberg called these pieces "drawings." He coined the term "transfer drawings." It was intimate work—his way of doing studies. Seeing how those images could be combined, juxtaposed, blending into one another, he suddenly wished that he could do the same thing on the scale of painting. And it occurred to him that if he had intimate work photographed, enlarged, and transferred onto silk screens, he could then screen those images onto large canvases and make them any size he wanted to—all the way up to the monumental thirty-two-foot painting *Barge*.

Never forget that the first Rauschenberg to enter a museum collection was a photograph—Edward Steichen bought two for the Museum of Modern Art in 1952. Take away photomechanical reproduction, and Rauschenberg becomes almost invisible. He started taking pictures in 1948 or '49. He studied photography at Black Mountain with Hazel Larsen Archer, who, Rauschenberg said, was very open to any subject matter but made sure that you learned your darkroom techniques. Like a Buddhist, he found the universe right there at the edge of his own garden. He was looking at the commonplace world without any preconceptions about having to take pictures of important people or dramatic events or wonders of nature. He shot an amazing black window, just a window frame with curtains drawn and a lamp inside. He shot an old carriage—the darkness of the carriage's interior fills most of the frame. He took a picture of Cy Twombly sitting on a bench at night. He shot a lightbulb in the ceiling—I finally figured out that that was over at Knox Martin's studio. I have given some lectures on why the lightbulb is so important as an icon to the artists of our time. Answer:

they work in dark studios. They are not out in clean air painting, like the Impressionists. They are in studios where the windows are practically opaque and they work at night a lot. No lightbulb, no painting.

As much as I love the abstract achievements of Pollock, Rothko, Newman, and Still, I cherish the ways in which Rauschenberg brought the literal world—literal images of the world—back into advanced art. He was not a guy sitting in Mesa, Arizona, painting an Indian woman standing with a pot on her head—although, if he happened to have photographed that woman, he would have known how to incorporate the image into a whole panoply of things. His literal images are not still lifes; they don't involve simplistic narratives. They are as panoramic and as complex as the visual matter we encounter when moving through time.

Rauschenberg was a crucial bridge between the previous generation of American artists—de Kooning, Newman, Still, and Kline—and the art that followed, from the late fifties on: Jasper Johns, Warhol and the world of Pop, and the postmoderns. In the course of his career, he had at least three different approaches to art. In those black, gray, and brown works with rugged textures, he was a consummate Abstract Expressionist. He was also a Minimalist. He did a series of matte white paintings and a series of matte black ones, most of which he painted over. When he didn't have canvas or money, he just grabbed whatever was at hand. He painted over some great early works. There was a piece in the Parsons show called *Should Love Come First?* I think it was made early in his affair with Cy Twombly. John Cage got hold of it later, and one day Rauschenberg was at Cage's house while Cage was taking a nap, and he just took it down off the wall and painted on it, turned it into a black painting. He was feeling restless that afternoon. Most of the original white paintings disappeared into other artworks. He replaced them with new versions—he told me that it was easy enough to remake them: "I never wanted them to have patinas or marks on them. I just make the canvas the right size and choose the right white and make them up fresh." The white paintings were modular—three or four or five or seven panels. He described them as "one white, as in one God." There was a transcendental side to Rauschenberg. John Cage called them

landing strips for shadows and motes of dust, and they inspired his work for piano 4' 33", in which the pianist goes to the piano, opens the lid, and sits there by a stopwatch for four minutes and thirty-three seconds, then closes the lid and gets up and walks away. Cage felt that the music was all the little bits of noise that happened during that time—the coughs and shufflings and so on.

Rauschenberg was also a conceptualist. He made a conceptual portrait of Twombly, *Cy + Roman Steps (I–V)* (1952), in which he used five shots of Twombly, just enough to make the sense of Twombly moving toward the camera clear. Then there was *Automobile Tire Print* (1953)—a twenty-two-foot-long tire track on a strip of typewriter paper, glued together, that could have kept going forever. He made *Erased de Kooning Drawing* in the same year. He said, "If I'm going to erase a drawing, it has to be one I really admire." And the astounding thing is that de Kooning had enough regard for the whole idea to go along with it. What a champ he was. He said, "Well, O.K., if we are going to do it, let's get a really good one. He narrowed it down to three drawings and let Bob choose. De Kooning had picked drawings that had grease pencil and smears of graphite on them. He said, "I'm not going to make it easy for you—it shouldn't be too easy." Bob confessed something to me. He looked at all three drawings and said that they were just fine—wonderful, and very similar—but the one he chose also had a drawing on the back. Not a great drawing, but a drawing. He said to himself, *You never know how this career is going to work out. If it all goes nowhere, at least I'll have a de Kooning drawing.* And, of course, the career worked out—and the damn thing is worth more than the de Kooning drawing that was there in the first place.

Rauschenberg was not involved with the grand Western tradition of drawing in the way that Jasper Johns was. Johns's drawing is bravura drawing, the kind of drawing that Cézanne or Seurat would have understood. Rauschenberg invented a new way of drawing. For him, collage was a kind of notational drawing. Perhaps his most beautiful traditional drawing was the third study for the final *Monogram*. Another is a very straightforward tracing of a pair of feet. I asked him, "Whose feet are those?" He said, "They're mine." I said, "How did you trace them?" And he said, "With difficulty—squatting down and just pushing the pencil around. I could feel

my way, but I couldn't see what I was doing." And he smiled and said, "I sort of liked that."

Then, of course, there were the Combines. When I was working on the NCFA show, Rauschenberg told me that there were a number of works that were privately coded for him as autobiographical. He didn't want to discuss this publicly at the time, and I never did. The works were *Bed* (1955), *Untitled* (1953–54), *Odalisk* (1955/58), *Canyon* (1959), and *Monogram* (1955–59). To make *Bed*, Rauschenberg used his own coverlet—a quilt with geometric designs—and his own pillow; I think they may have come from the first bed that he and Jasper slept in together. This was his first use of a pillow, an object that was of great importance to him, which implied both comfort and rest and a cushion to break a fall. The bed suggests, of course, both sleep and sensuality. The paint splattered around where the quilt meets the pillow suggests excitement. The word "bed" also has the meaning "seed bed."

The untitled Combine (1953–54), is a strange, somewhat ramshackle three-dimensional standing object, taller than a man, and its conspicuous element is a portrait of an elegant young man in a white suit with white shoes. Under the porch of this piece is a stuffed Dominique hen. And in a chamber open to the back there is a pair of white buck shoes. When I was installing the show in 1976, I said to Bob at lunch one day, "You know, it breaks my heart that so many of your important works are just called *Untitled*. When you do come up with titles, they're very specific and vivid." He said, "Well, those titles always come after the fact, anyway. I christen them, you know. I don't think of the title before I make it." So I said, "Well, how would you like—before the catalogue is printed—to go around and title some of these works." And he said, "That'd be terrific. Let's do it." He titled one Combine painting from the fifties *Levee*; I don't know where he got that or what he was thinking about. Another, earlier work he called *Collection*, because it had an accumulation of reproductions of other artworks in it—and also to honor the fact that he was having his retrospective at the National Collection. And then we came to the untitled Combine with the man in the white suit; he looked at it and he became very thoughtful, almost brooding. Then he looked at me and said in a grim way, "No, I can't title that. That one is always going to be untitled." I asked him,

"What does that figure in the elegant white suit and white shoes mean to you?" He replied, "That's the father I wish I had." The hen was a kind of companion to the man—a wife, a mother. The shoes in the back were a pair of Bob's own shoes. It's interesting how certain great artists have used shoes as a subject—there are those extraordinarily humble workmen's shoes in Van Gogh, and a mysterious enigma of shoes in Magritte, shoes as a sexual fetish in Méret Oppenheim.

In *Odalisk*, the main body of the work is supported by a found newel post or table leg, which rests on the base but is cushioned by a pillow. It's as though there were a precarious balance to the whole assembly—with the suggestion of something phallic plunging into a pillow. On the other hand, the pillow also implies gentleness and comfort. The body of the work has no opening to the outside; there are walls made of scrim, which are pasted with images of imaginary women—pinups and nudes, fantasized, fetishized women—and in the ambiguous, vague interior there is a lightbulb that turns on and off, on a timer, to illuminate the piece. Surmounting the work is a great proud white rooster. It's as though Bob were thinking about the women who had been in his life and at the same time using images of the conventional stereotypes—women as seductresses or sex objects. When he made it, he had been with at least two women sexually, and, as far as I know, no men. Once, when I was giving a lecture on Rauschenberg in San Francisco, the activist and writer Jonathan Katz popped up and asked why I was ignoring the homosexual iconography in Rauschenberg's art. I said, "Because I don't think he's homosexual." There was all this tittering and weirdness in the audience. And Katz was shocked. He said, "You're just denying his homosexuality." And I said, "No, Jonathan, I'm not." He said, "Well, then, what is he?" And I said, "He's pansexual." He said, "What on earth does that mean?" I said, "It means that he has had and does have loving relationships with women, men, animals, and the earth." That made the audience roar, and that's where that ended. Later, Jonathan was waiting for me outside and asked, "What do you mean 'the earth'?" And I said, "Jonathan, Rauschenberg is one of two men I know who got so ecstatic at one time or another, he just pulled down his pants, got down on soft soil, and fucked the dirt." Which was true. It was a moment of real ecstasy. He had a physical, engaged, intimate relationship with all things and beings.

Installation shot of Rauschenberg show at Galerie Ileana Sonnabend, Paris, in 1963. Works shown include Monogram *(1955–59),* Broadcast *(1959), and* Charlene *(1954). Photograph by Shunk-Kender.*

Monogram is owned by the Moderna Museet in Sweden. Pontus Hultén, who was one of the people chosen by the king of Sweden to found a museum of modern art in Stockholm in the mid to late fifties, and was given something like $3 million to buy work for it, came to the U.S. at a time when most American museums were just sitting on their hands about Rauschenberg's new work. Hultén saw *Monogram* and bought it, just like that, and this masterpiece went off to the far north of Europe. It's difficult to borrow the piece now; it's considered too fragile. The work has been interpreted in some really bizarre ways. The literal genesis is a memorial for Rauschenberg's pet goat, Billy. Rauschenberg's father, to supplement the family's meager income, liked to hunt, and was known as a good hunting guide for other people around Port Arthur. One day he took some people out but came back without any game. They were frustrated and they were drunk, and Rauschenberg's father saw Bob's goat in the yard and said, "Well, let's barbecue that damn goat!" So they killed it and barbecued and ate it. Rauschenberg was probably ten or eleven, and it just devastated him. He struggled not to hate his father, but something was always bringing

those feelings up again. When his father was dying, years later, Bob was at his bedside for his father's last words: "I never liked you, you son of a bitch."

In the years that Rauschenberg was in New York, he had very little money. He did odd jobs—working as a janitor at the Stable Gallery, for instance. He got to know Joseph Cornell's work because one of the jobs he had was to drive out to Utopia Parkway, in Flushing, and pick up Cornell's pieces and bring them back to the Egan Gallery for a show. (His in-laws were friends with Charles Egan.) Rauschenberg got very familiar with Cornell's work, hauling it back and forth. He knew it intimately before he'd ever seen anything by Schwitters. In any case, one day, as Rauschenberg was walking through Manhattan, he saw a gorgeous Angora goat, stuffed and mounted, in a shop window. He thought of it as an apparition of his goat, so he found out the price—$35—and scraped together the money to buy it. He did a number of drawings of possible ways to build it into an assemblage. One was sideways on a kind of shelf—a Combine painting with a shelf attached. Another was on a kind of elongated plinth. I think he even imagined it looking out of a little house. But what he finally decided on is what makes it clear to me that the piece is both a memorial to his pet goat and a self-portrait—the most important self-portrait he ever made. He took one of his black paintings from an earlier era and laid it flat on the floor as the base, so that *Monogram* literally stands on his work. He had saved, or got from his mother, the little footprints that were made of his feet when he was born, so his own feet are at one end of the black painting. There's also a tennis ball sitting on the black painting beside the goat. I asked Bob why it was there, and he said, "Oh, so he'd have something to play with from time to time."

There are two very curious details on the goat itself. There is paint splashed at the base of the horns and on its face, in a kind of Abstract Expressionist outburst. Without being a dandy, Rauschenberg was a handsome man, who took pride in his costuming, so the Angora goat, an elegant animal, was an appropriate choice to represent him. Between its horns is this sign of the painter, the gestural signature. And the other element is, of course, the tire circling the body of the goat. Tires fascinated Rauschenberg because they represent mobility. Much later, he made some beautiful cast-glass tires, a pair of them chained together. When I asked him about them,

he said, "Well, you know I have a companion, Darryl"—his partner and assistant Darryl Pottorf—"and I wanted a tire for him, too. I wanted us to be together." *Monogram* for him meant a monogram ring. He said, "That's my identification, but how do you put a ring on a goat hoof? Then it occurred to me that the ring was something my goat could wear around his middle." Robert Hughes did an analysis of this piece that is all scatalogical and about tortured sexuality, but the reality was so simple.

Bob could be very direct and straightforward. At around the same time as *Monogram*, he made two paintings that are almost identical: *Factum I* and *Factum II*. Each painting has two newspaper images of Eisenhower, two trees, two calendars, and so on. He made *Factum I*, then set it aside, and as a kind of experiment for himself he made *Factum II*, to see how close he could get to the first piece. The answer was: very close. I remember looking at the two images, and noting all the doubling within them, and I said to him, "Bob, there's this big red letter *T* in the lower right-hand corner of each one, but there's only one—you don't repeat the *T*." He laughed at me and said, "You don't get it? I didn't have to repeat it." I said, "Why?" And he said, "*T* for two! Already taken care of." He was a little Duchampian at times, with his wordplay and puns. He made a painting called *Rebus* which almost asks to be decoded. But he said, "I didn't make it to be decoded. People can get out of it whatever they want to, but I didn't put it there." Early on in his career, he was dismissed as being a neo-Dadaist, but he wasn't at all. He was never dealing with the world in a bitter or ironic way, and a lot of his material was not meant to be absurdist at all.

The year before the show at the NCFA, I got to watch Rauschenberg make his piece *Rodeo Palace (Spread)*, a thirty-two-foot-wide construction with three doors. It took all of one day, all of the next, and then the next night, and it was finished on the third morning. I watched Rauschenberg struggle with one piece, which he couldn't get into the right position, in the center section where the screen door is. I told him that it wasn't going to fit right, and he tried it and it didn't. He said, "Bring me the knife." And he sliced off part of it so that it would fit, then gave me an angry look—because I'd been correct and he hadn't. The cut he made left a little hole—there's a white

space in the upper-left corner, above the screen door. He said, "Gimme a pencil," and he wrote "Walter's Hole," dated it, and signed it, and said, "This is for you." The last thing he did on the piece, in the early hours of the morning, was to take a soft pencil and, with force and slow deliberateness, not quite complete a line going from left to right across the top of the painting. There are any number of those lines in his work, which fall just short of finishing the full distance. Rauschenberg took *Rodeo* as a kind of metaphor for the artist going out there and putting on a show. The work is also based on his love of the movie *The Misfits*. The strip of white with red polka dots is a tribute to Marilyn Monroe. The striped patch behind the other door is the shirt of the soulful Montgomery Clift.

I went out of the way to make a good installation for Rauschenberg at the NCFA, and I got away with some special touches. The building had heating and air-conditioning vents at the base of the walls, which could get in the way when you were hanging a big painting. I was able to build a false wall, sitting about a foot out from the real wall, thirty feet wide and twelve or fourteen feet high, floating about four inches off the floor, so that the air could pass underneath. And I made smaller rooms out of the larger spaces, simple, clean rooms. You could have built a house with all the lumber we used in that show.

By then, Rauschenberg was living most of the time in Captiva, Florida, so I went down there often to work with him. I worked like a fiend for a year and a half, along with Neil Printz, a predoctorate fellow from the University of Michigan, who had been assigned to the NCFA. The retrospective became Printz's main activity, and never mind the other things he was supposed to be doing. We worked day and night. When his fellowship ran out, I got what was called "a thousand-hour appointment" for him, and he became de facto staff. Long before any work was at the Smithsonian, we knew exactly where each piece was going. We planned that show out like a Hitchcock movie. Even so, when the work arrived, along with Rauschenberg and his entourage, for the installation, it looked like chaos to the Smithsonian officials. It was as if a horde of cowboys and Indians had set up camp: they saw no reason that they couldn't eat and drink and live in the galleries. There were officials who were trying to tell Rauschenberg and his assistants not to touch the work, because they weren't professionals and weren't on staff.

We were lucky to be able to get so much of the important work that existed at that time—most of the major Combines and a really broad array of other work, including prints, drawings, sculptures, and paintings. I did a whole salon of Rauschenberg's posters, and I got him to produce a custom design for the cover of the catalogue. I fought to get that catalogue printed somewhere outside the U.S. Government Printing Office—I wanted something more refined. It was in color and had a hardcover version, as well as a soft-, and I got an essay from the critic Lawrence Alloway, who had written incisively and brilliantly about the emergence of British and American Pop Art. I had first asked Robert Hughes, who was at *Time* magazine then. I knew that Hughes loved Rauschenberg, so I went to see him at his office. He was sitting at his typewriter with an open bottle of champagne beside him, just drinking straight from the bottle. He heard me out and then he said, "I have a better idea. How'd you like to have him on the cover of *Time*? I think I can pull it off." And he did. Rauschenberg was one of very few artists, living or dead, ever to be on the cover of *Time*. Interestingly, Joshua Taylor never mentioned the fact that we'd made the cover of *Time*; that was the everyday stuff of the world and he was beyond all that. He found public success or clamor a bit reprehensible. But it meant a lot to Bob.

Touring the show—transporting all those works and installing them in different places—was a circus. Every physical situation was different, and, as much as we planned ahead, we came up against things we couldn't have

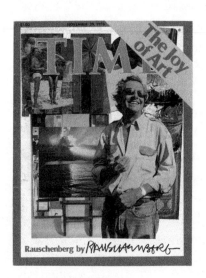

Robert Rauschenberg on the cover of Time *magazine, November 29, 1976.*

predicted. One of the early, complicated Combines is a work called *Minutiae*, which is full of collage and structure and fabric. Early in his career, Rauschenberg had worked with John Cage and Merce Cunningham, making sets. *Minutiae* was the centerpiece for a Cunningham dance performance, and Bob had configured it so that it could be packed up in a crate and tour with the company. He had left it with Cunningham, which was why it hadn't been sold like the other early Combines. It belonged to Bob, but there was some tension with Cunningham, who figured that because he'd had it for all those years it really should belong to him. This tension surfaced when the show was about to open. PBS was filming a special on Cunningham at a studio in Nashville, Tennessee, and Cunningham wanted *Minutiae* to be there for his performance. It was an important piece in our show, so I was facing a terrible dilemma. Finally, I came up with an idea. I said to Bob, "What if we can make an exact duplicate of it?" He said, "Jesus, that's a complicated piece. Do you think you can?" I said, "I'm going to assemble a team of artists and we're going to work day and night and get that thing duplicated. We can send the duplicate off and it'll be fine for the TV cameras in Nashville. As a matter of fact, we'll just give the copy to Cunningham for his own use." Bob said, "That's good! I want to have my *Minutiae* back." So I put together a team of people. I assigned an artist called Caroline Huber to the fabric, and I had somebody else finding objects, and somebody else on woodwork and on silk screens. One of the hardest things to find was this Chinese tea tin—the top had a kind of orifice where the metal lid screwed on—but one of our guys eventually found one in Chinatown. We worked through the night before the piece was due to go off to Nashville—we had a truck waiting to take it to air freight—and, when it was done, we took a few Polaroids, and wrote on the work, "This is not a Rauschenberg. Made by . . ." and had everyone sign. We sent it off and kept the original in the show. Rauschenberg didn't, in general, hold on to the Combines for himself. They were almost all out there in the world. He drew so much from the world and then he let it run right back out. He always had faith that he could replenish, and, as long as he had energy, there was an endless wellspring of ideas.

When the exhibit was at the Art Institute of Chicago—James Speyer was the curator of twentieth-century art then—there was a dinner after the

opening, and we went to a fancy club to eat. Rauschenberg sat at the head of the table, next to a very rich big-time collector. In the course of the evening, the collector—who was usually a pretty severe, almost grim man, with little interest in contemporary art—offered Bob a million dollars for his oil-and-silk-screen work *Barge*; he wanted to buy it for the Art Institute, where he was on the board. Bob turned him down. He couldn't believe it. (Bob said, "Do you know that old man was feeling me up? He had his hand on my leg under the table.") Rauschenberg later sold it to the Guggenheim for several million. Until Jasper Johns sold the big *White Flag*, it was the most ever paid for a work by a living American artist.

About ten years after the NCFA show, Rauschenberg started creating a series of paintings on metal surfaces: the "Shiners" (1986–93), the "Urban Bourbons" (1988–95), the "Borealis" (1989–92), the "Galvanic Suite" (1988–91), the "Night Shades" (1991), the "Phantoms" (1991), and the "Off Kilter Keys" (1993). The most beautiful of these were the "Borealis" and "Night Shades" works. Rauschenberg often began an important body of work in black-and-white—the early lithographs and the early Combines were mostly on a gray scale. The "Night Shades," a lush, gorgeous series, are all black-and-white. They involve photographic images transferred to the soft gray of an aluminum surface and combined with expressionist, painterly passages. *Holiday Ruse*, one of the "Night Shades," is particularly impressive to me, a rich, emotional, humane work. One of Rauschenberg's great linear pieces, it moves from left to right and is conspicuously longer than it is high. It works in a kind of measured, sequenced way; it's divided into five separate units horizontally and three units vertically, so it has this kind of ⅗ rhythm to it. The photographic images at play here are fragments of architecture—a railroad crossing, a porch banister, city and street scenes that disappear beneath the informal painting or tarnishes on the aluminum surface of the panels. On the one hand, you have the grunge of the city, and the grunge of the tarnished metal. On the other, there is real beauty—the movement and activity is Abstract Expressionist, gestural. As you walk by the work, things appear and disappear; the images go in and out of focus in a dreamlike way. In the lower-left corner of the painting is a walking duck; above it is an image of Pegasus, taken from a Mobil Gas sign. In the next panel, there's a statue of a classical goddess, and at the top of the third panel is an image of a

Byzantine saint that Rauschenberg photographed—it was painted on a building in New York. (When I asked Bob who it was, he said, "I think of him as Moses.") In the fourth panel is a clear image of a Venezuelan worker carrying a stack of boxes on his shoulders, and in the final panel, in the lower portion, a shepherd with his staff on the road. He has given us pairs of animals, spiritual icons (Christian and pre-Christian), and humble humans—dignified workers. (Rauschenberg revered animals, by the way. He had an intuitive understanding of Medieval Christian iconography, in which animals appear as innocent witnesses to the affairs of human beings.) These three pairings encompass the world of beings for Rauschenberg—the cosmos. There are no giant things here—none of the galaxy imagery you find in Johns—but Rauschenberg made human events vast. When I talked to him about how much there is in *Holiday Ruse*, he said, "This painting even has music!" I said, "I didn't hear anything." He said, "Look again," and pointed to some lettering on the signs in the painting: the most conspicuous word happened to be "music."

Rauschenberg's other great late painting is *The ¼ Mile or 2 Furlong Piece*, which he made over the course of more than two decades, from 1981 to 1998. The Big Bertha of linear paintings, it's the world's longest notebook of ideas—more than four hundred and forty yards long. To walk around it is to traverse a literal and abstract landscape. Another amazing linear work is *Soundings* (1968)—a nine-unit, thirty-six-foot-long sound-activated Plexiglas structure with images of chairs imposed in such a way that they seem to be flying around in different positions or dancing when you clap your hands. The chair was one of his major tropes—a stand-in for the body, the human presence. Jean Tinguely and Rauschenberg really hit it off when they met, and they have a similar goofy humor and anthropomorphism in their machines.

23.

THE MENIL COLLECTION

I first met John de Menil when I was doing the Jasper Johns show at the Pasadena Museum. He called ahead to say that he was coming and was wondering if someone responsible for the show could meet him. He was a fascinating man, alert and dedicated. The next time I saw him was in 1969 or so, when I was at the Corcoran. John tracked me down and invited me up to New York, to visit him at his town house on East Seventy-First Street, which had once been the Albanian consulate. He wanted to know what I thought was of interest in contemporary art. I was fascinated by what I saw in the house—School of Paris paintings, excellent ones, Surrealist work, Max Ernst, and I think I remember a Magritte. Hanging in the hallway was a work by John McLaughlin, a California abstract artist I had shown at Pasadena. There was a great late Georges Braque, a de Chirico painting— works that are now part of the Menil Collection, but I was seeing them then for the first time. He also had a wonderful work in his bedroom by Yves Klein, whom I had got to know before he died. There was tribal art, too—pieces from the Pacific Northwest, as well as Oceanic, Micronesian, Melanesian, and African art. I hadn't seen the Houston house yet or the big house in the countryside outside of Paris. I knew of his wife, Dominique de Menil, but I hadn't met her. She was living in Houston, though on occasion she was at the New York house. They shared a passion for art and a passion for human rights and liberal politics.

Not long after that, I was visiting New York, and I went to some slightly seedy club on Gansevoort Street. While I was there, my wallet got lifted. Fortunately, I carried cash in my pocket, so I had enough to buy a shuttle ticket back to D.C. I went back to the Corcoran and, two or three days later, my secretary told me, as I was coming in, "There's something on your desk that I think you'll be very interested in." I went into my office and there was

a little Tiffany box that she had unwrapped. I opened it, and inside was my wallet, with everything still in it, and a little note that said, "I think you need this more than I do. All best, John de Menil." He must have been in that club and spotted me and somehow saw someone take my wallet and managed to get it back.

John de Menil (he was born Jean and anglicized his name after he moved to the United States) and Dominique Schlumberger, heiress to the Schlumberger engineering company, were married in 1931 in Paris. John had already begun a career in banking, but, a few years after the marriage, he joined the Schlumberger firm and rose in the ranks. Eventually he became a key executive and a co-head of the company. John was born French-Catholic and Dominique had a Huguenot background. She converted to Catholicism after she married him—they were that much in love. The French Protestants were like American Yankees; that is to say, they had family portraits and good silver and that was the extent of their luxury. Given their wealth, they lived quite simply. John de Menil loved fine art and didn't have much money, though he came from an aristocratic French background. His family had sided with the Revolution way back, and Napoleon had endowed the male line of the family with the honorific title "Count." But John, being a good socialist, never traded on his nobility.

Dominique de Menil was once asked where she came from, and she said, "Well, in the sixteen-hundreds, we were in what I think you call Alsace-Lorraine." She wasn't being pretentious; she just took the question quite literally. The family had made arms and armor; it went that far back. They had been steelworkers, and steelworking had segued into the world of electrical engineering. Schlumberger Ltd. had a particular invention that generated a great deal of its revenue. Near the turn of the century, Dominique's father and her uncle had devised a kind of electronic sounding device to explore for oil underground and also log oil productivity. They did something quite extraordinary at the time. Instead of manufacturing and selling the product, they got patents on it all over the world, so that anyone who wanted this service performed had to come to them and lease it, and their fieldworkers would go out and oversee the use of it. The Schlumbergers

wouldn't sell the product, so they had a monopoly on this device, which was so crucial for oil development. From the Soviet Union to the Far East to La Cienega Boulevard—you name it—they were there. Beverly Hills High School happens to be the only high school in North America that has a working oil well on its grounds.

It was John who began the de Menils' involvement with art. While they were still living in Paris, he bought a Cézanne watercolor, and, for his mother-in-law, he bought an oil study by Gauguin. Then he decided that he wanted a portrait of his new wife. He'd been hearing through friends that there was an interesting German artist living in Paris, Max Ernst, who was semi-starving and needed somebody to help him by buying his work. The de Menils knew nothing about Surrealism and they had no idea what Ernst did, but they went to see this young artist's work and they were just astounded. They didn't know what to think of what they saw in his studio. They weren't yet ready to start buying Max Ernsts. But John, wanting to get some money to this artist, asked if he would be willing to paint a portrait of Dominique. Ernst, glad that these people hadn't recoiled in horror at the sight of his work, said that he would consider the idea. It is the only commissioned portrait work he ever did. When the painting was done, Ernst had it sent to a frame shop in Paris. This was shortly before the Germans invaded France, and the de Menils closed up their house, leaving their art there. In the terrible rush of events, John de Menil did something that saved the Schlumberger company: he arranged for all of Schlumberger's money to move to banks outside of Europe, in the Caribbean and so on. The company moved its engineers, its devices, and its patents to the United States and to Venezuela. Meanwhile, the Ernst portrait was left at the frame shop. The de Menils had no way of getting to it. Ernst himself was off and running. It wasn't rediscovered until the war was over and they returned to the Paris house. (Luckily, the house hadn't been broken into or occupied, though one of the Tanguys left there had received shrapnel wounds.) One day a local priest mentioned to the de Menils that he had seen a painting in a shop window that resembled Dominique: the framer had put the Ernst in his window to be rediscovered or sold.

John de Menil loved Cubist work, and he bought all he could get of Picasso and Braque. He also bought some Juan Gris and Fernand Léger;

Dominique had great regard for Léger—of all the Cubists, he was her favorite. In New York, the de Menils met a French clergyman, Father Marie-Alain Couturier, who was very involved with art and encouraged them to look at Surrealist work as well. Surrealism had come to America in the late twenties and early thirties, most of it shown by the dealer Julien Levy.

A number of key people in the arts in America at that time had come out of Harvard University and sort of divided up the cultural landscape. Among them were Alfred Barr Jr., who founded the Museum of Modern Art; Lincoln Kirstein, a cultural guru who cofounded the New York City Ballet; Chick Austin, who was the great director of the Wadsworth Atheneum; and Julien Levy, who started his extraordinary modern gallery in 1931. Levy was Joseph Cornell's first dealer; the gallery had an early two-man show of Cornell and Picasso, a very unusual pairing. Levy also showed two great photographers: Walker Evans and Henri Cartier-Bresson. And he brought Surrealism to the U.S. before Sidney Janis, before Peggy Guggenheim, before anybody else, other than a very narrow band of collectors. Levy had to shut down in 1949—he just couldn't carry the gallery financially anymore—and the Surrealist baton was picked up in New York by a wealthy woman, who was also a patron of ballet, Maria dei Principi Ruspoli Hugo, who had opened the Hugo Gallery in 1945.

Working at the Hugo Gallery was a Greek ex-ballet dancer and gay impresario named Alexander Iolas, who eventually took over. He was a strange and colorful character with a vivid, theatrical presence. He could not have been more different from Dominique or John de Menil, but he had the art that fascinated them. It was through Iolas that the de Menils amassed the largest holding of Max Ernst anywhere in the world, and probably the largest holding of Magritte: 50 or 55 Magrittes and 123 Ernsts, sculptures, drawings, paintings. The other Surrealists, whom they collected in smaller numbers, were Yves Tanguy, Victor Brauner, and Roberto Matta. (John liked Matta very much, though the work scared Dominique. Whenever I proposed doing a full show of his work at the Menil, she said no. I said, "Why?" She said, "Don't you see what those little figures are doing in those paintings? They're all fucking." I said, "Mom, Dad, and the kids aren't going to see that. They won't interpret that." And she said, "How can they miss it?")

Other than Surrealism and Dada, there was no modern German art in the de Menils' collection. As much as Dominique admired certain things by Max Beckmann, or Emil Nolde, or George Grosz, they just avoided it. It was a feeling that was held over from the World Wars. They didn't buy any Franz Kline, sadly, except for drawings. They were fascinated with antiquities, though, and that was what they started collecting next, through dealers they knew in New York and Paris. It was still possible, if you had a keen eye and knew where to look, to get amazing things—they had a Paleolithic bone fragment, a carving with deer on it. Dominique eventually moved on to Byzantine art, which interested her aesthetically. She felt that the pre-Renaissance flatness had a resonance with modern art, and the spiritual quality appealed to her. She sometimes despaired over the lack of great religious art. She once wrote about what it meant to possess a work of art: she named a small pre-Renaissance painting that was in the National Gallery, which she went to see whenever she was in Washington. It was of a saint disrobing in the wilderness—not a major saint but a beautiful man, taking off his cloak in the sunshine. She said that she loved that painting so much that it was hers. You don't actually have to own an artwork for it to be yours—you just need to love it, learn it, know it. A subcollection that the de Menils started—the black iconography research project—looked at the depiction of black people in Western art, from Egyptian times forward. They collected those images, too, from the Egyptian Nubian figures all the way up to Horace Pippin's *The Crucifixion*.

Both John and Dominique knew what a stamp-book survey of art would look like, and they could have approached their collection that way, but they chose instead to catch a thread here, a moment there. There was no sense of duty: they didn't have to have everything.

The de Menils decided to settle in Houston, where Schlumberger's main offices had been set up. Dominique described moving to Houston, culturally, as like arriving on the moon. It was an oil town, and they missed Paris and New York, where there were museums to go to. At first they were just commuting to Houston, but they knew they were going to have to get a house there. John wanted to build a modern house, so he talked to someone

at MoMA, who told him, "Well, if you want to go through a lot of rigmarole and pay a lot money, you could get Mies van der Rohe, but if you want to work with someone who's just becoming an architect, who's built a brilliant house for himself, is head of our architecture and design department, and would cost you a lot less money, you could get Philip Johnson. He's good. He's really good." So Philip Johnson designed the de Menil house in Houston in 1950, and it was the second house he built.

It was a very Miesian structure, but with an inner garden court and some interesting innovations: black tile floors, high glass walls. Once it was built, Johnson put in Mies van der Rohe chairs and hard-edged, slick, minimalist furniture, but this looked too cold to Dominique. One of the few luxuries in her life—she was quite ascetic in most ways—was a wardrobe of evening gowns by the great dress designer Charles James, whom she'd somehow come upon in New York. She adored his couture, and she learned that James did interiors as well. So before the de Menils settled into the house, certain liberties were taken. For one, Johnson had designed a severe façade, which included a solid brick wall in the kitchen. Dominique couldn't stand the idea of standing at the kitchen sink and not being able to look out, so she asked to have a window put in that wall. Johnson wasn't very happy about that at the time. Worse, she got rid of all the Mies van der Rohe furniture and brought in Charles James, who put velvet on some of the walls and designed built-in furniture. He also found some antiques and cheap things from thrift stores that looked just right. In a way, he created the first postmodern house: modern, with this other element inside it. Eventually, Johnson became postmodern himself and accepted what had been done, but when it happened he was furious.

I first met Dominique in 1971, at the MoMA opening of the Barnett Newman retrospective. That was the only time that I saw Dominique and John together; John died two years later. It seems appropriate that they were both at that Newman show. Newman's is some of the most challenging art of our lifetime, and their support of it underscored their openness. Jasper Johns was the last artist to really mean something to John. He acquired an extraordinary double drawing of a flag, a couple of lithographs, and a great

painting, *Voice*, which he bought just before he died. He also acquired two Frank Stella works: a copper U-shape and a wooden relief. In 1963 or so, John, who kept his ear to the art world, learned that Leo Castelli owed Rauschenberg what seemed like a vast sum of money and couldn't pay it. Leo was selling Rauschenbergs and having some success with his work, but with certain other artists—Dan Flavin, Donald Judd, and so on—it was still slow going. So the money that Leo made on Rauschenberg was being advanced to these other artists, to keep them going, instead of being given to Rauschenberg. But Rauschenberg wanted to get a new studio and he had expenses that he really needed to pay. Somehow John got his number and called him up and said, "Look, I hope you don't feel that I'm prying into your affairs, but I've heard that Castelli owes you money and he's in a fix and can't pay it. I would like to make you a personal loan to cover that, if you're interested." Bob said, "Of course I'm interested." And John said, "Tell me where you want the check sent." And he sent off a check for fifteen or twenty thousand dollars. They'd never even seen each other face-to-face. Rauschenberg told me, "You know, I never worked harder to repay a loan." But that's the kind of man John de Menil was.

He and Dominique collected much more art than they could possibly house, with the thought that they might start giving things to the Museum of Fine Arts in Houston, where they had become board members. Then, in the late forties, when the idea of creating a small museum devoted to modern and contemporary art took hold in Houston, the de Menils were actively involved in its formation. It began as the Contemporary Arts Association, and later became the Contemporary Arts Museum. When it was in need of a professional director, they were instrumental in hiring Jermayne MacAgy, a pioneer in museum work who had worked at the San Francisco Palace of the Legion of Honor. After MacAgy died, in 1964, Dominique said, "When the floor collapses, it's time for an act of faith." She and John commissioned Mark Rothko to make a series of mural-size paintings for a chapel to be designed by Philip Johnson. A few years later, they bought Barnett Newman's *Broken Obelisk* and offered it as a gift to the city of Houston, with the request that it be dedicated to Martin Luther King Jr. When the city said no, they installed the work across from the Rothko Chapel.

After John died, Dominique mounted exhibitions at the Rice Museum, a facility that John had built on the Rice University campus. In 1979 or 1980, when I was still at the NCFA, she summoned me to Houston for an interview—she knew that John had sized up my career—and she hired me to direct that facility. Soon it became clear that she wanted to open a museum herself, so I worked with her on that as well.

When I began working there, the collection had very little modern American art, so I went to bat for the new Americans: Newman, de Kooning, Stella, Rauschenberg, and Johns. I added to the Cornell holdings, which already had a wonderful base, thanks to MacAgy. Dominique was interested in all these artists. She once said a wonderful thing about discovering new artists: she said that new art would always look strange, would always surprise you or startle you or look alien to you, because not only had the artist made new art he'd also rewritten the language; you don't know the language yet when you first encounter it.

In June, 1983, I was visiting Dominique at her family flat in Paris. I'd discovered that two superb Jackson Pollock drawings from 1951—large drawings, approximately 30-by-40 inches, which rarely came on the market—were for sale. I had black-and-white photographs of the drawings

Walter Hopps and Dominique de Menil at her Houston home, 1987. Photograph by Adelaide de Menil.

to show her. I told her that the price was high but it would be well worth it to buy one. She said to me, "You love his work—you choose." So I chose the one that was most closely related to his important painting of the period. When it was shipped to the Rice Museum by the dealer some time later, the registrar told me that a mistake had been made: two Pollock drawings had been sent. I asked Dominique what was going on, and she smiled and said, "I liked them both so much that I just decided to get the other one, too."

At the same time, Dominique had her passion for antiquities and Byzantine art. While we were in Paris, she got a call from the curator Bertrand Davezac, back in Houston, who had heard about some major Byzantine frescoes that were for sale in Germany. Davezac stopped in London to pick up Yanni Petsopoulos, a distinguished Greek-born, British-educated dealer of Islamic and Byzantine art. Then we all converged and headed off to Munich, where a man called Aydin Dikman had some fragments of the frescoes. Davezac and Petsopoulos were really knocked out by what we saw, though it was tragic to see these frescoes broken into fragments and faced with a rough burlap-like cloth, which had been attached with strong glue—the kind you might use to glue the soles on shoes.

I think it was Petsopoulos who initially raised the question of the origin of the frescoes. Although it was possible that they came from a ruined church in Turkey, as Dikman claimed, they could have come from almost anywhere that there were Byzantine churches. Dominique made some calls and was referred to Eisenhower's former Attorney General Herbert Brownell Jr., who was then at the law firm Lord, Day & Lord. He was a very good man, and he was a good choice, too, because he had been outside counsel for the Metropolitan Museum of Art. Brownell and Petsopoulos came up with a plan to send the meager documents that had been given to us in Munich off to various governments, to see if any country claimed ownership of the frescoes. One or two countries did, but the most convincing claim came from Cyprus, which argued that the frescoes came from a chapel in Lysi in Northern Cyprus.

So Dominique, Brownell, and I took a trip to Nicosia, where we met with Vassos Karageorghis, the director of Cyprus's department of antiquities. We stayed at a modern little hotel in Nicosia, where there were all sorts of

people in the restaurant and cocktail lounge. Brownell told us, "This place is like Casablanca or Lisbon during the Second World War. Be very careful what you talk about when you're in the bar or having a meal. You never know who's listening." Karageorghis was a wonderful man and he got right to the point, to several points. In meetings, he explained to Dominique that all Christian art on Cyprus was the property of the Church, not the state, and that it couldn't be sold or given away, but that he'd relish any help we could provide in getting the frescoes returned and restored. Karageorghis warned us that dangers were involved, not just to the works themselves but to Mrs. de Menil, her staff, and her family. He told us of an instance in which a collector acquiring antiquities from some purported pirates had his apartment bombed when he failed to meet a scheduled payment. He said that it was best to communicate by letter when at all possible, because he couldn't entirely vouch for who might be listening on his phone lines. That was all very sobering.

Arrangements were made for a major conservator in England, Laurence Morrocco, to become involved. Money was agreed upon and an account was established in a Swiss bank, which would be released to Dikman when the fresco fragments had safely arrived in London. There was a very tense moment in Munich at one point, when I was there with Petsopoulos. He had been informed that we needed to see a particular Turk, who was somehow part of the deal. Petsopoulos told me that he had a bad feeling about this but that we needed to go. So we turned up at a loft-like space, with an anonymous-looking office, where, sitting behind a metal desk, was a very large Turkish man with a shaved, bullet-shaped head, whose neck descended straight into his trunk without articulation. Behind him on the wall were a series of black-and-white photographs of him on a yacht, presumably in the Mediterranean, with various blond girls in bikinis. Petsopoulos talked with him a bit in Greek, which he seemed to understand, and then all of a sudden the man opened a drawer and pulled out a large revolver, cocked it, and pointed it at my head. He demanded $125,000 on the spot. Petsopoulos, in a very heated fashion, told him that he was a fool for thinking anyone would carry that amount of cash around and that there was no earthly reason he was entitled to it. The Turk was protesting this, I was sweating, and Petsopoulos started yelling at him in Greek. Finally, the

Turk slammed the gun down on the desk, Petsopoulos reached for my arm and said in a soft voice, "Let's get out of here," and we made our way out to the street. When we were outside, I said, "What the hell were you saying to him?" He said, "Oh, I was insulting him every way I could, telling him his mother was a dog, he was the son of a dog, and whatever else I could think of." And I said, "Why were you doing that? The gun wasn't pointed at you. It was pointed at me!" He sort of shrugged and said, "Oh, you never back down to a Turk." Clearly, it was some competitor or colleague of Dikman's, who just wanted to see if he could extort an extra chunk of money.

The process of retrieving the frescoes was so long and involved that at one point I suggested to Dominique that we just give up and turn the project over to the Getty Trust. But she said, "I don't want *my* frescoes to go to the Getty." The beauty of the work and the high spiritual quality it embodied had great meaning for her. Ultimately, we were able to get the frescoes restored, and Karageorghis and the then-Archbishop came up with a scheme whereby they would be loaned to the Menil Foundation with an agreement that had to be renewed every twenty years, and which could end up lasting in perpetuity. I think there was a provision that, if the northern part of Cyprus was recovered from the Turks and the Lysi chapel could be restored, Cyprus could reclaim the frescoes. In 1988, they were taken to Houston and, several years later, they were installed in a chapel that was designed by Dominique's son François and consecrated by the Archbishop. The chapel forms an intriguing counterpoint to the Rothko Chapel at the Menil Collection. Nowhere else in the world can you walk, in that way, from the height of thirteenth-century Christian faith to mid-twentieth-century iconoclasm.

For my first few years of working with Dominique, I was commuting back and forth from D.C., where I was seeing the artist Caroline Huber. Caroline came from an old Pennsylvania family, though one of her mother's ancestors had gone, prior to the Civil War, to a town in Georgia called Marthasville and turned it into an important railroad crossing—renamed Atlanta— which was built up and made prosperous just in time to be burned down by the Yankees. Caroline had rebelled against her upbringing, dropping out and

running away to Europe at an early age. She was blond and very beautiful—she reminded me of Veronica Lake, whose movies I used to go out of my way to see—and she'd come to Washington to make her way teaching art in schools, working in galleries, and pursuing her own art. I met her and virtually from the first encounters, though Caroline didn't realize this, I was falling in love with her. I used to go to the gallery where she was working and hang around, just to be with her. I proposed to her on a trip to California, while we were staying at my father's house in Eagle Rock. All I could find for an engagement ring was an old ring that I'd spotted in one of my father's fishing tackle boxes full of lead sinkers. There were only single beds in the upstairs bedrooms of my father's house, and I remember fastening two of them together with carpenter's clamps to make a sort of makeshift double bed.

Caroline and I married in 1983. We decided to do it in Philadelphia. The Hubers were Episcopalians, and Caroline and I had to meet first with the Episcopal minister who was going to marry us. He was a gentle, intelligent man, and with some trepidation I explained to him that, although I didn't consider myself an atheist, I didn't really believe in Christ as the son of God, nor did I believe in the Christian God. He smiled and said, "That's all right. He will understand. Just say the words." So that's what I did. Bill Christenberry was my best man. Much to our delight and surprise, Dominique came down from New York and attended the wedding. And she gave us a very interesting wedding present. Quite apart from all the art, she also collected objects made of iron and steel—just for the love of the material and its history in the Schlumberger family. One day Caroline admired a

Caroline Huber and Walter Hopps in the parking lot of the Corcoran Gallery, Los Angeles, 1981. Photograph by James Corcoran.

decorated iron box that she had on her coffee table, and Dominique said, "Then you must have it." She explained that it was a paymaster's box; it would have been bolted to a table, with money inside, and, when people lined up to get their wages, the paymaster would take the money out of that box to give to them. I knew that it was important to her; it was a very personal gift.

Caroline and I had two additional ceremonies. The secular one that I wanted was performed on the steps of Independence Hall, where Thomas Jefferson's Declaration of Independence was signed. The ceremony was written and spoken by my great friend and intellectual mentor Marcus Raskin; just the three of us were there. For a third, more metaphysical ceremony, Caroline and I went to the Philadelphia Museum of Art and into the section that held the Arensberg Collection. We sat on a bench in silence, meditating before Duchamp's *The Large Glass*, perhaps one of the most complex works ever made that marries sexuality and transcended spirit.

Dominique had invited us to come to Paris for a honeymoon, and we did, quite soon afterward, staying first at her wonderful flat on the Left Bank, which had been owned by the Schlumbergers. Dominique had heard that Caroline was an artist but had never had a chance to talk with her about it. So, in Paris, after breakfast one morning, she asked Caroline what kind of art she made. Caroline was at a loss to explain it, so Dominique said, "Well, can you tell me whom you particularly admire?" Caroline named the Swiss Surrealist Méret Oppenheim, who was famous for her fur-lined teacup, saucer, and spoon at the Museum of Modern Art. Dominique smiled and said, "Oh, I think she's in Paris at the moment. I can arrange for you to meet her if you'd like." I thought Caroline was going to faint. Dominique left the room and arranged a meeting for ten o'clock the next morning.

Oppenheim lived on an upper floor of a bland, modern building. When we rang the doorbell at the appointed time, the door popped open immediately. There are two female artists I've had the chance to meet who had an extraordinary sexual vibrancy at a considerably advanced age. One was Georgia O'Keeffe and the other was Méret Oppenheim. Oppenheim, who was a lesbian, glanced at me and shook my hand, but her eyes absolutely locked onto Caroline. She was smoking a thin, black cigarillo and staring at Caroline like a cat looking at a little bird. As we left, she took Caroline's

hand, put in it a package of her Spanish cigarillos, and closed her fingers over them.

After the wedding, Caroline moved down to Texas, but until then, when I was in Houston, I would stay at Dominique's house for a month at a time, sleeping and working in her son François's former bedroom. Dominique worked in the bedroom next door, running the entire Menil Foundation from a card table she had set up. There were several phone lines in the house, because Dominique never wanted to miss a call. Bulletin boards were important to her, too: she'd fill them with clippings of art reproductions, world events, and family photographs. She had converted the garage into what she called the Collection Rooms and she had a small staff maintaining the records of her collection. I'm a night person, and often, when I worked late, she would meet me in the kitchen, having woken up at one or two in the morning; we'd share a snack, talk, and watch CNN, then, when I turned in, she'd go back to bed for a few hours. She usually woke up very early. I never could beat her to breakfast.

One day we were sitting together in her kitchen and I was reading something in the *Times*, some new discovery about quasars and black holes, and she asked me, "What is a black hole?" I said, "Well, it's where a star burns out and implodes inward, and it's so strong, it sucks in even light." "It sucks in light?" she said. "Planets, everything, will go?" I said, "Yeah, the whole Milky Way will go." She looked stricken, and she said, "But what's to become of all our work?" I said, "Don't despair. We'll talk about it tomorrow and I'll have an answer for you." So I thought about it, and the next day I told her, "What we can do is record everything we want to save—images, books, whatever. And it can be sent by rocket, out into space, as a coded message. Like a seed, to be picked up." She said, "Do you really believe that?" I said, "Yes, I believe it. It's just a matter of the will to do it. And I suspect, within the next five billion years, before our star dies, we're gonna be elsewhere in the universe as well." And she said, "Well, I'm very relieved." There's a saying: the rich are worried about the next generation, while the poor are thinking about Saturday night. But I've never known anyone other than Dominique to worry five billion years into the future.

Once, when I first starting working for her, Dominique asked me what I was. I said, "I'm a Californian." She said, "No, no, no, I don't mean that.

Walter Hopps and Dominique de Menil installing artwork in preparation for the opening of the Menil Collection, June, 1987. Photographs by Adelaide de Menil.

What religion are you?" I said, "I don't have any organized religion." She said, "Are you an atheist?" I said no. "Are you an agnostic?" I said, "No, I'm never clear on what that really means, 'agnostic.'" She said, "Well, what do you believe?" I said, "I have high regard for people who have faith and those are the people I have faith in." She said, "That sounds fine."

The majority of the money it took to build the Menil Collection came from the Menil Foundation and Dominique personally. Some family members put money in, and Dominique went to a small number of friends who had the means to make serious contributions. In Houston, one of the grand wealthy families was the Browns, whose fortune initially came from

construction—everything from the highways in Harris County to cement-hauling ships in the Second World War to landing strips in Vietnam. The family had established one of the major philanthropic foundations in Texas, the Brown Foundation, and the de Menils were particularly close with George and Alice Brown, who lived in River Oaks, near the de Menil house. George Brown was an active Democrat and helped put his fellow Texan Lyndon Johnson into Congress, and Alice Brown was very fond of certain examples of modern art. When Dominique went to the Browns' house to ask for money for the Menil Collection, I went with her. She wanted me to explain the museum—what it would be like and what it would do. At the time, George Brown was going blind and couldn't really see. When we arrived, we were taken to a room where he and his wife were sitting, and we were invited to sit across the room from them. The first thing that happened was that George Brown said, "Dominique, stand up and walk over here to me so I can hug you." So she did, and then she started talking about the museum and told him that I was going to explain what it would be. And he smiled and said, "I don't need to hear all that. Just tell me how much you want." She said, "Well, I was hoping to ask you for a million dollars." He thought a moment and said, "That's not enough. You wouldn't mind if I gave you three million, would you?" She said that that would be wonderful, she'd arrange to get his lawyers and the Menil's lawyers together to draw it all up. And he said, "Dominique, you and I don't need any damn lawyers. I'll get the money wherever you want as soon as you want it." That was exactly what he did. We chatted a moment and then we left. I've never seen that much money raised so graciously and quickly.

Walter Hopps, Caroline Huber, and Billy Al Bengston, at the opening of the Menil Collection, Houston, 1987. Photograph by Ed Daniels.

Dominique used to say, "Really fine works of art always cost a little more than you want to pay." When we opened the Menil Collection, in 1987, people were after her—reporters from all over the world—wanting to hear the value of the collection, not all of which was on view. She came up with a wonderful answer. She said, "Depending on how you look at it, it's either priceless or worthless. That's all I have to say on the subject." They'd say, "What do you mean by 'priceless or worthless'?" She said, "You only put a price on art when it's for sale. Nothing here is for sale, therefore it's priceless or worthless, depending on how you look at it."

ACKNOWLEDGMENTS

We would like to thank Karen Rinaldi for signing this project up at Bloomsbury USA years ago; Kathy Belden for sustaining interest in it through a long stretch of silence; Nancy Miller for carrying it through the final stages with insight and grace; and Alexandra Pringle for enthusiastically taking it on in the UK. Many thanks to Sarah Chalfant for believing in the book, even when it was at its most inchoate, and for making the protracted gestation process as unstressful as possible.

For the use of additional interviews with Walter, gratitude is due to Sarah Goelet, Carol Mancusi-Ungaro, and especially Jean Stein, whose generosity and sensitivity were much appreciated. For their help in verifying elusive facts, we'd like to thank James Demetrion, Hal Glicksman, Jim Newman, and Nancy Reddin Kienholz. Thanks, also, to Don Quaintance, who was a much valued collaborator when Walter was alive and has continued to help in his absence.

For their assistance in researching and securing images reproduced in the book, we are indebted to James Cuno, at the J. Paul Getty Trust; Lisa Barkley, Geri Aramanda, and Margaret McKee at the Menil Collection; Alberta Mayo, at the Frank J. Thomas Archives; Winston Eggleston, at the Eggleston Artistic Trust; and Callie Garnett and Lorena Tamez, at Bloomsbury. For their generosity in allowing reproductions of artwork to appear in the book, we'd like to thank Sandra Deane Christenberry, Jim Corcoran, John Gossage, George Hixson, Adelaide de Menil, and Nancy Reddin Kienholz.

Caroline Huber's support for the book—including her exhaustive work on research, photography, and more—was invaluable.

Most of all, thank you to Walter, up there in the dream colony of the

afterlife, for allowing me to immerse myself in your voice and your many, many stories. It has been an amazing journey and an education.

—Deborah Treisman

WALTER HOPPS:
A SELECTED CHRONOLOGY
By Caroline Huber

May 3, 1932: Walter Wain Hopps III is born at Glendale Research Hospital, in Glendale, California, to Katherine May Phinney and Walter Wain Hopps Jr., both physicians. He is delivered by his maternal grandfather, Dr. Carle H. Phinney.

In Walter's baby book, his mother notes that among his first words were "Hello," "Bye-bye," "Outdoors," and "Get down": "The last several words came in rather rapid succession in the fourteenth month and were used as often as possible."

June 9, 1934: Walter's brother, Harvey Byron Hopps, is born.

1938: When Walter is about six, his mother takes him and Harvey to Tampico, Mexico, to stay for an extended period of time with his grandparents, Belle and Walter Hopps, on their ranch.

1939: Back in Eagle Rock, Walter is forced to drop out of the third grade because of rheumatic fever and is homeschooled by Belle, a former schoolteacher, under the strict medical supervision of his parents.

1940s: Walter attends Polytechnic School, a private school in Pasadena, and sets his sights on becoming a physicist. In ninth grade, he contracts rheumatic fever again. He drops out of school for the second time and is confined to the second floor of his home. Walter discovers the photography of Ted Croner, Walker Evans, and Richard Avedon. While he is ill, he is given a darkroom and a Voigtländer miniature view camera. He begins photographing still lifes and rephotographing images from books and magazines in the family library.

1948: In eleventh grade, Walter is selected for a Saturday-morning experimental enrichment program in the humanities, for students who are gifted

in math and science. One of the outings takes him to the Hollywood home of Louise and Walter Arensberg, where Walter sees works by Duchamp, Brancusi, Magritte, and Mondrian and journals of Surrealist photography for the first time. He drops out of the program in order to spend Saturdays with the Arensbergs. On one of these occasions, in April, 1949, he meets Marcel Duchamp, who is visiting the Arensbergs.

September 9, 1948: William Copley and John Ployardt open Copley Galleries, at 257 North Canon Drive, in Beverly Hills, with an exhibition by René Magritte. In its short existence, the gallery has six exhibitions: Magritte, Yves Tanguy, Joseph Cornell, Man Ray, Matta, and Max Ernst. Walter's visits to the gallery as a teenager have a profound impact; he later develops a lifelong friendship with Copley, an heir to a newspaper fortune and an idiosyncratic artist himself.

1949: Walter is given a 35mm Exacta Camera and begins photographing at night in the tenderloin section of L.A. He makes mosaic-like montages of cut-up photographs influenced by certain works by Man Ray and Ted Croner. In his senior year of high school, Walter acts as a sort of agent for his classmate Craig Kauffman, trying to get him into galleries. He founds the Photography Society at Eagle Rock High School.

1950: Walter graduates from Eagle Rock High School, having received the Bausch & Lomb Honorary Science Award and the Bank of America Achievement Award in Mathematics and Science. Walter's yearbook lists the following activities: "Senate Charter Committee Chairman; Fire and Safety Crew; Prom Committee; Name, Emblem and Color Committee; Basketball, Gymnastics, Football and Track Manager; *Totem* [Yearbook] Photographer; Publicity Committee; Key Club Vice-President; Camera Club President and Secretary; Manager's Club; Scholarship Society; Silver Service Award; Open House Photo Salon, and the Gold Service Award."

1950–51: Walter completes his freshman year at Stanford University, where he pursues physics and microbiology. He meets classmate Jim Newman, with whom he tries to book jazz concerts at Stanford.

Walter transfers to the University of California, Los Angeles, in 1951, for his sophomore year. At UCLA he studies microbiology and art history. He

attends UCLA from 1951 to 1954 and from 1956 to 1957. (He later teaches extension courses in art history there, despite being a few credits short of a degree.)

Walter frequents local jazz clubs, hearing concerts by Chet Baker, Dizzy Gillespie, Charlie Parker, and Gerry Mulligan, and sometimes photographing them. He meets the photographers William Claxton, Lee Friedlander, Edmund Teske, and Charles Brittin.

1952: Walter and Jim Newman, who has transferred to Oberlin College, found Concert Hall (also called Concert Hall Workshop), an enterprise to book and record contemporary music, predominantly jazz, with other charter members William Crocken, Ron (Horowitz) Guest, and Craig Kauffman. The first concert they book is the Dave Brubeck Quartet, at Oberlin, March 2, 1953. In July, 1953, they present the Dave Brubeck Quartet at Wilshire Ebell. Their fifth concert is the Gerry Mulligan Quartet in L.A. in 1954. At Oberlin, they present Charles Mingus, Count Basie, Chet Baker, and others. Walter later arranges jazz concerts with Jerry Perenchio.

Walter makes biomorphic abstract drawings on photo paper in his darkroom using light and chemicals. In 1952, he has a one-person exhibition of his photographs at Raymond Rohauer's Coronet Louvre Theater gallery in West Hollywood. The exhibit is seen by Wallace Berman, and Berman asks Walter to contribute to the first issue of *Semina*, a handmade limited-edition folio/journal containing poetry, art, and ephemera that is published from 1955 to 1964. After seeing Walter's photographs, Berman creates a set of light-and-chemical drawings with Walter in his Eagle Rock darkroom.

While at UCLA, Walter, with Craig Kauffman, rents a space in a building at 11756 Gorham Boulevard in Brentwood and turns it into a working studio and exhibition space. In 1954, this evolves into Syndell Studio, a gallery cofounded with Jim Newman, with the participation of Kauffman, the poet and mathematician Ben Bartosh, his wife, Betty, artist and mathematician Michael Scoles, and Shirley Neilsen, an art-history student.

January, 1955: Walter is drafted and serves in the Army. He receives an honorable discharge for medical reasons in July.

February 14, 1955: Walter and Shirley Neilsen are married at the Watts Towers, Los Angeles. (Walter is later instrumental in attempts to save the Towers.)

May, 1955: Syndell Studio presents "Action 1: Concert Hall Workshop Presents Action Painting of the West Coast." Better known as "The Merry-Go-Round Show," "Action 1" takes its title from Harold Rosenberg's essay "Action Painting." The show is installed on a merry-go-round on the Newcomb Pier in Santa Monica: fabric is stretched around the wooden horses and works by twenty-four California Abstract Expressionist painters slowly revolve to a sonic montage that includes carousel, jazz, and experimental music. Artists shown: Richard Brodney, Bill Brown, Relf Case, Larry Compton, Ed Corbett, Jay DeFeo, Roy De Forest, Richard Diebenkorn, Madeleine Dimond, James Budd Dixon, Sonia Gechtoff, Wally Hedrick, Gilbert Henderson, Craig Kauffman, James Kelly, Adelie Landis, Jack Lowe, Philip Roeber, Paul Sarkisian, Hassel Smith, David Stiles, Maurice Syndell, Julius Wasserstein, and Paul Wonner. The show is considered a seminal moment in the recognition of the contemporary art scene in California.

Edward Kienholz opens the Now Gallery at 716 N. La Cienega Boulevard. He wins the contract for the 1956 All City Art Festival, an outdoor art festival staged in and around the Frank Lloyd Wright buildings in Barnsdall Park. Walter persuades Kienholz to take him on as a partner. For the first time, the festival shows art from commercial galleries around L.A., including the NOW Gallery and Syndell Studio.

September 5, 1956: Walter and Robert Alexander, nicknamed Baza, organize "Action²: Works by West Coast Painters," an exhibition of works by Robert Alexander, Elwood Decker, Jay DeFeo, Sonia Gechtoff, Wally Hedrick, Gilbert Henderson, Craig Kauffman, James Kelly, Gerd Koch, Paul Sarkisian, Julius Wasserstein, and Fred Wellington. Syndell Studio and the NOW Gallery open the exhibit at the NOW Gallery and at the Coronet Louvre Theater in West Hollywood.

1957: Walter rents a small storefront on Sawtelle Boulevard, where he helps to establish a printing shop and press for Robert Alexander, who lives in the back. Wallace Berman has a studio there. Berman names it Stone

Brothers Printing, a reference to the "stoned brothers," his nickname for himself and Alexander. Poetry readings, jazz, and other performances are held there. Dennis Hopper attends events, and he and Walter become friends.

Walter remains serious about his own photographic work, often shooting scenes at night, cutting and altering his images, and experimenting with light to create abstract images. (In 2000, some of these images are included in the Twentieth Anniversary Issue of *Gulf Coast*, a journal of literature and fine arts, guest-edited by Terrell James.)

1957: After the All City Arts Festival, Walter and Kienholz decide to pool their resources, and on March 15 the Ferus Gallery opens at 736 N. La Cienega Boulevard, with its first exhibition, "Objects on the New Landscape Demanding of the Eye," which features Jay DeFeo, Richard Diebenkorn, Sonia Gechtoff, Jack Jefferson, Craig Kauffman, James Kelly, Frank Lobdell, Hassel Smith, and Clyfford Still. Walter supplies the core operating funds for the gallery by working odd jobs, while Kienholz mans the gallery, where he also has a studio. Ferus holds poetry readings, music performances, and weekly film nights. In June, Wallace Berman's first exhibition is shut down by the L.A. Vice Squad, which charges that the exhibition contains pornographic material.

1958: Jim Newman opens Dilexi Gallery in San Francisco with Robert Alexander. After eight months, Alexander leaves the gallery and moves to Venice, California, where he establishes the Temple of Man, an archival center for underground art. Dilexi and Ferus exchange artists and exhibitions, maintaining a close relationship for several years.

Realizing that neither he nor Kienholz is particularly interested in the business side of Ferus, Walter buys Kienholz's shares in the gallery and takes on Irving Blum and Sadye Moss as his new partners. Walter and Shirley continue to live behind the gallery. Walter is president of Ferus Gallery Inc. from 1959 to 1962.

1959: Pasadena Art Museum director Thomas Leavitt invites Walter to be a guest curator. From 1959 to 1962, Walter lectures in art history at the UCLA Extension, Division of Arts and Humanities. His courses include "Painting

of This Decade," "Current Art in the Galleries," "Art Since World War II," and "Aspects of Western Art from 1400 to Present." Classes often meet at collectors' homes, galleries, and museums. Walter nurtures a group of collectors, including Fred and Marcia Weisman and Betty and Monte Factor.

December 20, 1959: Walter is fired from his job as a night orderly at the University of California Hospital for falling asleep on the job.

July 13, 1960: Robert Irwin's first museum exhibition, "Robert Irwin," opens at the Pasadena Art Museum.

1961: "Recent Works by Edward Kienholz" opens at the Pasadena Art Museum on May 17, and "Drawings by Richard Diebenkorn and Frank Lobdell" opens on December 5.

1962: In February, Walter meets Jean and Bruce Conner and they spend four days on his uncle's property, Rancho San Louis, about forty miles outside Mexico City, looking for archaeological relics. On February 24, Barnett Newman visits Ferus. Walter's calendar entry on March 2 says, "Yes on Pas. Mus.!" He joins the Pasadena Art Museum as curator/registrar. He divides his time between Ferus and the Pasadena Art Museum through May. To avoid a conflict of interest, Walter gives his stock shares in Ferus Gallery to Irving Blum, requesting as payment that Blum one day donate an artwork of Walter's choice to a museum.

Leavitt and Walter establish a policy of pairing exhibitions of historical twentieth-century art with complementary shows of California art. Exhibitions curated that year at Pasadena include "John Altoon" (May 16) and "Kurt Schwitters: A Retrospective Exhibition" (June 20), organized by the Museum of Modern Art and augmented with additional works at Pasadena. Schwitters is paired with a survey show, "Collage-Artists in California (Directions in Collage)," featuring Clinton Adams, Robert Alexander, Roger Barr, Larry Bell, Billy Al Bengston, John Bernhardt, Irving Blum, Lucile Brokaw, Joan Brown, C. V. Comara, Bruce Conner, William Copley, Gwenda Davies, Jay DeFeo, Roy De Forest, William Dole, Tom Eatherton, Leonard Edmondson, Jules Engel, Ben Fisher, Llyn Foulkes, Harold Frank, Charles Frazier, Matt Glavin, Hal Glicksman, Frank Gonzales, Joe Goode, George Herms, Jack Hooper, Henry T. Hopkins, Joan Jacobs, James Jaravise, Daniel Johnson,

Edward Kienholz, William Kohn, Louis La Barbera, Robert Loberg, Fred Martin, Fred Mason, Ron Miyashiro, Edward Moses, S. Z. Perkoff, Richard Pettibone, Shirley Pettibone, Don Reich, Ed Ruscha, Tom Ryan, Michael Scoles, Jack Stuck, Ben Talbert, Sam Tchakalian, Philip Van Brunt, Stephan von Huene, Howard Warshaw, Emerson Woelffer, and Norman Zammitt.

September 18, 1962: Llyn Foulkes's solo show opens at the Pasadena Art Museum.

September 25, 1962: The landmark show "New Painting of Common Objects" opens at the Pasadena Art Museum, with work by Jim Dine, Robert Dowd, Joe Goode, Phillip Hefferton, Roy Lichtenstein, Ed Ruscha, Wayne Thiebaud, and Andy Warhol. This is the first museum exhibition of American Pop Art.

October 24, 1962: "Emerson Woelffer: Work from 1946–1962" opens.

Walter hires artists Ben Talbert, Joe Goode, and Fred Mason to help install shows, and takes on Hal Glicksman as chief preparator.

June, 1963: Leavitt resigns, and Walter is appointed acting director of the Pasadena Art Museum.

October, 1963: Walter and Shirley buy the former home of the Rose Tree Tea House, the first teahouse in the Los Angeles area, which opened in 1910 on Orange Grove Boulevard. Walter had dined there with his mother when he was a boy. The house, originally built for a family of artists, continued that tradition, as artists Joe Goode, Richard Jackson, Bruce Nauman, Jay DeFeo, Michael McCall, Jason Rhoades, Ahava Brooke, and Rachel Khedoori, among others, would eventually live and/or have studios in the house.

October 8, 1963: "By or of Marcel Duchamp or Rose Sélavy," the first retrospective of Duchamp's work and the only American retrospective in his lifetime, opens at the Pasadena Art Museum. Duchamp collaborates with Walter on the exhibition catalogue and poster design.

November 12, 1963: "John McLaughlin: A Retrospective Exhibition" opens at the Pasadena Art Museum.

February 11, 1964: "New American Sculpture," featuring Lee Bontecou, John Chamberlain, Edward Higgins, Kenneth Price, and H. C. Westermann, opens at the Pasadena Art Museum.

March, 1964: Walter is named director of the Pasadena Art Museum. Just thirty-one, he becomes the youngest director of a major museum in the U.S. He hires James Demetrion as curator.

January 26, 1965: "Jasper Johns" opens at the Pasadena Art Museum.

1965: The State Department chooses Walter to be U.S. commissioner of art for the VIII São Paulo Bienal, São Paulo, Brazil, which is held from September 4 to November 28. (He is the first person from the West Coast chosen for the honor.) He selects seven artists: Barnett Newman, who is presented hors concours, in honor of his artistic achievement and independence, and Larry Bell, Billy Al Bengston, Robert Irwin, Donald Judd, Larry Poons, and Frank Stella. Organized by the Pasadena Art Museum, the exhibition is also presented at the National Collection of Fine Arts, the Smithsonian Museum, from January 27 to March 6, 1966.

January, 1966: Walter is profiled in the "Movers and Shakers" section of *Los Angeles* magazine.

January to March, 1966: In a closed-off gallery at the Pasadena Art Museum, Jay DeFeo works on her painting *The Rose*, which Walter helped to extricate from her San Francisco studio and bring to Pasadena.

February 28, 1966: Morton Feldman gives a lecture and concert as part of Walter's "Encounters" series, begun in 1964, which invites new American composers to the Pasadena Museum of Art. Other composers such as John Cage and La Monte Young are presented as part of the series.

September, 1966: Walter is appointed U.S. commissioner of art by the State Department and the U.S. Information Agency.

October 18, 1966: Frank Stella's first museum show, "Recent Painting by Frank Stella," opens at the Pasadena Art Museum.

1966–72: Walter serves on the National Exhibitions Committee of the American Federation of Arts, New York City.

Late 1966: In conflict with the board over the new museum building, exhausted, and on the verge of a breakdown, Walter resigns as director of the Pasadena Art Museum.

Shirley and Walter divorce.

January 9, 1967: Walter's final exhibition at the Pasadena Art Museum, "Joseph Cornell," opens. It is the first museum retrospective of the artist, and the largest during his lifetime, including more than 70 works.

January 11, 1967: Walter moves to Washington, D.C., to become an associate fellow at the Institute for Policy Studies, a progressive think tank, cofounded by Marcus Raskin and Richard Barnet. He serves as an associate fellow until 1974. Walter and Raskin organize a conference, "Art as a Reconstructive Force in American Society." They also begin the Artists-in-Neighborhoods program.

January 15, 1967: In the *New York Times*, Walter is named "the most gifted museum man on the West Coast (and in the field of contemporary art, possibly in the nation)."

1967: Walter serves as a juror, along with Lawrence Alloway and A. James Speyer, for the Seventieth Annual Exhibition by Artists of Chicago and Vicinity at the Art Institute of Chicago, which opens on March 3.

August, 1967: Walter is appointed director of the Washington Gallery of Modern Art. At the WGMA, he initiates the Workshop Program, awarding fellowships that provide cash, studios, and materials to local artists in the fields of painting, sculpture, photography, graphics, and architectural design. Recipients are encouraged to engage with children and members of the community in low-income neighborhoods and throughout Washington through workshops, apprenticeship programs, and other endeavors. At the time, this is likely the only museum program of its kind.

1967–69: At the WGMA, Walter mounts "Edward Kienholz: Work of the 1960s" and "Intercourse," a 152-hour composition of light, sound, jazz, and visual imagery by Washington artist and musician Lloyd McNeill. Walter and James Harithas, director of the Corcoran Gallery of Art, initiate overlapping, complementary programs not only for the arts community but for the

community at large. For financial reasons, in October, 1968, the Washington Gallery of Modern Art merges with the Corcoran Gallery of Art, becoming the Dupont Center, with Walter as its director and also director of special projects for both galleries. He is a member of the executive committee of the new Theater School of Washington.

April, 1969: At the Dupont Center, Walter presents "Hairy Who," an exhibition of Chicago Imagists James Falconer, Art Green, Gladys Nilsson, Jim Nutt, Suellen Rocca, and Karl Wirsum.

May 20, 1969: "Comix," a show of original drawings for underground comic strips, opens at the Dupont Center. Artists include Gilbert Shelton, R. Crumb, Art Spiegelman, Trina, and Spain.

With Anne d'Harnoncourt, Walter coauthors the June 25, 1969, Philadelphia Museum of Art Bulletin "Étant Donnés: 1° La Chute d'eau 2° Le Gaz d'éclairage": *Reflections on a New Work by Marcel Duchamp*, a seminal publication on Duchamp's enigmatic work *Étant Donnés*.

July, 1969: After Harithas resigns, Walter is appointed acting director of the Corcoran Gallery of Art.

October 17, 1969: Walter opens "Gilliam, Krebs, McGowin," presenting the work of Sam Gilliam, Rockne Krebs, and Ed McGowin.

November 24, 1969: *Newsweek* declares, "Within the last decade, Washington, quietly but surely, has disentangled its hodgepodges, cleared off its dust, and, as a result, has become the second most important city in the nation, after New York . . . Washington, the new center of art power, has attracted new men of power to direct its museums . . . Of all of them, Hopps is the most turned on to the now-scene."

April 27, 1970: Walter is unanimously elected director of the Corcoran Gallery of Art by the board of trustees. He hires Hal Glicksman as associate director. In 1967 or '68, Glicksman sees, in Philip Leider's office at *Artforum*, a paste-up of letters spelling out "Walter Hopps Will Be Here in 20 Minutes." At the Corcoran, with curator Nina Felshin, he produces an edition of two hundred button pins, bearing the slogan.

1970: Walter is elected to the Association of Art Museum Directors.

June 6, 1970: Walter and Helen Goldberg are married in Alexandria, Virginia.

January 28–April 4, 1971: For the 32nd Biennial Exhibition of Contemporary American Painting at the Corcoran, Walter selects eleven artists, who, in turn, select eleven artists. This type of exhibition has been done in Germany and New York, but never on this scale in an American museum. Walter invites Roy Lichtenstein, Sam Francis, Frank Lobdell, Philip Pearlstein, Robert Irwin, David Novros, Richard Jackson, Richard Estes, David Stephens, Edward Ruscha, and Peter Saul. Saul invites Peter Dean; Novros invites Robert Duran; Ruscha invites Joe Goode; Lichtenstein invites Robert Gordon; Pearlstein invites Alex Katz; Stephens invites Simmie Knox; Francis invites Ed Moses; Jackson invites Frank Owens; Estes invites Wayne Thiebaud; Irwin invites Joshua Young; and Lobdell invites Clyfford Still.

1972: Walter judges the 17th Mid South Exhibition, at the Brooks Memorial Art Gallery in Memphis, Tennessee, and the 12th Midwest Biennial at the Joslyn Art Museum in Omaha, Nebraska.

Walter is chosen as U.S. commissioner for the XXXVI Biennale di Venezia, Italy, sponsored by the National Collection of Fine Arts, Smithsonian Institution. He is the first person to organize American exhibitions for both the Brazilian and Italian biennials. The artists he chooses to represent the United States are Diane Arbus, Ron Davis, Richard Estes, Sam Gilliam, James Nutt, and Keith Sonnier. The inclusion of Arbus's work marks the first time that photography is shown at a Venice Biennale. The Biennale opens on June 11.

June, 1971: Walter is forced to resign as director of the Corcoran Gallery for aligning himself with staff members who are trying to form a union. Joshua Taylor, director of the National Collection of Fine Arts (now the Smithsonian American Art Museum) at the Smithsonian Institution in Washington, hires Walter as visiting curator of twentieth-century painting and sculpture.

1973: After Joseph Cornell's death in December, 1972, Walter is called in to sort through the contents of the artist's house on Utopia Parkway in Flushing, New York, with Richard Ader, a lawyer at the firm hired to handle

the estate. Walter obtains permission to set up what becomes the Joseph Cornell Study Center at the National Collection of Fine Arts and stores Cornell's belongings and artwork there. He enlists Lynda Hartigan, assistant curator of twentieth-century art at the museum, to help establish the center, for which she becomes the curator. (Hartigan becomes a leading Cornell scholar, presenting an important traveling retrospective of Cornell's work, "Joseph Cornell Navigating the Imagination," in 2007.)

December 18, 1973: "Anne Truitt: Sculpture and Drawings, 1961–73," curated by Walter, opens at the Whitney Museum of American Art, in New York, before traveling to the Corcoran Gallery.

January 28, 1974: Walter becomes curator of twentieth-century painting and sculpture at the NCFA.

1974: The Pasadena Art Museum is acquired by industrialist Norton Simon, who changes its name to the Norton Simon Museum. The museum's collection of contemporary art is soon relegated to the basement.

1975: Invited by the U.S. Information Service to lecture in France and Austria, Walter delivers "New Forms and Directions of Representational Art in the U.S." (later titled "Twentieth-Century Art in the National Collection of Fine Arts") at the Centre Régional de Documentation Pédagogique, Toulouse; the American Cultural Center, Paris; and Palais Pálffy, Vienna, Austria.

At the Los Angeles Institute of Contemporary Art, Walter curates "Current Concerns, Part I," which includes work by Billy Al Bengston, Ron Davis, Richard Diebenkorn, Sam Francis, Llyn Foulkes, Joe Goode, Richard Jackson, Craig Kauffman, Ed Ruscha, and Guy Williams.

September 18, 1975: "Mindscapes from the New Land," curated by Walter and Nina Felshin for the Centre Culturel Américain in Paris, opens.

October 3, 1975: "Sculpture: American Directions, 1945–1975" opens at the NCFA. The show later travels to the New Orleans Museum of Art.

Walter is one of the commissioners for the 9th Biennale de Paris.

1976: Walter curates "Robert Rauschenberg," a retrospective of the artist's work, for the the NCFA. The exhibition then travels to the Museum of

Modern Art, the San Francisco Museum of Modern Art, the Albright-Knox Art Gallery, and the Art Institute of Chicago. Rauschenberg is featured on the cover of *Time*.

Walter and Henry Hopkins organize "Painting and Sculpture in California: The Modern Era," which is cosponsored by the San Francisco Museum of Modern Art and the NCFA. The exhibition opens at the San Francisco Museum of Modern Art on September 3, in honor of the twin bicentennials of the nation and of San Francisco. (It opens at the NCFA in May of the following year.)

1977: Walter and Helen divorce.

1977–78: Walter is the project consultant to the Project Advisory Committee for the commission of a work of public art for the Civic Center Complex, Rockville, Maryland. William Calfee is the artist chosen.

1978: Walter is one of three panelists nominated by the District of Columbia Department of Housing and Community Development and the D.C. Commission on the Arts to select an artist for the commission of a major artwork for Fort Lincoln New Town, a totally new community under development.

December 7–9, 1978: Walter curates the exhibition "36 Hours" at the Museum of Temporary Art, a nonprofit alternative art space in Washington, D.C. Artists are invited to submit any work of art, within a given size range, during a thirty-six-hour submission period. Walter is present at MOTA from 9 p.m. on December 7 (Pearl Harbor Day) to 9 a.m. on December 9, to receive and install the work of every artist who enters. A line forms around the block and continues at all hours of the day and night. The final installation includes 426 entries, hung floor to ceiling, on all four floors of the building.

1979: Walter is invited to serve as a national consultant to the newly created Center for the Study of Southern Culture at the University of Mississippi, Oxford.

May 28–June 1, 1979: With Alanna Heiss and John Coplans, Walter is invited to participate in a Romanian-American Symposium, "The Artist at Work in America," at the Palace of Sports and Culture in Bucharest, Romania,

to accompany an exhibition of the same name. Both symposium and exhibit are sponsored by the United States International Communication Agency. The Romanian participants are Dan Grigorescu, Dan Hăulică, Alexandru Cebuc, and Amelia Pavel.

Walter is invited to join the board of Washington Project for the Arts, an alternative arts center in Washington, D.C. In September, "In Honor of: Ten Veteran Washington Painters," organized by Marti Mayo and Walter, opens there.

1980: Dominique de Menil asks Walter to become a consultant to the Menil Foundation in Houston, and shortly thereafter he joins its board of directors. He becomes director of the Rice Museum, Institute for the Arts, founded by John and Dominique de Menil, at Rice University in Houston. Walter commutes between Houston and Washington, working on projects in both cities.

April 16–June 4, 1980: Walter teaches a course titled "Twentieth-Century American Art" at the Washington School, Institute for Policy Studies.

June 4–7, 1980: Walter is curator, along with Eleanor Green, of the 11th International Sculpture Conference, a presentation of sculpture from around the world, installed on public land and in spaces throughout Washington, D.C.

March 10, 1981: The first survey of the work of photographer Louis Faurer, "Louis Faurer: Photographs from Philadelphia and New York, 1937–73," curated by Walter and John Gossage, for the Art Gallery at the University of Maryland, opens.

Plans are announced for the creation of the Menil Collection, a new museum that will house the extraordinary collection of art and objects assembled by Dominique de Menil and her late husband John de Menil, with Walter as its founding director. The architect Renzo Piano is hired to design a building for the Menil Collection. Walter jots in his notes: "R.P. thinks like a fine, disciplined engineer, which means a special mix of modesty, strength & dignity. There is a natural sense of process, activity, materials, not just spaces. The complex issue of light & structure is central to his thought in developing this building."

1982: Walter serves as a member of the 1982 Arts Panel, for the D.C. Commission on the Arts and Humanities.

For the Rice Museum, Institute for the Arts, Walter and Dominique de Menil curate "William Christenberry: Southern Views," a survey that then travels to the Huntsville Museum of Art and the Corcoran Gallery of Art.

Walter curates two shows for the Washington Project for the Arts: "Five From New York," which includes work by young artists Angela Cockman, Billy Copley, Anne Doran, Phillip Allen, and James Mullen; and "Poetic Objects, an Exhibition of Imagist Sculpture Employing Found Objects," alarge survey of artists working with found materials, which opens on December 3, 1982. Artists include Don Baum, Wallace Berman, Roger Brown, William Christenberry, Suzanne Codi, Bruce Conner, William Copley, Noche Crist, Roy Fridge, Sam Gilliam, George Green, Caroline Huber, Jasper Johns, Ed Kienholz, Rockne Krebs, Laurie Le Clair, Jim Love, Kim MacConnel, Ed McGowin, David McManaway, Robert Rauschenberg, John Pittman, Lucas Samaras, Yuri Schwebler, Charlie Sleichter, Alexis Smith, Carol Sockwell, Clay Spohn, Bob Wade, H. C. Westermann, and Margaret Wharton, among others.

January, 1983: "Recent Acquisitions: The Menil Collection," curated by Walter and Dominique de Menil, opens at the Rice Museum Institute for the Arts.

February 5, 1983: Caroline Huber and Walter are married in Philadelphia. Two private ceremonies are held the day before: one in front of Independence Hall at the Liberty Bell, with Marcus Raskin officiating, and one in front of Duchamp's *The Bride Stripped Bare by Her Bachelors, Even* (*The Large Glass*) at the Philadelphia Museum of Art.

June 17, 1983: "Five Surrealists from the Menil Collection," organized by Dominique de Menil, David Sylvester, and Walter, opens at the National Gallery of Art in Washington, D.C., at the invitation of the director, Carter Brown.

1983: Menil curator Bertrand Davezac is alerted to the discovery of a cache of rare thirteenth-century Byzantine frescoes. Dominique de Menil, Davezac, Walter, and Yanni Petsopoulos, an antiquities dealer living in London, travel

to Munich to view the frescoes. After determining their authenticity, the Menil Foundation embarks on an elaborate process to discover their origin— they had been looted from the ceiling of the apse of a Byzantine chapel in the Turkish-occupied section of Cyprus—and get them to safe harbor. This process involves dinner in a German brothel in the middle of the night, various unsavory characters, and a gun pointed at Walter's head. With the blessing of the Archbishopric and the Republic of Cyprus, the Menil Foundation purchases the frescoes and begins the painstaking and expensive process of restoration, finally installing them in a "chapel museum," designed by François de Menil, to house them on the Menil campus, where they remain on long-term loan from the Church of Cyprus. The Menil campus becomes the only place in the world where a Christian chapel with thirteenth-century frescoes is a short walk away from a mid-century nonde-nominational chapel with great modernist works of art, the Rothko Chapel. The methods employed to determine the origin of the frescoes and to rescue them establish "what has become known in the museum field as the Gold Standard when it comes to dealing with stolen and smuggled antiquities," according to Thomas Hoving, former director of the Metropolitan Museum of Art. (At the end of the loan period, in 2012, the frescoes are returned to the Republic of Cyprus, and the chapel is deconsecrated and refurbished, becoming a gallery for special projects.)

Walter becomes a board member of the Georges Pompidou Art and Culture Foundation, created by Mme. Pompidou and Dominique de Menil, until it is dissolved.

1984: Walter is invited to be on the selection committee for the 80th Exhibition by Artists of Chicago and Vicinity at the Art Institute of Chicago, with panelists John Baldessari and Marge Goldwater.

Dominique de Menil is invited by François Mitterrand and the French government to present an exhibition of her collection at the Grand Palais, Paris. "La rime et la raison," a survey of the Menil family collections, beginning with Paleolithic carvings on bone and continuing up to the present, with a work commissioned by Jean-Pierre Raynaud for the exhibition, is organized by Walter, Dominique de Menil, and Jean-Yves Mock, assisted by James Hou. It opens on April 17, offering a preview of the new museum to come.

July 21, 1984: Walter is guest curator for the exhibition "Automobile and Culture," based on Gerald Silk's dissertation, for which he was an advisor. The exhibition, which was initiated with Pontus Hultén, the Los Angeles Museum of Contemporary Art's founding director, opens as part of the Olympic Festival held in Los Angeles.

November 11, 1984: "The Art Show, 1963–1977: Edward Kienholz, Nancy Reddin Kienholz," curated by Walter and Neil Printz, opens at the Rice Museum Institute of the Arts.

January, 1985: Caroline and Walter move to Houston.

February 26, 1985: "Twenty-Seven Ways of Looking at American Drawing," curated by Walter and Neil Printz, opens at the Menil Collection.

May 3, 1985: For the École Nationale Supérieure des Beaux-Art in Paris, Walter and Neil Printz organize *"Cinquante ans de dessins américains 1930–80,"* an exhibition of works on paper, which later travels to Germany.

July 11, 1986: Walter organizes "A Brokerage of Desire" with artist Howard Halle, and assisted by James Hou, for the Otis Art Institute of Parsons School of Design, Los Angeles, which features Alan Belcher, Gretchen Bender, Anne Doran, Jeff Koons, Peter Nagy, and Haim Steinbach. A version of the exhibition, *"Carte blanche: les courtiers du désir,"* is organized for the Centre Pompidou, Paris, and opens there on April 15, 1987.

October 17, 1986: "Four Walls," an exhibition staged by Walter in celebration of the fifth anniversary of the Houston Center for Photography, at the invitation of its director Lew Thomas, opens. The exhibition is divided into four sections, each occupying a different wall. A selection of important photographs from the Menil Collection is installed on a wall titled "There"; on a wall titled "Now" are three abstractions made by Herman Detering, John Gutmann, and Lew Thomas constructed from photographic material Walter provided to each of them; on the wall titled "Here," Walter arranges photographs he took at HCP a week before; "10 Hours" includes photographs taken by HCP members who were invited to bring in work during a ten-hour period. Walter serves on the advisory board of HCP until 1991.

June, 1987: The Menil Collection opens to the public in the internationally acclaimed building designed by Renzo Piano. The opening art selection and installation of the Menil Collection are done by Walter, Dominque de Menil, and Paul Winkler, the museum's assistant director. Walter organizes two exhibitions for the opening: "John Chamberlain: Sculpture 1970s and 1980s," in collaboration with John Chamberlain, and, with Kathryn Davidson, "The Adrenalin Hour: Wartime Art by Ben L. Culwell," in addition to the exhibition "Surrealism: Selections from the Menil Collection," an ongoing installation that he revisits three times. Culwell is a relatively unknown artist whom Walter feels was seminal to much of the expressionist art made in Texas. This pairing of Culwell and Chamberlain is indicative of Walter's philosophy of pairing the known with the undiscovered or redis-covered. Also, "Warhol Shadows," organized by Walter and Neil Printz, opens at Richmond Hall, an exhibition space in a converted market on the Menil campus. Walter has ensured that the new museum includes a room for installation design, where a scale model of the galleries is installed, measuring 33.5 feet by 8.5 feet by 23 inches. Miniatures of the works to be displayed are created, for the first several years, by the artist John Peters, later known as Mark Flood. A periscope is made that provides a view from inside the miniature galleries.

December 23, 1987: "Marcel Duchamp/Fountain," curated by Walter and William A. Camfield, opens at the Menil Collection.

March 2, 1988: "Photographs: Henri Cartier-Bresson, Walker Evans," curated by Walter and Kathryn Davidson, opens at the Menil Collection.

May 20, 1988: "Robert Longo: Selected Works" and "David Salle: Selected Works," two concurrent one-person exhibitions, open at the Menil Collection.

July 21, 1988: "Richard Jackson: Installations 1970–88," curated by Walter and Neil Printz, opens at the Menil Collection's Richmond Hall.

October 21, 1988: "Andy Warhol: Death and Disasters," curated by Walter and Neil Printz, opens at the Menil Collection.

October 22, 1988: "Selected Prints by Jacques Callot, Stefano della Bella, and Francisco Goya," curated by Walter and Kathryn Davidson, opens at the Menil Collection.

April 14, 1989: "Works on Paper by Jasper Johns, Robert Rauschenberg, and Larry Rivers" opens at the Menil Collection.

May, 1989: Wanting to concentrate on curatorial projects rather than the administrative and fundraising responsibilities that are required of a director, Walter resigns as director of the Menil Collection, remaining as a curator. He resigns from the board of directors as well. Paul Winkler becomes director of the Menil Collection.

October 27, 1989: "Max Ernst: Selections from the Menil Family Collections" opens at the Menil Collection.

1990: In a collaborative project between the J. Paul Getty Museum, the Republic of Cyprus, and the Menil Collection, Walter and Dr. Vassos Karageorghis, advisor to the president of Cyprus on cultural property, with whom Walter worked to secure the frescoes, organize "The Birth of Venus: Neolithic & Chalcolithic Antiquities from Cyprus." The show opens at the J. Paul Getty Museum in Los Angeles and then travels to the Menil.

1990: Walter becomes the art editor of *Grand Street*, a quarterly literary and art journal, edited by Jean Stein and published by Jean Stein and Torsten Wiesel. (Walter retains this position until his death.)

September 27, 1990: "Josef Albers" opens at the Menil Collection.

February 6, 1991: "Dan Flavin: Three 'Monuments' for V. Tatlin" opens at the Menil Collection.

June 15, 1991: "Robert Rauschenberg: The Early 1950s," a landmark exhibition and catalogue produced by the Menil Collection, curated by Walter with Neil Printz and Susan Davidson, opens at the Corcoran Gallery of Art before moving to the Menil. It then travels to the Museum of Contemporary Art, Chicago; the San Francisco Museum of Art; and the Solomon R. Guggenheim Museum, SoHo, New York City.

July 31, 1991: "Object & Image: Recent Art from the Menil Collection," featuring work by Haim Steinbach, Gretchen Bender, Anne Doran, Howard Halle, Peter Nagy, Cindy Sherman, Donald Lipski, and Lew Thomas, opens.

1991–99: Walter serves as guest curator and member of the selection committee for the Museo de Arte Contemporáneo de Monterrey, Mexico.

May 29, 1992: "Six Artists," curated by Walter and Paul Winkler, opens at the Menil Collection, featuring the work of John Chamberlain, Willem de Kooning, Yves Klein, Brice Marden, Jean Tinguely, and Andy Warhol.

August, 1992: Don't Gag the Arts, a rally to protest funding cuts and political censorship by the National Endowment for the Arts, is held on the campus of the Menil Foundation; Walter is one of the speakers.

September 25, 1992: "Contemporary Art from the Marcia Simon Weisman Collection" opens at the Menil Collection.

October, 1992: "Joseph Cornell: *Años Cincuenta y Sesenta*" opens at the Museo de Arte Contemporáneo de Monterrey.

October 5, 1992: Sponsored by Rain Forest International, in conjunction with Fernbank Museum of Natural History, "Picturing Paradise: Art and the Rain Forests," organized by Walter, John Beardsley, and Frances Fralin, opens in Atlanta to celebrate the new museum building.

January 14, 1993: Walter is photographed by Brigitte Lacombe for a Gap ad that runs in Texas publications.

March 14, 1993: "Max Ernst: Dada and the Dawn of Surrealism," organized by the Menil Collection and curated by Walter, William Camfield, Susan Davidson, and Werner Spies, opens at the Museum of Modern Art and then travels to the Menil Collection and the Art Institute of Chicago.

September 10, 1993: "Jacob Kainen," a traveling retrospective curated by Walter for the National Museum of American Art, opens there.

March 10, 1994: Walter suffers a brain aneurysm. He is hospitalized for three months.

1995: Walter is one of thirteen curators invited to participate in "Changing Perspectives," June 23–October 1, 1995, at the Contemporary Art Museum, Houston. Each curator independently selects a work of contemporary art for the exhibition. The original works are installed by the CAM staff. Then, on

a rotating schedule, each curator, in response to the exhibition, replaces his or her original work with a new one and reinstalls the exhibition.

October 20, 1995: "Edward Kienholz: 1954–1962," opens at the Menil Collection.

February 29, 1996: "Kienholz: A Retrospective," a large survey of the work of Edward Kienholz and Nancy Reddin Kienholz, organized by Walter and Alberta Mayo, opens at the Whitney Museum of American Art, then travels to the Museum of Contemporary Art in Los Angeles and the Berlinische Galerie, Berlin.

1996: Walter rejoins the board of the Menil Foundation and serves until 2002.

September 19, 1997: "Robert Rauschenberg: A Retrospective," Walter's second survey of Rauschenberg's work, organized with Susan Davidson, opens at the Solomon R. Guggenheim Museum, the Guggenheim Museum SoHo, and the Guggenheim Museum at Ace Gallery. The exhibit then travels to the Menil Collection, the Contemporary Arts Museum, and the Museum of Fine Arts, Houston (it is presented simultaneously at all three institutions), and on to the Museum Ludwig, Cologne, and the Guggenheim Museum Bilbao, where it ends on February 26, 1999. Rauschenberg creates new works specifically for some of the venues.

1998: Walter works with colleagues Lynda Hartigan, Ann Temkin, Susan Davidson, and Ecke Bonk to realize "Joseph Cornell/Marcel Duchamp . . . in Resonance," an exhibition and catalogue based on Walter's conviction that the mutual admiration and friendship shared by Cornell and Duchamp yielded fertile ground for both of them. The award-winning catalogue was designed by Ecke Bonk and Don Quaintance. Coproduced by the Philadelphia Museum and the Menil Collection, it opens at the Philadelphia Museum of Art on October 8, 1998, and then travels to the Menil Collection.

March 19–20, 1998: Walter is invited to participate in New Traditions II: Intellectual Leadership in the New Century, the opening conference for the newly formed American Academy in Berlin. The participants are leaders from American and German political, cultural, and economic life,

including German chancellor Helmut Kohl and Richard Holbrooke, who was then a U.S. special envoy to the Balkans.

1999: Walter travels to Gothenburg, Sweden, to introduce William Eggleston, recipient of the 1998 Hasselblad Award, at the award ceremony. For the Menil Collection, Walter organizes "William Eggleston Photographs: Then and Now," which opens on May 28, featuring works from the collection, and "Remembering Saul Steinberg," which opens September 24.

March 24, 2000: "David Salle: Paintings and Drawings," curated by Walter, opens at the Museo de Arte Contemporáneo de Monterrey.

2000: Walter and Robert Rauschenberg are the first recipients of the San Francisco Art Institute McBean Distinguished Lectureship and Residency. To mark the occasion, Rauschenberg and Walter hold an informal discussion on April 13. At Rauschenberg's invitation, Walter travels to New York to participate in the first installation of *Synapsis Shuffle* a fifty-two-panel artwork by Rauschenberg, to be unveiled at the Whitney Museum of Art on June 26. Each invitee selects three to seven panels from the original fifty-two to arrange as he or she likes. Other participants in the inaugural shuffle include David Byrne, Chuck Close, Merce Cunningham, Renée Fleming, Robert Hughes, Mathilde Krim, Michael Ovitz, Edwin Schlossberg, Ileana Sonnabend, and Martha Stewart. Like a deck of cards, the fifty-two paintings are reassembled by different individuals for each new installation, to create a continually changing work.

January 28, 2000: "John Chamberlain Sculpture: Selections from the Menil Collection and the D.I.A. Art Foundation," curated by Walter and Susan Davidson, opens at the Menil.

June 9, 2000: "Sharon Kopriva: Works, 1986–1998" opens at the Menil Collection.

January 27, 2001: The Walter Hopps Award for Curatorial Achievement is established by the Menil Foundation, with a gala dinner and fundraiser. Dennis Hopper and Jean Stein are honorary cochairs; Nancy Allen and Marilyn Oshman are cochairs. The evening includes a musical toast by Terry Allen and tributes from François de Menil, Anne d'Harnoncourt, Dennis Hopper, Nancy Reddin Kienholz, Robert Rauschenberg, and Ed Ruscha.

Administered by the Menil Foundation, this biennial award aims to continue Walter's tradition of innovation and excellence through grants given to younger curators who have made adventurous contributions to the field. Houston mayor Lee Brown declares January 27, 2001, "Walter Hopps Day," with a signed proclamation.

February 26, 2001: "Post-Modern Americans: A Selection" opens at the Menil Collection. Artists presented are Gretchen Bender, Anne Doran, Mark Flood, Howard Halle, William Harvey, Rachel Hecker, Sherrie Levine, Robert Longo, Manual (Ed Hill and Suzanne Bloom), Michael McCall, John McIntosh, Jack Pierson, Rachel Ranta, Cindy Sherman, Alexis Smith, Al Souza, Haim Steinbach, Lew Thomas, and Robert Williams.

2001: Walter is appointed adjunct senior curator of twentieth-century art at the Solomon R. Guggenheim Museum, in addition to his position at the Menil Collection.

May 17, 2003: "James Rosenquist: A Retrospective," organized by Walter and Sarah Bancroft, opens concurrently at the Menil Collection and the Museum of Fine Arts, Houston, then travels to the Solomon R. Guggenheim Museum, New York, the Guggenheim Museum Bilbao, and to its final stop, the Kunstmuseum, Wolfsburg, Germany, where it opens in February, 2005.

2004: Walter is the recipient of the 2004 Award for Curatorial Excellence from the Center for Curatorial Studies at Bard College. At the gala dinner on May 4, Ann Temkin and James Rosenquist present Walter with the award.

March 5, 2005: Walter is guest curator for "George Herms: Hot Set," which opens at the Santa Monica Museum of Art, Santa Monica, California. A panel discussion with Anne Doran, George Herms, and Walter takes place at the museum on March 8.

March 20, 2005: Still in California, Walter succumbs to complications from heart failure, a few weeks shy of his seventy-third birthday. He is buried in the high desert in Lone Pine, California, where his father's ashes were scattered. It is a place he appreciated: the nexus of the Continental United States's highest point, Mount Whitney, and its lowest, Death Valley, and the Ancient Bristlecone Pine Forest, home to the oldest living trees on earth. Walter's

coffin is a simple pine box, similar to the coffins John and Dominique de Menil were buried in. The lid of Walter's coffin is an old door, with its door-knob intact, from his Pasadena house. He is buried with a telephone, some photographs, and a cloth "Alice in Wonderland" doll that was given to him by Jean Stein and became his good-luck charm. A phrase he loved from T. S. Eliot's "The Love Song of J. Alfred Prufrock" is engraved on his headstone:

> Let us go then, you and I,
> When the evening is spread out against the sky
> Like a patient etherized upon a table

Walter Hopps surrounded by friends and artists at Nancy Reddin Kienholz's studio, in Houston, 2001, the night before the inauguration of the Walter Hopps Award: Walter Hopps, Caroline Huber, Robert Rauschenberg, Ed Ruscha, Virgil Grotfeldt, James Rosenquist, Dennis Hopper, Jim Love, Sharon Kopriva, Ed Moses, James Surls, Pixi Herms, Jim Nutt, Lukas Johnson, William Stern, Tray Allen, and others. Photograph by George Hixson.

ILLUSTRATION CREDITS

Institution, Gift in honor of James T. Demetrion, Director, HMSG (1984-2001), by Robert and Aimee Lehrman, 2013. Photograph by Cathy Carver.

Walker Evans in Front of Brick Wall with Commercial Signs, Alabama. © Estate of William Christenberry. Walker Evans Archive. © The Metropolitan Museum of Art. Image source: Art Resource. © Pace/MacGill. Used with the permission of Sandra and Kate Christenberry.

Red Building in Forest, Hale County, Alabama, © Estate of William Christenberry. J. Paul Getty Museum, Los Angeles. Gift of Nancy and Bruce Berman. Used with the permission of Sandra and Kate Christenberry.

Untitled, from *Los Alamos.* © Eggleston Artistic Trust. Courtesy of Winston Eggleston.

California, 1974 (Walter Hopps in Phone Booth), from *Los Alamos.* © Eggleston Artistic Trust. Courtesy of Winston Eggleston.

April 4. Smithsonian American Art Museum, Washington, D.C. / Art Resource, NY.

Helmholtzian Landscape. © The Estate of David Smith / Licensed by VAGA, New York, NY. Courtesy of The Kreeger Museum.

The Throne of the Third Heaven of the Nations' Millennium General Assembly. Smithsonian American Art Museum, Washington, D.C. / Art Resource, NY.

Untitled, c. 1954. Courtesy and © Robert Rauschenberg Foundation. The Museum of Contemporary Art, Los Angeles. The Panza Collection.

Portrait of Dominique de Menil. The Menil Collection, Houston. © 2017 Artists Rights Society (ARS), New York / ADAGP, Paris. Photograph by Paul Hester.

IMAGE CREDITS (B&W)

Page xii, 7, 12, 14, 18, 41, 45, 51, 144: Courtesy of Caroline Huber.

Page xvii: Courtesy of the Ed Ruscha Studio.

Page 32: Philadelphia Museum of Art, Arensberg Archives.

Page 36: Beatrice Wood papers, 1894–1998, bulk 1930–1990. Archives of American Art, Smithsonian Institution.

Page 57: The Getty Research Institute, Charles Brittin papers © J. Paul Getty Trust. Courtesy of Lauri Richer.

Page 59: The J. Paul Getty Museum. © Edmund Teske Archives/Lawrence Bump and Nils Vidstrand.

Page 66: The Getty Research Institute, Charles Brittin papers. Courtesy of the Temple of Man, Inc.

Page 69: © Patricia Faure. Courtesy of the Estate of Patricia Faure.

Page 71, 74, 78: The Getty Research Institute, Charles Brittin papers. © J. Paul Getty Trust.

Page 79: Estate of Wallace Berman—Shirley and Tosh Berman. Courtesy of Kohn Gallery.

Page 85, 160, 187: Courtesy of the Frank J. Thomas Archives.

Page 92: *The Washington Post.* Courtesy of Getty Images.

Page 96, 123: © SPACES—Saving and Preserving Arts and Cultural Environments.

Page 101: The Getty Research Institute. © J. Paul Getty Trust and Joe Goode.

Page 108: Courtesy of Dagny Janss Corcoran.

Page 119: Addison Gallery of Art, Phillips Academy, Andover, Massachusetts (gift of Marion Faller, Addison Art Drive, 1991).

Page 142: [Photographs of California artists]. Archives of American Art, Smithsonian Institution.

Page 148: Pasadena Art Museum. (Photograph by J. Allen Hawkins Studios; courtesy of the Archives, Pasadena Museum of History, Main Collection, M17-6-7).

Page 150: Artworks © Llyn Foulkes; image courtesy the artist and Sprüth Magers, Los Angeles.

Page 158: © 1963 Julian Wasser. Courtesy of Julian Wasser and Craig Krull Gallery, Santa Monica, California.

Page 167: Courtesy of the Factor Trust.

Page 175: The LIFE Images Collection/Getty Images.

INDEX

Note: Page numbers in *italics* refer to illustrations.

A NOTE ON THE AUTHOR

Walter Hopps (1932–2005) was a curator and museum director who worked at the Pasadena Art Museum, the Washington Gallery of Modern Art, the Corcoran Gallery of Art, the Smithsonian's National Collection of Fine Arts, the Menil Collection, which he helped create, and the Solomon R. Guggenheim Museum.

A NOTE ON THE EDITORS

Deborah Treisman has been the fiction editor of *The New Yorker* since 2003 and was deputy fiction editor for six years before that. She hosts *The New Yorker Fiction Podcast* and was the editor of the anthology *20 Under 40: Stories from The New Yorker*. From 1994 to 1997, she was the managing editor of the art and literary quarterly *Grand Street*, for which Hopps was the art editor.

Anne Doran has written for *Art in America, Artforum, ARTnews, Atlántica,* and *Time Out New York.* From 1996 to 2004, she was an editor at *Grand Street.* Her artwork has been shown in New York at Invisible-Exports and the New Museum of Contemporary Art, and in Europe at the Stedelijk Museum Amsterdam and the Centre Georges Pompidou in Paris, among other venues.